Vision in Design
A Guidebook
for Innovators

Paul Hekkert
Matthijs van Dijk

B**IS**

>Designing actually starts by establishing the 'raison d'être' (the reason for existence) for the final design.

ViP was invented for designers who value taking this responsibility<

Foreword
By Peter Lloyd

The first edition of *Design Methods: Seeds of Human Futures* was written in 1970. It's author, John Chris Jones, sensing a growing complexity in technology, and concerned that designers should make their decisions demonstrable, looked at how to formalise the process of design. No longer should design be a craft process, a slow intuitive shaping of form and function, but a structured, controlled process. "We should really know what we are doing when we design," thought Jones. In the America of the 1960s, designers like Henry Dreyfus had already begun to integrate ergonomic studies into the process of design; Jones just took the idea a bit further. *Design Methods* introduced systematic ways of analysing a wide range of what might be termed 'situations'. The methods themselves had been inspired by the precision found in scientific language: *investigating*, *selecting*, *classifying*, *ranking*, and *weighting*. The design process itself was a process of *divergence, transformation*, then *convergence*; paradoxically inspiring something vaguely religious-sounding, like three consecutive John Coltrane albums. It turned out to be a fully realised theory of designing.

 Designers could now exercise their creativity from solid theoretical ground – not the shifting sands of individual craft knowledge. And other designers could stand proudly with them. That was the theory anyway; in many ways it was laudable. After all, it was human futures that we were talking about, the seeds of a new world. History tells it somewhat differently, of course, as history would. The book was well received, a breath of (nearly) fresh air. More power to the fist of the designer who, slowly but surely, began to thump the cover of the book in design meetings. "This is how we've done it" he'd say (for it was mostly a he), "we followed the method, we did the analysis, we know this is the right decision because it was properly ranked and weighted", he'd continue, "the solution structure perfectly fits the problem structure." The misgivings anyone had were forced to adopt the same language and consequently were revealed as a sham. Indefinable judgement, a niggling feeling that things were not quite right, was ignored unless evidenced. The book thumping continued as text was quickly transformed into pretext.

Once the boat was floating, other people clambered aboard, desperate to be part of the journey. The "-ologist" – the not-quite scientist looking for a discipline – acquired a "method" prefix, and a discipline was born. Bruce Archer worried about the boundaries of science, art, and design. Nigel Cross collected best practice. Stuart Pugh, perhaps after watching the Dutch football team at the 1974 world cup, came up with *Total Design*. Pairs of oarsmen climbed aboard: Roozenburg and Eekels, Hubka and Ernst Eder, Pahl and Beitz. All with the best intentions of course. Design problems were getting increasingly complicated, and their scope extended much further than anyone had first thought. Urban planners and architects were even fetching up in the boat. What nobody realised, however, was that Jones had already, quietly, disembarked.

Jones continued walking on foot. Maybe he was following the river; maybe he was finding his own path. Either way he worried about being misunderstood. The methods were not meant as blunt instruments to beat people with, thought Jones, they were tools to think with, to play intuition off against. If we follow a set of rules properly we arrive at a place that we couldn't have foreseen, outside of the intuitions we had when the problem was first put in front of us. Intuition must form part of the ongoing process, thought Jones. Together, analysis and intuition balance one another out. And following rules creates new intuitions. The methods were meant to make things discussable and questionable, not definitive; to bring private thoughts out into the social world; to share responsibilities. The problem was that the most obvious question to ask after applying a method was always, "Do I like the answer?" Intuition always seemed to hold the best cards.

Somewhere on his long, still continuing walk, Jones embraced the idea of chance. "If we create a method that has elements of chance within it, we can really find out what we think", thought Jones, "our intuitions become explicit." This was method as revelation. If you can design a process that includes chance *and* live with the results, then you really know where you are going. "Method and intuition are two sides of the same coin," thought Jones, as he carried on walking…

Contents
ViP

Foreword
By Peter Lloyd 4

Preface
What is ViP about? 10

Introduction
The roots of ViP 12

PART 1
Why use ViP?

Example student concepts 25
1. Mobile Communication 26
2. Mobility 27
3. Gaming 28
4. Office Technology 29
5. Medical Supply 30
6. Baby Care 31
7. Domestic Appliance 32
8. Public Transport 33
9. Health Care 34
10. Education 35

Professional cases 36
1. Retail for Dutch railways 38
2. Pininfarina Nido, a city car concept 46
3. Dutch Ministry of the Interior and Kingdom Relations 60

Interview
Thinking and feeling 77

PART 2
How to apply ViP?

A ViP Process in 11 sessions 84

An invitation to ViP
A model, and some playful practice 118

The ViP Process A how to 131
Preparation: 'destructuring' 134
Step **1** Establishing the domain 137
Step **2** Generation of context factors 141
Step **3** Structuring the context 148
Step **4** Statement definition 154
Step **5** Establishing a relationship: designing human-product interaction 158
Step **6** Defining product qualities 163
Step **7** Concept design, or 'concepting' 166
Step **8** Design and detailing 177
Final words on the process: on user involvement 183

Discussion of
interaction images 190

Interviews 202
Dealing with values
in the context 204
What do we mean
by 'principles'? 208
'Interaction' in
the context of ViP 214

Dealing with the client 222

Essays
On designing a context 230
On understanding interaction 240
On product meaning 248

The ViP Process in Practice
10 (abriged) Student Cases 254
❶·❷ Street Furniture 256
❸·❹ Laundry Process 258
❺·❻ Male Emancipation 260
❼·❽ In-flight Experience 262
❾·❿ Train Journey Time 264

PART 3
What inspired ViP?

Essays
On adaptation and fitness 278
On creativity 284
On innovation and novelty 284
On feeling and thinking 296
On the primacy of universal
human principles 300

Discussion
Talking design methodology 310

Epilogue 322
References 326
Glossary 330
Acknowledgements 334

>The dialogue form also reflects the underlying philosophy of ViP: that designing is itself a conversation; a construction through a certain kind of dialogue;

and a working out of meaning by watching, talking, and communicating ‹

Preface
What is ViP about?

Student Mister Van Dijk, I've been trying to get in touch with you. I really wanted to ask you about this ViP approach I've heard so much about. People say that you use it in your design work and that it's successful. Is that true?
Van Dijk At the moment it's fairly successful. But to be honest it took me a lot of energy to get ViP accepted as a tool. It is like any innovation process… it took 15 years to implement. It took me 10 years to sell the expertise to clients. I started working with ViP in 1995. The funny thing is that now ViP is part of me; it's just how I work.
Student Wow, that sounds personal...
Van Dijk I think anybody can learn ViP. I have seen students increase their expertise through the process, but I have also seen very confused designers try to understand the benefits of the approach.
Student I've used other approaches in the past – design methodologies – but they haven't really worked for me.
Van Dijk Same here.
Student How will I know if ViP is for me?
Van Dijk Just try and keep an open mind. Just experience ViP and make a judgement afterwards. It is just like football, or cooking, or yoga, or any technique or practice: talking is fine, but in the end to find out whether you like it, whether it benefits you, you have to try it yourself. ViP helps me face complex systems and reduce them to insightful design starting points…
Hekkert Now Mr. Van Dijk is getting complicated. Sorry to interrupt, but maybe I can help by explaining the basics?
Van Dijk Yes, go ahead.
Student I just want to know where to start.
Hekkert It all comes down to where a designer looks for the starting points for a design. Many methods start by asking you to list the requirements that the final solution should meet. These requirements form constraints that limit your search. If you already have what kind of object you want to design in mind then this approach can be reassuring. But some students find it frustrating…
Student Yes! I've often felt like that. I don't like having to write down concrete requirements – you called them constraints – but then what's the alternative? Aren't there always constraints in designing that you have to face?
Hekkert Yes, but with the ViP approach these constraints are considered as late in the process as possible. Instead, we want designers to think about what is possible. What would you really want to put into the world...But how do you know? Well, you ask yourself, what is this world I am designing for? What matters in this world? You use your imagination, and your sense of what is changing in the world and the people living in it. What do they really need? What are they looking for? What are their lives like? And not only what is changing, but also all the traits and propensities that make us human in the first place. We have developed some nice distinctions to help you with this.
Student Right, that sounds more like what I'm after; I quite often think about what I *should* put into the world. But is this technique something I can really make a living with?
Van Dijk The idea is that a designer has to assume responsibility for the things created. So any tool that helps a designer predict the future meaning of a product will help.
Student So is it a kind of future-based approach? I've tried scenario planning before, but it didn't agree with me...
Hekkert There are some similarities, but also crucial differences. Scenario planning is a strategic tool where a small number of likely futures are envisioned. With ViP, the designer constructs just one future world that he or she believes is most relevant and interesting for the current project. It could be the most likely or the most fascinating! We leave it up to the designer to decide.
Van Dijk The most significant aspect of ViP is creating a frame of reference for future product development. This is an act of re-framing. The frame of reference sketches a future world, without taking any moral standpoint.
Student Is it kind of like science fiction – you imagine a whole world, and then think of the products to put into that world?
Van Dijk Exactly.
Hekkert But, you can't just invent *anything*! That world has to be plausible, with solid

arguments, if only to defend it to your clients. ViP is not about building castles in the sky.

Student Mr. Van Dijk, do you feel that by using ViP, you have made new worlds possible?

Van Dijk Definitely! After defining this future world comes a crucial step however: the designer defines how he or she wants people to act in that future world. This step describes the goal to be accomplished, not in terms of product specs, but how people experience and act with the product to be designed. It is about creating future human behaviour.

Hekkert When you know what you want to offer the world, you can then decide which solution may work, whether it's a physical product, a service, or any other 'thing'.

Student Cool! Do designers already use ViP?

Hekkert ViP was partly developed by talking to designers we considered 'visionary'. For example, they talked about getting rid of preconceptions, freeing the mind…Only if you are 'free', they said, could you consciously decide what to take into account – and what *not* to take into account.

Over the years we have explained the ViP approach to many professional designers who recognise themselves and their work methods. It shows that the approach resonates with what designers do…

And, of course, we have trained students to work with ViP. Many of them still use it, in some form or another.

Introduction
The roots of ViP

Imagine you are on an 11-hour flight from Amsterdam to Hong Kong. After six or seven hours you've seen most of the in-flight entertainment, you are halfway through the book you brought, your body is stiff from the small space you've been squeezed into for such a long time, you're hungry, and you still have no idea who that stranger is sitting next to you. The situation is all but comfortable, and you want out! Luckily, personnel has started their tour through the plane again, this time to serve dinner; a distraction is approaching…Ten minutes later – or was it hours? – the stewardess serves you a tray with soup and a salad. In between the two dishes is a little bag with croutons to use with both the salad and soup. Puzzled, you turn to your neighbour to see how she is dealing with the situation. Upon meeting your gaze, she helplessly indicates she also has no clue and the two of you decide together to put all the croutons in the soup. The conversation continues over dinner, and she turns out to be lively and engaging company. Surprisingly soon the plane starts to descend and you see the city of Hong Kong looming through your window.[1]

We live in a designed world. In the Netherlands, where we (the authors) happen to live, everything around us is designed. Even the ground beneath our feet has been designed to stay dry. Designed products – from cars to telephones, from medicines to voting systems, from houses to landscapes, from television formats to airplane meals, from insurance policies to banking services – reflect what we need and value in our personal and social life.

As much as designed products reflect what we *want*, they also determine what we *do*: how we communicate, how we move and entertain ourselves, how we sleep, eat, dress, and work, how we behave in many ways. Taking this notion one step further, designed products can shape the way we live together: how we shape our society and our communities, how we live our lives, what we aspire to, nurture, and desire.

Considering this role of design(s) in the lives of people and society, it is safe to conclude that designers – of any kind – have an enormous responsibility. Are they sufficiently aware of this responsibility? Do they always strive to bring to the world what they believe is best for people and society? To support designers with this responsibility, we have designed the Vision in Product design approach (ViP).

Meal for KLM in-flight services, 2006

ViP is a design method which is *context-driven*, and *interaction-centred*. It offers designers and students of design – again, of any kind – a unique way of coming up with products that bring people (new) meaning or value.

As hollow and forced as these words may look now, in the next 325 pages we will explain in detail what these words and promises actually entail.

Let's start by looking at why products are the way they are. Read the following observations about people in the past, present, or future that might come:

1. People need social relationships, and want to belong to (a group of) other people.
2. People are impatient and want things to happen instantly.
3. People love sharing (little) secrets.
4. People communicate their feelings more easily in an indirect way.

If you consider these four behavioural drivers together, what product could possibly be designed to meet those needs simultaneously? Whenever this question has been put to our class of industrial design students, there has always been one or two who 'know' the answer: SMS messaging![2] Sending SMS messages allows people to be connected to others, irrespective of time and place – from the senders' point of view – and safely share very personal thoughts and feelings. Now (2010), we can hardly remember what life was like before its existence. It is so important to us because it touches upon some of our most fundamental concerns. Millions of messages are sent around the globe on a daily basis. The SMS service is one of the most successfully designed "products" of recent decades. Yet, as the story goes, the product was never designed...at least not for the purposes explained above.

In 1997, I (Paul) went to a design conference in Stockholm. The evening after I arrived, I visited a local bar for a beer. At first, it looked like a normal bar, with several young people sitting around tables together. In fact, there was nothing really *wrong* with the bar. However, when I started looking around more closely, I noticed something strange. The youngsters weren't talking to each other; all were busily engaged with their mobile devices, typing and receiving SMS messages! There, with the service

actually in use, I saw the dawning value or meaning of this service for the first time in my life. It is crucial to observe people interacting with a product to see the product's real meaning; in interaction, products reveal meaning and absorb meaning.

Interactions with products do not take place in a vacuum. Both products and people are part of, and shaped by, a context. This context is much more than the momentary, physical environment in which the interaction takes place, like the bar in the SMS example above. The context of any interaction is also composed of social and cultural conditions, laws of (human) nature, economic and technological changes, etc. In sum, a seemingly endless number of mechanisms – we will call these 'factors' later – co-determine what people are and need, and what products could or should provide.

Recently, we were hired by a large, pan-European client. We started by asking their representatives for their impressions of their current product portfolio. What do your products express? How do you think people see your products? Much to our surprise, they characterized their own products as cold, aggressive, complex, and inaccessible, qualities not perceived as desirable by the company itself. Within an hour they understood that there was something fundamentally wrong with their products. Instead of immediately transforming these products by generating new ideas that would solve their problems, we asked them to describe the products' background: where did they come from? Why are they the way they are? After some reflection, they discovered that their current products were based on observations, considerations and views that were totally outdated. These background ideas belonged to a world – a context – that had fundamentally changed over the past 10 years.

Another story. Some years ago, we visited the design department of a multinational in the field of fast moving consumer goods. They showed us eight concept designs for the packaging of a new product, designed by a major international design firm, and paid for with serious money. The job for the company design team was to choose the best concept design, and they had set up an ingenious system to find out which one was best. Each concept had to be rated using a wide array of criteria related to usability, brand identity, sustainability, production, shelf impression, etc. Their system had revealed that one concept was the winner, but they were still not convinced…

We cautiously explained that they could have saved a lot of energy and resources if they had developed a clear vision of how the new product

ought to be perceived and experienced by their customers beforehand. One or two concepts that fit that vision probably would have sufficed... and saved them a lot of money too.

This book shows you how to build such a vision, to see order and meaning that is 'not yet there'. This book aims to guide you in your creative process. It presents a design framework that supports you in your search for the 'right' things at the 'right' time, to make the proper design decisions when needed. Such a framework is called a 'design methodology', and because forming a vision is central to the approach, we have coined it Vision in Product design, heretofore abbreviated as ViP.

A design framework or methodology, covering a number of steps to take, is, understandably, based on premises, both logical and personal. At least, that is our view.[3] Below is a short summary of what (we believe) are the three most important premises of the ViP approach. "We believe", because it is not easy to pin down exactly *why* we believe things need to be a particular way...

- Designing (according to ViP) is about exploring what is possible tomorrow instead of solving the problems of today.

Rather than looking at the world in terms of problems, we feel it is much more productive and challenging to look for possibilities and opportunities to contribute to the lives, dreams, habits, peculiarities and goals of people, whether they have been clearly articulated or not. For that reason, unavoidable constraints and limitations (often referred to as 'requirements') – stemming from clients' wishes or resources, regulations, production methods, and inherent properties of the to-be-designed product – must play as minor a role as possible in concept generation.

Designers often like these limitations, and some even argue that they need them to perform at their best. The *freedom* we promote might be slightly intimidating at first; the designer asks, "Where to begin?" But put in the right hands, it is this freedom that can make designers flourish.

- Designing is not only the making manifest of some (physical) object, but foremost the generation and development of the idea that provides it (the product) with a *raison d'être*.

Designers need to have a clear idea where they want to go before they start concepting and materialising. 'Materialising', however, is only an option if a physical solution seems most apt; using ViP requires the designer to translate an idea into its best possible manifestation, whether a tangible product, a multimedia application, an environment, a brand, a service, or a combination of these.

ViP is really an approach that helps define what to design, and *why*! It makes little sense to adopt the ViP approach if your client insists on a 'flexible, fashionable, modestly priced 3-wheeled trolley for city dwellers'. The product idea has already been fixed. Still a serious task, but not one for which ViP can be used to guide you.

The focus on idea generation makes the ViP methodology applicable to all design fields: industrial, product and graphic, and also to the design of services, brands and public policies.

By placing emphasis on the underlying reasoning, or '*raison d'être*', or 'Daseinsgrund' of a designerly intervention, we make the designer personally *responsible* for the outcome and eventual impact of this intervention.

● A designer is an individual with
preferences, values, beliefs, and desires,
like all other human beings

It is our strong belief that personal values are always present in any design process. Designers simply cannot take every possible consideration into account when coming up with a solution. They need to be selective and prioritize. Designers also need to make a range of decisions during a design project. In all this, designers involve personal values and opinions, often implicitly. These values and beliefs are part of their being, shaped by previous experiences, cultural norms and standards, and acquired convictions of what should and should not be. By challenging the designer to apply them deliberately and emphatically – and remain conscious of their consequences – ViP asks the designer to take personal responsibility for the design. Moreover, by giving room to a designer's personal views and values, we try to stimulate *authenticity*, so designers act on genuine beliefs and come up with credible solutions.

Embedded in these premises are the key values needed for any designer who wishes to follow this approach: *freedom, responsibility* and *authenticity*. 'Freedom' means liberty from the restrictions (to move in

a certain direction) made by external forces, unless they are agreed upon; 'responsibility' means an attitude of complete awareness and acceptance of the consequences regarding any decisions made; and 'authenticity' is the hallmark of a personally genuine and unique contribution to a future world. The three values are clearly related, and can be easily opposed to traits like docility, indifference, and pretending. Only if you are free can you act authentically, and acting authentically evidently leads to responsibility.

However, the three values are also independent, at least to some extent. A designer can be authentic and free, but not responsible, as when he deliberately designs a game that is highly addictive, while he generally opposes addiction. Similarly, a designer might be responsible, but not free and authentic, when for example he designs a product-service system persuading people to lose weight whereas he has no personal interest in health issues. Only when a designer embraces all three values in a design process is ViP used the way we believe it should be.

We have some additional beliefs that we would like to share with you here. First, we believe designers can and should look at the world differently, with a fresh and original perspective. Just being authentic may not be enough – people can be authentically predictable! By being original in their choices and viewpoints, designers can open up avenues for interventions that are surprisingly clever and uniquely appropriate. Originality, in terms of something being new and appropriate, is therefore regarded as a key quality, both of the designer and of every design decision.

We also believe designing to be largely a research process. Designers investigate what a future world may be like and what needs to be taken into account to shape that world. In this, as we will show, they look, listen, and read around for interesting, relevant and inspiring facts and thoughts. This may all sound very analytic. However, we do not underestimate the power of feeling. In many design situations, designers have hunches or "gut feelings"; we believe that designers should follow that track and trust their intuition. Intuition as such can never be (mis)used as a justification, however. Thinking and feeling should be complementary: whenever a decision or idea is felt, it should be backed up with sound argumentation, and whenever something has been carefully analysed, the designer should live and feel out all the consequences.

ViP is a human-centred design method[4] that makes you carefully examine and determine what meaning to offer people in a future world.

We have divided the book into three parts, each with an underlying specific goal and focus. Elements belonging to the three parts are spread throughout the book, and have been colour-coded.

Part 1 of the book is devoted to the question: *why* would designers of any kind learn or adopt ViP? Here we make clear what ViP has to offer, and why it makes sense to take such a seemingly exacting approach to designing.

Part 2 is the core of the book: *how* to apply ViP? The section entitled *A ViP Process in 11 sessions* is formed by a lengthy conversation, broken into several parts, between a student, a ViP designer, and a ViP thinker.
The main component of Part 2 is 'the ViP process'. It describes the various stages of the ViP process in detail. This part is written in the 'you'-form to emphasize that we are addressing you, the reader, *as a designer*.
The *Invitation to ViP* section eases readers into some of the key distinctions of ViP, and there are also a number of mini-essays and dialogues in which these concepts are discussed or explained in depth.
Finally, the stages of the ViP process are illustrated through a number of student cases presented in an abbreviated, step-by-step manner.

Part 3 contains a series of reflections and essays that treat the most influential theories related to the development of ViP. Dealing with design methodology, human principles, creativity, innovation and adaptation, these essays are only for those interested readers who would like to find out where ViP ideas and insights come from, and how they relate.

In 1963, the Argentinian writer Julio Cortázar published his classic novel *Rayuela* ('Hopscotch'). The novel has 155 chapters that can be read from start to finish "with a clean conscience", but there are also several other ways to read the novel, by 'hopscotching' through the chapters based on a table provided by the author, or as the reader sees fit.

Without offering any predefined sequence, this book also allows for several different reading strategies. If you intend to read the book in full (or most of it), it makes perfect sense to start with Part 1, then move to Part 2, and finish with Part 3 (if you are really taken by the message). Most readers, however, will use the book as a guidebook to create better designs.

If you are a ViP novice, the *An Invitation to ViP* section in Part 2 is the perfect place to start. From there, the full process makes for a fine next step, and after that a jump (or hopscotch) to other elements of Part 2, finally to those sections of Parts 1 and 3 that provide you with more in depth insights and background ideas.

"Everyone designs who devises courses of action aimed at changing existing situations into preferred ones." (Simon, 1996, p. 111)

This book is intended for designers who perceive themselves as innovators placing interventions into the world. Although the approach laid down in this book is rooted in industrial design – the main discipline of both authors – we believe it offers a powerful framework (ok, or a method) for designers of any stripe: policy makers, campaigners, and architects; web designers, strategic designers, 2D and 3D designers, and designers of systems and services. All these people design products to make something happen; to serve people's needs, desires, goals, and well being; or to contribute to society at large. We want these designers to become aware of and responsible for why and how they do the things they do.

There are many ways to digest the contents of this book. We hope that the various narratives invite you to jump from dialogue to essay, or from case study to process description. We found it useful to employ various styles, as they more thoroughly convey our message; we hope you appreciate this diversity for its variety and richness. Above all, the book can remain open on your worktable to support you in every stage of the design process. And it is our intention that you discover the hidden order in the ViP design paradigm that makes it possible to look at the designed world differently. And design differently.

1 The meal described here was actually designed for KLM in-flight services by Reframing Studio (Matthijs' design consultancy), together with our colleague Pieter Desmet, with precisely this scenario in mind. Over the years it has been extensively tried and tested by KLM on long distance flights.
2 Other typical, and nearly correct responses from students are 'the Internet' and 'mobile phones'. You, the reader, are invited to find out why we think these two proposals are almost, but not entirely, appropriate.
3 In fact, design methodologies are often not based on a vision of the profession, but on careful analysis of what (professional) designers do in practice. A discussion of design methodology can be found on page 310.
4 When designing something, often it is completely unclear who the eventual users will be. We would rather use the more generic terms 'humans' or 'people', hence 'human-centred design'.

>Solutions that fundamentally change the way people interact with products can only emerge

if the designer wants to change the meaning of a product-user relationship<

Example student concepts

To illustrate what ViP has to offer, we have selected 10 graduation projects that were carried out over the past 10+ years in Delft, at the faculty of Industrial Design Engineering. The students used the ViP approach to come up with innovative design concepts, usually in collaboration with an industrial partner.

Above all, the concepts are clearly interaction-centred. The concepts speak for themselves – or so we hope – thus each is only briefly explained.

1

Mobile Communication

Sonny Lim

Sony-Ericsson Mobile Communications
Creative Design Centre, Sweden, 2001

→ Exploring a possible future of mobile communication

An individual's memories and experiences are what makes that person unique. Sharing these memories and experiences in the form of 'memes', carriers of cultural information, has become essential for human communication. This future 'communication tool' concept, created for Sony-Ericsson, captures these memes and organises them into a "time landscape" for easy sharing. The goal of this context-sensitive device is to achieve effortless fluidity between digital life/lives and communication.

2

Mobility

Olaf Wit

Koga-Miyata, 2002

→ GO Bicycle Design

The GO is a commuter bicycle designed to facilitate "flow", turning necessary, everyday journeys into joyful, imperturbable, and challenging experiences.
The bike's construction entirely focuses on helping the rider "become one" with the bike through control and personal optimization.
The geometry of the stiff aluminium frame is made for agility and direct handling, while the carbon fibre fork and seat-stay enhance comfort by absorbing vibrations. Its fixed gear drive train (no freewheel, no gears) forces the cyclist to stay focused, and provides unbeatable speed and steering management.
Adjustability of gear-ratio (simply exchange the whole chain-case) and saddle/handlebar height facilitate an optimal rider/bike relationship.

3

Gaming

Richard Boeser

www.ibbandobb.com, 2007

→ developing a cooperative computer game for two players

"It's not winning that counts (but taking part)"

"ibb and obb" is a cooperative computer game for two players. The players have to find their way through a world split in two. In the bottom half, gravity is reversed, and players move around upside down. Every element in the game has been designed with two main goals in mind: challenge players to explore ways to navigate through a world with double gravity; and reward players for working together smoothly.

4

Office Technology

Marc Mostert

Océ Technologies, 2002

➔ Photocopier Design

A multifunctional copier, scanner and printer concept, created to achieve 'resonance' in human-product interaction.
The product consists of a (horizontally- and vertically-oriented) multifunctional body for technical volume and paper storage, together with a user touch-interface "arm" that controls print, copy or scanning functions in an intuitive way.
The result is a design that affords an intentionally rich experience through every feature: it "invites you to dance".

5

Medical Supply

Børge Lund

Laerdal Medical, Stavanger, 1998

➡ CPR Training Aid

Design of a training aid for life-saving/life-support procedures. Traditionally, CPR manikins have been designed as realistically as possible. The result, however, has often been a poor imitation of a human body, combined with technical feedback about CPR performance. The LightManikin simply uses light as a metaphor for oxygen, motivating the student to keep the manikin glowing. This rewarding and "magic" condition is only possible through continuous and determined interaction.

6

Baby Care

Stephanie Wirth

2009

→ Baby Carrier Design

Freehugger is a baby carrier concept that addresses the shared responsibility of both parents. It invites them to share the task of carrying, and at the same time encourages each parent to explore different ways to develop their unique child-parent relationship and interactions.
A key feature is the ability to position the baby freely and spontaneously on the body, without losing the trust of a physical connection between baby and parent.
If necessary, the harness can be released in one secure move.

7

Domestic Appliance

Sietske Klooster

Design moves, Commit, 2003

→ Flower Arrangement

Commit choreographs a flower arrangement interaction (to 'commit' to the art of flower arranging). It asks for careful carrying hands, gentle scooping of the tulips' corollas, and composition into a greedily whirling embrace, bringing in one flower after another. The culmination of this flower arrangement act is a plane of corollas, resting like a lid on top of a glass vase, their stalks hanging in the water, growing downwards.

8

Public Transport

Doeke de Walle

Pininfarina Ricerca e Sviluppo, 2005

→ Connecting Europe: a high speed train for 2020

The aim of this design is to unify Europeans. It addresses the uniqueness of every member state by allowing passengers to engage with or disconnect from the outer environment. The design is based on the metaphor that the incoming external culture has an effect on the train like 'the shaping force of water'. To enhance the relationship between the external environment and train interior, a metaphoric force pushes the skeleton of the train inwards, thereby creating seats, baggage racks, and subsequently daylight openings. The train design allows for numerous interrelated spaces, each with specific qualities. They provide different levels of privacy and different social possibilities for interaction between passengers and the outer environment.

9

Health Care

Femke de Boer

Philips Design, 2007

→ Body Space – designing for the ailing body

One of the greatest (but often unmentioned) causes of both happiness and misery is the quality of our environment. This is particularly true in the context of a hospital, yet this factor has often been neglected. This project, based on the embodied nature of experience, develops a new perspective on hospital design. The result is a series of small interventions that relieve the experience of serious illness and being bedridden.
The concept shown here attempts to 'break through' the restricted space experienced in illness. It consists of a glowing light, attached to the ceiling, and a counterweight. Raising the lamp away intensifies the light, while pulling the light close results in a very soft, dimmed light.

10

Education

Piem Wirtz

The CED-Groep: quality and innovation in teaching and education, 2004

➡ Pogi – enhancing concentration in school

Pogi is a playful object developed for children with ADHD. It can be described as a three-dimensional hoop, connected to the floor and the ceiling with elastic straps. The design and construction of Pogi allows children with an excess of energy to let off steam while playing with it.

Production: Janssen – Fritsen, http://www.pogi.nl

Professional cases

Over the years, the ViP method has been used for many professional design projects, most notably by Matthijs' design consultancy Reframing Studio. Three of these cases are presented as follows:

❶ A retail design solution for the Dutch Railways (Servex), selected to emphasize the multi-layered aspect of design projects;
❷ A car design for Pininfarina (the NIDO), to demonstrate that a vision can also give direction to construction and engineering; and
❸ A service design for the Dutch Ministry of the Interior and Kingdom Relations (relationship between citizen and state), to illustrate that ViP can be applied in various design domains.

The cases will be presented in the form of a dialogue between:
- (**S**) a student asking most of the questions,
- (**D**) a designer who carried out the projects, and
- (**T**) a theorist/thinker who plays the double role of explaining concepts and occasionally asking additional questions.

Instead of focusing on outcomes, these dialogues primarily deal with reflections at various stages of the process. The main aim is to show what ViP has to offer, and how thorough and powerful an approach it is.

Case 1

Retail System

Dutch Railways (Servex), 2004

→ A retail design solution for the Dutch Railways (Servex), selected to emphasize the multi-layered aspect of design projects

S What I heard about ViP sounds very grand – and I like it – but I want something that makes a difference in practice, that's why I'm interested in your work. Can you think of a project where ViP has really made a difference?
D *You* choose! There's one about the desired relationship between the government and the people in the Netherlands; one about a small shop for the Dutch Railways; one about a vision of how future work could be organized; even one about a public dustbin.
S OK, I take the train a lot – let's go with the one about the shop for Dutch Railways.
D At first, the assignment was to design a new shop situated on the platform in a railway station that takes passenger platform dynamics into account.
S That's a pretty bland design assignment, like one I'd get, I suppose. Did you start off looking at users' needs ?
D The current shops had become really old fashioned, and turnover was decreasing. It did look like a traditional assignment. So the first thing that needed to be done was an assessment of the suitability of the assignment itself. In this case, we said that the shop wasn't the central component of the assignment. People in a railway station want to have a relationship with the products they buy, not the shop where the products are sold. So, we determined that the assignment needed to be rephrased in terms of the product portfolio they wanted to offer. The first thing then was to understand which product portfolio was appropriate for that specific situation. Next, understand how (in what manner or format) to present the products. Self-service or assisted? And then design an outlet that brought everything together.
S And how did ViP help you?
D ViP really helps a designer to see the core of the assignment. The approach focuses on user-product relationships, so the order of the design steps to be followed becomes immediately clear. We talk about design layers of the 'first order', 'second order' and 'third order' – in this case product portfolio, service concept and outlet. We had determined that we initially needed a firm grasp of which product portfolio would be appropriate for that specific location. To that end, we started building a context. The context not only described the physical specifications of the location but also covered psychological principles to be taken into account, among other factors.
S So, where did the context come from? And what are the 'principles' you mentioned?
T When we say 'build a context', we mean 'bring together all kinds of forces' – we call them factors – 'that together shape the world the designer is designing for'.
The thing is, there is not *one single* context, so it's impossible to incorporate all the possible factors of a given context. So a context is *always the result of a selection* and combination process: choosing what to include and deciding how to bring it together.
To help designers collect factors, we have defined four conceptually distinct types [developments, trends, states and principles]. The term 'principles' refers to laws of nature, for example, of the human mind.
D The conclusion we drew in our context design stage was about the support people want for the role they play in public, in this case on the railway platform. So the product portfolio on offer became an instrument to emphasise a specific role to engage with.
We saw that roles were driven by travellers' concerns. An individual can play different roles at different times, and with each role comes a different concern. We drew a

Above The new kiosk
Below An old kiosk on a Dutch railway platform

parallel with the distinction between genres in movies. Depending on a particular concern, there are action movies, romantic comedies or art house flicks. To demonstrate how important a starting point this was, we showed the railways people a kind of 'film ladder' we had put together. There were all kinds of movies depicted on the ladder but all from the same genre: action. During the management presentation, we gave every manager the ladder with this question: tonight you are going to the movies; what film do you want to see?
After five minutes they were supposed to tell us which movie they wanted to watch. It was astonishing: they said, "There's only one genre," or "I don't want to go to the movies tonight"!

S Interesting, but so what?

D The analogy is that movie genre distinctions are related to possible 'concerns' that are appropriate within the domain of movie entertainment. When one of the genres isn't presented, some people feel the list is not complete and therefore find it difficult to make a choice. This is exactly the situation on a railway platform. If products only emphasise one role to play, one way to be, for most people it becomes too much of a hassle to choose between them.

T I like the way you managed to make the management feel (and thus understand) that people's concerns (needs, values, etc.) change over time and in various situations. After an exhausting day we may want to relax and see a 'feel-good' movie, when we've had a boring day we may need some action or want something to make us think. You approached the individual minds of the board members simultaneously, and helped them see that the kiosk issue was not one primarily about the differences between people, or target groups, but the differences in how people *felt* in different situations that mattered.

D Right, we had to present the products in a way that emphasised all the different roles travellers may identify with. We demonstrated that the idea of completeness is a simple yet major contributor to success. Shall I explain the different roles you can play in public space?

S Wait – was it really ViP that helped you do that?

T I do think the context-interaction-product model of ViP helps designers see a specific situation differently, and come up with a tool or analogy that makes it not only clearer in the designer's mind, but makes the task easier when it comes to communicating the situation to others.

D Up to now, we've only talked about the context and its underlying structure. The structure clarifies the relationship between every factor selected for the context. It's a way to reduce the complexity of the context to an insightful, operational framework.
So, from the structure we derived five different roles that people may want to play on a railway platform.

S Go on...

D They covered enjoyment in a group (*bond*), entertaining oneself (*disconnect*), identification with socially accepted behaviour (*role play*), imitating other people on the platform (*flow*), and commanding attention in public spaces (as performers do). Performers are so extroverted that they usually don't need products to support their behaviour, so that left four roles that we, together with Dutch Railways, thought were relevant to focus on.

S How exactly did ViP help you to come up with these roles – aren't they just good ideas?

D ViP is about focusing on the most relevant ideas instead of creating all kinds of ideas that will need further reduction. The beauty of working with ViP is that its purpose is not just to come up with some idea but also grasping that this idea is *the* one to go for.
So, when I say 'design starting points' I'm usually describing how I want people to act in a future situation. The design starting points were not the need to create an elegant or beautiful kiosk, as the initial assignment stated. The starting points are the desired interactions that people would have with the products, which in this case are combined in a kiosk service.
Let's look at how those roles helped us to get grip on the product portfolio. Obviously, each role needed different kinds of products. We needed products that would seduce people to interact with each other, that would allow people to play or disconnect with the environment, and products that would make people part

individual pleasure

disconnect
entertain yourself

~~in focus
I want attention~~

focus on self

role play
express yourself

focus on surroundings

bond
entertain each other

flow
go with the flow

social consumption

situations

Five different roles on a railway platform (simplified version)

of society, like healthy products, and products that would make travellers part of a 'whole', like a coffee or a croissant in the morning, a sandwich for lunch, and a beer in the afternoon.
S So you were thinking less about products as such, and more about relationships between people and products.
D It was really interesting that the old shop only sold one type of product: the ones that helped people imitate one another or be part of the whole. And at the beginning they were convinced that the shop had to be an efficient selling machine that worked as quickly as possible. So we introduced new product groups that fit different passenger or traveller roles and this had a tremendous effect on the turnover.
T The ViP angle is that segmentation is not based on people's characteristics – age, sex, lifestyle, etc. – but on contextual differences (time of day, in a hurry, etc). Basically, the concerns touched upon are a reflection of the designer's context. *They have not been defined beforehand*, nor based on what is currently at play, nor based on targeting a specific user group.
In ViP we design for anyone who shares concerns and wants the kind of interaction we envision. This may mean that some people are excluded, people who have other concerns and want other interactions. But at railway stations or airports, however, you cannot exclude too many people. That's why the design team came up with different concerns/different roles, to serve as many people as they could (although there may be a few niche roles they did not consider...).
S I get that, but I don't see what factors brought you there.
D The four new product groups were the outcome of a context vision in which a lot of factors were taken into account. It would take too much time to isolate and examine every factor, so let's look at the clusters, which are usually formed by taking all the factors into consideration, and uncovering the resonance that binds them together into groups.
There was a cluster that dealt with personal states of mind on a platform, which happened to be divided into 'disconnecting from the public space' and 'being part of the public space'. And another one was about social motives like 'wanting to be on one's own' or 'wanting to be a member of a group'. The relationship between all four possibilities defined people's potential roles in public space. We then knew what kind of products we wanted to sell on the platform: not only products that were adapted to rail travel, but also products that would create a bond between people who were travelling.
When you talk about people who want to feel a bond with others on a platform you are not talking about every single person on the platform.
S And do you think that is what people really want – to have a bond with the other people around them?
T Interesting, I would like to see an example of a product that evokes bonding on a platform...
D In certain situations, travelling as a group is an example of bonding, or there's something going on in society that makes bonding the most obvious thing to do. Like going to a national football match; selling products that create a feeling of bonding are very appropriate. A product in that case could be the national team scarf...
T ...or a six-pack of Heineken!
D Back to the shop. We had to think about how to get these 4 product groups together as a coherent whole. So we came up with the idea that the character of the shop itself would create that coherence while emphasising the idea that the products sold are just instruments used to play a particular role on the platform. We came up with the character of a "typecasting coach". The shop would be like a director who stressed the role to be played. The shop would direct people to take a six-pack of Heineken! So there had to be a distinction in the experience provided by the four different product groups in the shop. The shop itself consisted of different zones for solitary amusement, bonding, role-playing etc. So the shop was actually a very transparent skin that made people sense the different roles available. That was the concept.
T And I suppose people had no idea...the role-playing was mostly automatic?
D So how did we make a design out of this? We did want to be sure, exactly as Paul said, that the role-playing was unconscious but also that the

DISCONNECT
Products that enable you to entertain yourself

BOND
Products that enable you to entertain each other

ROLE PLAY
Products that enable you to express yourself

	Idealist	Artisan	Rational	Guardian

FLOW
Products that enable you to go with the flow

| generic action | play | taste | surprise | | play together | share | compete | | Idealist | Artisan | Rational | Guardian | | daily ritual | traditions |
|---|---|---|---|---|---|---|---|---|---|---|---|---|---|---|
| drink | tactile drinks | new drinks | weird drinks | | cheers | 6-pack | drinking game | | authentic drinks | comfy drinks | smart drinks | classic drinks | | daily drinks | traditional drink |
| eat | finger food | new bytes | strange food | | prepare food | share food | eating game | | authentic food | comfy food | smart food | classic food | | daily food | traditional food |
| care | tactile care | dental care | mental care | | care game | sharecare | beauty contest | | authentic care | comfy care | smart care | classic care | | daily care | |
| smoke | cigarette play | new taste | experiment | | smoke together | cigarette share | smoke game | | authentic smoke | comfy smoke | smart smoke | classic smoke | | | |
| inform | immerse | taste-o-rama | glossy | | trivia | share info | knowledge game | | authentic info | comfy info | smart info | classic info | | daily news | tradition info |
| entertain | tactile game | try out | mind game | | group game | celebrate | contest | | | | | | | | |
| communicate | body language | try language | learn language | | karaoke | conversation | debate | | authentic comm | comfy comm | smart comm | classic comm | | | |

Searchmap product portfolio, simplified version

shop was a natural element of the platform. At that point we had to take all the product requirements into account. For instance, the shop was not allowed a big footprint, it had to facilitate platform traffic flows. The shop had to contribute to the natural ebb and flow of travelling people. So on one hand were product group experiences, and on the other hand, the natural flux on the platform that couldn't be obstructed.
S So the shop became a way of facilitating interaction, like a stage?
D Exactly, those were the words we used to explain the concept to Dutch Railways. Clever!

Case 2

Mobility

Pininfarina Nido, 2004

→ A city car concept to demonstrate that a vision can also give direction to construction and engineering

T I heard that Pininfarina has used ViP to design their cars. Is this true? Can you think of an example project where ViP was applied?
D In all honesty, I can't say Pininfarina uses the ViP methodology (yet). But there was the case of a small city car (presented to the public in 2004) by Lowie Vermeersch. Lowie, who became design director at Pininfarina in 2007, was educated at the faculty of Industrial Design Engineering at Delft, and carried out his graduation project for Pininfarina in 1998. Using the ViP approach, he envisaged future mobility in 2012 and designed a new family car. The vision he developed at that time showed three lifestyle directions that might be appropriate within the mobility domain in 2012, and what kind of meaning products should have to elicit these behaviours. He called these different types of user behaviour "Zapping", "Sampling" and "Subscribing". The car he designed in 1998 addressed Sampling behaviour. Nido, developed in 2003 and 2004, was based on the same vision (5 years later it was still applicable), but was designed to zap around the city!
My role in the Nido development process was to consult (from a design research point of view) on how to synthesize car structure, safety and styling, i.e. how to translate the product qualities as defined in the vision into feasible new chassis and wheel suspension designs, in relation to active and passive safety.
The beauty of working with Pininfarina is that they fully support the idea that styling and technology go hand in hand. Working with a vision creates one *leitmotiv* for both aspects, and is a beautiful starting point for designing a coherent whole. Because technology and styling are so intertwined, a small 'Autosicura' design team was composed, consisting of designers and engineers.
S What was Pininfarina looking for?
D Pininfarina is traditionally a very research-oriented company. If you look at their history, the most iconic concept cars they have designed are a result of their research. For example, research into aerodynamics led to the BLMC 1800 in 1968, and research on safety to the Pininfarina Formula 1 safety concept in 1969.
The mission of the Nido project was to develop a small city car to improve urban mobility. In realising this project, Pininfarina wanted, in parallel, to emphasise their research culture, and bring styling and engineering closer in their search for an optimum synthesis between form and technology.
T Didn't the Italian government commission the project?
D Yes, they did.
S What was the first stage?
D First, our aim was to understand what kind of urban mobility we wanted to create. Then we tried to define the specific features that, when combined, would lead to a new mobility concept. And finally, we looked for ways to get people to accept that mobility concept.
T Could it have been any kind of mobility? Even a bike? Or did you need to design a car?
S You didn't end up redesigning the city then?
D Of course, in this case, they asked Pininfarina to design a car because of their specific expertise in car design. From the start it was clear that this project was about designing a new car, and not about the design of another type of product or the design of a new infrastructure. On the other hand, as I said before, Pininfarina wanted to use this project to showcase their expertise in research and what that means to the design of new cars. The aim was to show the project at a big motor show. In the end it turned out to be the Paris

BLMC 1800 and Nido, both designed by Pininfarina

Mondial de l'Automobile 2004. Nido became concept car of the year in 2004 and won the *Compasso d'Oro* in 2008, one of the most prestigious design prizes in the world.

T Lowie built the context: he figured out what the city of tomorrow would be like, right? And how people behave and feel in that environment?
D Yes. But he had already defined his vision in 1998. With the development of Nido, Lowie had unconsciously created a synthesis between the outcomes of the vision he created in 1998 and the design starting points he had to work with at Pininfarina.
Lowie (together with 7 other students) had developed a vision of "life in motion" for a student workshop, some time before the graduation project. It was interesting to note that if any time is spent trying to understand what the domain of mobility is all about, it becomes part of one's intuition. Basically, a good vision is applicable for a long period of time. Over time, a solid vision gives you a lot of new ideas you can relate your designs back to. The original vision still contributed to what Lowie wanted to achieve.
S Was it a problem to be context-driven while Pininfarina is normally object focused?
D No. In ViP, the designer tries to understand upfront what kind of product qualities are meaningful in relation to the context. This was fully applied by Lowie and guided the Nido development decision-making process.
At Pininfarina, product qualities are the end result of the car design and development process. These qualities evolve over time, when the car literally becomes more tangible. Again, those qualities are defined in relation to the context where the car will perform.
T Could you briefly explain the 3 kinds of mobility? I suppose they somehow reflect the context of the car?
D Lowie came up with three mobility domain lifestyles: zapping, sampling and subscribing. Nido fits the zapping lifestyle.
To keep up with an ever more complex society, flexibility became the central theme of the car. Only a constant change in product characteristics can sustain the desired experience needed. 'The new' is more important than 'the known'; there is no time to lose.
S And what were the context factors that led to this conclusion in your analysis?
D There were many context factors that reflected aspects of technology, equality, emancipation, individualism, hedonism, etc.
S And what is "zapping", exactly?
D Zapping is the act of switching from one activity to another in a very hedonistic way.
T So, zapping is a kind of reaction to the context. Could you say your statement was: to allow people to zap around in a city context?
S And was this just in Italy, or worldwide?
D We wanted to allow people to zap around in a western European city, exactly!
S Can't they zap on a tram, or a scooter?
T I think a scooter is perfect for zapping! A tram will not do, I'm afraid.
D You're right. But Pininfarina had redefined the domain as city mobility by *car*.
S That's disappointing, considering that ViP can really take you to new places, yet this brief was really just another car design!
D There's nothing wrong with that.
T It's a reflection of reality: companies usually specialise in a particular manifestation; it's hard to introduce completely new ones.
D In reality, we are already in exceptional business territory when companies like Pininfarina want to do research…
T …and strive for real innovation!
S Alright – but I thought ViP is supposed to produce completely new solutions. What I am asking is, how does the ViP process differ from a "traditional" design process?
D It depends on the freedom in the product portfolio companies allow for. If you do research for Apple, the possibility of coming up with a product idea that does not fit their typical product categories is far higher than with…maybe… General Motors, for instance…
T It all depends on the domain. If there is the opportunity to broaden it – as with most student projects – you can afford to look at your domain from a wider perspective.
D So, companies have to create their *own* 'freedom' to

The mechanical principle for crash safety

look at the domain from a wider perspective. And it has to fit their original strategic plans. ViP is not about being afraid of existing product domains; ViP is about defining appropriate product qualities and being able to design products that express this meaning.

T Even if the type of manifestation is fixed – a car for example – ViP can enable you to redefine what a car is and could be.

S Yeah, but wouldn't most non-ViP design processes claim the same thing? What was the distinctive thing that ViP brought to the party?

D The need to provide people with the ability to 'zap around a city'. This was the first outcome of ViP. So we had to understand what kind of product qualities enable and express this kind of behaviour.

T The interesting thing is that you didn't start from a set of requirements: the car *has* to be this or that. Instead, you first defined what you wanted to offer people, then justified this goal on the basis of a thorough, research-based context analysis.

S Can you talk a little bit about the product qualities?

D To be able to zap around the city, the car had to be 'agile', 'powerful' and 'trustworthy'. As a result, the car had to have features that gave expression to these characteristics. Agile meant the car had to be small, light, and have exceptional road holding characteristics. Agile also referred to the car's soft 'skin'; it could move through the city without sensing resistance. Powerful meant it had to be safe, and had to provide tools to explore the city…Trustworthiness was applicable to all the qualities. That had to be the primary factor…sort of 'in your face', as it were.

T Can you say the product features were derived from the characteristics, in a way?

D Yes, they made the characteristics tangible and perceivable. What is interesting is that if a connection is made between 'powerful' and 'safe', for example, solutions are imagined in a totally different way. That kind of safety is sort of aggressive; for a small car, design problems car can be felt immediately. On one hand the car had to be small, and on the other it had to be powerfully safe: how?

S So…how?

D Well…this car was the tool to manifest the vision of 'zapping around the city'. In an urban environment, small cars aren't the only cars. Bigger cars driving around fit other behaviours. There the problem arises: what they call 'compatibility'. How should the small car behave in a road accident with a big car?

T So, while zapping around you stumble upon SUV's that block your behaviour? They are a serious threat to your safety. How to deal with them, right?

D Right.

T Can you explain the 'zapping' characteristics a bit more?

D Since all kinds of things take place in a city, this car helps you explore and get a taste of everything that is going on.

T I see, so that's why the car needs to be powerful and agile.

S Is that what people do in a Smart car as well, or is it a completely different interaction?

D The thing with a Smart is that in comparison to a big car, it's not safe enough. So when I was talking about the car being powerful and agile at the same time, the Smart mainly focuses on the latter. The level of safety a Smart provides is not enough to zap around a city!

T And we talked about those SUV's before: they are all over the city, even in the future, threatening zap-behaviour. Are you saying the Nido is a safe way to zap around, whereas the Smart is not?

D You have to be able to explore the city while feeling unassailable.

S How did you formulate 'safety' in the interaction vision?

D The interaction was characterized as 'confident zapping'. Because of that confidence, the car had to be safe.

S What are the characteristics of zapping around?

D Zapping is about exploration, sampling, rhythm, fleetingness, flirting, and impudence...

S What kind of people zap around?

D People who want to explore the city, taste it, and flirt with it.

T ViP does not define a group of people beforehand, it lets the target group emerge from the process. We defined a particular interaction based on

Above Final body in white
Below First sketches

a context view, and this interaction applied to those who want to interact with the world as we saw it.
S I understand. It really is a 'vision' in that respect, something that you would like to see people do?
T Right, or believe people would like to do...
S So for the Nido, what was that belief based on?
D The context factors I mentioned earlier. Things like hedonism, breaking with traditional patterns, cultural diversity, an overload of offerings, and the condensed city environment.
T Could we go back to safety? How did you define it at car level?
D Because the car affords the 'zapping around' interaction, two main characteristics were defined. It had to be powerful, to provide a feeling of confidence in the city, and on the other hand it had to be agile, to be able to explore the city. The beauty of 'safety' as a design feature is that it addresses both aspects: from a 'passive safety' perspective, safety is about the performance of the car in an accident; from an 'active safety' perspective, we were looking at how to 'play' with the car in a condensed city environment and avoid accidents.
S How did the ViP process differ from a normal car design process? What did ViP give this project?
D Before answering that, I have to say more about how we translated the design characteristics into product features/specifications. Being agile meant 'small', with good road holding performance. Being powerful, in this case, meant very good passive safety performance. Smallness and good road holding performance go well together. But 'small' plus 'very good passive safety performance' meant finding some really original mechanical solution to resolve the ambiguity. Typically, the crash performance of a standard family car is two times better than that of a small car like a Smart. This is exactly the reason why people who want to zap around the city wouldn't use a Smart. ViP first clarifies what kind of qualities the object needs to have, and then forces designers to think of a completely new safety concept, instead of applying existing mechanical solutions. Otherwise the product would not afford and express what it has to.
T Exactly; and these qualities do directly follow from the interaction you defined. Predefining interactions, based on the view of a future context, is crucial to ViP and, I think, not a common step in a car design process. So, the ViP approach forced you to reconsider car performance and mechanics.
D Exactly.
S How do people 'interact' with safety then? Is it just a feeling they get when they climb in the car or is it more obvious than that?
D Good question…
S So the logic goes something like this: ViP vision > Zapping > Increased feeling of Safety > New crash protection mechanism.
D Right, but what was important was the increased feeling of safety *combined* with a feeling of agility. Otherwise, we could have also come up with a big safe car. Again it is in trying to resolve the ambiguity in the product features: between safety and being small and light. And so this new mechanism of crash protection had to be invented.
T Do you have an image of the crash protection mechanism?
D There is a picture of the idea behind the mechanism. It looks like eggs running into each other; there are also images of the designed mechanism itself. It looks like a structure, a bridge or something. Can you imagine it?
T Do you have the energy to explain exactly what the considerations were behind it? It must be a long story.
S I suppose this is where a normal development process takes over. I can imagine that if the technology was right, you could design a force field around the car to stop it crashing. So the actual mechanism used to ensure safety is probably not that important.
D Yes, but what I really find interesting is that ViP forces designers to come up with innovative technical solutions. The qualitative characteristics of the desired solution are defined, but the way these can be translated into a feasible mechanism had yet to be designed. ViP guides the engineering team in the right direction, in a way. Truly amazing to experience!
T I agree; design starting points are much more clearly

First styling sketches of Nido

articulated in ViP, forcing designers to realise the full interaction as defined. This applies to the look and feel, but also to the construction, mechanics, materials applied, etc.
S Because ViP indicates the qualities to aim for, right?
D Right.
T So the mechanism you came up with *does* matter! It explains what ViP has to offer an engineer.
D The biggest problem was not making it safe to hit a tree or wall, for instance, but making it safe to crash into other cars driving on the road. This is that 'compatibility'. Cars have to have the same crash performance to protect the occupants in both cars. This compatibility is almost impossible to realise, however, when there is a big difference in the weight of cars involved in a crash. This is because the volumes used to absorb energy in the crash zones are related to the weight of the car. The volume of a small car is small, and big for a big car. If the same kind of passive safety principle is used for a big and a small car, in a crash, the crash zone of the big car 'eats' the crash zone of the small car first, before absorbing its own crash energy. So when a big car hits a small car, it's ok, even better, for the big one.
S So how did the design team solve this?
D It is impossible to use the same passive safety mechanical principle to make both cars safe. Instead of allowing the big car to eat the crash zone of the small car, we wanted to do it the other way around. The small car has to be given enough capacity to eat the crash zone of the big car first. We decided that the small car had to act like a parasite, or a bullet. The small car would be very rigid on the outside, could eat the crash zone of the big car, and would have an absorbing element in between the passenger seat and this rigid shell to protect its occupants. In this way, we managed to give the small car very high crash safety performance, even as good as the most safe Mercedes, the Mercedes S class! The working title for the car on the team was 'little bastard'.
T Impressive; did it work for both front and side crashes?
D It was mainly designed to perform in front crashes. With side impact crashes, compatibility is not the biggest issue. But the mechanism functions in every direction. So the car is very safe. Further explanations? Or shall I move on to the interior?
S Actually, I was interested in how ViP helped you to design the specific mechanism, not just in hearing a description of the qualities the mechanism should have.
D Well, I already explained that if you want to zap around the city, the small car, when part of an accident with a big car, has to eat the crash zone of the big car.
S Yes, but the actual way in which it does that – the mechanism – could be achieved in different ways. Did ViP help in that process or was that beyond the scope?
T So you mean, did we use ViP to make the step from knowing what to achieve (small eating big) to how to do it (mechanism)?
S Exactly!
D Good question. Do other design processes also give guidance on that process?
S Sure, I think so, perhaps using methods like Function Structure graphs, Quality Function Deployment, Morphological Charts…
D What you do, as an engineer, in a way, is a mini ViP process related to the development of a mechanism. My statement is: I want to crumple the crash zone of the big car before I crumple my own. The funny thing is that when you use all the 'old school' instruments, like a morphological chart, you can't come up with a new innovative mechanism. By understanding all the relevant physical principles behind what happens, you find the answer.
S How do you know a principle is relevant?
D By attempting to understand exactly what kind of quality is needed from the mechanism, and which physical principle will help you to translate what you want to achieve. You match up the desired mechanical performance and the way the product as a whole is perceived by its user.
T Basically what you do is reason from the vision (statement/interaction/ meaning) to a concept solution that has the character you want it to have, interacts with the user in the desired way, and fulfils the goal you set in the statement.

Crash test of Nido's mule

Of course you need knowledge of the world (and the principles governing it) and how people experience this world in order to move from vision to concept. Without the proper vision, you would never come up with an innovative mechanism.
Yet without the proper domain knowledge (in this case: mechanical engineering, physics) the solution wouldn't come either. Both are needed to make the transition, especially in a complex domain. That's why designers need to know and understand what is possible under what laws, how materials and other properties behave, how people perceive and experience things, etc. in order to conceptualise a feasible solution that fits the vision.
D Beautiful!
S Can you explain the new mechanism to me again?
D What we tried to do is make the small car as safe, if not safer, than a big car. Instead of making a very rigid cabin, with an absorption zone connected to it at the front, we came up with a very rigid outside shell, and a moveable 'sled' inside. In between the sled and the rigid shell, we created an absorption material able to absorb the energy generated during a crash by the occupants of the small car.
The best part was when the first Finite Element Analyses (FEA) calculations for this new principle were carried out by a special department of Pininfarina. The behaviour of the sled holding the occupants was so tranquil, so linear, and so controlled, that it completely fit with the starting point of offering people a secure feeling when they hit another car. When a designer's vision thinks and feels like an engineer's, performance-wise, new solutions that fit the desired characteristics of the car are possible.
S So did you do crash tests with people in the car, and ask them what they felt? Is the 'feeling of tranquillity' empirical, or one that you, as designers, wanted to create?
D Being able to empathize with the desired interaction, and the characteristics needed, the designer steers in the direction of an appropriate solution. Coming up with all kinds of alternatives is no longer needed. The fact that knowledge of the physical principles and mechanism performance are matched up means the designer is on the right track.
So back to your question: the feeling of tranquillity was inferred from the graphs created through testing the performance of the mechanism. Instead of a very steep acceleration peak, the mechanism kind of gently introduces the passengers into an accident. Body accelerations of the occupants where 5 times smaller than in a similar small car!
After these virtual tests, Pininfarina produced a mule: a car that mechanically resembles the original design. This mule was crashed with dummies in a controlled way, using Euro NCAP guidelines.
S That reminds me of a crash mechanism that Audi developed. In front collisions the action of the crash forced the steering column to move from the driver and put extra tension on the safety belts – maybe that came from a ViP-like process?
D Could be. I think it is ViP-like when every component adds to the character of the car. In the case of Audi, it is more of an added benefit, based on the conclusion that the steering column is often the cause of lots of injuries.
T I think we should move back to how the car enables drivers to zap around. The interior, for example.
D The sled in the interior expresses the ability of the chairs to slide inside the rigid outer shell of the car. From the outside of the car you can perceive the area where material can be demolished to absorb energy, through the front screen, in a very explicit way. Also, when opening the doors you would see the side impact crash zones.
The car had to be powerful enough to explore the city. So there was the idea of using personal electronic tools: they had to stick to every surface on the inside of the car with Velcro, wherever the driver or passengers wanted. These electronic tools would help find a destination, listen to local radio, etc.
The exterior, on the other hand, expresses the character of agility, by being small of course, but also by being very smooth. The 'powerful' character is expressed by the use of very soft surfaces, where sometimes the basic structure of the

Matthijs (back) at Pininfarina

rigid outer-shell pokes through the surface, like the bones of our skeleton are visible through our skin in places.

S So the form expresses the characteristics and qualities generated during the ViP process. In that case is it more about the product expressing power, or actually being truly powerful?

D Both, of course! We were looking for a 'coherent' product.

T Otherwise you would fool your user, which is a different interaction…

Final prototype of the Nido, exterior and interior

Case 3

Service Design

Dutch Ministry of the Interior and Kingdom Relations, 2006

➔ A service design for the Dutch Ministry of the Interior and Kingdom Relations (relationship between citizen and state), to illustrate that ViP can be applied in various design domains.

T We have often emphasized that ViP is a generic design method that can be applied to all sorts of situations where design thinking is required. The heart of ViP is developing a vision of *what* the product offers or brings to people, and *how* the product accomplishes this. At this particular stage of the process, the final manifestation/solution/concept, whether a physical thing, a multimedia application or some non-physical solution, is yet to be determined. In fact, in many cases, a physical product may not even *be* the best solution. Have you ever used ViP for a project that eventually led to a non-physical solution, such as a service, a policy, or a campaign, for example?
D Yes, I have.
T For which client? What was the assignment?
D Over the past several years, I have noticed that working with ViP has opened up domains where my design skills weren't applicable before. Because ViP primarily aims to understand what to accomplish for people in the future, as a design process it is applicable to any conceivable development process.
So. I was interested in politics. I had noticed that politicians are very good at understanding why (and emphasizing that) the current world is not functioning the way they want it to function. But when it comes to new ideas, these politicians are terrible designers! I wanted to bring design thinking into the political sphere. The funny thing is: if a designer can design a policy, he or she can design for banks, pension funds, insurance companies, broadcasting corporations, etc. The world opened up for me. I knew somehow that designers were, and are, desperately needed in these domains, to come up with really novel and appropriate products and services.
T What kind of 'design thinking' are we talking about?
D The design thinking here is that a designer first has to understand what direction a certain domain is taking; next, the designer has to take a position in the here and now about what to accomplish relative to that domain – this is the most important part, I think; and then lastly, the designer has to think of products that fulfil the goal as defined in the statement. Needless to say, I am talking about ViP.
T So this is not design thinking that conceives products, functions and features, but thinking that sees solutions for the (changing) world.
S Can you give an example of how a politician might make a bad design decision?
D Let's look at an assignment given by the Dutch Ministry of the Interior and Kingdom Relations. They had been having problems reaching the populace. Their conclusion (from experience) was that when the government provides a service to the people, the people often don't like or even understand what they are supposed to do. The relationship between civilians and local or national governments, from the people's perspective, was perceived negatively. The government was afraid of the negative attitude people had, and wanted to change it for the better. They tried doing this by giving people all kinds of new rights. Of course, in the end, that doesn't work. They had applied a kind of 'reactive design process' just to make people happy, instead of thinking about what they wanted to accomplish for the country generally, as a whole.
T So they thought that by pleasing people they would get a positive response?
D Exactly.
T And 'pleasing' means doing things the way 'the people' say they like them done, and not doing things in a way 'the people' say they dislike, right?

Intention of the government

	giving perspective	representing	collective good
independent	1	2	3
interdependence	4	5	6
dependent	7	8	9

States of being of citizens

Nine possible relations between government and citizens:
nine directions for designing public services

Cut taxes if people say so, and then fix the problem that arises from that. And the next...
S Excuse me for being naive, but isn't that the purpose of design? To please?
T Right, this is exactly what you see all too often in product design. The initial solution is extremely poor (i.e., is not appropriate) and then is fixed, and fixed again, and again, and the end result is a product nobody likes and nobody understands and nobody wants.
S You sound like a politician!
T And yes, that is a naive take on designing: give people exactly what they think they need or want, ignore the possibility that the 'frustration' (that created the need in the first place) may have been due to a faulty design!
D Absolutely right. So in this case the project was initiated to reduce administrative burden. The government thought that by reducing the fee paid for a service and reducing the amount of time spent to get a service, people would be happier. So they aimed to reduce time and fees by 25% in 2007. They reached the goal, but when they asked people if their experience of the services had changed, they hadn't noticed a thing.
S But with no idea of what people need, where can a designer start? I think that's the question I would ask about a service design like this. Doesn't the designer have to start with what people say – and think – they need?
T People say what they need based on what they know and have, right? That is their frame of reference, I believe. So if a particular tax system exists, they want it to be more user-friendly, cheaper, etc. As a result, the designer may try to fix the original system. But the core of the system stays the same, and no matter how much is changed, new frustrations and needs will arise. So, the core of designing (according to ViP) is envisioning a system that fits into the world of tomorrow. People will recognise its unexpected, anticipated quality and be satisfied.
D I remember how difficult it was; we didn't know where to start ourselves at first. We could sense that reducing time and money was not the way to optimize the relationship between the government and the populace. The essence of ViP is to start from context research, which helps locate the doorway to new insights.
S I understand – what were the factors that you came up with for your context?
D We started by interviewing five 'important' people, experts in the field of politics and government-civilian relationships. We asked these people to indicate what factors are or will become relevant to the domain of government-civilian relationships. In the end, we had a list of 250 factors, including principles, states, developments, and trends, drawn from various perspectives.
T Wow, 250 factors from 5 people = 50 each?
D No, 30 each or so; plus the factors brought up by the design team from the Interior Relations ministry, plus ours.
S Can you remember the most striking one?
D Isn't that a bit of a digression?
T A few would be nice...just name a few that were highly influential.
D Very well.

> Principle: In an organized society, people always need checks and balances.
> State: National and local governments are bureaucratic.
> State: Government services always assume the people's distrust when they design their services.
> Principle: Reciprocity is a characteristic of social relationships as a starting point for sense making, identification, and trust.
> Principle: To be able to take responsibility, people must be able to direct possibilities; without choices it is impossible to take responsibility.

S Just to be clear: were these the factors you found when talking to people? Which ones did you use to design your context?
D The above factors are almost all principles and states. We found out that the relationship between these time-independent factors formed the core of the context's coherence, a timeless core. We also found a lot of developments and trends, and we used these to be able to give

"Making a decison on organ donation should feel like part of becoming a Dutch adult"

moment 1:
growing up

12 years old

out of idealism

moment 2:
becoming an adult

18 years old

out of moral responsibility

moment 3:
being an adult

childhood | puberty | adolescence | being an adult

Example design of a public service for organ donor registration, based on the 'nine-directions' model

Above Shift in relationship: from organ donor registration as a free choice to moral norm
Below The concept is built around key moments in becoming an adult

timeliness to the seemingly permanent core. We did use all the factors, but before we were able to translate them into a coherent context, we had to determine what kind of *clusters* would give structure to the 250 factors...what was *behind* the factors, if you will.

T 'Behind'? That sounds as if the factors were part of a greater whole. Clusters are mostly shaped by seeing relationships between factors, how they affect each other, can be grouped into forces pointing in the same direction, etc.

D I don't know if 'behind' is the appropriate word. Clusters should usually describe a mutual quality hidden among factors. Often this mutual quality is described on a higher level of abstraction than the factors themselves.

T So, you found what they had in common, sort of a common strength, right?

D Exactly. Their common strength...beautiful!

T Great; so would you explain to our student how to detect these strengths?

D In this case, we came up with 4 clusters: 2 time-independent and 2 time-dependent. I will only explain the time-independent ones. They form the basic structure of the context's coherence. From here on in, we will only work with this time-independent framework, ok?

So we had two time-independent clusters. One was about the government, and how people perceive governmental tasks: the government is a kind of 'democratic engine'. This cluster had three values: the government can give a person perspective (it protects the vulnerable); the government mirrors society, and is representative of societal and democratic values; and the government creates social coherence, civic consciousness, within the country (or it decreases people's selfishness).

The other cluster was about civilians, about the feeling people might have in relation to another entity, like the government. According to the cluster, as a human being, there are three states: independence from others, dependence on others, and reciprocity between self and other. These three 'Dutch civilian states of being' were also supported by psychological research.

The beauty of these two clusters is that *in relation to* each other, they defined possible interactions between civilians and the services the government offers. Because each cluster consists of 3 values, the conclusion is that in the Netherlands, (3 x 3 =) 9 possible relationships can be realised between the people and the services the government offers. For each of those interactions, we were able to define the product qualities and qualitative characteristics needed to evoke the appropriate interaction between the civilians and the services.

S Wow! So you basically boiled these down from the original 250 factors? Was it the way you understood the factors?

D Yes; but what we really understood was that we needed the factors to understand which were the important dimensions, the ones that described 'the truth' behind government-civilian relationships. What is really important is that with the 9 possible relationships we had described, we always kept in mind what was 'behind' them: what led us to them.

S As a student trying to learn ViP, this sounds a little like magic! Speak to a lot of people who tell you a lot of things, 250 in this case, and then go away and think about it all, and then distil those 250 factors into a 3x3 table. How can I, as an inexperienced ViP-er, ever learn to do that?

T Great question!

D This kind of complex case can only be performed after a lot of experience. As a student, just start with a simple case, with only a few factors. It's like juggling. You start with 2 objects and then try to increase that number in time. My experience is that understanding the reduction from 250 factors into 2 clusters with 3 values each is not that difficult. There is this funny feeling that tells you everything is already in all the factors; the ViP designer only uncovers things which are already there, which is like magic, but not magical at all.

T Right, it is very much about seeing patterns, relationships, how things affect each other, albeit at a very abstract level. And this requires practice, and training, and basically doing it over and over again. And Matthijs is right, if you can do it with 5 factors, you can also do it with 500. It just takes a wider scope and thus more time.

New organ donor registration service (by Reframing Studio & KesselsKramer)

S But practically, what do you actually *do*? Do you make notes of your discussions? Do you talk to people again and again to see if you have understood them right? Do you use sticky notes and flipcharts? Or do you write it all on a computer? A simple question I know, but for me it's important.
D We do all that. We do interviews, write them down, translate them into factors, show them to the interviewees and see if they recognize them. Then we put all the factors on the wall, start juggling them around, and start to form clusters. We show the clusters to the experts and then the coherence between the clusters starts to emerge. Show this to the experts again, etc.
S Thanks, that makes it a bit clearer for me…So did you work alone on this, or as a team?
D At Reframing Studio we worked as a three-person team. The government team also consisted of 3 people, and we interviewed 5 experts. Doing a project like this asks for a lot of content management.
T I want to understand the step from context to interaction: how did you create 'desired interactions' from these 9 possible combinations between the government and civilians? Did you create one for each combination?
D Exactly: we created one interaction for each combination or field, as we called them. Political preference determined the position of the service in a particular space on the grid, hence in a particular field.
T So a particular political view would 'automatically' lead to one or two fields? And for each field the appropriate human-service interaction was defined. Perhaps you could provide an example of one field, its related political statement and the interaction that follows from it? It would be very helpful. Can you give one? Or two?
D OK, here goes…
If you look at the relationship that occurs when the government provides perspective to the populace, and the populace feels dependent: the corresponding interaction can be described as 'vulnerable conditionality'. Put in a metaphor, it's like 'being the chosen one'. In that case, the services should have qualities like 'empathetic' and 'accurate'.
Another example: If you look at the relationship that occurs when the government is the 'democratic representative' and the civilian feels reciprocity, the interaction can be described by 'down to Earth engagement'. The metaphor is 'the search for mutual ideologies'. In that case, the services should have qualities like 'inventive' and 'passionate'.
S I have a more general question: when you describe what you have done, you use phrases like getting to the 'truth', and understanding what interactions 'should' be like – but aren't these just your interpretations – other people, other designers especially, might disagree with you, right? I suppose you could say that they were wrong, but they might say the same to you! You are very confident that you have discovered the 'right' things at this point – is that confidence justified?
D Of course *you* are right, they *are* interpretations. But because these interpretations are the outcome of expert interviews, expert feedback, and poring over stacks of published research, there is a feeling of confidence about the 'truth'. It feels like the truth, but of course, it's one of any number of possible pictures of the future. On the other hand, I think it is really important that it *feels* like the truth, otherwise there isn't enough confidence to start playing with insights like these. In playing with a system like this, the understanding of its truth emerges. And one more thing about this 'truth' thing: it is always a *relative* truth, relative to the context factors that have been selected.
T Your system may reveal 'a' truth, but no position has been taken, yet. It's a nice toolkit for civil servants to serve their ministers: for every political colour, we have the appropriate civilian-service interaction ready at hand! Or am I being too cynical?
D But a position like this is bold, because they had thought up to that point that there was only one relationship between the government (and their services) and the people: a bad one. And they wanted to translate it into a 'good' one. Now they agreed that there were 9 different options. This had enormous consequences on the design of the services they offer.
T So who decided (finally) which interaction was the appropriate one for a particular case?

New organ donor registration service
(campaign by Kesselskramer)

D What we discovered is that when democracy is functioning correctly, a civilian should be able to experience all 9 possible relationships.
S On the same day?
T Nine different counters at city hall?
D It got interesting. What we first thought was that civil services stood on their own. But no: a civil service is a means to emphasize an aspect of democracy. So, the design of any service had to be the derivative of the role the service had in the democracy.
T "Please civilian, pick the one that fits your democratic mood today!"
D If the service dealt with 'labour', different statements were defined from a governmental perspective, like "I want to help the unemployed find new jobs". Or, "I want to minimize the collective costs of caring for the unemployed by forcing them to find jobs". Obviously, choosing one or the other of these two statements had enormous impact on the kind of service being developed.
T Aha, so here is where the statement comes in! You had designed a context-interaction-meaning framework, and depending on the service domain you were looking for and your political view of this domain, you derived the interaction that was appropriate, right?
D Right. In creating each statement – or vision, or goal – the government had to take a position on the model. By taking this position, they understood what kind of relationships, and product meanings, were appropriate…and they became responsible for the outcome and impact of the designs. The model we had developed – that 3x3 grid – helped the government express their political ideas through the services they were developing for their citizens, and forced the government to be aware of the consequences of their political expression.
T I think it is important to stress that the model never led to ONE design, but to a design framework. Depending on the goal/statement (here that translates into 'political view'), a particular place in the model could be chosen.
D Exactly.
T You could even say it was 9 visions in 1!
S And you were saying the services the government is able to provide emphasise the political hue that colours their operations. Say I want to develop a service for ABC and my political view is XYZ, where would that bring me? For example, I am a South American dictator (benevolent of course), and I want to find a new way for people to engage with my government (because they are so lazy)…can you give me an example of something you might come up with?
D No, I can't, because I have to know what kind of service you are thinking of, or even better, for which domain. With this system, we (re)designed dog taxes, volunteer aid, the 'Apeldoorn environmental city', the Historic Buildings Act, income taxes, and 'the citizen's initiative' for the Apeldoorn Local Authority. These examples were not the services currently in operation in the Netherlands, but new design proposals for more appropriate services!
T What? All based on the model! You were responsible for all those laws and taxes? Obama should hire you!
S When you say you 'designed' them, do you mean you came up with the idea, or that you did specific physical things?
D A design is something with meaning. That something is a combination of features and properties that express this meaning.
T A design does not need to be physical; a service also has properties, so does a law or a policy. So when you see a design as the carrier of meaning, it becomes much more than just things or visual manifestations.
S Got it. Can you take the example of Dog Taxes and explain how that fits into the system you designed?
T I want an example too!
D Traditionally, dog taxes in the Netherlands were taxes to collect money for the design, or maintenance of, in this case, dog walking spaces, or for catching stray dogs. So the money collected was reinvested in the domain. Before we could design anything we had to understand what the goal behind the dog taxes ought to be. So in conjunction with the Apeldoorn Local Authority, we defined this goal as "limiting the social and physical nuisance of dogs". It was possible at a local level, because a few years ago the national government decided that local governments could exercise their own authority as regards what they wanted to

Les Voitures à Chiens — Le Caïffa

"The new dog taxes concept should be characterized by shared responsibility of dog owner and local government"

Above Dog taxes orginate from using dogs as a transport mode
Below Shift in relationship

addess in (some) local services. Having defined the goal of these taxes, the local government had to decide what relationship it wanted to create between this dog tax and the dog owner.

T I would say, now a political position was needed. It would determine *how* to limit the nuisance, therefore where to place yourselves in the model.

D Together with the local government, we decided that the best relationship was in the 'reciprocal dependency' field from a citizen's perspective, and that the government itself was trying to create a social collective. In this case, that was field number six in the citizen-government relationship model. It was clear what kind of interaction to accomplish between dog owners and the taxes they need to pay. The interaction was likened to a 'win-win situation', and the character of the service had to be 'ambitious' and 'critical'.

T Wait a second, how did you decide together where to step into the model? Why "reciprocal dependency" and "social collective"?

D The choice was directly related to the goal we had defined. It is imperative in ViP to always understand the relationship between the goal on one hand, and the factors – here, the two clusters of governmental roles and the civilian state of mind – on the other hand. And this understanding turned out to be very political. Of course, the definition of 'social inconvenience' could be interpreted completely differently by, for instance, right-wing or left-wing politicians.

T Exactly, and that would in turn direct them to another role of government and another view on civilians wouldn't it?

D Right!

T That's why I wanted to know how you chose #6 in the model... was the Reframing Studio team's political view involved? A designer with a political view, is that allowed?

S ...or are you just the tool of a particular government? I think it's an interesting question, because ViP is a process of context creation by intentional selection of those factors the designer wants to work with – in that choice it's feasible that the politics of the designer comes in.

T Definitely! That's one of the distinctive features of ViP: it allows the designer, to bring in personal views, political or otherwise, personal standards and taste, personal hopes and dreams!

D The decision to select option 2 or 3 or 6 was not my responsibility in this case. It was the responsibility of the local government to choose the kind of services that reflected their political colour, to help them 'practice what they preach' in a way. Of course, I was able to help them make decisions, and of course, they might have chosen positions that did not match my own ideology. In those cases, I took a step away from the design process. Until that point, that had never happened.

T You would 'step away' if there wasn't a common feeling?

D Yeah, when I had to design something where the government asked for a service that made people "feel independent" (because the government thought this feeling would lead to lower costs) but they were actually still dependent (because of personal circumstances), I took a step back.

T Even if this is a legitimate position derived from your own model? You designed the model for different political positions.

D It was my own model but of course it was possible to misuse it. Going back to the example. In designing the new dog taxes, we compared the desired characteristics with the current ones. Just to feel if it was necessary to design a new dog tax system. The character of dog taxes up to that point had been one of indifference and mistrust. That was completely different from the qualities we were looking for. At the time there was the feeling of paying for support to take care of the dog. Since the space to walk the dog had to be paid for, using that space became a 'right'. So reciprocal dependency was not the behaviour. There was even the feeling that the local authority was being paid to get rid of the dog poop.

S You wanted people to *care* about dog taxes? I don't understand how people (particularly dog owners) could feel indifferent to the then-current tax system.

D Because they felt they were paying for nothing. There weren't that many dog-walking spaces or other instruments to help take care of their dogs. So they felt the money was not being spent the correct way. Their reaction was abuse of the urban space and/or try and get

Taking responsibility to train your dog
is rewarded by lower taxes

out of paying. In Apeldoorn, they still have teams that visit houses through the day to check for dogs. If no one answers the doorbell, they look through the letterbox...There are still a lot of dog owners who don't pay dog taxes. In the current system, the personal responsibility of the dog owner is not stimulated and the behaviour of the owner in taking this responsibility is not taken into account.

T How did you try to give them this responsibility?

D We looked for features that would lead to the product meaning 'ambitious and critical'. We called the concept the 'Golden Dog License Disc'!

S I want to know all about it.

D The goal was to have dogs and their owners display 'civic-minded behaviour'. So we came up with the principle that people have always been motivated to train their dogs in socially acceptable ways, to go to doggie obedience training and eventually get a certificate for model behaviour. Even the local authority could design training sessions like these with the money they received from dog taxes. Obtaining this proof of good behaviour would reduce the amount of tax paid for the dog. So people would be rewarded for having a 'civilized dog'. The idea behind this is that civilized dogs would create less annoyance for other people. A Golden Dog License Disc is tangible proof of good behaviour. Other people can immediately see that a dog owner took the responsibility to train the dog to reduce civic disturbance as much as possible. The medal was also something that would demonstrate the dog owner's love for the dog and the sense of responsibility for other people.

S I can really see how it all fits. But did people consider it 'cool'? In my view, many dog owners do not want to be seen as social and responsible...it sounds like "see me being a good citizen". Didn't you run the risk that only the good guys would obey and the 'bad guys' might keep on doing what they were doing, leaving the shit on the street?

D This could have happened of course, but they would pay more tax for it. I agree with you that not everybody is happy with an idea like this. But that's precisely why it works. This idea is a reflection of the goal defined by the government. If someone doesn't feel engaged with the goal the options are to accept that that person is just being him-or herself, or try to make that person change their behaviour by, for instance, increasing the tax enormously for having a dog without a 'proof of good behaviour'. In a way, the desire to be in control of your dog is a universal principle. So in the end I was not that afraid it wouldn't work. The Golden Dog License Disc tells the world that you are in power of your dog!

T Got it...that's interesting: there is a principle at play! Did you need to consider new context factors for the design of that specific tax system? Or was it enough to just find your position in the model and design from there?

D This dog tax example was one of the first concepts presented to the city of Apeldoorn, to show them what working with the model had to offer. I fully agree with you that in designing a specific service, new factors should be introduced. Or maybe it is better to say that the designer wants to accomplish something, and to do that, how people work, think, and reason has to be taken into account. So if to create reciprocity is the goal, being able to understand how this is established is required. This can only be done by understanding basic human principles. Not at a context level, but at an execution level.

T Like an aesthetic principle applied at the embodiment level?

D Right.

The Golden Dog License Disk

>ViP establishes the connection between a designer's unconscious and conscious thoughts.

That's why feeling is so important; feeling tells you if your subconscious is on the right track<

The following interview about thinking/feeling takes place between Peter Lloyd and the authors, Paul (P) and Matthijs (M).

Interview
Thinking and Feeling

Peter Lloyd *One of the original inspirations for ViP was the realisation that the products designers were producing didn't have a soul somehow, and that you wanted to find a method that would result in products with a soul. Can you describe those beginnings and what you mean by 'soul'?*
Paul Hekkert The main characteristic of this so-called 'soul' is authenticity. With the methods students were given to work with, they were not challenged to ask themselves 'what do *I* think?', 'what do *I* feel?' 'what is *my* opinion about this problem I'm working on?'. It's a very depersonalized way to work. They were detached from the problem, the problem domain, and the kind of products they were working on. They weren't asked to take a personal position. As a result, their products failed to have an identity…a soul.
Matthijs van Dijk Right; soul is also about originality, and what was glaringly obvious about our university-developed products was a definite lack of originality. But to be original, besides being new, a design has to be appropriate. It's difficult to see the difference between appropriate and inappropriate if the only thing you know is how to turn a program of requirements into a product.
P We can't blame the students. That's the way they were trained. The products they came up with were perfect solutions to a program of requirements and the requirements were based on a very careful analysis of existing products, the market, the target group, etc. One of the consequences of this rational/analytic, problem-solving approach is that any improvements are mostly to what is already there, which is fine; yet it remains very limited, and implies that any newly-developed product will rarely offer new meaning.
M The word 'soul' also has an element of responsibility, which is equally important. You can see in the product if the designer really believes in what he or she has been doing: taking responsibility for the design and its practical and implied consequences.

Would you say that the students' work had lost its sense of humour somehow, that the work had become serious, too rational?
P It's true that they were very serious; they were seen as 'near perfect' solutions to problems. In that way they were serious. They weren't interaction- or experience-based, as ViP products are. So students rarely came up with a surprising product or an engaging product or a disruptive product; that would never have been the goal, since they only wanted to solve a particular problem. Solutions that fundamentally change the way people interact with products can only emerge if the designer wants to change the meaning of a product-user relationship. Humour could be one of the elements in there.

M I think humour is a means to accomplish something. Some designers were used to working with humour as a starting point: 'make something funny' and welcome to the Alessi club. What's important for us is that a designer takes responsibility for the means that work best to realise a certain goal. It's not that we want to start a moral discussion, but we want to be sure that designers are aware of what they are doing, because they have to be responsible for their actions in the world. I think that's important. In a way it *is* a moral starting point, and we *do* want to reflect the values of humanism – freedom, autonomy, responsibility – but we don't want to be moralistic about the fruits of our students' design labours. That's their responsibility.
P What we often saw with students following a rational problem solving approach was that they came up with solutions that they didn't really believe in, and they said so, but they also said 'my analysis brought about requirements that I have to comply with and that's why it has to be this way'.

So they'd set a mechanism in motion and then they had to follow through with the consequences of the machine…
P Yes…follow the rules. And the rules were external, they didn't make the rules themselves. The rules were brought to them by…let's say…technology, the industry, production techniques, or marketing people.
M This ViP process is not just about understanding the world and what its effect on product

design can be, it's also about understanding oneself. It's a parallel process. ViP establishes the connection between a designer's unconscious and conscious thoughts. That's why feeling is so important; feeling tells you if your subconscious is on the right track.

But how is that different from how an art academy might teach design? On one hand you've got the technical university engineering method and on the other you've got the art school academy-led design method.

M Simply put, students at an art school use their feeling to immediately make an object. So there's a feeling, there's a transition inside the designer and then they come up with the design of a chair, or something, and there's nothing wrong with that. What we do is ask the students to use their feeling or intuition as well, but we ask the student to understand where their feeling on a specific subject comes from. For us, feeling is only the beginning of a process of understanding.

P What justifies a design education at a university, what makes design education academic, is related to this idea of context building, that's where you need science. Scientific insights and scientific research are needed in order to build the context, in order to establish viable starting points for a design. That's what we teach the students with ViP: to actually build a context on the basis of observations from research, but also on the basis of principles from science, and/or from the humanities. All the skills that relate to building a context are very much skills that belong to university students. That depth or that level of complexity isn't present at an art school.

M Right. Weaving a coherent context is also academic, an academic exercise. There's a lot of logical reasoning involved.

P That reminds me of the whole appropriateness issue. The term 'appropriate' is ideally used to describe the relationship between a product and the context from and for which it has been designed. A ViP product should fit neatly – coherently, if you will – into its context. And of course the ViP designer is responsible for – has deliberately chosen, in fact – every element of the context.

Even though the designer creates the context, it must be justifiable. This is probably very different from an art school student's creation, where the context might be quite personal or conceptual. There may be appropriateness, but that appropriateness might be very personal, and may not seek to provide common ground. Since a ViP designer builds the context from principles that are mostly grounded in science, and on developments from the world at large, that context is, to a certain extent, solidified in the world. It has its foundations in the world out there. Although the designer shows personal discernment when selecting factors, and deciding how everything is brought together, the context is rooted in the world, and users will recognise that.

M What I think is interesting about people from art schools is that they really start from the inside; they feel something and they act out of that feeling. They create very beautiful objects and ideas from this way of working. I think with ViP we use our feeling to decrease the complexity of an assignment by following a process. We work with a process, we are process-driven, and this is different from someone at an art school. Our process delivers, I think, what a student at an art school can realise by critical self-reflection. But the outcome of a process can also be personal!

So on the one hand you've got the technical schools, the engineering schools, that have too much analysis, which distances a designer from the problem too much, and on the other hand you've got people that are perhaps too involved with developing their own identity, expressing themselves, and that also creates distance from the problem.

P We want to take the best of both worlds: give room to feelings and intuition as they do at art schools, but simultaneously require students to develop a sound argument, in order to justify and explain each and every decision they make, which means understanding where each decision comes from and what its consequences are. ViP is about reasoning from top – the context – to bottom – the product – a kind of 'systems thinking'.

M The marriage between two worlds that we have tried to establish with ViP can be found at all levels. What we always say is, "Whenever you think of something, try to feel what it means to you; feel the potential impact of an observation you've made or the information you've discovered, or try to understand what your feelings are all about. So if you feel there is some connection at the context level, or you feel that some interaction is appropriate, try to support it rationally, try to think it over." There's a consciously sustained interchange between thinking and feeling. That's not something that our students, nor the students from the academy, to the best of my knowledge, have been trained in.

And do the products that you've seen developed by using ViP have soul?
M Yes, it works; the products become more original and authentic. But, you know, sometimes students really get stuck! It all sounds so simple, but it takes time to adopt the values of ViP. The values are crucial: they turn everything upside down for the students. So when a student does get stuck, either he or she needs time to identify and digest what is going on inside, or, he or she can't cope with ViP. There's nothing wrong with that. Using ViP is not a guarantee of success.
P We make it hard for the students. We want the conceptual quality and freshness of art academy products, and at the same time we want products that fit our world… or into the world that a student has made, but that's essentially our world as well. We think that's the best thing that you can strive for as a designer, finding that balance.
M That takes us back to the thinking and feeling. What I feel is that a step forward is always made by 'feeling' and never by 'thinking'. To understand if this step forward is an appropriate step, that's thinking, that's using my mind to understand what is really making sense, in relation to the context of course. That's exactly how artists like painters or composers often work.

I think that's fundamental to design. You do things and then discover the consequences of what you've done.
M But that's the strange thing about many methodologies: they force you into taking a specific step. That's why engineering methodologies like those of Pahl and Beitz don't work for mechanical engineers either, for exactly that reason. I never use Pahl and Beitz. I don't think – but this is an assumption – that Adrian Newey or Collin Chapman or Gordon Murray ever used a method like that. That kind of method doesn't stimulate and teach a designer how to use intuition, to come up with an even more appropriate idea. In mechanical engineering, there aren't many methods that emphasise bringing in your intuition.
P Then a good question would be: how does ViP stimulate intuition?
M *Can* you stimulate intuition?

It's like that experiment by Sternberg where he compared groups of people solving the same problem. He gave one of the groups the instruction to 'be creative', nothing more. The other group was just given the problem. The independent panel ranked all the designs in terms of creativity by some measure and they found that by just being told to be creative, they were more creative! You're doing a similar sort of thing, you're saying "trust your intuition, use your personality", and people act on that.
M I think that using ViP really makes intuition tangible; the process starts with a feeling, and by the end there is a rational understanding about why this feeling was an appropriate feeling.
P Right; and if the designer is to feel responsible for a design, that rational understanding is crucial. Being allowed to let intuition in is nice, and stimulating, and gives flow to the work, but the important thing is that this intuition is placed within a larger framework. You can never get away with "this is what I intuitively feel". Intuition is not a *carte blanche*! It's the start of a process of thinking, understanding, and argumentation.
M Real strides in personal development are made through this kind of understanding. It contributes to personal growth, this kind of self examination. I think with traditional step-by-step processes, once they have been completed five times designers don't learn anymore.

P They become a trap; at first the designer thinks it's fine to have these pre-established steps to go through, but after a couple of times, their hands feel tied.

Like solving a crossword puzzle.
P Well that's what we eventually found out. In the beginning, about 10 years ago, we did a lot of interviews with designers. None of them, including the ones trained in industrial design in Delft, were using any of the methods they'd learned at school; we wondered why that was. Why did we teach them all these methods when they're not using them anymore? And what are they doing in practice then? What is their method, if any? The way some described how they work much more closely resembles what we try to do. Rely on intuition.
M What is your definition of intuition?
P Knowing…not yet conscious…pre-conscious knowing.
M Ah, OK…
P I didn't make that up myself. It's a kind of knowing what is right, or what should be done, without being able to consciously explain it…but you *can* explain it with time and effort. That's why people cannot justify a decision by saying 'that's what I intuitively feel'; they can't stop there!

Maybe we should stop here?

>We won't tell you what you have to do, but rather help you articulate the appropriate questions at the right time<

A ViP Process in 11 sessions

To introduce how the ViP design approach works, and why it can be a valuable tool for the designer, we have set up a case in which a student (S) unfamiliar with ViP goes through the whole process step by step.

He is supervised by two experts: us. We are:

- a professional designer (D) who provides practical comments and suggestions based on his own experience with the method, and
- a theorist/thinker (T) who delivers background ideas for the various themes that arise in the dialogue, and keeps track of the stages in the process.

The case as such is not particularly original, and the end result may not be completely satisfying. The main aim is to illustrate the process and show what it has to offer. To that end, and in the interest of clarity and speed, we occasionally 'bulldozed' the student.

Session 1/11
> design is about contexts, not solutions

S Supervisors, I have this project...I'm interested in the space outside a home...maybe using garden space as workspace. I've got this idea for a kind of capsule sort of thing. Could you give me some advice on it?
D Interesting. However...
T What do you want with a 'sort of capsule'?
S I was thinking about people working away from their offices, working from home, wanting a nice place to work. So I thought about designing a kind of transparent box where people could feel at home working, or maybe just sitting...
D So your domain is 'working from home' and the idea of the capsule is a new product idea that seems to fit the domain. I think it would probably be more interesting to start by deconstructing 'home workspaces'.
T FYI, deconstruct means to pick a few current products in your domain and ask yourself *why* they are the way they are.
S But I'm positive I want to design *this* product. I don't really care about workspaces in general. How is 'deconstructing' going to help me here?
T A-ha, a tough one...! A student who comes to us for help, but is absolutely fixed on his first idea! Listen. You are focusing on a solution, but to *what*? That's what we like to find out first. Only when we know what you want to achieve, and, more importantly, *why*, can we assess whether you have found the best possible outcome. And knowing this will provide you with very solid arguments to support your choice for the final design.
D We usually start at a more abstract level than the 'product idea'. With this approach, you can see how your new garden object design can have value for people.
S Well, I think it will! But don't I need to design it before I can tell if it will have value? After all, if people don't like it, they won't buy it!
D I can see what you mean. In my practice, before I start designing the product itself, I try to understand how successful this product could be in the future. First, you need to envision that future to see if your product idea will have value. That's interesting, don't you think? So I have to ask you *why*, as a designer, you think this 'capsule' will give value to a user.
T Right...your capsule may not be the 'best' design; and by 'best' here I mean in terms of 'appropriateness'.
S Appropriateness? What do you mean?
T This is the idea that products should fit the world they are designed for. Before you start to design something that may turn out to be *in*appropriate, first take time to shape the world where it will be launched. With ViP you literally have to *design* this 'future context'. If you have a clear image of that future world, you can then work out what is appropriate for that world.
D Yes! Instead of jumping on the first idea that pops into your head (even if you think it's a good one), we want you to think in terms of your goals, and the appropriateness of the design fulfilling these goals. Designing in ViP terms is less about objects as such...and more about designing objects as part of a system.
S I can kind of see what you're saying – I do want it to be successful in the future...and 'appropriate'. But, you're losing me a bit now – are you saying that I need to design a system? It's been my dream for quite a while to design this capsule.
D Sorry, I'm going too fast! I am talking about a system that describes the relationship between a future world, and the products and people interacting with each other in that world.
T Maybe your capsule will turn out to be the perfect fit, but to see that, first grasp how people you are designing for think and feel in the context of their lives. The crucial thing to understand is that we behave and interact with things and people the way we do partly because of who we are, as human beings, and partly because of the environment we find ourselves in. A designer needs to have a full understanding of what drives and motivates people internally and externally.

Session 2/11
> the domain

S I like the idea of designing a future context for my outdoor workspace, but since I'm going to use ViP, where is the best place to start?
T First, let's define the *domain* as best as we can. The domain is the focus of your design activity, the area you're working in. It can be a 'problem', but not necessarily. It could be a particular phenomenon, or an area of life.
S So…can you give me an example of a well defined domain?
T It's not so much about well defined…we are more concerned with finding out what *you* are really after. We try to keep the number of constraints to an absolute minimum to give the designer the utmost freedom.
You are interested in 'working from home', right?
D So let's try to clarify whether the context you intend to build is relevant. This relevancy is only clear in relation to the domain you are working in.
T First up is the timeframe. Are we looking at tomorrow? Three years ahead? Further?
S Uh, well, I was thinking about a product for today's market.
T OK, so that means we need to consider the circumstances of 'today' as influencing this domain. The circumstances would be completely different if we were to design for, let's say, ten years from now.
S Hey! Obviously I want my design to be used in ten years' time! I think one of the most important aspects of what I do is that the designs continue to be relevant.
D If you think about it, 'today's' market doesn't exist for a designer. It always takes time to develop, manufacture and market a product. For the simplest product, the development time is probably, minimum, one year. So, designing is – by definition – a future-driven activity!
T Sure, so that definitely impacts the degree to which current trends and developments are taken into account in your context. We'll explain this in a minute; but basically, if you focus too much on the present, your product may already be outdated when it is launched.
S Right, so what's my domain? Is 'working from home outdoors' OK?
T Why the 'outdoors' qualifier? Is it relevant to your final solution? Would you be happy designing something that allows people to work perfectly from home but is inside?
S OK, ok, obviously I've missed something. What are the criteria used to set a domain?
D *Number one*: the domain has to suit the time that has been allocated (by you or the client/company) to the design process. If you only have two weeks, your domain must be much more specific than if you have months to work on it. The more broadly you set your domain, the more factors you can consider and incorporate when you build the context.
Number two: the domain has to fit the strategy of the company. A car manufacturer won't readily adopt 'public transport' as a domain.
Number three: the domain must feel natural to the designer. Some designers prefer to get very specific with their domain, whereas others like to remain quite open.
T Don't forget: the domain has usually been largely predefined by the client (and their marketing department). But, since you are a student, you can set your own goals; you are now designer AND client at the same time. Just tell us what you want to design *for*.
S Well, I originally had this idea for a product, but I guess you'd like me to put it aside for the time being. I don't really want to be too broad, so I like the idea of working from home, but outside. Is that too narrow for ViP?
T It could be too narrow if you don't have valid reasons to go outside. I mean, you say, "I like the idea". But *why* do you like it? Your "liking" is based on *some*thing, and if we unravel this, we find out if you have any preconceptions in your head leading you to think this is a fruitful direction for a design. Remember, we want to give you as much freedom as possible and as much as you can handle.
S When I say 'I like the idea', I think I like the idea of the form that I have in my head – I think it would look good (and of course function well) as a working environment in the garden. But I think you're telling me

that as a designer I should not become fixed on this particular outcome, but rather define a domain that I can really make a difference in?

T Exactly. You may think yours is an appropriate idea in light of some background context you have not yet made explicit. We make you aware of this by forcing you to define it. And in order to establish a fresh context, first you have to clarify your domain. Again, setting aside your first idea for now, do you still want to make a difference in the area of working from home?

D Maybe this will help you: remember that if you use the ViP process, the product you are going to design is just a means to create the desired relationship between the to-be-designed object and the user. So the process of designing is not about designing an object, but about designing 'desired user-product relationships'. We call these 'interactions'.

S OK. So now I think maybe I'm interested in 'working' as a general domain – is that too wide?

T Not necessarily, it only means that you have many more options in your context. Many more starting points or considerations become relevant if your domain is defined more broadly. The ultimate domain would be 'human life'. (*smiles*)

D I think 'working' as a domain is too wide for you.

S Yeah, me too! So 'working from home' it is, then, OK?

T But is *that* too wide? Sorry to keep on at you like this… Initially, the domain can be as wide as possible, and you do some preliminary research to gradually narrow it down. Let me give an example...
A student of mine was concerned with 'problems in city neighbourhoods', and wanted to design something to contribute to their improvement. We considered this a fine, yet comparatively wide domain (anything could be relevant here: it's hard to think of a consideration that would *not* play a role). So, first she started to research integration problems, the sociology of cohesion, that sort of stuff...

D Trying to get a grip...

T Wait, just a minute… And then she narrowed down her general domain to the more specific 'problem of cross-cultural misunderstanding in Dutch city neighbourhoods'. You can 'play' with the broadness/narrowness of your domain, till you feel you have found a core.
She eventually came to the conclusion that 'integration' allowed for too many things to look at/take care of, and that months would be needed for the entire ViP process. By narrowing yourself down, you can focus on a sub-area that seems to have the most potential or inspires you the most. Just like you did with 'working from home' instead of 'working' in general.

S So I guess it's best to narrow down the domain you plan to work in.

T Not necessarily. Sorry again…but you know, more often, I think it's a question of opening up the domain rather than narrowing it down.
Hey D, I remember you actually negotiated the domain of a design assignment I did recently, didn't you?

D I did; what I often experience is just what you say, to varying degrees. As a designer, I often feel that a given domain is 'saturated', which means that existing products in a domain completely fulfill a desired 'performance'. That is why we define the domain at a higher level of abstraction than the product itself.

S I see: so it's more about getting away from thinking at the product level? I guess clients usually come with a request for a particular product (that fits in their range, for example) and you've got to convince them to widen their thinking a bit…

T You've got it!

D If you have an assignment to design a family car, the domain is 'family cars'. But this is too restricted, in a way. The domain description is *too* clearly defined (an object with pre-defined functionalities), so it may be difficult to come up with new and appropriate means of transportation for families. Therefore, a more interesting domain would be 're-establishing family values in personal transport' for example. But you always have to keep in mind your client's level of acceptance. The MAYA principle is applicable here.

S Wait, you lost me there.

T Most Abstract, Yet Acceptable?

D Exactly!

T Back to our student: what was it that you wanted to do again?

S Ha ha, very funny. You've convinced me. I think I need to move up a level and look at the whole domain of 'working from home'.
D So glad you are convinced...and I hope we've been clear.

Session 3/11
> Deconstruction 1

S A friend of mine is also doing a ViP project, and he mentioned something about a 'deconstruction phase' – will I be doing that?
T You could, especially if you feel your head is already full of existing or potential solutions – like the capsule in your garden. One goal of deconstruction is to 'empty your head', so to speak. Free yourself from all kinds of preconceptions about what a product for working from home is/or should be.
D It's a valid exercise, because it also helps you absorb the underlying structure of ViP. In feeling and understanding the present, you give yourself confidence about feelings you have for new design opportunities for the future.
S I think I need to deconstruct the domain – how should I start?
T Pick a product you know was specifically designed for doing work from home.
S Well I guess there are entire ranges of products that are meant for 'work from home '. Printers for example...
D Because printers became cheap, it was possible for individuals to buy them and use them at home for work. That's true. But they are not products intentionally designed to suit working from home. What is typically made for working at home?
S Yeah, it's almost like the work-from-home *environment* is the product, the arrangement of business-like things in a home context.
D Exactly! Hey...what's the name for those typically English writing desks for home?
S A 'bureau'.
D Not in French, that uniquely strange British one!
S The 'workmate'?
T The 'Davenport'!
S OK, so how do I deconstruct it?
T Start describing the product as it is. What do you see? First in terms of concrete attributes, then in a more qualitative way... go ahead.
S Well, there's a work surface, and lots of storage, and it's on wheels...which means you can move it from place to place, I guess.
D OK, now try to describe aspects of the object that are not on the surface.
S It's designed for one person, it's made out of dark wood, with a leather inlay for the work surface. The person working is supposed to sit and work.
T It's small.
S Which means you have to focus on one thing at a time, you can't spread out a lot of work on the surface.
T Right!
S There can be no distractions.
D And what kind of character does this object have?
T Is it cheap? solid? pretentious? friendly? That sort of thing.
S Well, it's kind of serious – it looks like somewhere you'd have to sign important documents – but playful at the same time – those ridiculous legs! I can almost smell the polish!
D Great! But *is* it playful? Or do you consider it playful looking at it through your modern eyes?
S There's a power thing there. Like the desk is only for powerful people doing serious work.
D You are doing a great job! Now try to imagine what it's like to interact with this object.
S I think the interaction would be characterised by focus and attention...and power and responsibility.
T Wow, very good. These are what we call 'interaction qualities'. They describe what the designer puts into the thing, plus what the thing is saying and making one do, simultaneously.
S There's quite a lot of things you can do with it – pull out the drawers, lift the lid, roll it around...So there's a certain *flexibility* in the interaction.
D I think you mean that the object itself is flexible. But how would you describe the interaction?
S Hmmm, not easy.
T Often it can be difficult to verbalize these interactions. You know, you could just say that it's 'like a pilot in a cockpit', for example.
D But, always be aware that when you are talking about 'interactions', you are not describing the intentions and the experience of the user. The intentions *lead* to the interaction and the experience *results* from it. Both are reflected in the interaction. Here's an example: Say someone has little time and needs

A Davenport

to buy a train ticket as quickly as possible. As a result, the interaction with the ticket machine can be 'hurried', 'sloppy' or 'uncoordinated' (especially if the machine is complicated). If this results in pushing the wrong button and missing the train, the person will experience 'anger', or 'frustration'.
T I think he get's it. Let's move on…
Now that we've looked at *what* the product expresses and *how* people interact with it, the question is: *why* all this? What ideas, thoughts, considerations were behind this design?
S Wait a minute, before we go further: were my Davenport observations accurate?
D Your observations up to now have been very good. The only thing missing is how the home/environment affects the interaction you described.
S So, if I look at the desk I can think of someone working away at home – I said 'focus' and 'attention' before – don't they cover that?
D I'm not sure. There's something ambiguous about using this desk to work from home. On one hand, the interaction *can* be characterised by focus and attention, but on the other, because the desk is small, you could say that the interaction can be characterised as 'cursory'. Like listening to a concert on a transistor radio, which is completely different to hearing the same symphony in a concert hall.
S OK, so then it's just there at home, and people put things in and on it, but no one really sits down to work at it, or at least not for any length of time.
D That's right. What kind of quality in the interaction between the Davenport and the user describes that ambiguity?
S Something transitory, temporary…but different from the way the object looks. It looks like something absolutely permanent, something that will last for years, and be passed down through generations.
D 'Temporary' sounds good… and you are completely right that the features of the object actually communicate the contrary.
T Interesting…this might be the right time to start looking at the context: *why* this ambiguity? Where does it come from? I would say the thing is designed for very brief and important occasions, like writing a letter.
S So when you talk about the context – do you mean the context that the product is used in? The home (or the palace)?
T Only partly. Of course, the space in which the product is supposed to be used – the home in this case – is part of the context. But the ViP notion of context incorporates much more: the designer's viewpoint on 'work' for example, ideas about what people consider important, how people behave, ideas of aesthetics maybe, or ethical beliefs. In short, anything the designer regarded as relevant to what he was doing…Thus the question is: what was in the designer's head when designing this desk: *why* is it the way it is?
S So you're thinking more of the context around the time the desk was designed…what might have influenced the designer?
T Not exactly. It's more the opinion about working (from home) the designer had at the time that forms the context for his design. Of course, this view is again influenced by shared worldviews of that era.
S Do you think there was actually a designer? It looks to me more like something that was crafted. I think the designer probably thought of it more as decorative than as a functional design for people at home.
D Are you sure about that?
T Ask yourself this: why is it heavily decorated? And why this particular way? The point is that we can always ask why things are the way they are, regardless of whom is responsible for them. Often we simply don't know.
D And when something is crafted, it's still designed, by the way. Look at the dimensions, proportions and style of the Davenport. There were important decisions being made that, in the end, had this object as a result.
S I would think that the designer thought that people like beautiful things in their houses, and that this was a beautiful thing.
T Right, and it's more than beautiful: it's pompous. Why?
S Yeah, it's totally overdone… Maybe there were pompous people around then, who wanted to show off who they were?
T I think it has to do with the kind of activities people were expected to do at this desk. Important ones. Official ones. The desk needed to express

this to others – "Don't touch me, I'm too valuable." And to the man of the house (obviously these things were mainly used by men): "You can trust me, I'll protect your precious documents and things, this is the kind of classiness you deserve... a man of your standing!"

D Don't forget the aesthetic factor the student mentioned before. It's not only about beautiful objects as such. The object had to match the interior style of the period, in this case Victorian.

S I see; are these the context factors you were talking about then?

D Absolutely, though I believe there is still one important factor missing. It has to do with the way all the elements of the cabinet fit together…like a puzzle. Why?

T C'mon student…what viewpoint could this 'designer' (the one responsible for the desk) have of what people needed at home? I think the weird configuration fits in here.

S Are you talking about 'needs' here? What the designer thought people needed?

T Needed, wanted, desired, thought, believed, any thoughts he might have had on people's motivations and behaviour. And not about desks or interactions with desks! In a more general sense.

D And in relation to the domain we are working in.

S So something like 'there was a need for people to show off their wealth'?

T Right: 'people want to show off their wealth' could have been a principle in this context.

D And, just to expand on that, what kind of principle is it?

T You could call it a 'psychological principle', a (more or less) 'universal trait' people share. Look at cultures all over the world, from any era: people show their status and wealth to others with decorations, possessions, tattoos, etc.

S OK, so there are a few factors: people needed something that would fit the style of their homes, something that they considered beautiful, somewhere to store all their private letters and documents…are these all factors?

D They certainly are. You could be more specific in your formulation, though. Take 'consider beautiful': what aesthetic principle is at stake here?

S People needed something that would fit the style of their homes, so 'people like congruency'.

D Great! Now, when you talk about letter storage you are getting too specific. You have to think more on the level that describes *why* people want to store letters. This could be a psychological principle: 'people want to hide personal things from others'.

T Like private thoughts, feelings or fantasies…

S Or maybe people want to think that their important possessions need to be kept in a suitably important place. In Victorian times, the man was really the king of the house; he needed to find somewhere to store all his important documents, and keep them safe…from the rest of his family! It made him think he had power over his family.

T And the documents could be found as soon as needed… that's probably why there are so many drawers.

S That makes me think of the Victorians in general, didn't they want to classify and group everything – like Darwin – could that be a factor? 'People feel the need to group and classify'?

T Sure! Think of Linnaeus!

D I think that's a beautiful observation. Whether this was really behind the design of the object I don't know. But to understand the structure of the object itself in relation to the philosophy of the time is really interesting…

T Right, let's go on. I think we only need to address the issue of the size now…what could explain it?

S It *is* weird…it's quite a small desk, but with very grand ideas – as if people wanted a piece of aristocratic furniture in their own homes – that's the pompous bit I guess.

D The status factor.

T And, please, don't think in terms of 'needs' *too* much. That's what marketers tend to do. We prefer to talk about such things as *principles* (of human thinking, behaviour, concerns, etc) and *trends* (temporary or culturally dominated patterns of behaviour).

S Home space is limited. Is that a factor?

T Yes, I would say it's a physical principle.

S People have to store more and more things in increasingly limited space, while keeping up the appearance of living in a palace...

I can really see how factors are beginning to emerge here, but I have a question. The designer who designed the Davenport didn't know anything about ViP, but we can still see the context factors upon which his design was produced – does this make him a ViP-er?
D Hm, difficult question. But… I think he may have been…his object was successful, it survived. For 200 years. So the designer was able to make something really appropriate for that time, and was also able to make people understand why the object is the way it is!
T Be careful here. There are always context factors underlying a design, as there are always considerations a designer had when he designed something. What makes a ViP-er is the awareness we maintain of these considerations, choosing them deliberately and taking responsibility for their implications throughout the design process. It's highly unlikely the designer did this.
S That's what I was thinking. Maybe he did all this unconsciously, without realising it.
T OK, enough for today, shall we try to summarise where we are so far?
S This is really useful, you know. It's been interesting to look at an object and think about the context it was created in and how the designer might (consciously or unconsciously) have incorporated those factors into the design.

The Davenport discussion revealed a number of context factors:

> people like to show off their status/wealth,

> people prefer order/unity,

> in Victorian times, people were interested in classifying the world around them,

> a house/home has limited space, and

> people want to protect their (inner) secrets/thoughts/feelings from others.

Session 4/11
> Deconstruction 2

D We did a great job with the Davenport…we may have actually found out why it is what it is! Now let's look at a modern-day product that is frequently used when working from home: the laptop. I'm using one now, actually. At home! Could you describe its features for me? Go ahead.
S Well, in the picture it looks like a standard laptop, just boring really.
T It's boring because it's so familiar. But try to see it as if you were looking at one for the first time: what do you see?
S Well, when I look at the picture the guy seems focused on what he's doing, active, engaged.
D Hmmm...what are you describing at the moment? Are you looking at the quality of the object, or the quality of the relationship between the user and the object?
S OK, if I have to concentrate on the object, I suppose it's businesslike, grey.
D Go on.
S Organised, open…
D Open?
S Yes, the laptop seems ready for business.
D So it's 'inviting'.
S Yes, I suppose so, inviting, almost saying, "Go ahead, use me."
T OK, now what about the keyboard and the keys? What do they express?
S Flexibility? I'm at a loss with this one.
D Geometric?

T Organised?
S Does it really *express* 'organised', or *is* it organised?
T Good question. I would say both.
D All the features of this object are organized geometrically... But what can you say about its characteristics? What kind of personality does the object have?
S It's boring. And businesslike.
T And 'trustworthy'?
S Up to a point. I do actually store a lot of valuable documents on mine, but it crashed a week ago. So I'm not as convinced now.
D Meaning…it's also quite vulnerable?
S Um, yeah, I think so.
T Very good. The character of the laptop is not only determined by what you see – its form – but also by what it offers you, and how. If it allows you to safely store your documents, you may say it's 'reliable'. And if interacting with it is smooth and intuitive – like many people say about Apple laptops – you may qualify it as 'understanding', or 'smart'. If you describe the product qualities of 'intelligent' products only using facets of surface design, you'll see only (a small) part of their character. It's akin to uncovering the character of a person: a person's character only reveals itself through a wide variety of situations. Got it?
S I guess so, but where will it lead me?
T If you *understand* the thing, you start to see *why* people relate to it – interact with it – the way they do. So, how does the man interact with the laptop and why?

D (Remember the things you thought and felt earlier.)
S He seems attentive to what is going on, poised to type important information.
T OK, go on...
S He's focused, concentrated...
D He is...but what kind of quality do you see in the wholeness of product *and* user?
S Well I guess he's not really seeing the computer, so a kind of transparency.
D Beautiful...continue...
T Look at his posture, and the thing's 'posture'.
S A lack of awareness…
T What do you mean?
S He's not aware of the computer; he's focused on the task he is performing.
D But haven't you already described that part of the interaction with 'transparency'?
T But the transparency is not *natural*. Look at the guy's posture...and at his hands, and their proportions in relation to the machine.
S You think he's too big for the machine?
T He certainly is, and so are his hands!
S So how does that affect the quality of the interaction?
D Well, 'transparent' is a rather neutral description for what is going on. Can you see something very positive or very negative in the interaction? 'Introverted-ness' maybe?
T Or 'intimacy'?
S Hang on, I don't see 'introverted-ness', more 'extroverted-ness'…
D What I meant by 'introverted-ness' is that the system created by the user and the laptop does not allow for any outside

interaction. It's like they are in another world.
T If you mean the interaction is one-on-one, the word is 'intimate'.
S So tell me this – is it a big deal if we disagree about interaction qualities? How do we work out who is right?
T Good question. It's not so much about being 'right'. Disagreeing is probably a matter of seeing or describing things differently. Or not understanding the situation the same way...
 What *I* meant was is: the product is inviting, plus the man is focused, concentrated, and the result of both together – which we call the *interaction* – is that the whole looks 'closed', intimate, not open to the outside world. Do you agree?
S I suppose I can see 'intimate', but then everyone interacting with a product is doing so intimately, aren't they? If I think of someone in a car, or on a mobile phone...I think 'closed' and 'intimate' are too general.
D Good point.
Getting back to the interaction...what do we have so far?
S 'Transparency', 'intimacy'...
T 'Forced'?
S In what way?
T The image of man and laptop may look natural because it is so mundane. Yet there *is* an imbalance between the man's body and the laptop's size, including the size of the keys and the whole keyboard. It's too tiny for that huge caveman!
S OK, now I get it. It limits him in some way, holds back his natural capacities. He should be off hunting animals, but he's stuck in his office tapping away at his computer!
T The result is that the interaction appears 'forced'...
D So, the *qualities* of an interaction are not right or wrong, our concern is which description (or image) of the interaction quality fits best.
You know it's just as hard for us, the seasoned practitioners, to understand and feel what is really happening.
T Or maybe it's just that an interaction is difficult to qualify…
S But what if I'm on my own, and I get stuck? What do I do?
D Stop for a few minutes, and try again later.
T Always reflect critically on your insights. Teach yourself to see, and see more, and not stop; then look even deeper, and understand even more.
D So when I said, "stop for a few minutes", I meant, "clear your mind, and change the direction you were heading in".
S Looking at the laptop picture again, now I see 'danger': the laptop looks like it's going to gobble the guy up, even though it's smaller than he is. It reminds me of a snake!
D So if you see aggression in the laptop, how can you describe the interaction? Based on your latest insight, you could say the interaction can be described by...
S 'Nervousness'?
D Not quite...but interesting.
S 'Tentativeness'?
T It doesn't need to be one word! You can also describe the interaction as a metaphor, for example.
S Like the snake idea?
T Exactly.
D Yeah, so the metaphor is...
S 'The laptop is about to gobble up the user, like a snake; it looks like it's going to swallow him whole and digest him down its tiny cable'.
T Now we can feel what you mean.
D So, tell us: has this little activity brought you to any new conclusions, or provided you with any new insight or knowledge, about using a laptop?
S Well, it's impossible to be sure what the qualities of that man's interaction are; we can only interpret what we see, and use our knowledge about how people look and what they might be feeling. I have to be able to communicate my interpretation of the interaction, in this case with a metaphor.
T Right, but don't forget: you are also bringing a lot of knowledge about the user to the situation. We know the guy has a job to be done, and we know he's carrying all kinds of needs and expectations (efficiency, feedback, etc.) into the situation. You built your interpretation out of all this. And since people more or less share this background knowledge, they more or less agree. That's why it sounds convincing. It's a *shared* interpretation.
D Look, we have to stop here. You should take these qualities home, and think about what context factors were behind the design of the laptop on your own.
S OK, will do.

Session 5/11
> New context 1

D Time to start designing!
T Now we understand the 'at-home working world' as it was, through deconstructing a couple of products that fit that domain. So, let's see what our new context might look like.
D First, state the timescale.
S OK, well let's say '4 years into the future'.
T We can set the scope to 4 years from now, that's our (arbitrary) choice. Remember that in most situations, the scope will be largely based on the client's timeframe.
One more thing before we start discussing trends and so on: what do we mean by 'work'? Is it 'paid work'?
S Not necessarily. I think it means something more like 'concentrated activity': this might be practicing a hobby, or paid work of course, surfing the net, meditating, even conversations.
D You should define that – what is meant by 'work' – right from the beginning. You can also think of factors that are relevant to this particular question.
T So that way the domain becomes more refined *during* context building. Your domain should not limit your context research right from the outset.
D Right, so let's start defining our context. You talked about the current trend of people using their gardens, so you have to demonstrate that this trend will still be relevant in four years. Defining context factors is more than just seeing what is relevant today.
S Well... I think the weather will get warmer, for sure, so I think people being outside for longer will become more of a trend...
D Good...
S Could I also say that one of the context factors for the near future will be the need for places outdoors in which focused activity can take place?
T Not exactly. When you define it as the *need for a place*, you are already talking about the properties of a potential solution (it being a place). The need for concentration in order to do certain activities could be a factor though. Maybe it does not need to be an actual place after all!
S Well, everybody has to be somewhere…
T Yes, but that reality does not need to be a part of your solution.
D So one factor could be that 'people need to feel secure': they want a kind of physical reference point, to be able to concentrate and feel physically sheltered, is that it?
S 'People need to be protected from distraction'! In a few years time, there will be so much competition for our attention that focusing on a single activity, whatever it is, will probably be a relief.
T Very good.
D Interesting. What I like is how original that is; see how real insight and originality can appear from simple research?
T Factors often deal with what people 'need' or 'want' either generally, which we term 'principles'; or specifically, for the time period you are looking at, which we call 'trends' or 'developments'.
S So, what's the difference between a trend and a development?
T Both trends AND developments deal with *changes*, like fluctuations in people's behaviour. For example: 'people will increasingly work from home'. *Developments* deal with changes in the world around us. They tend to be on the level of culture, technology, politics, economics, etc. *Trends* are the reflection of such developments in people's everyday behaviour. For example, because of globalisation (a development), people have started to value their local cultural practices more and more (a trend). Got it?
S So, 'people will become increasingly concerned that they don't have a place where they can perform focused activities', perhaps? Or, 'people will become increasingly distracted'.
T Because homes are getting smaller? You've lost me.
S Not really, it's just something I've noticed around me now, people having less attention and getting distracted, and I think it will continue in the future...
D Fine.
OK, now let's go back to the factor 'people will increasingly work from home'. Do you mean that people will be 'forced' to stay at home for all types of reasons?
S What's forcing them?
D Well…traffic, children, money, etc.
S So people will feel trapped?!

D The only thing I want to address is this: working from home is not only the option that makes a job simpler and easier to perform, but the decision to work from home could also be the result of all kinds of things happening around a person…like needing to take care of the children, for example.
S How about this for a trend: 'home life is becoming more integrated with work life as a result of increasing equality between men and women'?
T Very clever! Now congestion: 'roads are getting more and more congested, and traffic jams longer and longer'. People waste hours looking at the brake lights of cars in front of them. This is a factor of urban environments globally.
S 'Congestion is getting worse', that's for sure.
D Yeah…that's a development!
S It's not a trend?
D A trend is when you talk about changes that relate to *human* behaviour.
T Right, it's a development because it involves a changing pattern in the wider world. Trends resulting from it could be 'people are making more calls from their car', 'people are eating their breakfast in the car more often', 'people usually leave home before or after the traffic jam', etc.
S OK, so trends arise out of developments?
D Right, and you have to decide if the trend OR the development is more relevant to your domain.
S So does the total number of context factors have to contain one or two of each type: 2 principles, 2 developments, 2 trends, etc.?
T Good question, but NO, of course not! It is not about 'have to'. You collect as many factors as you think are needed, of ANY type. The distinctions we were looking at – between trends, principles and so on – are only to demonstrate the types of factors you might consider.
S But how do I know how many factors should be used, especially if I haven't used ViP before?
D Use the distinctions between types of factors to help you check and see whether you have addressed every possibility. That's the way I use them… If I have identified all kinds of trends, for instance, I look at whether developments, principles, and states might be applied to form a more well rounded, or *complete* context. But what is 'complete'? How many factors do you need? An excellent…it is a difficult question...So what to do?
S Are you having a conversation with yourself?!?
T He's saving time...
D As a designer, please understand that whatever factors you identify must describe the full spectrum that is possible; you should have the feeling that many different perspectives of the domain have been addressed. So, if it's relevant, you could potentially say there is a social perspective, an economic perspective, a psychological perspective, etc.
T Right, but that kind of thoroughness is only possible when you have plenty of time. Sometimes you only have time to take a few factors that feel 'right', trust your intuition, and hope you have covered the most important ones.
D If you only have a short time, it's better to select factors that are the most different from each other. Look for the big chunks. In this way you create a broad spectrum. And if you have more time you can try to fill in the gaps between the chunks.
S OK let's summarise…We've identified the domain: 'working from home', and set a time-scale: four years from now. We've arrived at some context factors, namely: 'the weather is getting warmer', which means people will spend more time outside (a development). 'People will become more and more distracted' (which is another development). 'There will be increasing congestion' (another development)… No, wait, sorry, 'people becoming distracted' is a trend.
T I would say 'people becoming distracted' is a development. There are more and more things around us that distract us. What effect this has on our behaviour would be a trend.
S OK…so…'people will want to stay at home more because of congestion', (another trend). 'There's a need for concentrated activity', and to 'be protected from distraction', (which is a principle?). There 'will be increasing gender equality', which means that 'home and work life will become increasingly more integrated' (a development). That's all I've got.
T A fine start…

Session 6/11
> New context 2

S So now we have a number of trends and developments. I've counted five; is that enough factors to continue the process, or should I have more?
D Could you try to come up with a factor that is completely different from the other ones, yet relevant of course; another cultural, economic, or technological type, for example? Although you are very close to 'completeness'…
S In my original solution, one of the features was the use of lots of glass. I'd like to include that in my list of context factors somehow…if I can.
T Try not to simply translate your initial idea into factors. Instead, look at the origins of the idea, and see if those underlying considerations are still interesting and relevant to your domain.
D And, you know, using lots of glass is just one way to express your vision. If you want to use context relevant technological factors, they should have an effect on the interaction between the user and the to-be-designed object.
S Well, the use of glass in a green environment was meant to help reflection, which is a kind of interaction with the environment, isn't it? But I could also think about it in terms of transparency…'In four years time, I would like the world to be more open and transparent'.
D Careful…"would like" is already an opinion…

A technological factor that fits your domain could be: 'in the future "smart materials" will be used in the home environment; these materials will have been specifically engineered for that application'.
T Hang on, this is important. Technology (of any kind) is just a means to an end. It's a tool. It can be argued that a piece of technology is developed as a response to some kind of concern. For example, if you think communications technology is important to your context, what you may be sensing is that people want to remain in touch with or connected to others. The underlying concerns should be part of your context, not something to be satisfied by any technology eventually employed in the design. Ultimately, you might discover that your solution does not need technology at all! It may be possible to satisfy the concern through other means, like a service.
But the designer was right, if a certain technology is expected to become part of the surroundings of your domain, e.g., 'smart materials will be used around the home', then it would make sense to incorporate it in your context as a *state*.
D Just let me return to the "would like" again…
It is very important to keep in mind that when you are identifying context factors, you should only consider them in terms of relevance. Don't make a value judgement on what you have described. This comes later on in the process.

Describing a context through its factors means simply describing what you think might happen, or what you see as interesting and relevant.
T Right, first we want the designer to face the world as it is, bright and dark, then make a *subjective selection* from objective, or 'objectifiable', context factors. Only when you have the clearest picture possible of all these can you formulate a personal position.
S OK, I understand. So how about a factor like this: 'because of the availability of information, the world will be a more open and transparent place'.
D You're thinking in the right direction. That's what we're looking for!
T I concur.
S Let me think of one more, maybe on the darker side… 'There will be an increasing obsession with security.'
D Can you be more explicit?
T Are you talking about people being suspicious and their fear of losing property and privacy?
S Well, I think the technological means to protect oneself against losing everything – without even knowing it! – will be increasingly marketed to people (in a way that insurance has been before).
D Why do you expect that? Because the gap between rich and poor is getting wider?
T I think it has more to do with increased openness and transparency, mostly on the web. There are more and more opportunities to store data remotely (government databases, shopping websites,

online banking, etc.) and share private information, so we are simultaneously taught to see danger everywhere, and to protect our privacy and our assets.
S That's it!
D (*nods head*) I see.
T OK, I think you've found yourself some fine factors to work with. Now let's summarize them once more, and then try to see how they are connected.
S OK, here we go...

> The first factor is that the weather will be getting warmer which means that people will be spending more time outside.
> Second, there will be an increasing amount of distraction from all sides.
> Third, people will want to stay home more often because of congestion.
> Fourth, home and work life will become increasingly integrated, due to increasing gender equality.
> Fifth, the world will be a more open and transparent place, because of the increasing generation of and access to (shared) information.
> And, sixth, there will be an increasing obsession with security, due to increased opportunities for information sharing and storage.
> Not bad, huh.

T Amazing, a great job indeed! A couple of friendly observations:
Firstly: all four factors involve 'more' of something. Any idea why?
Secondly: every factor is phrased in a "cause A, effect B" type of structure. This is not necessary, but probably your style...So basically, you discuss a number of relevant developments and make an argument based on what the consequences of these developments could be...
S I suppose it's because I think in terms of trends and developments that originate in the present.
T Shall we have one more look at each of them and see if we can't phrase them differently? Just so you have a complete example...
D The second factor could be described as a principle: 'If exposed to too much information, people are not capable of grasping the value of that information'.
T The thing is, you have a particular way of looking at the world: in terms of things that are changing and what the consequences are. There's nothing wrong with that. You could also look at the world in terms of things that are *not* changing! These are the so-called *states* – things that stay pretty much the same over time, but not necessarily, like rules of conduct – and *principles* – 'laws' of nature, or social and psychological mechanisms, like 'people always want more than they get'. Maybe there is a principle that seems relevant for your domain... Again, you don't have to include any, but we at least want you to consciously consider these types of factors.
S 'People like the feeling that there's "no place like home"'. Could that be a principle?

T If you believe that *all* people feel that there is 'no place like home' it could be a principle of human nature.
S I would think that all 'people like to have a feeling of having their "space"', however temporary, so I would put it forward as a principle.
T OK, I agree, if you add this principle to your list, I think you have a fine basis to work on your full context picture.
S Thanks, so the seventh factor is the principle that 'people like to have a feeling of "their place" in the world'.
T Great. Before we meet again, I would like you to carefully look at all your factors and see how they are related, how they contradict each other, accelerate each other, etc. The goal is to come up with a coherent, unified 'world view'. After that, you can determine how you as a designer want to respond to such a world. Shall we meet again soon?

1 The weather will be getting warmer which means that people will be spending more time outside
> **development**

2 There will be an increasing amount of distraction from all sides
> **development**

3 People will want to stay home more often because of congestion
> **trend**

4 Home and work life will become increasingly integrated, due to inceasing gender equality
> **trend**

5 The world will be a more open and transparent place, because of the increasing generation of and access to (shared) information
> **development**

6 There will be an increasing obsession with security, due to increased opportuinities for information sharing and storage
> **development**

7 People like to have a feeling of "their place" in the world
> **principle**

Summary of context factors

Session 7/11
> Structure in the context + statement

T So did you have a look at your context? Did any patterns emerge?
D Was it difficult? Designing is not that easy...
S Yes, I had a look at the seven factors.
D ...and...
T What did you see?
S Something like increasing amounts of information leading to various outcomes. People not needing to travel, anxieties about security, openness and transparency.
D Did you understand what I said about making clusters, and looking for relationships between the clusters?
S In terms of clusters then... factors 2 (distraction), 4 (home/work integration), 5 (openness and transparency), and 7 (feeling of 'home') seem like they may go together...
D What do they describe?
S Hang on! Then factors 1 (more time outside), 3 (congestion), and 6 (security) also feel like they go together.
D Interesting...but a little harder to see as a cluster, at least from where I'm sitting.
T Now try to explain what these clusters characterize as a whole...
D ...but take your time! It's really not an easy task, even for us! You have to uncover the relationship they have to each other.
S Well, the first cluster seems to describe advantages and disadvantages that more information creates; the second cluster is on the level of global change (information access and environmental warming).
D I understand what you are after, but I'm not convinced. You are actually looking at the causes, the origins of each factor. We think it is more appropriate, by which I mean 'meaningful', to cluster the factors into the effect they have on people's lives.
S Hang on, I'm not sure I understand. Could you give me an example?
T Well, some factors 'force' people to make their world smaller, to stay close to home, hide and protect themselves; other factors make people face the world – the danger! – look for new things, look around... do you see?
S Um...
T Look more closely at the effects each of these factors will have on people's lives. I can see two patterns emerging from the data. There's distraction, openness, it will be warmer outside: people will be seduced into going out and looking around, won't they? At the same time, it's dangerous out there, and people do not have time to explore all of it...
S Well, I suppose we also feel secure at home, in our 'shell'; it's a good excuse to ignore the bigger things that are going on in the world.
D So the garden is about 'safe' exploration. It gives the impression of openness but is also a safe haven.
S As a designer, how would *you* cluster the factors that we have here?
D To me, one cluster would be about feeling safe, together with the family, etc. And the other one is more about things that come from the outside that are unpredictable and can therefore lead to a feeling of anxiety. But this anxiety can have two faces: one of positive surprise but also one of discomfort.
T The difference is here: having access to all this information and entertainment has its appeal; at the same time, it's threatening, as it could take up all people's time and energy, and make them feel very insecure (not knowing or being able to control what might happen next).
D So now do you understand what we are trying to describe?
S Yes, I can see what you're doing: put all the factors together and see what they imply...
T Exactly! Now try to summarize the clusters in your own words.
S OK, well if we look over all the factors, we can see two distinct areas. Some factors indicate that home is a haven of security...other factors suggest the possibilities and threats related to how the outside world is connected to the home environment.
T I would say, not 'connects to', but 'enters into', or 'intrudes upon'!
S Yes, I like the word 'intrudes'.
T ...and this fact is both appealing and threatening at the same time.
S So a 'security' cluster and a 'positive/negative intrusion' cluster. How about that?

D You are doing great. But wait a minute…how does the structure 'feel' to you?
S Well, I guess I can see how these two clusters have come from the factors that we've identified. Now I'm looking forward to seeing how we arrive at a vision.
T Patience…there's progress here. Now the crucial question: If you look at that future 'world' (it's a bit one-dimensional, I have to say) how would you (as a designer) want to respond to it? I mean what would you like to offer people who will be part of that world?
D You know, by "one-dimensional" he means that the context factors do not differ that much, so as a result, the final context structure is rather one-dimensional. When you're working on a complex assignment, you can use more than two clusters to represent the context structure, in which case the context would have more dimensions. At the end of the process, you'll see that solutions have a '*raison d'être*', or purpose, in relation to the context. Not only one solution will fit the context, so it helps to have more than one dimension to find a solution for.
S Whoa, you're losing me. If my context is 'one-dimensional', as you say, what other dimensions should I bring in?
D Having just one dimension works fine for now. We just wanted you to know that more is possible. Let's focus on the statement… How do you want people to behave in relation to the distilled structure of your 7 context factors?
T Usually your answer would begin with "I want to offer people…", "I want to enable people…", or "I would like people to see/experience…"
D "to feel...to understand..."
S Is this where the moral standpoint comes in that you were mentioning earlier?
T Yep, now you can give a personal and moral opinion on the matter.
S Well, 'I would like people to feel secure, yet open to the world; not afraid.'
T OK, sounds like a reasonable statement…could you also indicate how you may achieve this, without referring to a solution yet? Are there context factors that may be of help here?
D I think you may have forgotten the 'working from home' aspect...
S Hmmm…'I would like people to feel that when they are working from home they are adding to the world, not destroying it.'
D So when you look at the factors, is the statement a reflection of all of them? Did you notice how radically the second statement changed compared to the first one…
S The factors are an objective statement about how things will be in 4 years, while my statement is a subjective response to this, so they are two different things really, aren't they? Or have I misunderstood?
D The statement is a response to the context. The context consists of clusters…the clusters come from factors… everything at the forefront of your mind now…that's why it's so difficult.
S I can see that! So break it to me gently: is my statement good?
T I think you have two statements now that both look interesting to work with, and both respond to part of your world. Do you see a way to combine them? Meaningfully?
S 'I would like people to feel secure enough when working at home so that they can work productively, both individually and for society.'
T I think your statement should inlcude something about 'not being part of the world', rather than 'not destroying' it. People may know that at home they can work sustainably, and they like being at home, but they may fear they are losing touch with the outside world, or that they don't have access to all the challenges and excitement the world can offer…I think this may be the key to your statement…
S I think I have to give it all a little more thought! To be clear, we've got: people feeling secure enough when working from home that they can work productively and creatively; keeping in touch with, and helping, society; and at the same time exploiting the challenges that the world has to offer. Sounds like a mission statement!
D Normally students take a fair amount of time to come up with a good statement. In our experience it usually takes days. If you decide too rapidly that the statement is good enough, you run the risk in the end that the final product will disappoint.

Session 8/11
> Statement + interaction 1

T Right. Last time you described the main clusters of your context and started to formulate a statement. Have you had a chance to develop it?
S After our last meeting, I thought it over for a couple of days, trying to get a statement that I think will cover all my factors and the way we clustered them. So, I've come up with this...
D Yes?
T We can't wait!
S 'I would like people working from home to experience any intrusion from the outside world as if they were at the centre of the universe, working safely and comfortably.'
D Nice.
T Interesting…
S It took me quite a while to get to this, and I had a few different statements, but I couldn't quite get it all to fit – what do you think?
T I like the fact that you turn the facts around: instead of the fear of being left alone, you say people should feel as if they are at the centre of things – even more so than when at the office, right?
S Yes, that was my line of thinking...I'm glad it came through.
D What I like is that in the statement you can immediately feel the structure of the context. It works with the clusters. Instead of being afraid of intrusion, you treat it as an opportunity.
S That was my big insight!
T Of course, we all know that the context, and consequently the statement, is not multi-layered; it represents only the briefest overview of the things that play a role in our domain. But I think we can work very well from this point, given the limited time we have for the case study.
S I'm eager to go forward with this – what's next?
T The big question now is (and this may be the hardest one to deal with in the whole process!): what *kind* of interaction could make the goal in your statement come to fruition? In other words, *how* should people interact with your (to-be-designed) product in order to have the experience you describe?
S That's tough…
D And by 'interaction', we mean the *qualitative relationship* between the user and the product. Structure your answer like this: "The interaction can be characterized by/ as…". Again, keep the richness of the context in the back of your mind.
T As you said, you want "people working from home to experience any intrusion from the outside world as if they were at the centre of the universe, working safely and comfortably." Can you picture that? Could you think of an analogous situation that may evoke similar experiences?
S Well, my first thought is that I'm designing an environment, not an object...so there might be a few different interactions. An analogous situation...I'm thinking of somewhere like a mailroom, where external messages come in and they're channelled to the right place.
T I like that; so these messages are not threatening, but comfortably and orderly put away, for you to pick up at your convenience?
S 'I would like the interaction to be characterised by order, concentration, peacefulness, control…'
D Hang on, I'm not convinced. When you see someone interacting with all the machines and tools in a post room, what do you see?
S Sorting? Filtering – that's a good one…is that it?
D I have the sneaky suspicion you're describing product qualities instead of interactions.
T I think 'peacefulness' is a nice one, although you need to add something to define the type of peacefulness you are talking about.
D So describing an interaction is neither about what *kind* of feelings the user will have, nor about what he or she *does*, but it is about the description of the relationship *between* a user and an object as a whole. And that relationship captures the experience one has with the object!
S Well, I'm thinking of someone filtering out distractions, honing in on relevant details.
T Actively? I don't think so …
S Why not?
T There would be too much to filter, which would lead to frustration!
S Maybe 'passive filtering' then…'ambient filtering'?
D Just a thought: you can't say the interaction can be characterized as 'compliant'

if you have an active role in the system…
T I think you can; the feeling I have is of someone experiencing being at the centre because absolutely everything is passing by, but there is no need to act, just go with it... people only think they need to look at the other side of the hill when they can't see it!
S Peaceful flow, 'the eye of the hurricane'…I like the eye of the storm, a safe place to experience what is happening around you, without the need to interfere with it.
D I agree with you.
T I like it too!
S The interaction is like 'being in the eye of a hurricane'…
D But what kind of interaction are we talking about? This is still just the metaphor!
T If this is the metaphor, how do we interact with the world from that position?
S We watch in amazement…
T Right, but in a very comforting way, no fear at all.
D What kind of relationship can you perceive while looking at someone who is in the eye of a hurricane...What is the relationship that person has to the hurricane?
S Isn't it something like… submission? Although that's not really an interaction I'd like to create with my solution though – 'submission'. It sounds like defeat.
D It works if you see 'submission' as a positive thing, like the 'letting-go' in Buddhism… fully delivering yourself to the incoming stream leaves you untouched; it cannot harm you!
S I see, I think it is an interesting interaction quality… 'peaceful submission'.
D Nice.
T Fully agree. Let's look at another one.
S Well, intrusion is an interesting quality in itself, could that characterise the interaction?
D If you look back at your context structure and factors, is this interaction the *appropriate* means to accomplish the goal you have defined?
S It's quite difficult to think of appropriate interaction qualities, rather than ones I just personally like. How do I know what's appropriate?
T I get you. Keep this in mind: let go (yourself!) of what you 'like' or 'want' – such likings are based on an irrelevant, personal context. In ViP, you only consider the context you have created, and the resulting statement, and ask yourself how to realise the stated goal through the means of an interaction. The appropriateness of the interaction can only be determined in light of your statement and context as defined.
D In this case, what is important is that you've come up with a good metaphor, and you feel what the metaphor means. Any exact interaction words you try to isolate are really secondary.
S How about the idea that the quality of interaction is characterised by being 'enclosed'?
T Don't you think 'enclosed' is already covered by 'peaceful submission'?
S 'Peaceful submission' to me suggests being open, and embracing the complexity of things. I'd also like a feeling of being enclosed, or partially enclosed.
T What do you mean by 'enclosed'?
S I suppose the 'partially enclosed' relates to a feeling of being sheltered, protected, but open to the world at the same time – like a tram shelter, it protects you, but lets you see what's all around...
T OK, I see. Can we us this as a starting point next time?

Session 9/11
> Interaction 2

D Last time, we came to the conclusion that there's still something missing in the interaction. It has to do with the feeling of being at the centre of the world. This feeling must be evoked by something. What do you think?
S I don't really get you…
D 'Peaceful submission' is too passive. When you feel you are at the centre of the world, it's probably a more active role.
T Right now we only have this 'peaceful submission'. It explains why we feel 'safe and comfortable', but not why we feel 'at the centre of the universe'. How could we put that into the interaction?
S Could you explain to me why we need to evoke this feeling?
T Because we stated so in our statement. This is our design goal, so to speak.
D Maybe it's about being 'on top of the world', like a castle on top of a mountain.
S So how about being in the eye of a storm then – is *that* too passive?
T Gentlemen. I think we should see the 'eye of the storm' as the overall metaphor. We have covered one aspect of interacting with such a situation with 'peaceful submission'. But there's another side to it, having to do with alertness, arousal, being in the middle of something huge, exciting. How often are you in the 'eye of a storm'? Have you seen 'Twister'?
S Yeah…

T Well, there's this 'awe' in it; you are part of some amazing phenomenon, in the middle of it!
S Ah, so the statement is the direction the interaction should lead to?
T Exactly!
S Are there any tools you have to help me?
T The metaphor is your biggest tool here. You are looking for words that accurately describe the interaction with the situation (the eye of a storm). This is partly covered by 'peaceful submission'; partly there is arousal, excitement, and awe, because the situation is so magnificent for people.
D Look for words like 'elevation' or 'alertness'. These two are completely different from each other. You have to determine which one fits best.
T 'Elevation', or 'exaltedness', implies control and power; 'alertness' is more about being wide awake and aware that anything could happen.
D So you see, an interaction is a *combination of qualities*. 'Peaceful submission' is one such quality. But we can have peaceful submission in many situations, like sitting in an airplane or waiting in a queue. What I am looking for is another element that completes our interaction of 'peaceful submission' and captures the metaphorical situation of being in the eye of a storm. This element could be (in my opinion) something like 'elevation'.
T The eye of the storm is the metaphor in this situation. Now try to describe how you would interact with this situation. Got it?

S So how I interact with the eye of the storm?
T You got it!
D What we are asking you to do is not easy. Usually it takes a few hours to really understand which combination of qualities describes the total interaction. By searching for these words or images, you really get an in-depth understanding of the interaction.
S But I am not designing for myself! I am designing for a user group, and they might interact in very different ways to being in the eye of the storm. Some people would be scared, some in awe, and some completely paralysed!
T So, yes, there are many ways to (inter)act in this situation, but only one or a few of those would create the result we set in our statement. You better choose one of those! Otherwise, the metaphor is not going to help us, because it's not appropriate.
S OK, ok, I know I have already asked this, but how do I know what is appropriate?
T Would you design something that paralyses the user?!? Again, it is appropriate when it realises the goal you established in your statement. And you have your context to argue from. As you indicated yourself a little earlier, only those who feel in awe will feel at the centre of the universe, the scared and paralysed ones can forget it.
S Can you give me some more examples to help me?
D Can you tell me why you are stuck? What is your feeling right at this moment?
S I feel that I have a context

peaceful submission

cognitive
privilege

▷

a larger idea
"something you don't
quite understand"
integrity
thrustworthy
fair
wise and just
unitity in variety

Interaction and product qualities

vision: any intrusion from the outside world should create the impression of being at the centre of the universe, while also being safe and secure. What's difficult is finding words to describe the interaction, and knowing that they are the right words. So the interaction could be characterised by 'being in awe'?
T Almost, if you are 'in awe', you feel at the centre of something amazingly special. But that does not describe *how* you interact. This would be something like 'exaltedness' or 'elevation', as our designer described.
D Don't be surprised that you need time and help. The interaction definition is a difficult step. It's really good to ask a lot of questions.
T We told you: this is the hardest part of the process!
S I think the hardest part is coming up with interactions, but also knowing that they are appropriate, when I go home and think – without you – I ask myself "is this really the right description for the interaction?"
D Since the interaction is the key to understanding *what* the product should do, you have to have a real understanding of (and feeling for) the qualities around which the interaction was built. So you must be able to feel a causal relationship between interaction, statement and context. This causality helps you understand that the interaction is the right description, that it is appropriate.
T These interactions are much more than words: they describe what people do and how they do it; they tell you what they experience and how the product evokes this. When I start to think of 'peaceful submission', I see and feel myself in this interaction; I enact it! Only then does the interaction come to life and only then will it 'work' for you. Or not.
D You know, it's also useful to make explicit your feelings of what the interaction could be so you can communicate with other designers, or the client.
S How about 'peaceful control'?
And – if I was protected in the eye of a storm, i.e. I wasn't scared of it moving on and killing me, I think I would look at the emergent nature of the hurricane, and how it all fitted together and behaved – so how about 'emergence'?
D That comes fairly close, actually. But simply saying 'control' is a rather neutral position. I'm looking for a word or expression that describes something more powerful, when there is a higher quality to the interaction.
S Go on…
D When there is 'exaltedness' in the interaction, a person can experience feelings of power, strength, or importance; the person plays a role at the centre of the universe!
S I think I'm severely lacking in imagination!
T You're doing well, give it time!
D The movie 'Twister' is not a bad example, because the film was about researchers being in the centre of a storm, and therefore they had what it took to understand exactly what was going to happen. The interaction between the storm and these researchers therefore had a component of 'elevation'.
S I don't really get this 'elevation/exalted' thing. Do you mean being raised up, in a powerful position, privileged in some way?
D Yes!
T I like this: 'privileged'! That's what you see!
S Like you're special?
T Yes, but not physically, more in matters of the mind, in terms of expanded thinking or perspective. 'Cognitive'…
S So the interaction is characterised by 'cognitive privilege'.
T Perfect; next time we will continue with the product qualities that may lead to 'peaceful submission' and 'cognitive privilege'.

Session 10/11
> Product qualities

S I think I've got a good interaction vision now. I've got 'peaceful submission' and 'cognitive privilege', so what's the next step I'll need to work on?
D Hang on, are you 100% sure that this interaction vision will work?
S Will work to make the goal happen?
D Yeah.
S I don't know...but let's try.
T You should know it, really *feel* it in your bones!
S Feeling what will work comes from experience, though.
T You're right, but do you feel that your interaction will have the intended effect, at least? If not, it will be very hard to take the next steps.
S Yes, I think so.
T Right. Let's try to find product qualities that might evoke this interaction, make it happen. You first, student.
D Think of two people meeting each other: when someone has a certain personality it affects the interaction with the other person. We are looking for the personality of the to-be-designed product.
S So when you say 'product qualities', do you mean things like 'honest' or 'springy' or 'transparent'?
D Exactly.
T What does the product need to be, express, afford, communicate, show, etc. in order to allow a peacefully submissive and cognitively privileged interaction? The best thing would be to support both interactions at the same time!
S OK, let me think. Quietness, wisdom, justice, subtlety, latent power...
T Whoa! Slow down. You need to explain why a particular aspect seems right. We are not brainstorming here.
D It should come from your gut.
T And an understanding of what your gut is telling you.
S 'Quietness' comes from peaceful doesn't it?
D But does quietness *lead* to peacefulness in the interaction?
S Do you have a better idea?
D Easy now. I think it's simpler to start with the nouns, like 'submission', and then try to understand what the nuances of the adjectives like 'peaceful' mean. To understand the relationship between the product and your vision of the interaction, just start with 'submission'.
S A 'chalice' suggests submission to me, the way you sip from a sacred chalice, for example. The idea of sipping from something never ending, slaking your thirst with it.
D 'Something never ending' is interesting.
T You submit to something that is bigger, more powerful, magical, sublime, endless, not understandable, and beautiful.
D Yes, do you agree?
S I like the idea of sipping, tasting a small bit of something, to find out what it's like.
T As for the product, this only works when the whole is not revealed.
D Why focus on the act of sipping? It's actually more related to user activity than part of a product quality description.
S I see...so can we say we tend to submit to things that only disclose themselves in part?
D Nice.
S We submit to a higher idea, something we don't quite understand, yet still want to engage with.
D Beautiful – 2 characteristics at once!
S Sorry, you've lost me – what were the two product characteristics here?
D That it is 'a higher idea' and that it is something we 'don't quite understand'.
S Ah, right – got it!
T And when is this 'peaceful'? I think we should include this one now.
S So, 'peaceful submission'...
D What characteristics fit *peaceful* submission'?
S What comes to mind is being relaxed, contemplative.
D Don't focus on peaceful in isolation but as an adjective of submission.
T To make the submission 'peaceful' (instead of 'fearful', for example) what should the 'larger idea' and the 'not under-standable' also be?
S I guess trusting, having faith means not being afraid to submit, or that there is no struggle in the submission.
D You are really close! Now instead of describing what a *person* would feel, describe the qualities of a product that would elicit a feeling of 'peaceful submission'.
T What about: familiar, comforting, wise, just?

You named those before!
S Solidity, integrity, completeness.
D So you trust something when it's reliable, for example, or characterized as 'having integrity'. I like integrity.
T Trust and integrity are probably the main things that might make submission peaceful.
S 'Trustworthy'…the product is…'wise' and 'just' and 'trustworthy'.
D Beautiful; let's go to the other interaction.
S …'cognitive privilege'…
D Do you have any idea where to start now? We are looking for the characteristics that elicit cognitive privilege.
S Well, I suppose 'cognitive privilege' suggests something like having your ego massaged…
T I like it. You are describing the feeling that everything is done right, that there is all encompassing mastery?
S Right, like the product flatters you…'massages your ego'.
T The product boosts you up, so to speak…
S Isn't it a bit like listening to music? Like Beethoven or something; you're engaged with a world that you may not understand but you have access to it nonetheless.
T I agree. So what in the music makes you feel this way? What qualities?
D What did these great composers do with music?
S I think they created a feeling of complexity, but also of coherence…
D So what did they do with this complexity?
S Composers allowed for a maximum of chaos and complexity, and then brought in unity or order to allow you to comprehend it. The product shows you just the necessary level of unity in the complexity of intrusive information. This will give you the feeling of mastery, the ego massage, the cognitive privilege!
T Very good! The quality you are looking for must therefore be similar to the aesthetic principle named 'unity-in-variety'.
D Nice, perfect. So can you finally summarize the product qualities we have found today?
S Let me see …
'A higher idea'
Something 'we don't quite understand'
'Having integrity'
'Trustworthy'
'Fairness'
'Wise and just'… and sharing
'Unity in variety'.
D When you see this line-up of qualities, does it surprise you? Isn't it completely different from the glass container you were talking about at the beginning of this case study?
S I guess so…I don't think a glass capsule is wise and trustworthy.
T You've got it. Now that we have these qualities, we can start generating concepts. You will see how easy concepting is now that the context and statement have been defined, and the interaction and product vision have been clarified.
S I can't wait to see what's next…

Session 11/11
> Concept development

S My statement was: "I would like people working from home to experience any intrusion from the outside world as if they were at the centre of the universe, working safely and comfortably." Next, to qualify the interaction, we came up with 'peaceful submission' and 'cognitive privilege'. The product qualities we had were 'a higher idea, something we don't quite understand, having integrity, being trustworthy, fair, wise and just', plus showing 'unity in variety'.
T Very good. Now, have you come up with a concept?
S Well, I sat down and thought about my product vision, and tried to trace it back through my vision of the interaction, to the context, and it started to occur to me that being in the eye of a hurricane was like getting a glimpse of chaos – with peaceful submission as a result. Then I began to think about it in musical terms. When I listen to classical music it seems that I am having something explained to me from the 'chaos' of music and sound... does that make sense at all?
T So what does music do to the information that intrudes into your space? What makes it fair, wise and trustworthy? Just to name a few…
S It structures chaos for me – it makes sense of something that I don't understand.
T I think I get it: the music structures the incoming information? Or the information is structured into music?
S Yes, the music gives me a window on chaos, making it understandable.
I'm thinking about a product that interprets the chaos of the world in a way that someone working at home could intuitively understand.
D Can you explain why that product idea fits your vision?
T How does it make you feel cognitively privileged, for example?
S I feel like someone is explaining something to me when I hear music, like I'm being let in on a secret. And that's a cognitive privilege. The fact that it's classical music also lends it integrity and wisdom, and I think that the fact that the music has a certain style or form ties in with the unity in variety.
D Sorry, but the way you are projecting product qualities onto your product is rather simplistic. Just because, as you say, classical music has 'integrity and wisdom' metaphorically speaking, that does not render it wise and fair.
S Music is just an idiom to help me explain the structuring of incoming info in a meaningful way. The core of the music idea is that the product 'knows' the person and filters out what is relevant while the rest is abstracted, to surround without interrupting.
T So, how does the product get to 'know the person', do you think?
S In the way that the person responds to it, maybe there are commands or actions that can tell it a person's preferences. Like lastFM: it plays songs according to the listener's taste, and suggests new ones; the listener can indicate approval or disapproval and it reacts accordingly.
T So it adapts to behaviour and taste, mmmm.
S Exactly.
T Not bad – for your first idea – and I did have something similar in mind. It feels a bit awkward as well, a product that is like a demigod, giving you just the thing you need...
S The product I'm thinking of would have a way of translating information into sound that people, in turn, tune in to according to their taste. The information that is important to the person is selected by selecting the various sounds.
D So the information you like is turned into music you like? But if you use a transition like that, will it initiate the desired interaction?
S Well, sound would mean that you could concentrate on other things (like your work) and unconsciously you'd have this information filter going on in the background.
D I understand what you mean, but I'm not sure…
S It provides cognitive privilege, and I also think it allows for peaceful submission. You relax and let it flow around you.
T Right, it seems to fit. But now have a look at the product vision: just, wise, trustworthy… and now yet another level…is it smart? original? It feels very much like a direct, almost one-to-one translation of your vision (in fact, you used music

to help you see the unity-in-variety product characteristic).
D I hate to be so blunt, but that idea feels pretty rough. Translating information into music, and filtering relevant information is too obvious. It's not going to realise the goal you set. You sort of translated your goal, instead of providing the means to realise it!
T Nothing personal.
S I see…but I was just trying to represent information simply – so when an email arrives, for example, a particular subtle sound is heard. Oh no, wait, that already happens…
D I think it's more interesting *not* to filter anything beforehand. What I like is the idea of being on top of all the information generated in the world at any given time.
S If the info isn't filtered somehow, how else can people feel privileged?
D The privilege is being in contact with *all* the information, being part of all the information generated in the world.
T I think that covers 'variety', but where is the 'unity' that will make submission possible? In other words, what makes the product 'wise' and 'fair', and gives it 'integrity', or makes it 'just'?
D The unity is represented in the way dynamic patterns of information generation are interpreted. You can peacefully work from home because you understand that the information you are generating has an effect on the dynamics of information generated in the world. Like being in your house, looking through the window, and seeing leaves and branches of trees being moved by the wind. The sight of these movements creates a feeling of being alive and part of a whole. To perceive the outside world as alive makes you feel alive; it provides a kind of reassurance.
S Do you mean that the moving branches are generating information?
D No, the movement of the branches only confirms that the world outside is alive and 'working' and that you are part of it, by seeing it.
S I quite like that idea, and I can see the trees moving outside now – but where is the 'cognitive privilege'?
T This is where your filter comes in. The filter creates privilege. The key question is: is a solution that does not require a filter possible? Otherwise, the issue is a filtering problem, like so many on the Internet.
S Well 'peaceful submission' implies that there isn't a filter – just submission and wonder at the surrounding chaos.
D Exactly!
T So, what creates a feeling of privilege, and allows one to work comfortably without having the feeling that a lot is going on that is being missed?
S Maybe the key is the unity… that all different types of info are unified into one type. There is one type of info trying to get to you and you decide when it can. It's just there, waiting patiently. The product orders it all, structures it in a very clever way, so that you see in one instant what is important, or relevant and what is not.
D So the person is on top of everything, and able to understand what is relevant or not immediately.
S Well, I like the tree idea, and I'm imagining a tree with wind that you can see – different colours depending on the information, so you can select the right coloured information. I'm looking at the tree in front of me, and thinking about its qualities as it blows in the wind – flexibility is one. And the user has to be able to interact with it – tune it, like an instrument.
D Be careful here: don't take the metaphor of the tree too literally. Again, I feel a simplistic exchange of one mode of representation (abstract info) for another (music, colours). I don't think that's the right direction.
T I thought of this: the type of info entering the home is varied: phone calls, emails, RSS, Twitter feeds, Instant Messages and so on. Some of these are specific – addressed to a particular person – and it can be frustrating to monitor all these modes of communication all the time. The product could just bring all different types together into one unifying type – I don't know which one yet – so that you get an orderly overview of all different types in one mode. This would really feel like a privilege; like the secretary who tells you who called, emailed, etc.
D Nice idea.
S Sounds like the Babel fish from *Hitchhiker's Guide to the Galaxy* – something that translates everything into one language.
T Right! One uniform language…like Esperanto! (*laughs*) So, what form could this language take?
S I have to say you are

thinking much more practically than I am, I was thinking of something less 'useful', more quietly entertaining, with quiet usefulness.
D Just a tiny reminder…we are looking for products that fit the 'working from home' domain. 'Entertainment' was not addressed in either the factors or statement, so the product doesn't have to be entertaining, just meaningful to the working process as such.
S Well, maybe the product could simply filter out the noun phrases and verb phrases from the stream of info to determine the content, using the structure of the 'language' to re-structure the information…
T Interesting idea; but what about non–verbal streams of info? Do we need to verbalize those?
D It could be interesting for all the information to have a 'voice'. A real voice!
S Like the hubbub from a crowd? And sometimes a crowd says the same thing in unison…
D Or the cocktail party effect…
T Yeah! You hear a stream of soft murmurs. Occasionally, a specific someone is addressed, simply because his or her name is spoken. It attracts their attention immediately.
S That would drive me nuts!
T Not when the stream is in the distance, and abstracted, into a soft stream of water for example.
S I would rather have something like cows in a field mooing instead.
T Well, there could be various settings.
S Actually there's a digital radio channel called 'Birdsong', which is basically just that. You feel like you're in a country environment, and the different animals respond to various events – so maybe a cock crowing is when your name is mentioned?
D Not too literal!
S Well I suppose you could select what background noise you'd like, it could be different on different days. I meant it to be quite subtle.
T Exactly! So, the core is this: information comes into the home, and the dynamics of it all is refracted into some abstract audio format – leaves rustling, water streaming, etc. When a piece of info is directed at a specific person, the stream is interrupted by a voice that draws the person's attention. If desired, the message can be listened to, the email opened, the website launched, etc – but saying 'later' is also an option.
S So the person identifies a number of key events or pieces of information, and the product learns how you react to these?
T Sort of. The product 'just' reacts to those types of info that are directed to the specific person – calls, emails, etc. It does not need to 'learn' much to do so. As for the websites, it could 'learn' from earlier search behaviour.
S I like the idea that the person can react in a subtle manner, by touching or pressing. So the product finds out how the person feels about the information it has provided.
D I don't know if 'feeling' is a good idea, because there are often different feelings, different concerns, about the same information. So the 'feel' tag is too one–dimensional, and probably not a valid way to structure information as a rule.
T The product is the central unit of the workspace, where all sources of info converge (literally). It sends meaningless info into a kind of stream, and alters meaningful info into auditory signals. The desktop is free for the one task currently being performed.
S What about the problem our designer just described, though? What is meaningful, and what is meaningless, changes from day to day, doesn't it? That is, within reason.
T Right, so we need to base ourselves on the sender, not the receiver. The sender is the one who determines what is needed, and the person could indicate what senders are trusted/liked/wanted, etc.
S I hear Schopenhauer – *The World as Will and Representation*.
D So the person, as a human being, is still required to 'make sense' of what is meaningful or not. The product does not interfere with this.
S Maybe it's a device that lets you produce an audio file for the day's activity, so in effect, depending on the type of information that is received, the person writes an ambient soundtrack for the day…
D It makes a kind of 'symphony' of the information stream. How this symphony is interpreted is the person's unique responsibility and can be played with, of course. The 'rules' and 'priorities' of the game can be played with.

S Yes! Set it some basic priorities at the beginning of the day, choose the desired audio landscape, and then let it do the rest, giving it a nudge every now and then when priorities change, so the soundtrack changes too.
…Wow, we've come a long way from the 'glass box'! ViP has really taken my underlying idea in a different direction. I think we've really found something new, in a structured and reasonable way. I'm going to go away and think about how I can develop this concept further.

T Well, it took a little while, but I think there's something good here. When you develop your concept further, make sure all the product qualities are addressed. But the important thing is that you've been through all stages of the process now and have a feel for what it can bring to your future projects.

D Yes, I agree. You did a great job for someone using ViP for the first time. Good luck!

>Here you are trying to get at the underlying reasoning behind the products we now know:

a shift away from thinking about 'what' to thinking about 'why' instead<

An invitation to ViP
A model, and some playful practice

We understand that perhaps you may not immediately understand the value of ViP. In this chapter we invite you to experience what it has to offer. Our goal is to help you to feel comfortable with the ViP way of looking at the world, to see it as somewhere you can feel at home, something to play around with. More importantly, we hope to help you understand, and use, the way of thinking that ViP is derived from.

deconstruction | **designing**
preparation

past context | future context

context level

interaction | interaction

interaction level

old product | new product

product level

Three levels of description in the ViP model

The stages of the ViP design approach are grounded on three basic principles[1], which we call starting points:

1. A designer's job is to look for possibilities, and possible futures, instead of simply solve present-day problems.
2. Products are a means to accomplish or develop appropriate *interactions* (relationships). In interaction with people, products obtain their meaning. This is why we say that ViP is *interaction-centred*.
3. The appropriateness of any interaction conceived by a designer is determined by the context for which it has been designed. This context can be the world of today, tomorrow, or may lie years in the future. Future contexts may demand new behaviours and experiences. This makes ViP *context-driven*.

In this chapter, we will show you how these starting points are reflected in the ViP model, with its three different levels of description, and how they govern the ViP design process that emerges from the model.

The model depicts the ViP way of looking at the world of products, and of all man-made things. The left half represents the "current situation": the world as it is today. The movement from the bottom of the model to the top shown on the left side of the model is what we call the *deconstruction* phase. You could also call it the "learning to read" phase. Here you are trying to get at the underlying reasoning behind the products we now know: a shift away from thinking about 'what' to thinking about 'why' instead.

The Product Level: Why products are the way they are

We begin in the world of things. Take a step back and give this a try: Go into a café with a pen and paper and sit down with a drink. Look around you. Choose a product; a coffee machine perhaps? Think about the product and try to describe it. What does it look like? What

colour is it? How does light fall on its surfaces? What materials is it made from? How has it worn over time? Does it have any kind of decoration? Does it look happy? How does it work? How big is it? Make up your own questions.

We are used to having products all around us, but we're not used to really studying them. Look hard; take a photo.

Keep looking and thinking. Where might the inspiration for the product have come from? What other products does it look like? What conventions or conveniences has it adopted? How long will it last? How has it evolved to its present state? Is it still evolving?

You should now have a list of descriptions for your product. Show the list to somebody and see if they can guess what product you chose. Pick another product – look in magazines, newspapers – and repeat the process.

This exercise is meant to show you that products have *qualities*, and some of these are *designed* qualities – intended to be that way by the designer(s). Look at your product descriptions and try to decide which qualities were designed and which were not. Which qualities seem to come from the product, and which seem to be projected (by you) onto the product?

There is a story about a professor called Agassiz and a fish. Professor Agassiz gives his student a (dead) fish and asks him to describe it. "That's easy," the student says, "it's a sun fish." "I know that," Agassiz replies, "I want you to describe it." The student finds a textbook and returns with a description, but it is still not good enough for Agassiz, so he tells the student to go away and come back again. This time the student interviews some fish experts, and returns a few days later with his revised description. It is still not good enough for Agassiz. For three weeks this goes on, the student regularly returning with more and more detailed descriptions until finally Agassiz tells the student to actually *look at* the fish. Even though the fish was in an advanced stage of decomposition and smelled horribly, the student knew something about the fish by then.

This is a story about looking, then looking again with understanding. The process of looking, reflecting, then looking again is essential to the deconstruction phase of ViP. At first you might find it difficult, but with practice, this way of 'seeing' products becomes natural.

So now that you have described a few products, what can you say you know about them? What can you say that you don't know about

them? Keep in mind that a 'product' can be anything: a service, a game, a strategy. Any man-made 'thing' can be deconstructed.

The Interaction Level: Products do not exist independent of the world of people

So far, you have described the static qualities (or characteristics) of products as though they were found in a museum. Yet it is really in the *interaction* between person and product, when a person uses or handles a product, that meaning is generated. In ViP, we seek to design or solicit interactions, so first you must be able to perceive them in existing products.

First, identify someone interacting with a product. Maybe you can see someone talking on a mobile phone, or someone reading a newspaper or opening a car door. Now watch the interaction closely – maybe take a photo – and try to list the *qualities* of that interaction. Try not to focus on the particular qualities of either the person or the product alone. It might be useful to think of them together, as a silhouette; that way you can be sure that you are looking at the qualities of the interaction.

Think of about five words. If you get stuck use the phrase: *the interaction can be characterised by… x*, and you fill in the x. For example, look at a person sitting in a chair: their interaction could be characterized by 'acceptance' and 'harmony' ❶, 'detachment' and 'tension'❷, or 'firmness' and 'compliance'❸.

The words that you choose don't necessarily have to come from a dictionary. You might describe the quality of an interaction as being 'blobish' or 'blur-like' or displaying 'plant-ness' or 'computer-ness' for example. Adding '-ness', '-like', or '-ish' to the end of a familiar word is often a good way of trying to describe an interaction. It's ok to build your own language to describe an interaction, as long as *you* know what you mean.

Walter Vincenti (1993) wrote about the mysteriousness of the qualities of flying – the qualities of an aeroplane a pilot experiences when flying. Engineers are notorious for not thinking about the qualities of the things they design, preferring to solve technical problems and let the interaction qualities emerge. Yet large technical systems often have very particular qualities, and the users of those systems, pilots in this case, are able to very accurately describe the qualities they

Interactions with a chair

experience when interacting with large machines. What driving qualities does your car or bike have when you interact with it?

Now that you understand how to look at products in terms of interactions, and the kinds of qualities an interaction may have, we shall move on.

The Context Level: Inferring a worldview

Look again at your product(s). Ask yourself: what did the designer(s) of this product have in mind to come up with this product? What was their worldview? What ideas did they have about people's needs and motives?

For example, there are a number of possible observations that may have motivated the design of the 1959 Mini Cooper. One obvious consideration was a world oil crisis that resulted in petrol rationing in the UK, and a demand for more fuel-efficient cars. Another may have been an increasing need for mobility and independence at a reasonable cost. There are other observations we can think of too. Maybe people felt a desire for discovery, an excitement for new places, or an urge to feel all this together? Maybe driving a small car with a lower driver's seat meant that speed could be experienced more directly – why would that be desirable? The sixties were also a time when equality between the sexes became an issue, so a car that both men and women felt comfortable driving would make sense – wouldn't it?

This is a natural progression from the interaction level, with one caveat: we are not necessarily trying to get at the original designer's exact considerations, although that is one possibility. It is (of course) impossible to read a designer's mind. The ideas that we are talking about are those that seem plausible. Often, we are able to infer these from what we see.

At the context level you need to ask: In *what context* would the quality/qualities I used to describe the product and interaction be considered appropriate? What views would make that relationship meaningful?

There are no right or wrong answers here. The purpose of this examination is to make you aware that products, and hence interactions, are created within well-defined contexts, and that clarifying the context can help in understanding why the product exists at all. In fact, that is

Mini Cooper (1959)

precisely what we are looking for: the answer to the question *why does this product exist?* Or *why in this form?*

Now go back to the list of qualities you used to describe the interactions you were looking at before. Can you identify any considerations that would make the qualities of the interaction you observed meaningful? For example, you might have observed 'comfortableness' as one quality, so you might come up with a psychological principle like 'people need constant reassurance'. Maybe you can take this further. Why might people need constant re-assurance? Do they feel insecure for some reason? Do they like to feel at home? By carrying on questioning you can get to ever more fundamental principles.

The principles and other considerations you arrive at account for *why* the interaction you observed has the qualities that you noticed and, consequently, why the product is what it is. Taken together they form the possible conditions that have resulted in that product's existence.

Looking according to ViP

Once you have gone through the deconstruction phase a few times, you will be able to do it quickly, almost without thinking. Whenever you see a product and/or people interacting with a product, you will probably start to wonder what views the designer(s) might have had to come up with these. You may no longer see the world *as it is*, but *why* it is that way.

Designing according to ViP

Simply put, the ViP design approach is a kind of "reverse deconstruction". If you see that products are always reflections of some set of views and considerations, you also see that you first need *to design* this set of views and considerations to come up with a new product. This is designing according to ViP: reasoning from context to product. That process is represented in the right half of the model.

1 Note that these initial principles are slightly different, yet follow from, the principles presented in our introduction. In their present form, these "starting points" have a direct consequence on the type and order of stages presented. For more information about the stages in the ViP process, see the section entitled "The ViP Process: A how to".

>give room to feelings and intuition as they do at art schools, but simultaneously require students to develop a sound argument, in order to justify

and explain each and every decision they make, which means understanding where each decision comes from and what its consequences are<

The ViP Process
A how to

In this chapter we will extensively describe the steps you will take to arrive at a new design. It is a detailed account of all the issues you will consider when following the stages of the ViP process, including criteria for evaluation. This introduction is a reading guide for the sub-chapters – each covering a separate stage – to follow.

Design assignments come in a wide array of formats and formulations. A client may ask you to design a new horse saddle, a container for a cool drink targeted to teenagers, or a new financial service that promotes sustainable consumption. Usually, assignments are accompanied by a list of requirements. But where do these assignments and their requirements come from? Often they are based on all kinds of observations made by (people in) the company: real world experience with current products, trends in society, what competitors do, or what a possible future might be. And these observations are 'simply' translated into a desired design, an idea of what might be an appropriate and successful response to what has been observed. As a designer, you could do what you are asked and design the saddle, or another container. And you may come up with a novel kind of material, a fresh shape, or a clever opening mechanism that does the trick and satisfies the client. There is nothing wrong with this, but then ViP may not be the right tool for you.

Remember that for us, designing is first and foremost the act of defining a vision of what you want to create, not simply creating something in response to a demand. In other words, designing actually starts by establishing the *'raison d'être'* (the reason for existence) for the final design. ViP was invented for designers who value taking this responsibility.

The steps or stages of the ViP process can be traced back to the model that was introduced earlier. Before going back to that model and explaining how the steps fit in here, let us first indicate how to look at the process and its stages from a beginner's standpoint.

When you 'do ViP' for the first time, it is probably better to stick to the process as described. After working with ViP a few times, you will find out that you can play with the steps, go back and forth, maybe skip one or add one yourself. Ultimately, ViP is about understanding and adopting the starting points – the fundamentals and values – as they were defined in the introduction. The steps below are built on those underlying ideas. You could just go through the steps and forget about the core values: freedom, responsibility and authenticity. Such behaviour might please your client or a marketing manager, yet it will certainly not give you the kind of fulfilment using the ViP process can offer you as a designer and a person. The steps are designed in such a way as to exploit the core values to the maximum, not to ignore them!

The model represents the three layers of description that are so fundamental to and characteristic of ViP: the context level, the interaction level

deconstruction / designing
preparation

past context | **future context**

- ① domain/time
- ② context factors
- ③ context structure
- ④ statement

context level

interaction | interaction

- ⑤ human-product interaction

interaction level

old product | new product

- ⑥ product qualities
- ⑦ concept
- ⑧ design and detailing

product level

8 steps of the process embedded in the ViP model

and the product level. As argued elsewhere, these layers explain that a product – or any design solution – is always a reflection of, or is reflected in, the interaction people have with it. At the same time, both the product and the interaction reflect the context from and for which the product was designed. Interaction is the crucial intermediate stage between the world (the context) and the things we put into that world. In this interaction, products come alive.

If you see these connections, it is also easy to see that we can look at the world and its products as they were or are (left side of model) and the world and its products as it will or should be (right side). The left side thus represents the past and, as we have shown [see *An Invitation to ViP*], it may often be very helpful to have a good look at the past before you enter the future. This process of deconstruction, as we have termed it, will be described in the next section.

The right side of the model represents the actual design process, which basically boils down to reasoning from context to design solution. First, the designer envisions a new context, then asks himself what kind of interaction fits in, and finally designs a product that makes the intended interaction possible. If only designing were so simple…

Starting from these three layers and their interconnections, we have, over the years, developed a number of in-between steps that help you to make the necessary transitions moving from context to design. This has resulted in a process that can be split up into eight convenient steps. The figure on the previous page shows how these eight steps are connected to, or fit into, the three layers of the ViP model. Before we start to describe each of these steps in more detail, let's go back to the left side of the model and look at what you can do to properly prepare yourself for the design process.

Preparation 'Destructuring'

When faced with a design assignment – whether your own or brought to you by a client – it is inevitable that existing designs pop into your mind (they were probably already in the mind of the client as well). You could say that these designs were solutions to the problem as it was once stated. Say a company asks you to design a brush to do the dishes, or something to help you clean the dishes. In both cases, you will think (as the client would) of dishwashing brushes, scourers, and other past inventions for cleaning dishes.

Even when the end result is not explicitly defined in the assignment, as in "design something that helps people find their favourite music", ideas for existing products come up. You may, for example, think of charts in magazines, websites like last.fm, or radio stations that play the latest hits. Before immediately starting the design process by (re)defining the domain (Step ❶), for a number of reasons it is going to be very helpful to first 'deconstruct' these familiar, existing solutions.

Destructuring (or deconstruction) is looking at an existing design, and asking yourself, "Why is this design the way it is?"

To be able to answer this, first describe the existing product at the product level. Initially this would be in terms of what the product literally is (e.g., buttons on the side, made of plastic), and also (significantly) in terms of what it expresses, its qualities. (Is the thing warm? strong? gentle? friendly? Does it look/seem complex? Is it approachable? Reliable? etc.) For us, a product quality is what the product communicates. This entails not only how to operate it, its "affordances" or "use cues", but also its figurative meaning, such as the associations it evokes, the personality the product seems to have, and so on. Qualities are significant because they largely determine how people experience and interact with products.[1]

When you have a fairly good idea of what the product expresses or communicates, you can go to the next level in the ViP model: the level of *interaction*.

At the interaction level, you no longer look at the existing product in isolation; you try to picture it in use. How do you see people interacting with the product, using it, playing with it, or just simply holding it? This may not be easy; it takes some practice to learn how to describe interactions [go to *An Invitation to ViP* for practice]. After a while, you will discover that you can describe what is going on when someone deals with the product: the interaction is 'smooth', 'interrupted', 'playful', 'modest', 'unlimited', 'passionate', 'secure', 'dedicated', 'intuitive'…

For some reason, our language is not very rich in descriptors for interactions, so sometimes it may be necessary to invent your own wording. Isn't it immediately clear when someone says an interaction is characterized by 'jellyness', or 'lingeringness'?

Once you have managed to carefully describe the existing product at both the product and interaction levels, you are ready to jump the last hurdle of the deconstruction process: what was the *context* the designer(s) of this product was (were) facing at the time of its design? Try to retrieve the factors that once induced the designer to design the object you have just analyzed.

What considerations did this designer have in mind at the time? What was his or her view on the world in general, and the product domain in particular? What kind of standards, opinions or values did he or she hold? How do you think he or she looked at people and their needs and wishes? "You think" because this exercise is about reconstructing what the designer *possibly* had in mind when designing the product, whether explicitly or implicitly. Since these background reasons and considerations are rarely documented, we have to do this on the basis of careful analysis and educated guesses.

This exercise is about finding the underlying factors *as they emerge out of any product and interaction qualities you have identified.* There are no right answers.

To repeat, there are a number of reasons why destructuring, or deconstruction, is a valuable preparatory activity. First of all, it is enjoyable to start any design process by examining something that is already there, instead of immediately diving into the unknown. Deconstructing is a warm-up. It enables you to playfully engage the domain you are going to design for.

Secondly, it helps you to free your mind from any preconceptions that might involuntarily or unconsciously affect the design steps taken later in the process. By regressing to the "context level" of past products, you may reach a stage in which you no longer think that a product of type X should always be or have Y. At the context level, there are no products with properties anymore, only ideas, views, opinions and considerations about life and people, culture, nature, society and technology. When you start to look at products in terms of the factors underlying their existence, you will also start to feel, and eventually see, new possibilities.

It is likely that the former context, the context underlying the existing product, contains a number of assumptions that are obsolete. They may have been quite current and valid at the time the product was designed; now they are outdated because the world has changed or because we look at the world differently.

Take a typical photocopier. When it was (first) designed, designers were probably driven by efficiency, professionalism, and the idea that 'people are only interested in the result, not in the process'. Today, at the dawn of the 21st century, we may have a different view of office life and the values people hold about machines.[2]

Another example. In the early 1990's, the most common assumptions and considerations underlying the design of baby strollers were that 'people want things to be cheap', 'people want to move their kids', and

'people want ease of use'. As a result, all the strollers on the market at that time were cheap and foldable transportation 'machines' that could be put away fairly quickly. Dutch designer Max Barenbrug – a ViP designer *avant-la-lettre* – looked at this context afresh and saw that times had changed. In more and more households, both parents were working, and as a result had less and less time to spend with their kids. To compensate for this, 'they want the best for their kids' and 'to appease their guilt'. Moreover, by that time cities had turned into 'urban jungles' where one could only survive when one could move around flexibly. The result of this fresh view on the context was the Bugaboo: a stroller that creates a comfortable space for the child, protects the child to the utmost, and provides the parents with a flexible and luxurious mobility aid. Despite being five times more expensive than regular strollers, the Bugaboo became an international bestseller that even made it into television's *Sex in the City*.

Seeing changes from the context level gives you a good feeling for the opportunities that may arise if fresh contextual considerations are taken into account. More becomes possible. This should certainly motivate you to start designing!

Now you are ready to start the first step of the ViP design approach: (re)defining the problem domain for which you will come up with a new design.

Following is an extensive step-by-step description of the 8 steps in the ViP approach. For each step we will mainly indicate what kind of actions are to be taken and the decisions that are to be made to move you through the process. We won't tell you what you *have* to do, but rather help you articulate the appropriate questions at the right time. There will be no univocal criteria to assess when a step has been completed; this can only be assessed in light of the next step and with a view on the full process. By 'running' the process more often, you will develop a feel for when you are ready to move from phase to phase.

Step ❶ Establishing the domain

In order to assess the observations and considerations (which we call *factors*) that should be taken into account when you design a new product or solution using ViP, you first need to determine the domain in which these starting points are relevant. Any ViP design process must thus start with a definition of the domain: a description of the area where you aim to make a contribution.

In some situations, the domain takes the form of a product type, as in 'a product that allows parents to move their babies from A to B' or 'a device that allows you to categorize your digital photo collection'. In most cases, and preferably, this domain can be defined more broadly, without specifying the function (or user) of the product, as in 'kitchenware', 'food preparation' or 'social cohesion'. In these latter cases, it is a product category, a practice, or a social phenomenon, respectively, that guides you in the direction of the kind of product you want. You could say that the domain serves as 'a lens' or filter through which you look at the world. Obviously, the more extensively the domain is defined, the more your observations and considerations will become relevant. In the case of social cohesion, for example, a wide variety of developing trends in society or socio-cultural principles may affect why cohesion is currently present or absent. Any or all might be taken into account to design a product that facilitates or affords cohesion.

Often a client will present a domain in the form of a design goal or problem. As we have seen, this goal or problem already presupposes the direction for a solution, a direction that is most likely based on limited information and/or preconceptions. In these cases, it is recommended to try to redefine the goal/problem more loosely, with a less restrained domain definition. Remember, "designing is about exploring what is possible tomorrow instead of solving the problems of today". To make such exploration possible, a more open definition of the target domain at hand is a must. So if your client asks for "a new TV that fulfils today's consumers' demands", you could try to negotiate a broadening of this domain into a more open formulation, such as 'a means to experience current television broadcasting options' or even 'entertainment at home'. A domain should never be a ready-made, ill-defined solution, but rather a map that guides your exploration of the context and the factors to be taken into account.

Let's look at another example. If BMW asks you to design a BMW-MPV, "like the Renault *Espace*", the assignment leaves little room for context exploration. If, however, you manage to redefine the domain in terms of 'a family car; a car that allows families to move and develop optimally', you are invited to study family life in general, and developments in the patterns of families of today and tomorrow. However, the more open the domain definition, the more time it will take to explore any and all factors (see next section) that could be considered relevant. Furthermore, the

Bugaboo stroller

domain definition must fit the strategic goals, or mission, of the client. In the case put forth above it would probably be more fruitful to redefine the domain in terms of general 'family mobility', but this kind of definition can result in non-car solutions that will certainly not please the automotive industry (yet may be appropriate solutions for other clients, such as a ministry of transportation). Basically, as a rule of thumb, try to define the domain as abstractly (broadly) as the client allows, while keeping in mind the time available for the design process.

As indicated through the above examples, assignments often predefine a particular target group toward which the final solution is aimed. When the domain group has clear properties that are not relevant to other groups – such as 'design a stroller for parents' (who else wants to use strollers?) – it cannot hurt to define the target user beforehand. In many cases, however, predefining a target group makes little sense and limits the design process in unnecessary ways.[3]

Another example: a case where a client asks you to design 'a new laptop for college students'. What justifies aiming for college students in particular? What properties are so specific to this group that a laptop for them needs to be different? The fact that they are poor? Many of us are. The idea that they don't take good care of their belongings? Well, many of us don't. If there are no 'good' reasons to limit oneself to a particular group – in the sense that the distinctive properties of the group logically ask for a clearly distinct interaction or solution – than you had better not set that limit. As we will show later, it makes much more sense to let the context factors 'decide' for whom, for whose needs, habits and abilities, you will design.

Finally, along with the definition of the domain, you also need to assess how far into the future your design is projected. A product solution for next year, let's say, may present very different factors for your consideration than a product that is slated for production over ten years. It is therefore important to carefully find out what your client has in mind for the launch of the new product. There could be various societal, technological or cultural pressures that urge you, on behalf of your client, to look closer or further ahead in time than originally anticipated. The full implications of the time setting will become clearer when we have a closer look at the type of context factors that will be generated in the next step of the process.

Step ❷ Generation of context factors

Building a world starts by collecting or generating "building blocks": these are what we call *factors*. Factors are observations, thoughts, theories, laws, considerations, beliefs or opinions. Factors can be found anywhere: in your mind and in your friend's (or colleague's, or an expert's) mind, in newspapers, on the internet, in books, movies, magazines or other sources in which people share stories or scientific insights. Factors can be true in general or true for you; they can be plain facts or highly debatable. Factors are not about what the final product should be or possess (we have no clue at this stage); and factors can, to varying degrees, point at a (possible) solution, as in "plants in your surroundings reduce stress". Factors are *value-free descriptions* of world phenomena as they appear (to you). They do *not* include moral judgements or standpoints as to how you believe the world should be! Evidently, as we will see below, the choice of factors can largely be affected by your values. When your context has been properly defined, can you decide how to respond to it (see Step ❹).

Now, let's look at some example factors in the domain of 'food preparation'. A factor of interest could be "nowadays, people in highly developed countries spend quality time on cooking once a week". This trend may persist for some time, it is certainly about food preparation, but do you also see (or feel) how it might eventually affect the way food is prepared? Possibly so. After all, if people only cook once a week, this could seriously affect how they cook or would like to prepare their food. You may want to look into this more closely to see if there are other factors of relevance.

Here is at another factor: "1 Kg of meat causes the same amount of carbon-dioxide emission as 50 kilometres of driving". Well, it looks like a stable principle, although cars are becoming more and more energy efficient. But is it relevant to the domain? Could an understanding of this factor make us ultimately design different products for food preparation? You may see an interesting connection here.

Now consider this one: "people are looking for honesty and authenticity more and more". This seems an interesting *development* that could have an enormous impact on how we want to prepare our food. What do you think?

In briefly discussing these examples, we have seen different types of factors and considered various criteria to evaluate their value. Factors can

be things that are changing or in flux, such as trends and developments, or more stable situations in the world, like states or principles. Factors can be about people's thinking, feelings or behaviour (psychological factors) or about people's dealings with others (social factors). Factors may have to do with the economy, or technology, biology, theology or any other field of study (science). And finally, factors can be, metaphorically speaking, very "close" to the domain at hand, e.g., the "cooking" factor in the domain of food preparation; or "far" away, e.g., the "meat/driving" comparison. How about a socio-psychological principle such as "in complex matters, like buying a house, one should rely less on conscious deliberations (and rely more on unconscious thought)"[4]? Although the principle itself seems quite remote from food preparation, could it still have an effect on our final design? It is very difficult to say no at this stage.

These typologies of factors are extensively described and explained in the 'On context' essay. Here we will look into *how* to collect them and to favour one over the other.

As we said at the beginning, factors can be found anywhere. But how do you decide if a factor you found is 'right'? First of all, and this may sound very obvious, the factor must be relevant to the domain you are working on.

Often, a factor's relevance is not immediately clear, but you have a "hunch" (an intuition, a feeling) that this factor might help you to look at the domain from a new and fresh perspective. If you have such a feeling, trust it! Keep the factor (for now), and try to explain (later) why you have selected it, i.e. why it is relevant. You may need to later justify choosing the factor to your client (or yourself).

Secondly, as the composer of the context, the factor you choose must be of interest to *you*; it should be appealing to work with, excite you, or give you this little sensation that you are "on to something" new and innovative, albeit at an embryonic stage. However relevant a factor may seem, if you feel it is boring or completely devoid of interest, you can consider putting it aside. In the domain of "food preparation" it may seem difficult to ignore a factor such as "people do not want to hurt themselves or get hurt". But would such an evident fact help you shed new light on food preparation? Factors should only be selected if you feel (or think) they will drive your concept development to interesting places. Clearly, seeing such potential in advance requires a fair amount of design experience.

Instead of including the 'injury' aspect as a factor, and having it play

FIELDS →

TYPES ↓	cultural	psychological	demographic	sociological	economic	biological	evolutionary	technological	...
Developments [D]	3	-	4	-	2	-	-	1	
Trends [T]	1	-	-	-	-	-	-	1	
States [S]	4	-	-	2	1	-	-	-	
Principles [P]	1	8	-	4	3	7	3	-	

Example of a field-type matrix with number of factors in each cell

a directional role in your vision and concept development, you could also consider it as a requirement, for 'safety' in this case. Requirements like these, for example stemming from legislation, ergonomics, production facilities, properties of the surrounding environment in which the product must (most likely) function, etc, will come up in most design projects. Too often, such constraints form the basis of a new design. Although you have to bear these requirements in mind, they should not unnecessarily constrain the originality of your concept. Instead, it is better to list all these constraints as early as possible in your process and put them aside, 'in the fridge' so to speak. You can trust that they will be in the back of your mind whenever you make a decision that may violate such a constraint. If so, that is the moment to make it active and let it affect the decision you are about to take.

A final consideration as to whether or not to include a factor has to do with originality. In ViP, we highly value originality; to us it represents an avenue to innovation and the exploration of possible new futures. In collecting factors, this drive for originality has already begun; your efforts to come up with an original 'solution' are greatly aided through the collection of original factors. Never forget that originality is about novelty *and* appropriateness [see essay 'On creativity'].

Novelty, distinctiveness, or obscurity alone is not enough to choose a factor. The factor must also be appropriate, and in keeping with the context of the ViP approach. (The idea of "appropriateness" is similar to that of relevance). Another aspect to originality is that it cannot be defined in an absolute sense, but is always relative to the domain we are looking at. In the domains of "gaming" or "sports", considering the factor "people want to be challenged and perform at the maximum of their capacities" seems rather straightforward, but in our domain of food preparation, this factor seems rather original (if you are willing and able to see its relevance).

When a factor comes to you, it is most often not immediately in the proper format. It may take some time to formulate it in such a way that it fully represents what you want to express. For example, if a food preparation factor is the trend that "people are introducing different cultures into their kitchens", this may not be specific enough. Does this factor consider the way food is prepared in other cultures, or the type of ingredients used? Or are we referring to completely different types of meals? Ask yourself (or make others ask you) exactly what you mean and try to formulate it as precisely as possible.

It may also be very helpful to ask yourself what the underlying forces of a particular trend or development are. Why do people bring different cultures into their kitchens? Because people are easily bored and need variety? Because people are curious and always looking for something new and different? Because people are always trying to find new ways to eat foods they see as beneficial to their health? Now we are talking in terms of principles possibly underlying the trend, and it may well be that these principles are more interesting to incorporate in your context than the original trend.

The most important lesson here is that a factor should not be adopted too easily and uncritically. A careful analysis of the factor itself is often required to define it in the best possible way, the way that is most appropriate, inspiring and original, for it to be used.

When it comes to adopting technological developments, a special note of warning is required. Technological developments can be selected for two different reasons. Firstly, determine whether any technological facet must be incorporated into the final design in some way. If so, it becomes a requirement, or constraint, that very much determines or compromises the final design; like any constraint, technology in this case should be allowed to enter the process as far along in the design process as possible and 'put in the fridge' (thus not be taken as a context factor) until then.

Secondly, consider the possibility that the desired technology reflects or promises to fulfil an interesting and useful human principle. In that case, it would be better to include the principle itself in the context, instead of the technology. Say a designer wants to include GPS technology in his context. Since GPS allows people to know precisely where they (or their things) are at any given moment in time, its success in various applications possibly reflects a human concern. This concern could be a context factor, while the question of whether the final solution requires GPS technology would remain to be seen.

There are a few questions you can ask yourself to find out whether you are ready to move on to the next step. Next to issues of relevance, what we call "appealingness", and originality, (as described above) you could check if there is enough *variety* in your catalogue of factors. Often, a domain 'forces' you to look for factors in one particular field (e.g. psychology, biology), and you may overlook the potential in other fields. You may also have a preference for one type of factor, say trends, and forget to look at the other types that could offer you a new perspective on the domain. (For more on factor types, see the 'On context' essay.)

Biological

The human body is most vulnerable from the front (turning a child close to you) (principle)

The increase in action radius that results from learning to walk stimulates the development of motor skills and the psychological development of toddlers (principle)

A two year old is a not able to sit still for more than 10 to 15 minutes (principle)

Being a mother is primarily a physical act, not only a mental act. It is to drag, to carry, to cuddle and to caress (principle)

In the first years the child's world expands from 'mama' to 'the living room' to 'the outside world' (principle)

The urge for nesting already starts in the second or third month of pregnancy (principle)

Mind and body interact constantly and are jointly responsible for your physical condition (principle)

Evolutionary

One's own child is the smartest and most beautiful child in the world (principle)

Bodily fluids of other children are 'dirtier' than those from your own child (principle)

'Infantile Signals' evoke a strong motherly or fatherly reaction (principle)

Psychological

The more choice a person has, the less likely it is that he or she will make a decision (principle)

An important function of a stroller is to be able to restrict your child's movement (principle)

The notion of being responsible all of time is the core of parenting (principle)

It is impossible to take complete responsibility for a child (principle)

Every step in the development of a child follows four phases: 1) 'doing for', 2) 'doing with', 3) 'standing by to admire' and 4) 'doing for oneself' (principle)

You can't learn to drive a car solely by observing other people driving a car (principle)

Parenthood puts strong pressure on the ability to regulate emotions (principle)

The experience of holding and comforting, bathing and feeding, strengthens you in the idea that you are a good parent (principle)

Human beings have the ability to incorporate objects into their body image very quickly, body and object become one (principle)

To raise a child without any tension or struggle is impossible (principle)

40% of the contact between parent and child is about disobedience (principle)

Young parents can be very insecure in the first months of their first child (principle)

There are five basic behaviours of parents: 1) safety of the child, 2) care of the child, 3) keep sight of the child, 4) placing demands, 5) setting limits (principle)

Cultural

Having children will have less and less influence on one's freedom of movement (development)

Baby strollers are more and more an expression of identity (trend)

In recent decades the time parents spend with their children has increased (development)

The language and understanding of psychology have permeated our everyday lives ('therapy culture') (development)

The cultural norm is that when it comes to your children only the best is good enough (state)

The cultural norm, as advocated by developmental psychologists, is that 100% of a child's disobedience should be corrected. (state)

The cultural norm is that raising a child is something that should come naturally (state)

A child's behaviour is seen as a measure of parental competence (state)

Experts and celebrities play an important role in selling goods (principle)

Demographic

The age women have their first child is rising (development)

Grandparents are becoming older (development)

The number of children per family is decreasing (development)

The time span between the birth of the first and the second child is decreasing (development)

Technological

IVF is more widely used and increases the number of twins (development)

Baby strollers come equipped with an ever increasing number of add-ons, from cup holders to GPS navigation (trend)

Sociological

Parents enjoy exchanging experiences with other parents (state)

'Word-of-mouth' is mainly based on arguments that can be verbalized (principle)

Parents and grandparents enjoy their children being noticed by others (principle)

It takes a village to raise a child (principle)

Misbehaviour of one's child can cause a parent to feel self-conscious (state)

To raise children you need to be able to fall back on 1) a social society, 2) a good network, 3) reflective ability, 4) 'good parenting' experiences (principle)

Economic

Strollers are most often bought in the second half of the pregnancy (state)

A stroller is typically a product which parents buy together. This increases the tendency toward rationalising arguments (principle)

When people are in a decision-making process they tend to verbalise and rationalise their arguments. However, less easily articulated or more unconscious arguments can be just as relevant (principle)

With the growth of the knowledge based economy, work has become a mental activity and less a physical activity (development)

Anticipated regrets: people are afraid of making wrong decisions (principle)

The labour market demands a higher degree of geographical mobility, living close to family becomes less obvious (development)

The future context of parenting
(Reframing Studio for EasyWalker, simplified version)

You may also wonder whether you have adopted factors that are directly or closely related to the domain along with those that are very distant, figuratively speaking. A typical 'mistake' is to select only factors that are close to the domain at hand. As a result, the context can be rather predictable and potential effects of more remote factors might not be considered. Factors that at first glance seem to have nothing to do with the domain might turn out to be the most original and influential.

Now that we have clarified what factors are, and what criteria can be applied to select them, some final words on where and when to stop collecting. In principle, a context range could contain from just one to tens or even hundreds of factors. There are no rules on how many factors are appropriate and what type of factors should be present; it all depends on how much time you have to execute the design process, the need to be as thorough as possible, your inspiration, etc. A final context can have only a few trends/developments and many principles, or just the opposite. Among all the factors selected, the majority may be psychological or economic. There are no criteria to limit this selection.

A selection as such, however, is not yet a context. For this, the selection must be turned into a composition. This is the goal of the next step.

Step ❸ Structuring the context

A list of fine ingredients does not yet make for a good meal; eleven skilled players are not automatically a good team, and a set of notes is far from being a beautiful composition. Analogously, a list of context factors, as appropriate and appealing as they may be, is not (yet) a context you can design from or for. For this, the set of factors must be turned into a unified whole, a coherent structure that explains how the separate elements are connected.

As a reader of this book, you may have discovered by now that we like principles of aesthetics. These principles not only govern the final design of a product, but also guide various more conceptual, pre-design stages. Possibly the mother of all aesthetic principles is the principle of 'unity in variety', that basically states that we like "to allow for as much variety as possible, while preserving unity or order". This principle can be observed in all human creations, from graphic design to architecture, to the way we dress or the design of our living room. Thus an aesthetically pleasing, or 'beautiful', context is one that carries with it a wide variety of factors,

and at the same time shows how all these factors are intricately connected. In the third step to the ViP approach, we indicate how to develop this kind of coherent structure.

First of all, see if your various factors can be combined into a smaller set of *clusters*. When the number of factors exceeds 10 – and this amount is easily reached in a typical design project – you need to reduce this variety (complexity) in order to start seeing the context as a whole. In statistics, a Factor or Principle Component Analysis (that looks for a limited number of dimensions on which sets of items co-vary) performs a similar reduction of variety in items.

Qualitatively, our clustering follows a similar procedure. Factors can correlate (positively and negatively!) and be combined in many different ways, but basically two types of clusters may be formed:

- a *Common-quality cluster*: a combination of factors that all point to the same (underlying) direction and together form a 'meta-factor'. Say for a particular domain you have found the factors "people go to the gym more often", "there is an increasing demand for vitamin supplements", and "many people want food that is organically produced". You could combine these into the one factor "people want greater control of their health".
- an *Emergent-quality cluster*: by bringing together various factors, a new factor might emerge that is not represented by the factors separately. For example, the two factors "teenagers spend two hours per day on gaming" and "employees increasingly work extra hours" could be combined into one emerging factor "disintegration of family life".

Exploring the world

The increase in action radius that results from learning to walk stimulates the development of motor skills and the psychological development of toddlers (principle)

In the first years the child's world expands from 'mama' to 'the living room' to 'the outside world' (principle)

Every step in the development of a child follows four phases: 1) 'doing for', 2) 'doing with', 3) 'standing by to admire' and 4) 'doing for oneself' (principle)

Delayed parenthood

In recent decades the time parents spend with their children has increased (development)

The age women have their first child is rising (development)

The number of children per family is decreasing (development)

The time span between the birth of the first and the second child is decreasing (development)

IVF is more widely used and increases the number of twins (development)

Cultural norms

Misbehaviour of one's child can cause a parent to feel self-conscious (state)

The cultural norm is that when it comes to your children only the best is good enough (state)

The cultural norm is that raising a child is something that should come naturally (state)

A child's behaviour is seen as a measure of parental competence (state)

Matters of the mind

A stroller is typically a product which parents buy together. This increases the tendency of rationalizing arguments (principle)

With the growth of the knowledge based economy, work has become a mental activity and less a physical activity (development)

When people are in a decision-making process they tend to verbalise and rationalise their arguments. However, less easily articulated or more unconscious arguments can be just as relevant (principle)

'Word-of-mouth' is mainly based on arguments that can be verbalized (principle)

The more choice a person has, the less likely it is that he or she will make a decision (principle)

Embodied experience

The language and understanding of psychology have permeated our everyday lives ('therapy culture') (development)

Being a mother is primarily a physical act, not only a mental act. It is to drag, to carry, to cuddle and to caress (principle)

Mind and body interact constantly and are jointly responsible for your physical condition (principle)

The human body is most vulnerable from the front (turning a child close to you) (principle)

Human beings have the ability to incorporate objects into their body image very quickly, body and object become one (principle)

Hedonism

Baby strollers are more and more an expression of identity (trend)

Having children will have less and less influence on one's freedom of movement (development)

Baby strollers come equipped with an ever increasing number of add-ons, from cup holders to GPS navigation (trend)

Experts and celebrities play an important role in selling goods (principle)

It takes a village to raise a child

Grandparents are becoming older (development)

To raise children you need to be able to fall back on 1) a social society, 2) a good network, 3) reflective ability, 4) 'good parenting' experiences (principle)

The labour market demands a higher degree of geographical mobility, living close to family becomes less obvious (development)

It takes a village to raise a child (principle)

Parent-child power struggles

Parenthood puts a strong pressure on the ability to regulate emotions (principle)

To raise a child without any tension or struggle is impossible (principle)

The cultural norm, as advocated by developmental psychologists, is that 100% of a child's disobedience should be corrected (state)

An important function of a stroller is to be able to restrict your child's movement (principle)

A two year old is a not able to sit still for more than 10 to 15 minutes (principle)

40% of the contact between parent and child is about disobedience (principle)

Evolution and behaviour

One's own child is the smartest and most beautiful child in the world (principle)

Young parents can be very insecure in the first months of their first child (principle)

Parents and grandparents enjoy their children being noticed by others (principle)

Bodily fluids of other children are 'dirtier' than those from your own child (principle)

'Infantile Signals' evoke a strong motherly or fatherly reaction (principle)

Responsibility

It is impossible to take complete responsibility for a child (principle)

The notion of being responsible all of time is the core of parenting (principle)

The urge for nesting already starts in the second or third month of pregnancy (principle)

Strollers are most often bought in the second half of the pregnancy (state)

Learning through experience

Parents enjoy exchanging experiences with other parents (state)

There are five basic behaviours of parents: 1) safety of the child, 2) care of the child, 3) keep sight of the child, 4) placing demands, 5) setting limits (principle)

You can't learn to drive a car solely by observing other people driving a car (principle)

The experience of holding and comforting, bathing and feeding, strengthens you in the idea that you are a good parent (principle)

Anticipated regrets: people are afraid of making wrong decisions (principle)

The future of parenting: clustering of context factors

Clustering is necessary and valuable, but also runs a risk. In the previous step you carefully defined separate factors, and now these careful definitions appear lost in one overarching cluster. This 'getting lost' is of course not the intention. The goal is to preserve and cherish the independent factors – their richness – and at the same time, see underlying or emerging patterns. This is exactly what unity in variety is about; unity should not make variety disappear, but bring it to the fore.

In this act of clustering, you may determine that some factors need to be isolated: they do not correlate with any other factors. You can filter these ones out or, if still considered important, leave them in, treating them as a cluster of their own. You may also discover that some factors appear to be much more prominent or promising, and that they form the core of a cluster.

To be clear: even though it appears that you are reducing a wealth of factors into common- or emergent-quality clusters, the original factors that make up the cluster should not be forgotten. They might still play a major role in the following stages of the process.

As for the number of factors, it is difficult to prescribe how many clusters are ideal. Generally speaking, you should try to minimize their number, without losing variety or differentiation among your factors. Each cluster should represent a clear and distinct part of the reality your context tries to reveal. The same criteria for the factors also hold for the clusters as such: they should be original, domain-relevant, and appealing.

With a limited set of clusters (or a limited number of initial factors), we are ready to look for relationships between the clusters. Clusters may point to a common direction or at conflicting forces; a series of clusters could indicate a pattern of causal reactions. Similar to factors, clusters can be combined in many different ways, yet two types are most common:

- *Pattern or storyline*: when you look at all your clusters "from a distance", a pattern or thread may appear that unites the clusters into a sort of narrative. This may eventually even be phrased into a main theme, like the theme of a movie or a song, which holds everything together.
- *Dimension*: when clusters seem to conflict or refer to opposing forces,

dimensions

pattern or storyline

Various ways to relate factors/clusters

it may be meaningful to place them in one or more polar and conceptually clearly distinct dimensions. Each dimension thus represents two different possible futures. Although more than two dimensions may be needed to locate all clusters, for purposes of representation and interpretation, two are often optimal.[5]

We have indicated various ways in which you can reduce the variety and complexity of your initial set of factors into a coherent structure that describes the main pattern(s) in your context.[6] If done properly, you will feel that you have developed a clear and consistent picture of your future world, and you have developed a fair understanding of it. Probably, you have come across many opportunities to contribute to or make a difference in this world. Up to now, we have suppressed this urge to change anything. In the next stage, you will finally decide what your response to this new context will be.

Step 4 Statement definition

Designing always involves taking a position. A neutral, fully objective designer, one who only deals with facts, does not exist. There are just too many facts (or factors) to take into account, and there are too many decisions to be made in any design process. After all, a designer always has the option not to design! And in designing, in deciding what to do and what not to do, the designer invests a lot of his or her values, beliefs, morals and views. A pivotal goal of ViP is to make these values and beliefs explicit; to make you aware of when and why you take a particular position, and how this, in turn, affects your design.

In generating context factors, you have already made a number of personal decisions that very much reflect you. You decided to include some factors, while choosing not to include others. You also decided to formulate the factors chosen in a particular way. Through this, you are expressing a lot about how you look at the world. As much as humanly possible, however, you have tried to avoid taking a moral position. Now is the time to take one; now is the time to define how your response to the world you pictured should be. Are you supporting the world you see?

related clusters:
Parent-child power struggles
Responsibility
Exploring the world

↑ struggle with child

parent type 1　　　　　　　　　　　　　**parent type 2**

raising by recognizing the　　　raising with a
uniqueness of the child　　　　laissez faire mentality

goal-oriented ←──── **attitude to life** ────→ reactive

related clusters:　　　　　　　　　　　　　　　related clusters:
Delayed　　　　　　　　　　　　　　　　　　　Embodied experience
parenthood　　　　　　　　　　　　　　　　　It takes a village
Matters　　　　　　　　　　　　　　　　　　　to raise a child
of the mind　　　　　　　　　　　　　　　　　Evolution and
　　　　raising by normative　　raising by doing　behaviour
　　　　behaviour　　　　　　　'the right thing'　Learning through
　　　　　　　　　　　　　　　　　　　　　　　experience

parent type 4　　　　　　　　　　　　　**parent type 3**

↓ struggle with society

related clusters:
Cultural norms
Hedonism
Responsibility

The future of parenting: context structure

Or do you want to 'fight' the future world you have described? If so, how? This position, or response to your context, is expressed in your statement. Since we design products for people, a statement typically defines what you want to offer people, *within the established context*. It could come in the form "I, (the designer), or we, (the company), want people to feel/ see/express/experience/understand/be able to/etc. X or Y (by A or B...)". In the domain of 'housekeeping', a possible statement could be, "I want people to be able to express themselves fully while engaging in routine tasks". A regular vacuum cleaner would not do the job, nor would a standard iron.

In addition to being context-based, a proper statement clearly opens up a new opportunity. It shows where the process is going, and what the end goal will be. And it does so *without* defining what the product is or does! In the statement, for the first time you define (in its most rudimentary form) where you want to go; for this reason, the statement is the first part of your *vision*.

A statement should neither be too generic, nor too specific. Maybe the statement above is a little too generic and could be refined by saying what kinds of expressive behaviour should be supported. If your statement is overtly generic, you may find out that too much is possible in the steps that follow and you are not able to clearly define where you want to go. If the statement is too specific, you may find out that nothing is possible. Trying out a statement and continuing the process is the only way to find this out. As always, practice will tell you what an appropriate level of openness or specificity is.

Of course, the statement should also be realistic. It is frustrating to set yourself a goal that turns out to be unfeasible in the end.

Finally, where applicable, make sure your statement or goal is in line with the strategy or mission statement of the company you are working for. It is advisable to involve your client in the statement conception stage of the process. If your client understands your future context, and you can together decide how to respond to this world, you have made the first step to a successful result, one that will be understood and accepted by your client. Above all, the statement you define should motivate you to look for a concept that will meet its goal. To arrive at that concept, a few other steps first need to be made.

struggle with child

parent type 1 parent type 2

"EasyWalker wants to enable
parents to raise their children
with a laissez faire mentality"

goal-oriented ◄───── attitude to life ──────┼──────────────► reactive

sense of responsibility

parent type 4 parent type 3

struggle with society

The future of parenting: turning one parent type into a statement

Step ❺ Establishing a relationship: designing human-product interaction

The core element of expertise in ViP design consists in understanding what kind of relationship, or *interaction*, fits a specific context.

We begin with what designers in general see as the most difficult step to take in the ViP design process: determining – specifically – which interaction will lead to the desired goal as it has been laid forth in the statement. Instead of trying to come up with a product idea that you think matches the goal, we ask you to come up with a vision of the *relationship between the user and the product,* without knowing what kind of product will be designed. The product to be designed can only absorb meaning in relation to a user.

Understanding this relationship is the hinge point between the context and the product. When you are able to clarify the interaction, you are able to understand how your final design will fit your context: the interaction mediates between the two. It simultaneously describes user concerns, needs, and desires, and matching product qualities. The interaction defines *how* the product is used and experienced, and what value or meaning arises from the relationship between the user and product. This relationship is metaphorically conceivable as 'the manner that is observed'.[7] Understanding the causal relationships between every element of the context/interaction/product system really helps you to make the most effective product.

When a designer immediately starts to think of product solutions, there is the possibility that those product concepts will only superficially fulfil the goal set in the statement. If the statement is "I want people to live a sustainable life", chances are that in trying to design the appropriate product immediately, you add specifications, properties and/or features to the product that you think (or know) are sustainable at that time, like choice of material, recyclability, power consumption, etc. But these product specifications, properties and/or features as such do not (necessarily) lead to a sustainable lifestyle. These qualities only contribute to what we already know is appropriate to the theme of sustainability. A good example is the Jim Nature Portable Television, designed by Philippe Starck in 1994. It is the same television we all know and love; the only difference is that it was produced out of sustainable materials. It hardly contributes to sustainable television watching, whatever that may be.

What we want to achieve is that people using the product (with its specific qualities) realize the goal presented in the statement. The product is just

a *means* to accomplish what you as a company/designer want to bring to people in the future. If you say that the relationship is characterized by 'commitment', you understand how you want people to experience the product you are about to design. This experience meets the goal and helps you understand what your final product must bring in to reach it.

So how can you 'design', or *define*, the appropriate interaction? In terms of form, the interaction definition can be expressed in words, images, movies, drawings, etc. For example, let's say that you feel that 'smoothness' is an appropriate quality for the interaction you have chosen. To meet the goal you have chosen in the statement, you can further refine it by asking yourself what *kind* of smoothness you need. Is it forced, sensual, or intellectual smoothness? If the quality does not make sense, i.e. does not seem to meet your goal, try another direction to uncover the qualities of the desired relationship.

In terms of content, initially you can simply trust your intuition. While keeping in mind the coherence between your context and your statement, – essentially 'living' in the context – try to come up with interaction definitions. Your unconscious is doing the job for you. You 'only' have to make the unconscious conscious. Capture what pops into your mind and then see if it makes sense. If it does, try to optimize the idea into a definition of the interaction.

Another way is to think of an analogous situation in another domain. Working with an analogy can help you to see the appropriate interaction from a fresh perspective. If your statement is "we want people in a house for the elderly to feel worthy", you can try to find an analogous situation in another, existing domain where people feel worthy, then explore what sort of relationships contribute to this worthiness. The analogous situation can be one in which people interact with products, other artefacts or other people. Here, you are looking for a situation where something perceived as invaluable, familiar or inconvenient (i.e. certain qualities of aging) is translated into something meaningful, something with special value (i.e. worthiness).

Let's try a few possibilities…maybe a birthday meal, a Christmas dinner, or a Ramadan feast is a good analogy? What kind of interaction is there between the guests and this kind of special occasion? Could it be 'excited' or 'ritualized'? Before seizing on this interaction, first you have to determine whether the analogy of a birthday or Christmas is the most appropriate one. We doubt it! Value creation in those situations only lasts a very short period of time. You can imagine that if you were to take part in this kind

of special occasion/dinner every day, you would get used to it and become bored after a few weeks.

The statement suggests that the effect of converting from one state (feeling unworthy) into the other (feeling worthy) has to last for a long time. The analogy selected should capture this longevity, and turn something that is seen as invaluable and inconvenient into something that has value. Remember: the analogy only serves as a 'springboard' for you to clarify the qualities of the interaction you desire. It is highly likely that there are other alternative interaction possibilities that fulfil the statement. But we are looking for the one that fits the context *best*. Use the context to help you better understand and decide which interaction is the one to go for.

Let's try again. An appropriate analogy in this case may be 'renovating your own home'. People who renovate their homes themselves turn something less valuable into something of great value; they often do this with considerable determination, dedicating much of their time and energy to the task. From this analogy, we could therefore derive interaction characteristics such as 'involvement', 'effort', and 'timelessness'. An interaction with these qualities may very well attain the goal set forth in the statement regarding our elderly.

By using your intuition, or trying and testing an analogy, you can find the most effective and meaningful interaction to serve your purpose. Yet most often, verbalization is the means used to capture and express the intended interaction. When using words to define the interaction, however, it often feels like a game. Accept it, and realise that words are only an expression of what you want to achieve in the interaction.

Imagine your domain is 'healthcare'. If your statement is something like "I want ill people to *feel* what their own body is saying again", then you might define the interaction in terms of 'caring'. Does this caring, as a relationship between the to-be-designed product and the user, lead to feeling one's own body? It does not seem so. You are actually looking for a relationship between the patient and the product that makes him trust what his own body is telling him. Maybe 'surrender' is a more appropriate quality? Feels more like the right direction. In learning to trust the signals of the body when ill, the patient has to give in to them, in a way.

Go back to the statement. If you feel – or see – that the interaction is still not exactly what it should be, try to qualify it even further. Add a word or two. In the case above, maybe 'soothing surrender' gives a more

struggle with child

parent type 1

distinctive
adventurous
inviting

parent type 2

playful
versatile
physical

goal-oriented ← attitude to life → reactive

professional
reliable
habitual

tender
familiar
intuitive

parent type 4

parent type 3

sense of responsibility

struggle with society

'like learning to walk on your parents feet' ▷ playful versatile physical

Above The future of parenting: envisioning product interaction and product qualities
Below From vision on interaction to product qualities

comfortable, relaxing feel to the interaction? It specifies that the illness has been accepted, and that this 'surrender' must not, in the end, be experienced as something hostile and stressful.

Finally, the interaction is often described using a *range* of different qualities, e.g., "the interaction can be characterized by control, vulnerability and passion". It may be hard to empathize with all these components of the interaction simultaneously. What you can try to do in this case is to look for the one overarching quality that brings these different components together.

If we return once more to the example, notice the subtle differences between interaction qualities like 'soothing surrender', 'devoted surrender' and 'controlled surrender'. You have to decide which fits best; you also have to be able to explain it to others. Build your explanation on the foundation created by the context factors and context structure, plus the statement

'Trying' and 'playing' are the ways to optimize your definition of the interaction. It is ultimately a search for what you have already felt inside since beginning the project, but without the words or images to immediately express this feeling. It has probably been on the tip of your tongue. Because all the elements leading up to the interaction were already 'inside you', the solution to accurately design the interaction is also 'inside you'. The funny thing is, when you force yourself to make combinations of descriptions, images, etc. that feel right, in the end it leads exactly to the appropriate interaction definition. So don't be afraid that the interaction you have defined is a new word and/or a new combination of words, for instance. The only criterion is the appropriateness of the quality of the relationship.

You may be wondering: is there a 'good' or 'bad' interaction? Forget good or bad; you have to be able to imagine and explain why the interaction can lead up to the goal set in the statement. This *appropriateness* is a key criterion in the (successful) application of the ViP approach. So don't be afraid to come up with an interaction description that looks 'negative'. Sometimes the interaction needed addresses what people see as 'negative'. Don't let your own or any other cultural value system override the appropriateness of the interaction (unless this is part of your statement). If the interaction you were looking for is best described by 'selfishness', just accept it. Even when you as a designer have the mission to create a 'perfect world' – and many people see this as your job – you have to stay true to the goal as you defined it in your statement.

We can imagine that what you have read up to now (probably) seems difficult to do. You have to trust that after a few exercises, you will get used to working like this. But you also need to have patience; you first have to understand the process. Start with a really simple statement and focus on the next step. When you are able to 'control' the process, you can start using the process to come up with innovative product ideas. Teach yourself to understand the principle of *appropriate interaction* before you ask yourself to come up with a new and brilliant interaction.

While your statement indicates *what* the product will offer, your interaction description tells you *how* it will be offered. Taken together, these elements of your vision define what *meaning* you intend to offer people. They also indirectly define the audience: anyone who would like to see the goal achieved and interact with the future product in the way described. Both statement and interaction are based on a range of insights of what (some) people need, render important, would like to see happen, or find difficult to handle. These people's insights, captured in principles or trends, form the basis of the statement and interaction, and determine to a large extent for whom the future product is appropriate, or inappropriate. Therefore, you might say at this stage, "My target group is composed of people who are attracted to the goal and interaction I have defined." To realise this interaction, the product needs to have certain qualities. Defining these qualities is the subject of the next stage.

Step ❻ Defining product qualities

In the previous step we argued that the core design activity of a designer is to define the interaction between product and user. To elicit this interaction, the product has to have certain qualitative characteristics, or what we call *product qualities*. If the product has specific qualities, the user of the product will experience/use the product (i.e. *interact with* the product) as you have defined it, as you have envisioned him or her experiencing/using the product. Therefore, defining product qualities is the last link in the chain between the three major stages of ViP (the context, interaction, and product stages), and the last element of your vision, which consists of your statement, and the interaction and product qualities.

The first rule in determining what product qualities are appropriate in relation to the interaction is to never see the intended interaction in isola-

tion. You must always take into account the context factors, the context structure and your statement, which itself implies the desired interaction. (NB: In the following examples, we break this rule! It would take too much space to explain the thinking in all the stages leading up to here. The examples are only provided to explain the product quality concept.)

To see the idea of product qualities from another perspective, think about the relationship between people. For example, if the relationship between you and your partner (presuming you have one) is described as 'tolerant', this interaction could be the effect of your partner having characteristics, or qualities, such as 'forgiving', 'open', or 'flexible'. Here, your partner is 'the product' with whom you interact. Closing the chain, i.e. eliciting the appropriate interaction, means your partner has to actually have these characteristics.

After completing this step it still will not be clear what kind of product we are going to design. This step is purely focused on developing an understanding of the to-be-designed product at a qualitative level, and still does not address any features or properties of a future product.

Product qualities can be of two kinds: qualities that express a product's character and qualities that describe how the product could be used or operated. *Product character* metaphorically describes the 'personality' or figurative expression of the product, as in the relationship example above. When we talk about character, we use words like 'open', 'stubborn', 'guilty', 'closed', 'light', 'powerful', etc., which are the kind of qualitative descriptions that are also often attributed to people. Be aware that when you use words like 'closed', 'light' or 'powerful' for instance, you are describing a figurative quality and not a physical property.

If the interaction is described by 'brutal intolerance', you could imagine the product character to be something like 'authoritative', 'powerful' and 'overwhelming'. These characteristics describe the personality of the to-be-designed product (and will eventually determine many of the properties of the new product). To understand which characteristics fit best, think of a situation where an interaction like 'brutal intolerance' occurs, e.g., witnessing the relationship between a squatter and the local government. Forming an analogy helps you to understand what the relationship looks like, and determine the character of the product that would elicit a similar interaction. What are the qualitative characteristics of the local government in this case? Violent? Stubborn? Responsible? Discriminatory? Maybe an analogy like this will help you find a proper

metaphor: "My product is like the attitude of a local government towards squatters, 'stubborn' and 'discriminatory'". Using a metaphor, in turn, helps you to come up with all kinds of characteristics that could be appropriate for your design.

Along with product character, you can also think of what kind of actions or movements the product evokes or calls for.[8] Products not only invite people to interact with them, they can also indicate how they 'want' to be used in a qualitative way. When the interaction 'brutal intolerance' can be accomplished through product characteristics like 'authoritative', 'powerful' and 'stubborn', use-related qualities like 'rigid' or 'immovable' could be appropriate. In the same vein, you could define a product as 'pushable', indicating the user is invited to push it, or 'touchable', communicating that it wants to be touched. These action-related meanings could also prescribe a sequence of actions to be performed. In addition to 'pushable', a (pub) door could communicate something like 'immovable' and 'bodily'. First, you have to *grab* the door handle firmly, next *throw* the weight of your whole body, and finally you have to *push* the door open.

Character- and action-related qualities are obviously linked, and work in tandem. If a door (handle) communicates 'pushable' and 'gentleness' it calls for a different interaction than when it expresses 'pushable' in combination with 'robust'. Together, both kinds of qualities describe what the full product experience conveys: in *using* the product the user perceives them as a *whole*. If there is too much unintentional conflict between product qualities, it may lead to confusion in the user. Needless to say, such confusion could also be the goal!

If you come up with certain characteristics, and they turn out to be exactly the same as those of an existing product in the domain you are designing for, *be alarmed*! You may have correctly defined and chosen the characteristics, but there is a chance that you may have been remembering something you already saw! Existing products and their respective qualities may have occupied your thoughts without you being aware of it. If the context is original (relative to the domain), and the interaction is original, then the product qualities should be original too. Always do an 'originality check'. If what you think are needed are similar qualities to what current products have, there is nothing wrong with that, but you had better be sure! We admit that there is always the (theoretical) possibility that after thoroughly executing the ViP process, you may discover that the immediate, pre-existing product meaning is exactly as it should be, and applicable

in the short- or long-term future. But, in our 15-year experience of working with ViP, this has never happened...

Qualities cannot stand alone; qualities need to be conveyed. The transition from product qualities to product *features* is what we are going to discuss in the next step, where the product is finally conceptualized.

Step ❼ Concept design, or 'concepting'

In this step we will finally make the transition from qualitative characteristics to some *thing* that has features or properties. We see concepting as the translation of your vision (statement, interaction and product qualities) into a manifestation, a combination of features that can literally be perceived, used and experienced. Note that the product qualities, as defined in the previous stage, do not yet prescribe what *type* of product will fulfil your goal. Only in this concept design stage do you decide what your final solution should be: a physical product, a multimedia application, a service, a policy or any other kind of solution that is deemed appropriate.

As in any design process, this step starts with idea generation; you need to conceive of a *concept idea* that matches your vision. This concept idea typically defines what kind of product you will design, and what that product can do (to meet your goal). The concept idea does not take a particular form. Sometimes, the idea almost automatically evolves from your vision; at other times it may take a lot of time and energy to find an idea that fits your vision. But at this stage you can finally take advantage of all the effort you put into developing a vision: you have a very clear idea of what you want! Instead of trying and testing a host of different solutions, you are directed toward the one idea (or the few ideas) that may actually work. In doing this, you may consider many options, but you will immediately recognize their appropriateness. In creating your vision, you have established solid ground for idea generation and evaluation.

Let us bring in an example to show how this works. This time, the example is not made up for the book, but drawn from a student project carried out years ago for Proctor & Gamble. The assignment was to "design something to make the laundry task less of a burden" [cf. other student cases for P&G].

Below follows (a simplified version of) the project completed by Joost, a student who worked on the project. On the basis of his context, Joost came up with the following statement: "I want people to live with passion by allowing them to develop their own style". To achieve this, he defined

the interaction characteristics as 'explorative', 'intense', and 'expressive', and the related product qualities as 'sensory-stimulating', 'open' and 'flexible'. With his vision laid out, Joost then had to come up with a product idea. At this stage he had neither defined what kind of product it would be, nor where in the laundry process his product should play a role. Since it was a project for P&G, Joost was mainly looking for solutions in the area of 'fast-moving consumer goods'. The product quality 'sensory-stimulating' also points in that direction. Note however that the other two qualities, 'open' and 'flexible' could have been implemented through other kinds of solutions as well, like a service or a web application. The concept idea Joost finally came up with was "Pep Up", a product that allows you to compose your own fragrance and add it to the laundry if and whenever you like, like adding herbs to your food.

So, where does a concept idea come from? When an appropriate idea 'pops into your mind' it feels obvious and easy. Your brain is doing the work, mostly unconsciously. As explained elsewhere[9], your unconscious brain is perfectly equipped to make decisions and solve problems. You can just do something completely different – in fact, this is even recommended – and 'suddenly' the right idea comes to mind. We often call this a *flash of insight*, or intuition. But it only works when you have prepared your brain for it and have carefully considered all the ins and outs of your vision.

To support the idea generation process, it is often helpful to think in terms of analogies that have the same (interaction and product) qualities as your future solution. In Joost's case, his analogy was 'adding herbs to your food'. He had concluded that this activity has many of the qualities described in his vision. Adding herbs to food can be an explorative and expressive activity; a selection of herbs is sensory-stimulating and open. When you have found an analogy that fits your vision it becomes fairly easy to transfer its underlying principle to the domain you are working in. An analogy is therefore a convenient stepping-stone in idea generation.[10]

When it is difficult to generate a concept idea, sometimes it might help to make an illustration composed of all the aspects you have found so far. The to-be-designed concept would be just an empty space in this illustration. Everything should be literally depicted in your illustration: the interaction, the user, his experiential state, his activities, the user environment derived from the context, but not the concept itself. Sometimes the kind of product that is relevant for the empty space immediately emerges.

As a concept designer, good sketching qualities are helpful! If you are not that good at sketching, use tools: make drawings based on images out of magazines, take photographs, or shoot video of people who are acting the way you want them to act.

Let's look at an in-depth example of idea generation that builds on one of the professional cases discussed earlier: the design of a retail kiosk for Dutch Railways. (We will also use this example to explain how to transform a concept into a detailed design in Step ❽).

First a quick summary. Servex, a subsidiary of Dutch Railways, asked Matthijs's design firm Reframing Studio to develop "a new retail formula" to sell products on railway platforms. The old kiosk, which was an 'office window' like a shop, had been showing a decrease in turnover. They felt it was time to investigate what a real shop in the same location might look like.

It was discovered through thorough context analysis that people in semi-public environments behave differently at various times: they play different roles. They may do things together with other people (i.e., bond), they may distance themselves from the environment and others by doing things by themselves (i.e., disconnect, like when they play a video game), they may show other people that they are connected to the current world (through 'role play', e.g. displaying a conspicuously sustainable and healthy life), or they may show that they can adapt to the most natural form of behavior in the given context (i.e., going with the "flow": having coffee in the morning, a beer in the evening, or just being). Reframing Studio felt that people like to be supported in the behavior they want to embody in semi-public environments, like railway platforms, as a means to attain their social goals.

Based on this perspective of the context, the following statement was defined: "Dutch Railways want to enable people on the railway platform to identify with the specific behavior – i.e., bond, disconnect, role play or flow – that suits them best at that moment." To achieve this, Reframing Studio came up with two interaction analogies that, when combined, created the desired effect as defined in the statement: "like the challenging relationship between a boxing coach and his pupil in training", and "like the relationship between a maitre d' and the guests in a restaurant". The interaction characteristic between the retail outlet and the traveler was summarized as 'comforting, role-emphasizing conditionality'. The related product qualities were 'self-evident', 'provocative', 'professional', 'worry-free' and 'affectionate'.

comforting
role-emphasizing
conditionality

▷

self-evident
provocative
professional
worry-free
affectionate

Interaction and product qualities for new Kiosk

Four types of product categories (bond, disconnect, role play and flow) would be sold on railway platforms. The concept had to make it as easy as possible for train travelers to choose the product that best suited the desired behavior they wanted to identify with at a specific moment. Therefore, a clear distinction between the four types of product categories had to be *experienced* by the traveler, and the threshold for contact with these product categories had to be as low as possible. The retail formula would address what the traveler unconsciously feels.

Three different concept ideas where then developed, with three working titles:

❶ *stage*: the formula gives travelers a podium (like the Spanish Stairs in Rome)

❷ *stepping-stone*: the formula makes the traveler slowly but naturally come into action (like a ritual temple visit)

❸ *pilot*: the formula is like a finely tuned mechanism, able to address the customers'/passengers' needs as optimally as possible (like a pilot flying his plane with the help of all the tools and feedback from the cockpit)

In the end, there may be more than one concept idea that perfectly fits your vision as well. If so, and if you are working for a company, together you decide which solution type fits the business strategy of the company best. Dutch Railways together with Reframing Studio decided to combine ideas ❶ and ❷: 'stage' and 'stepping-stone'. The combination was seen as most effective in relation to the defined statement. The new working title of the concept was, "typecasting coach".

Later on we will show how the idea of a typecasting coach was transformed into a concept.

Let's return for a moment to Joost's product. The idea of 'Pep up' is not yet an actual concept. In order to turn it into a product concept, Joost had to make a series of further decisions in which his vision remained directional (and the pivotal instrument for evaluation). One concept Joost

The three concept ideas: stage, stepping-stone and pilot

'flavour'. Depending on the mood of the day, or your laundry goals, you could pick one or more bags and add these to the machine. When the concept starts to take shape, it defines the *form* of the product (bags, a box) and the *way* the product is used. Unfortunately however, this particular concept did not match the vision. Tea bags are not very flexible, the bag concept limits exploration and composition, and interaction with 'teabags' is not very expressive. In order to address the interaction and product qualities better, the product had to provide for more 'active' possibilities, like mixing and squirting. And this is what the final concept entailed: a collection of (rubber) balls containing basic fragrance liquids. When a ball is squeezed, either the liquid is pressed through a nozzle, or some fragrant air is released from a valve at the top of the ball. The user can smell if the combination is right for the occasion and adjust the type of fragrance and dose accordingly.

 The concept itself is not yet a final manifestation (see Step ❽). It addresses various aspects of the final product in a rudimentary way: How does it (technically) work? What main components does it have? How do you use, handle, or operate it? What kind of sensorial properties (e.g., sound, form, colour, smell, tactile feel) does it have? How are all the components structured and composed? Most of these questions apply to physical as well as non-physical solutions, and some of these questions may only be relevant for a particular kind of solution. For example, in the case of a web-application, you may ask yourself: what will the user see first, and what next? How does the user navigate? What is the 'look and feel'? Together, all these aspects should give expression to the interaction and product qualities defined. This (incomplete) differentiation in aspects and related questions will help you understand how people interact with the product, and the kind of sensory properties and organisation necessary to make people understand, consciously or unconsciously, what the product means to them.

 Once more, it must be stressed that your vision can lead to concepts in the domain of objects, a virtual domain, but also in the service domain. For example, if the assignment calls for it, using ViP you can design new mobility objects together with new mobility services. You can even design new policies for the government related to mobility, if that turns out to be the most appropriate solution. This requires major skill on the part of a designer: to generate concept ideas independent of the solution type (or 'channel'), to translate these ideas into concepts for these different pro-

duct domains, each with their own and specific features. A (ViP) designer should not be bound to one single product domain or solution type.

Let's return to the relationship between your vision and the product domain/category once more. Sometimes the domain has already been defined at a product category level, e.g., 'design a family car for 2020'. Similarly, in the kiosk example, the solution was predefined as a retail outlet. By contrast, in the P&G example described above, Joost did not have a clear notion of the kind of product to design.

For example, if the domain is defined as 'family mobility for 2020' there are all kinds of possibilities for future concepts within other product domains and categories. You may think of cars, but also bicycles, mobility services, buses, airplanes, or even completely new object or service domains. The Segway is a good example of introducing a new product category to the individual mobility domain. iTunes is an example of a new service category in the domain of music exchange. The advantage of working with ViP is that your vision makes the *type* of product *secondary* to the *intended effect*. ViP can help you to get rid of biased ideas about product categories that "best" fulfil particular goals.

There are various strategies to help you understand how a product concept can give expression to product qualities. Here we will describe the two most obvious ones. Like Joost, as an example, you can try to devise a concept immediately. With this strategy, your accumulation of knowledge, feeling and understanding of the domain, plus your intuition, to come up with appropriate concepts. Make sketches, drawings, quick and dirty prototypes or (3D) models, or simply write down what the product will do and how. Always keep in mind the goal set in the statement, and check if the concept gives expression to the interaction and product qualities. If not, try to adjust the first attempt and check again. If these adjustments do not help, try to come up with concepts that are completely different from the first attempt until you find one that seems to fit the vision fully. Now every feature should be explained in light of your vision.

You can also create a concept the 'other way around'. In this case, first design all kinds of features that give expression to the desired product qualities in the specific product domain. The features should lead you to determine what main components are needed to make those features work. For example, if a feature is defined as 'zero emissions', a component could be a fuel cell powered electric motor. In the end, you compose the most effective concept by combining all these relevant features, taking into

account all the constraints that are relevant at this stage. Because all the features were derived from the same product qualities, it is possible to make all the features and components work together in one coherent concept.

The latter strategy was used when designing the "Kiosk" concept. All kinds of features were first designed separately: the type of "routing", the visual theme of the Kiosk as a whole, and the architectural structure. The act of bringing all the features together led to a kind of corridor between two 'walls' of displayed products. At the end of the corridor, customers pay for the items they have chosen. The products are clearly, vertically categorized based on the various behavioral roles discussed earlier. This expresses the 'self-evident' and 'worry-free' product qualities. To evoke the 'provocative', 'professional' and 'affectionate' product qualities, the on-site employee became the key factor. He or she stands on a 'platform' to personify the "typecasting coach" the outlet is intended to be as a whole. A fluent transition between self- and full-service was designed, in order to instill the feeling that everything in the shop is under the control of this "coach". The environment around the Kiosk would be arranged in such a way that every element would function as a stepping-stone leading to the entrance of the Kiosk. The traveler would be introduced naturally and comfortably to the shop on the platform.

Laws or principles of nature can actually help turn a concept idea into something useful[11]. Laws of nature make the concept perform within the physical boundaries of the world we live in, and provide insight into the limitations you have to take into account during the concepting stage. They enable the designer to seamlessly transition from an idea to something realistic, something that performs. They connect what is required by the statement/vision with what is possible in the physical world.

For example, if a car has a product quality like 'responsible', the car should have optimal aerodynamic properties. To implement this, you can apply physical principles to come up with a small frontal area of the car, together with a low drag coefficient. These features follow from your vision and are essentially different from the constraints we discussed previously (see Step ❷).

Constraints from the 'outside world' have been put aside until now ("in the fridge") so as not to affect the generation of concept ideas. They may stem from certain company/client desires or requirements, from competitor analysis, or from limitations in the production process. We have argued elsewhere that you should bring in these constraints as late

bond
entertain each other

disconnect
entertain yourself

flow
go with the flow

role play
express yourself

bond

flow

role play

disconnect

Above Concept layout of the Kiosk
Below Routing of the Kiosk

as possible, and concepting is the moment to take a few of these constraints into account. If your furniture company is only capable of welding steel tubes, then you should use steel tubes in the concept of the table you are designing for them. The concept must, of course, still express the desired product qualities. Concepting is about creating a synthesis between (vision-driven) features and (outside world) constraints to form a coherent and realistic product.

To evaluate if your concept is the 'right' one, you can ask the following questions:

> Does it fit with all the elements of your vision?
> Is it the most effective concept (in relation to the statement) with the "minimum of means" (features) applied? (This aesthetic principle is very useful in concepting. You should immediately feel if you have succeeded in implementing this principle.)
> Does the concept 'make sense'? Is it acceptable (or even desirable) to people?

This is the hardest test, because the concept is meant to fit the context, and this context lies ahead of us. If the context is set 20 years ahead, the concept is meant to fit this future world. The concept may, for example, rest on features that do not exist in current solutions. The only way to convince people that your concept makes sense is to evoke the future context within them: make them feel and understand the future context where the concept fits.[12] Keep the context and the statement/vision fresh in people's minds. People do not have a frame of reference for their judgement otherwise.[13]

After internal and external testing, if you are finally convinced that your concept is the most appropriate response to your vision, there is only one final step: ready the product to act and function independently in the world.

Step 8 Design and detailing

The key activity of this next step is to transform the concept into a final manifestation. There has already been a lot of literature written about this transformation, and in ViP does this step not differ that much from already existing methodologies. All the design and engineering skills that are normally needed at this stage must be put to work. The only big difference is that the *vision remains the driver* for every decision in this step; you are aiming to express the concept purely, with as much integrity as possible. The key activity in this design and detailing step is to make the idea behind the concept tangible and realistic. The constraints that we have put aside as long as possible, some of which were considered in the previous stage, must now be entirely taken into account.

Instead of listing the multitudes of activities of any design and detailing process, we will return to the Kiosk case to show you how complex the process can be.

The technological aspect of the project really added to its complexity. One of the technological innovations came from a desire to combine cooled and non-cooled products in one cabinet. This resulted in a new cooling technology.

The beauty of using the ViP approach is that your vision determines the kind of technology needed. If the technology does not exist, you have to develop it yourself (or have it developed). Instead of trying to think of how to implement existing innovative technologies in new products (the "technology push"), the vision makes it clear whether new innovative technology has to be developed ("design-driven innovation") to make your idea work, since it may not be possible to create it with "off-the-shelf" technology.

There is a difference between designing a retail formula and designing a single product like a chair, an insurance product or a policy for making the country safer. This was already visible in the previous concepting stage. In designing an original retail formula, decisions at many different, but related, design levels need to be made.

In general, the retail formula initially deals with the products to be sold in the shop. First, these products are defined, thereby creating a *formula-specific product portfolio*. Think about a supermarket: there are all kinds of fresh products like fruit and vegetables, dairy products such as milk, yoghurt and butter, and sections that deal with canned food, for example.

All the following steps depend on that specific portfolio. Next, determine what kind of service concept (self- or full-service, for instance) is most appropriate for customers to experience what you want them to experience. After that, work out a *route*, a kind of predetermined direction through the shop, which brings order to the introduction of product groups to the customer. Finally, think about what kind of shop "furniture" (cooling cabinets, shelving systems, check-outs, etc.) is needed to display, dispense, distribute or sell the products, and what kind of architecture is needed to make the formula one coherent whole. The service concept, route, furniture, and architecture are combined into the *retail formula*. The formula supports how you think the customer will experience the product portfolio.

The 'Kiosk' concept was based on the designed character of a 'typecasting coach'. To transform this kind of concept into a realistic retail formula, you need to consider the consequences of your product portfolio decisions and bring in a range of constraints. Here are some of the questions you should deal with:

> How many products are going to be displayed in the shop? What are the dimensions of all the products that are going to be sold?
> How much storage capacity do we need?
> Which products need extra attention?
> (For instance, what products need to be cooled? What products need to be heated?)
> How do we create a hygienic environment required to sell fresh food, if necessary?
> How do we create a pleasant working environment for the floor worker? (What kind of lighting do we need? How can we meet all the ergonomic requirements that may 'protect' the floor worker, such as the working height of a counter?)
> What is the maximum average cost per square meter of the new shop, so as to earn back the investment made to change from the old formula to the new one within a reasonable timeframe?[14]

These questions had to be answered before getting a grip on any necessary shop elements for the interior, like a counter, cooling cabinets, shelves, ovens, coffee machines, doors (and all their dimensions) and the requisite technological components, like climate control or air-conditioning, condensers for the cooling cabinets, fuse boxes, etc. Again, a designer of retail formulas must initially quantify the product portfolio, and understand its consequences on the dimensions of the shop, before defining anything about the design of the shop. In quantifying the product portfolio, always keep in mind the qualities it has to express, as defined in your vision. In the case of the 'Kiosk', the product portfolio had to support the various types of behavior people on the platform want to identify with. Any product would have to be recognized as a meaningful 'staging item' or 'prop' on the railway platform. Some products would emphasize people's connection ("bond") to others, e.g., a six-pack of beer or a large bag of chips, other products might allow people to "disconnect" from the environment, such as a fashion magazine or a newspaper. The number of items that could be displayed for each type of behavior was constrained by the formula's size, which was determined in turn by platform safety regulations.

The Kiosk case had yet another major constraint. Dutch Railway had pre-defined guidelines for all railway platform facilities. The guidelines had been defined to ensure the overall quality of the platform, based on the brand identity of Dutch Railway, and to achieve aesthetic coherence between the facilities on a platform, e.g., the height of a roof, or the width of a door opening. Guidelines were also defined to ensure that the platform would function as optimally as possible, guaranteeing safety and surveyability on the platforms through defining the amount of kiosk "transparency" and the maximum footprint, in length and width, of platform facilities.

Decisions being made on the basis of your vision and concept may result in an extra set of requirements. Add these requirements to the list of pre-defined constraints. Often, the list of constraints will grow during the execution of the design process, because of course in designing, the complexity of the full design and the relationships between constraints are revealed.

In a retail formula, it must be decided which shop elements, such as shelving and cabinets, are essential to make the vision work and which elements do not make a difference to the experience of the new formula (or can be bought off-the-shelf). This is a very important decision. Too

often it is decided to customize every fitting and fixture, resulting in a project that becomes exceedingly costly. Another 'beautiful' advantage to working with a vision is that it helps you understand what is conditional and what is optional, and then deciding what to develop yourself is easy. In the case of the Kiosk the decision was made to develop the unique cooled/un-cooled shelves/cooling cabinet combination to be able to present the different product categories as explicitly as possible, and also to establish the connection between self-service and in-shop service. It should be clear to the customer/passenger where self-service ends and full-service begins. Otherwise, the passenger won't experience the floor worker as "in control" of the whole shop, necessary to the 'typecasting coach' formula.

Ultimately, the design is about the desired effect as defined in the statement. The design of the shop is just one means to this end. There is no one ideal solution. What a relief for you, the designer, to see your design as just one of the possible means. It is much more difficult when a design assignment is defined in terms of a stylistic goal. It is difficult to accept that you have to make concessions regarding exactly how the final manifestation looks, and instead you may start fighting for every minute detail (nuance in color, perfect surface finish, etc). These details usually have very little influence on how people will experience the qualities of the design. If the experience is your goal, these nuances will not typically make a difference. For ViP projects, it is incorrect to assume that 'God is in the details'. It is, moreover, easy to see that the costs for realizing a perfectly detailed design are very high and use (too) much of the available budget. If your goal is an experiential one, 'the detail' is foremost in the execution of perfect proportions and the dimensions of the object as a whole. These Gestalt qualities are felt and perceived instantaneously and determine people's overall experience of your design.[15]

Returning to the Kiosk example, first the shop as a whole was designed (interior and exterior). The routing inside the shop was determined, based on the maximum dimensions of the footprint allowed on a platform and taking into account the amount of space needed to display the products. It was really important that the width of the corridor through the shop fit the 'self evident' and 'worry-free' product qualities. On one hand, the traveler should be able to take products off the shelf as easily as possible, but on the other hand, when there are other people in the shop, the corridor should not be jammed immediately. Next, the exterior design was

Floor plan of the Kiosk

made based on findings of how the interior design would perform best. As explained before, the exterior only 'supports' the products displayed in the shop. It was very important, despite the number of products on display, that the shop maintained a transparent feel and made staff easily visible from the outside as well. Therefore two structural 'arches' were chosen, emphasizing the direction of the corridor inside and expressing the product quality 'provocative'. The entrance and exit are experienced as the beginning and ending of the corridor. Sketches of first impressions were made and the choice of materials and colors of the Kiosk as a whole were determined. To make the products sold in the shop dominate the shop itself, and thereby emphasise that they are mere tools for playing certain roles on the platform, the colours had to be very reserved, and not override the 'provocative', 'professional' and 'affectionate' staff member.

 Establishing different relevant 'groups' reduced the complexity of this assignment: shop cabinets, counter, overall Kiosk architectural structure, ceiling, floor, etc. Emphasis was then on further development of each group, looking for a synthesis of aesthetics, ergonomics and technology from each. Proposals for each group were presented, and together with the client, choices were made about which proposal to adopt. The architectural structure for instance, consists only of two very simple steel arches, emphasizing the "corridor" between the two walls of products. The dimensions and wall thickness of the steel tubular case used for the arches were based on constraints related to rigidity and strength of the shop as a whole. Simple calculations were carried out to verify that these arches would do the job. The volume in the ceiling was used for technological component allocation, such as air-conditioning, condensers, etc. The design of the previously described cooled/un-cooled cabinets also had to be very reserved, so as not to overrule the "expressive" quality of the displayed products.

 In making all these decisions, you should constantly take into account how groups *together* can create the desired Gestalt, and what effect group design has on the average target price per square meter. The third (and perhaps the most important) advantage of using ViP is that it isn't necessary to generate a wide range of alternatives to determine if you are on the right track. The vision is so outspoken that what needs to be designed is very clear. Every component and part of every group has to be designed, described and listed. For every group, every property is known, with as much detail as necessary, in relation to the vision.

The last step was to bring together the groups and experience the Kiosk as a whole. The combined elements had to convey the character of a 'typecasting coach'.

A year after the new kiosk opened, Dutch Railway changed their guidelines! Thanks to a very clear vision of what was needed to accomplish the Kiosk formula, it was relatively easy to adopt these new guidelines without losing the main identity of the Kiosk. This is yet another beautiful advantage to using ViP: adaptability.

This case describes the transition from concept to design using physical properties. If you are developing a service for a financial institution, the types of parameters, properties and constraints will clearly differ. Nevertheless, the role of your vision in every decision made will be similarly powerful, and the four main advantages to using ViP are equally prominent. A well-defined vision governs idea generation and concepting, but also plays a major role in designing and detailing the whole and parts of the final product.

As we have shown, although having a vision is very helpful in translating an idea into a concept and in further designing and detailing the concept, the main surplus value of ViP is not in these concepting and detailing stages. The emphasis of ViP in general and this book in particular is on developing a vision of *what* is to be designed.

Final words on the process On user involvement

If we are so human-centred, as we claim, where do users fit into the ViP process? In our view, human-centeredness does not automatically lead to studying user behaviour and needs in the current world or involving users in the design process.

In ViP, it is the task of the designer to (fully) understand people, their goals and concerns, their aspirations and motives, and the world surrounding them. This understanding is summarized in the statement, e.g., "I want people to experience/understand/be able to…" for which the designer takes full responsibility. Anything a designer can do to increase this understanding is strongly encouraged, and all kinds of input – from experts and non-experts – can be mobilized to help the designer (when generating context factors, for example). Potential end-users can also be called in to evaluate a final design proposal. Since these designs are developed in light of a new context, 'users' must first be brought into this context.

In our view, many in the present-day design community make the myopic assumption that human-centeredness requires allowing end-users to engage in various stages of the process through observation, interview, or some form of 'participatory design'. What we take issue with is not end-user involvement, but that the insights thus obtained are often rooted in the situation the user is in *at that moment.* Users act in certain ways because of the designed environment they are *in*. They tend to reason from 'what is' instead of 'what could be'; their frame of reference is the present, not some future world. This input perspective may allow a designer to improve the situation, the designed environment, but it makes it very difficult to completely reframe and rethink the situation in the first place![16]

ViP is all about showing the courage to synthesize the world...

The Kiosk final interior design

1 As repeatedly stated throughout this book, when we talk of products, we are also referring to non-physical solutions to a problem, such as services or web applications. For these intangible products, we can also talk about qualities of expression, communication and personality.
2 This example is extensively described in Hekkert, Mostert and Stompff (2003). See also p. 29.
3 It is often a marketing department who comes up with the idea to target a new product to a predefined user group. They do so on the basis of market research that shows that these people do not yet use this type of product or may need such and such a product in the near future. They may be right, but that is still not a good reason to put it in the brief. What holds this group together may not be a relevant property for (the interaction with) the desired product at all. Furthermore, by limiting oneself to characteristics of such a group (exclusively), you may end up with a solution that only superficially fits these people and no others. Instead of increasing sales, you have deliberately limited potential market penetration and success.
4 See Dijksterhuis, Bos, Nordgren & van Baaren (2006).
5 When dimensions are created out of a set of clusters, the context looks very much like the outcome of a "scenario approach". Here, possible futures are typically represented by laying out the driving forces in two independent dimensions. Similarities and differences between common scenario approaches and our "context generation" approach are further discussed in the essay 'On context'.
6 An alternative way was proposed by one of our former students: "I… imagine that I walk into an empty, white room. At that moment I allow each factor/cluster to come in, one by one. This way, the world that I just created comes into being, and from there I start to feel what the proper response (my statement) should be."
7 To talk about interaction in terms of 'manner' works much better in the Dutch language where manners is translated as 'omgangsvormen' (literally: the way you associate with someone).
8 These qualities, related to use or action, variously called "affordances" or "use cues", have been popularized by Norman (1988) and are subject to much debate in the field of human factors. At the core of this debate is the extent to which products can possess meaning and enforce a certain way of use, and the role actual interactions and contexts of use play in this attribution process (for an overview, see Boess & Kanis, 2008; Krippendorf & Butter, 2008, and the 'On product meaning essay').
9 See essay 'On feeling and thinking'.
10 A famous example of the power of analogical thinking is that of the medical doctor who wanted to destroy a cancer tumor with radiation (e.g. Gentner et al, 2001). The level of radiation needed to kill the tumor was so big that it would also destroy the surrounding tissue. How to solve this problem? An analogous situation brought the solution: when armies in the middle ages wanted to attack a fortress, they did not all approach it from one side – this would make the defense too easy – but divided the army into subgroups, each attacking a different side. This strategy is much more effective. It is now easy to see how a doctor should radiate a tumor without harming the healthy tissue.
11 Here we refer to all kinds of technical, physical, and mechanical principles that determine what is (physically) possible. Although such principles could 'in principle' also be part of your context, they are typically applied at this stage of the process.
12 Various techniques have been developed to bring people in the proper state of mind to enable them to evaluate concepts for future situations. *Information Acceleration*, for example, attempts to create an environment that mimics the context in which future consumption choices will be made (Urban et al, 1997). Techniques vary from virtual reality showrooms and imaginary news bulletins, to fake advertisements and simulated word-of-mouth recommendations.
13 This is what happened to the GM Impact, a highly innovative electric car designed in the US in 1994. GM had also developed a range of new services around the car, such as the option of not owning it. They tried to make this concept work, but it had no success at all. At the time, there was no urgency to accept such a paradigm shift in the meaning of a car. People preferred their familiar, uneconomical V8 (SUV) cars to this sustainable, efficient, electric car…
14 Average price per m2 is a typical retail parameter. Total cost to build the new shop (including all elements) is divided by the number of square meters in the shop footprint, equaling average price per m2.
15 A recent study by Lindgaard and colleagues (2006) showed that people form a consistent first impression about the quality of a website in less than 50 milliseconds (1/20th of a second!). How much detail can be processed in such a short time span?
16 To make our case, we cannot resist a final analogy, borrowed from the biological world. It concerns everybody's friend, the dolphin: "Despite its streamlined, fish-like exterior, and despite the fact that it now makes its entire living in the sea and would soon die if beached, a dolphin, but not a dorado, has 'land mammal' woven through its very warp and woof. It has lungs not gills, and will drown like any land animal if prevented from coming up for air, although it can hold its breath for much longer than a land mammal. In all sorts of ways, its air-breathing apparatus is changed to fit its watery world. Instead of breathing through two little nostrils at the end of its nose like any normal land mammal, it has a single nostril in the top of its head, which enables it to breathe while only just breaking the surface. This 'blowhole' has a tight-sealing valve to keep water out, and a wide bore to minimize the time needed for breathing. […] The dolphin's blowhole goes to great lengths to correct a problem that would never have arisen at all if only it breathed with gills, like a fish. And many of the details of the blowhole can be seen as corrections to secondary problems that arose when the air intake migrated from the nostrils to the top of the head. A real designer would have planned it in the top of the head in the first place – that's if he hadn't decided to abolish lungs and go for gills anyway." (Dawkins, 2009, p. 340/341).

> **The process of looking, reflecting, then looking again is essential to the deconstruction phase of ViP.**

At first you might find it difficult, but with practice, this way of 'seeing' products becomes natural<

Discussion of interaction images

Seeing, interpreting, and defining interactions plays a prominent role in the ViP process. In the following discussion, we take a look at a couple of scenes from real life that involve interactions between people and products.

It is a discussion between three design experts, P1, P2, and P3, who try to describe what happens when people with (presumed) intentions meet products with design qualities. In trying to describe an interaction as a whole, the experts will often slip back and forth between the (presumed human) intentions and (visible product) qualities that together shape the interaction. Since any interaction results from the interplay between these entities, understanding what both bring to the situation is important in order to capture the 'right' interaction.

Barcelona chair

P1 OK, let's start with the Barcelona chair.
P3 Is that a copy?
P1 Yeah, it's a copy of the Barcelona Chair.
P2 You see it immediately; it's fake…a fake interaction.
P1 Well there are actually two interactions, aren't there? There's the phone interaction and there's the chair interaction… interesting…
P3 Do you think so? I don't think so. I think it's one interaction.
P1 Phone only?
P3 No, everything combined. He interacts with the phone because of the chair and vice versa.
P1 OK, but the chair gives him a certain physical attitude, doesn't it? The quality…he doesn't look relaxed in that chair, does he?
P3 No, exactly! So this is characterized by a kind of, hmm, resistance.
P1 Resistance? How do you see that?
P3 Because he's fighting: he's fighting with his body and he's fighting with his tools.
P1 And his interaction with the phone then?
P2 I very much have a feeling of, how do I put it…
P1 Desolation. Sadness?
P2 Sadness, yeah…it's also because he's wearing his coat. Wearing a coat, sitting uncomfortably in the Barcelona chair: it feels like he should be comfortable, yet here he is with this very tiny, urgent phone. It's completely out of proportion.
P1 You really see the smallness of the phone there, don't you.

P2 It's not the phone for that chair; it looks pathetic. You can't just shoot off a quick text message from a Barcelona chair!
P1 *laughs*
P3 Sure, but it's also that the chair is not suited to the environment.
P1 Why not?
P3 Because this kind of chair invites a person to sit back. You are supposed to relax in it, sit back…and in this environment…
P2 Is it an office environment or…?
P1 No, it's a warehouse.
P3 It's too low for that space. If the person wants to get up there's no support whatsoever. So he has to struggle with his body. Look: he's kind of alert; he looks like he wants to be ready for anything. That's why he's sitting upright, yet this chair is made for sprawling.
P1 Yes, there's transience in the interaction: he's got his coat on… It doesn't look like he'll be sitting there for a long time; he's clearly not enjoying it.
P3 It's the same with the Marcel Breuer chair, the Wassily: the seating angle is so wide that you slide backwards in it. You are really propelled backwards in the Barcelona, too.
P2 Which means you are supposed to stay there for a while?
P3 Exactly. Effectively glued to the chair, so to speak; sit in this one position and give in to it.
P1 Right, there's awkwardness in this interaction, then.
P3 This is the resistance I see. The chair is so dominantly trying to pull him in, and he

doesn't want to allow himself to get into that position. That's why we see resistance.
P1 Back to the phone: I'm really struck by how small that phone is in relation to him and how pathetic that is, as you said.
P2 It would be pathetic to actually see someone send a text message on some tiny phone perched on this chair. The size is fine for calling, having a nice chat, but not for texting…
[silence]
P1 It's really sad, it's a sad image isn't it?
P3 But what's really strange, if you really study interactions, is that a lot of them – 80 or 90% – are tragic…and we still think we're doing a good job as designers! Look at people in buses or on trains, it's always the same. Come on!

< 193 > **ViP** Discussion of interaction images

Cash machine

P1 Shall we move on to the next image? This one is at a cash machine: she's getting some money out.
P3 I would describe it as closed or something, it's really...protected.
P1 Maybe she's not interacting with the thing itself? I think she's just taken some money out, hasn't she?
P3 Yes, but she's interacting with the wall.
P1 It's the size of the thing that she's interacting with.
P3 What's interesting is that she's really close to the wall.... the wall wasn't built for the task of shielding her...
P1 You can't really see her face can you? I wonder if that is an indication of the interaction quality.
This one is difficult for me.
P3 Really? I think it's interesting; there are so many qualities in there that it's difficult to express. There's... what's the word for when people join close together because of a conspiracy? It looks like there's something going on that we're not allowed to join.
P2 Conspiratorial? See how close she's stayed to the thing in the wall, made the area as small as possible; it looks as though she's isolated herself as much as possible, together with the machine, as from outsiders and passerby.
P3 Excluding?
P2 Uninviting, this is a very uninviting interaction. That's why I like this image. There are so many qualities in it, but you can't see expressions, not from the girl and not from the machine.
P1 Let's go to the next one.
P3 What I like is that they're not aware that a photograph has been taken and yet we are looking at it.

< 19b > **ViP** Discussion of interaction images

Lighting cigarette

P2 For me there's real kindness and intimacy in this interaction. There's the simple cigarette lighter, and that little cigarette lighter really enables a relationship here. It practically forces her to touch him. And I love the plastic bag! As an object, that plastic bag is completely insignificant, but there's a relationship with it and it's directly in her hand, it has weight.
P3 But I don't think their relationship is intimate, even though they are standing close together.
P2 No?
P3 No; you see that there isn't a motive for them to touch. They don't feel the touching at all.
P1 It's functional touching.
P3 It's attracted your attention, and you've forgotten everything else.
P2 What I find interesting is that it's fleeting, temporary. The very fact that this guy also has a cigarette in his mouth, and he cannot afford to have it there for too long without touching it. The next moment he'll take it out again, and the moment is over.
P3 I think they're strangers.
P2 I think so too, they're just passing in the street. Look at how their bodies are positioned.
P1 Ah, so you think she was looking for someone and just said, "Oh have you got a light?", and he said, "Here," and I suppose she wants to shield the flame.
P3 But the interaction is not only about lighting the cigarette.
P2 There's a van in the back.
P1 They're not interacting with that though, are they?
P3 Of course they're interacting with the van!
P1 Are they?
P3 Of course they are, because they're aware that there's something in the street, that's why they're positioned the way they are.
P1 So what are the qualities of the interaction with the van?
P2 Mmm, carefulness.
P1 Remoteness.
P3 Something like that, yeah.
P2 Unrelatedness!
[laughter]
P1 But I can see an intimacy in their interaction, and also in the interactions with the things they've got; it's almost kind of loving. The guy is really enjoying that cigarette, isn't he?
P2 It's a habit, a routine, a ritual…
P1 And it's such a natural part of what he does, isn't it.
P2 That's true. I'm coming to realise how we put a lot of personal experience in what we see, like in the cash machine example before. You know how you would behave in front of it, and that's the knowledge we put into what we see. And I personally recognise these moments: walking down the street, stopping for a minute to give someone a light, and then continuing on my way.
P3 That's interesting, and there are a lot of differences between people interacting with lighters…

< 197 > **ViP** Discussion of interaction images

ATM

P1 OK, next photo!
P2 What's this?
P3 A guy about 3 meters tall, kneeling down.
P2 The machine's quite low. Look at the girl.
P1 It is, but I think that's because of the way the building was constructed. It looks funny…why would the designer put a cash machine that low? Basically everyone has to kneel to get money.
P2 But that bar…isn't that one of those special cash machines for handicapped people?
P1 Oh yeah! It could be.
P3 So what do you see in this interaction then?
P1 What I see there is that he's kind of locked into a familiar process: put my card in, put my number in…there's a sort of mundane quality to it.
P2 It's acquiescence. He accepts that the thing is lower than it should be.
P1 Yes, he's probably thinking, "I just have to do this to get my money."
P2 "And I don't mind squatting for a minute to get it." He's not resisting.
P1 He's really come down to the level of the machine, hasn't he? Because, presumably, he could just stand up and bend over. There's some sort of equality there: they're on the same level.
P3 Exactly.
P3 Yeah, but it's a strange kind of equality. What I find interesting is that he's lost himself completely; he's not aware that he's in a silly position. The machine, the process, the interaction is so strong and so dominant that he adapts fully, he gives in.
P2 In a way this one is much more intimate than the one we saw before.
P3 It's a somewhat negative intimacy…
P2 Surrender?
P3 Supplication, or dominance…
P2 He has to give in to the machine and therefore the machine accepts him. It's like the love you get from a priest, if you'll pardon the comparison.
P1 Absolution.
P3 Absolution! That's the first time anyone has described an interaction as absolution. That's what it is!
P1 It *does* look like he's praying; the money that comes out is confirmation that everything is OK…judgment is being passed on his financial health, and if the money comes out it's OK. He doesn't have to worry until he goes to another machine. The interaction is as repetitive as a religious rite.
P2 I have a Catholic background…I can remember, at the end of the service, for Communion, we had to go to the priest and stand there like this [adopts palms out position] and then he gave us part of the host. I get that feeling, looking at the man.
P3 Exactly, he has no choice – it's part of the ritual.
P2 And he has no other option but to bend down. There's a dominance in the machine…'I will make you yield.' I remember feeling that way in front of the priest, too.
P3 The power of the 'man in the machine'.
P2 The power of money!
P1 There's hegemony in this interaction…control through consensus: this is how we must act.
P3 Yes! These two words: absolution and hegemony. Perfect!

< 199 > **ViP** Discussion of interaction images

Boy with discman

P1 One more photo?
P2 Inwardness. It's what you always see when people have these things on their head. It's in their eyes...or rather, it's NOT in their eyes...they're looking around, but aren't seeing.
P3 That's the interaction between *you* and this person. But what's the interaction between him and his CD player?
P2 Point taken...
P3 He looks like he's puffing himself up, his movement and physical attitude are really strong, so it kind of helps him to be who he wants to be. Supportive?
P1 But that's also about you.
P3 Yes but the thing *is* helping him; it looks like he has an image of someone in his mind, some guy who's really strong, whatever, and thanks to the device he's able to get into a similar state.
P2 So in what way does this device help him?
P3 Because he's in a certain state of mind...
P2 But how does the *device* do it? It's not only the device, it's also the music, that's what you're not seeing.
P1 But he's holding it a certain way, a little bit indifferently, maybe it's too big – you know? – and he doesn't really want to have to carry it around.
P3 You see indifference because he wants to show that his strength is not from the music, but from his inner being. There's a kind of denial in this interaction.
P2 Denial of the machine?
P3 Yes: it's helping him, but he wants to show that it's not about the machine. So there's denial...but on the other hand he needs it a lot...
P2 He doesn't want to admit that it's the device that makes his pride possible.
P3 Or the music from this device.
P2 But as soon as he turns it off...or it runs out of power...
P1 So what sort of music do you think he's listening to?
P2 Hip hop!
P3 With a Jack Daniel's t-shirt? Maybe...I think he's a raver! Techno!
P2 Jack Daniel's! I mean what is a guy with a Jack Daniel's t-shirt listening to?
P1 Heavy metal...?
P2 So what about the trousers and red shoes?
P1 I think it would be some sort of dance music. But he doesn't look like he's happy, does he? It's like the music is playing on, but he's just passing time, isn't he...
P3 Dependent denial!
P1 Do you know what it reminds me of? It reminds me of a hospital when you're on an IV drip, and you have to push it, the device or the rod-on-wheels or whatever, around with you. It feeds you things that you rely on to stay alive, but you have to drag it around with you.
P2 You don't want to be aware that you depend on it! Yes, I see that. The music listener's whole existence depends on the music coming into his ears, but he wants to deny the machine making it possible. It's also a little pathetic...
P3 And the speed, see it? It's really nice to feel that his speed is three times the speed of anyone else.
P2 Big steps...

< 201 > **ViP** Discussion of interaction images

Interviews

There are a number of key issues in the ViP approach, and these are explained in various ways throughout the book. As you will see, we have elected to present this crucial information through dialogue, interview, or group conversation. All are conversations, of one form or another, in fact.

There are several benefits to employing the conversational form. Issues are presented in a more ambiguous, open-ended way, and the reader is thus invited to take a position in the discussion. The dialogue form also reflects the underlying philosophy of ViP: that designing is itself a conversation; a construction through a certain kind of dialogue; and a working out of meaning by watching, talking, and communicating. The following three interviews about (1) value in context, (2) principles, and (3) interaction take place between Peter Lloyd and the authors. Paul (P) plays an explanatory role, answering questions and elaborating concepts. Matthijs (M) supplements, and often refers to what he has learned, or does, as a practicing designer.

Interview
Dealing with values in the context

What is the relationship between an 'old' and a 'new context'?
P The 'old context' describes the set of considerations that underlie an existing product. The process of deconstruction helps uncover it. The 'new context' is the one the designer builds as the foundation for a new design. They can partly overlap, but do not need to. It all depends on whether the designer thinks that some factors from the old context are still relevant to the domain and scope of the new context.
M The new context may represent a scope of time extending 10 years into the future, and maybe you have redefined the domain. Both of these elements have to be taken into account when creating a new context. When you are deconstructing a 5-year-old coffee cup to uncover the old context, and the scope of your new context is 15 years from that point, chances are the context will be different.

And is this 'new' context the one that you believe should arise, or could it even be something you wouldn't like to see happen?
M That's a good question. We want to be as objective as possible here; it can be very difficult. Because the designer takes a position after establishing the context, the idea is more to draw from appropriate, authentic factors and interesting factors. It's not 'what I want', but 'what is relevant'.

P Authenticity is the key. Objective or subjective. If I (as the designer), choose 'people are confused about their political position' as one of my context factors, for me (as the designer) that idea is authentic: I genuinely see around me that many people have no idea how they should relate to politics. Others may agree, but they may also disagree. It is my personal interpretation of what I see. In that sense it's subjective…

Can I say 'people should show more interest in politics'? There are things as a designer that I believe people should feel motivated to do, like 'we should save the planet'.
P No, I must recommend avoiding the word 'should'! The context can contain words like 'the condition of the planet is regressing', 'the environment is polluted', or 'the level of CO_2 is increasing'. So the context is about what you see, what you believe to be true. The world as you see it.
M And you normally see beautiful things and ugly things. Both belong to your future context.

What you see now and what you can conceivably foresee in the future are different things, aren't they? When I look around me, I see things in my environment that other people don't. I see wasted space for example. But what I see in the future is something that I would like to imagine, or maybe wouldn't like to imagine, would happen. So if I look around now, and I see that there is a lot of waste, that's something that I can't really accept in 10 years time. It's not something that I'd really want in the future, more waste.
P If you have good reasons to believe and argue that your future world will be waste-free, you could add this observation to your context. But are you being honest in your belief? Building a context is not about what you *want* to see happen, but what you *expect* to see!

So wars are happening now, and I could say that in 10 years time I still expect wars to be happening.
M Right, so what you are saying is that 'war' is what we call a principle. So now there is war, and I think in 10 years time there will be war.

So war is a constant factor?
M Yes. It's a bit of a confronting principle, but yes, it is a factor which may or may not be relevant to the domain you are designing for.

That doesn't really lead me anywhere, though. It just says 'this is the way I see it now, and I don't think it will change'.
P Well, that remains to be seen. If you include it in the new context, that means it has to be dealt with, one way or the other. It becomes a personal choice, yet it has major implications. Another decision is *not* to include the factor. Be blind to it. But don't forget: if you *do* choose to include 'war' as a factor, later on in your statement you have the opportunity to indicate how you want to respond to what is, for you, a painful situation.

OK, so now I can see the value of thinking up a bad scenario… 'instances of war will increase', 'war will be closer to home', 'terrorism will increase', 'in 10 years' time every other person is going to be a suicide bomber', which is an exaggeration, but it may become more frequent. These are context factors that hypothetically I could then work with.
M OK, now it gets interesting. Is the increase of terrorist actions itself an interesting development, or do you think the underlying, presently masked principle is more important to bring into your context? I think terrorism, as the perceivable behaviour of people, isn't *that* interesting as such. For me it's more about people who are afraid of other cultural values, afraid of losing their power, and are therefore not open to other cultures. There is a chance that if the context is built out of factors that describe behaviour, you as a designer only want to change the behaviour and do not understand where it comes from.

OK, but my scenario was that 'there will be more terrorists', we need products that help protect us…
M No, you're going to fast! Go deeper. Why does terrorism exist? Why is there a fear of terrorism? We need to understand the causes, the roots. Maybe there is more terrorism because people aren't interested in each other's culture.

Cultural indifference?
M Cultural indifference is worsening. So there's globalism, but instead of globalism in a positive sense, globalism also means that everyone raises walls to keep hegemonic influences out, literally building walls and gates around living communities to help inhabitants feel safer. So this is the new scenario. And then you can say "this is what most probably will occur", and there are two options for the designer: make tools that render those walls even higher, or stronger, or make tools to break those walls down. This is the choice you make when you clarify your position, in the statement.

So the designer imagines a future and then asks: do I want to reinforce that future, or do I want to change it?
M Exactly, but this particular scenario we have been discussing is only based on one factor, and the world never depends on one factor. It's never the case; life isn't that easy. I see this often in design nowadays: something that is only the reflection of one driving force. It's easy to understand why the product makes sense, granted. But products that only are related to one single factor will eventually lose their meaning. A context is always based on lots of factors.
P That's the difference between the concept of 'context' in ViP and the concept of 'scenario planning'. We've thought about this a lot. In scenario planning, designers look for the driving forces within in a particular domain and…

They're looking for trends aren't they?
P …yes, things that are developing, changing. Designers planning a scenario basically ask "what are the possible futures?" And they often come up with two broadly definable dimensions as driving forces, such as 'individualism vs collectivism' and 'worldwide threats vs global peace'. For each combination they develop scenarios: what will happen if we have individualism and peace, for example. They develop these scenarios not to stimulate or provide direction for product development; they make the scenarios to prepare themselves. The scenario thinkers are anticipating what might happen. And so it suits a decision maker on the board of Shell to decide whether to buy a particular platform…

They describe possible futures, and then they look for indicators that the world is progressing toward one dreamed up scenario over another.
P That's the main difference. What we do with the context in ViP is not just describe a possible world, but the world – even a future one – the designer actually *sees*. Whether or not it's possible or likely or agreed on by experts, it's the world as the designer sees it. And the designer has to defend it, take responsibility for it, invest in it.

As the designer sees things happening in the future?
P Yes, but there is a particular 'want' in there, a will. It's in the

factor selection. The designer selects those factors that are deemed interesting to work with and relevant for the domain. That can be a very deliberate, personal choice.

That's what I'm trying to work out: whether the context is either 'value free' or 'value laden'.
P It's never value free! Here's a particular trend I like: 'people are becoming more and more understanding towards each other'. I could say this about the Middle East conflict between Israel and Palestine; they are beginning to understand each other better. It's debatable, but a part of it is what I see. But I also see it because I *want* to see it, that's the way I *want* to look at people, that's very much reflected in this observation. So you can never fully separate the 'see' from the 'want to see'.
M That's true.
P I see it this way because it reflects my values and my standards and my morals. That's why I see it in the first place…do you see?

If we return to the 'terrorism' discussion…the idea of people not understanding other people's cultures…if I imagine a future of cultural indifference, that's not something that I would want to see.
M That's what we mean about being authentic. It's not about closing your eyes to things that you don't want to see. Keep your eyes open.
P What you are expressing is also a value. To *not see* things that you don't want to see, that's not value-free.

M Often there are factors that conflict with your personal opinion of how the world should look. But you still bring them in.
P The type of factors that you select and the way that you describe them, there are values there.
M That's why if a designer describes the context to a lot of people, the personal dimension, the way the designer sees it, becomes the responsibility of the group. So in a way you can reduce the amount of personal subjectivity.

Isn't it more about imagining things than seeing things? Seeing has that direct relationship with here and now…
P Well, the designer *foresees* something, or predicts how the future will look. When specifically dealing with factors that do not change – what we call states and principles – they are visible in the here and now. As to trends or developments, they are projected into the future to see where they're going.

Can you give me examples of good context development and bad context development?
M It is a difficult question, but let's try. A good context is primarily authentic, something the designer genuinely sees. We discussed this aspect. Then, of course, it has to be inspiring; you must have the feeling that it shines a fresh and exciting light on the domain. It must invite you to go ahead and design for it. And finally, there are all kinds of criteria to select context factors to build a complete context. Are all the factors relevant? Is there enough diversity in the factor list? Have the obvious ones been forgotten? Are there reasons not to incorporate the obvious factors? Have all relevant topics been addressed? If the purpose of the context is understood, it's easy to infer what makes it 'right'.

Interview
What do we mean by 'principles'?

When you talk about 'principles' in relation to ViP, what do you mean?
P A principle is a factor type. It's unique to the contexts that we build using ViP and distinguishes them from the contexts that you see built using something like scenario planning.

Why do you want to do that – what's wrong with other approaches?
P Often they focus on things that are changing; they look at trends or developments, which form the basis of any scenario approach. Now there's nothing wrong with that. The ViP approach also defines the context as a set of factors or parameters that together define the starting point for design. But it doesn't make sense to just base your context on things that are changing, and not think about things that are stable or fixed or constant.

Why doesn't it make sense?
P Because if you only react to things that are changing, you miss more fundamental things. So when you look at tomorrow, or the near future, or the distant future, you should also consider factors that will remain pretty much stable over time. For ViP, these factors come in two forms: states and principles.

Let's just concentrate on principles first. Do you mean scientific theories, like the principle of relativity for example?

P Yes, that is certainly something that we mean by principle. A principle is a kind of law or a general pattern in nature or human behaviour, for example.

So how do principles apply to design?
P Take a well-established domain like automotive design. There are a number of well-known principles that are very often used. These are factors to do with safety, speed, and masculinity. For example: 'people want to survive', 'people want to understand the causes of their actions', 'a moving object will always be affected by friction', 'people want to protect themselves from the environment', 'men are still hunter gatherers who want to show their masculinity to women', etc. It can be argued that such principles underlie every car that has been designed!

I see. A principle like 'people are thrilled by speed and horsepower' has also been applied in car design then?
P Yes, that's a good example.

And a new principle could be something like 'people like to play.'
P Exactly! This is an emerging principle in the domain of car design that, if applied, will drastically affect final outcomes. What you also can see here is that selecting such a principle is a normative process that reflects your personal values or beliefs. You, as a designer, may regard this principle as valuable or interesting, and that's why you bring it up, and perhaps choose to include it. In this, the designer takes responsibility for any result.

So how would you define what a principle is then?
P A principle is a fixed phenomenon, something that was so in the past and will remain the same in the future. To us, these phenomena don't have to be scientifically proven to have this fixed status, but they must appear as fixed in the eyes of the designer.
M And there are also principles that are somewhere in between science and perception. Take something like 'if one is in motion it is more difficult to see movement elsewhere'. This could be taken both ways, as a scientific fact or as a personal perception.
P So principles can be of many types: physical, natural, biological, psychological, or sociological, to name a few… and might also be personal perceptions that appear as principles to a certain individual looking at the world.

Ah I see, sort of like a world view? Like science describes a world view that we can all more or less agree on, but I can have my own world view too?
P Yes. I could come up with something like 'people have a tendency to chase the wrong goal': a very subjective principle. You could easily disagree with me, but that is the way I look at the world.
For me it *is* true. If it's true in the eyes of the designer, it can be a useful factor.
M I think scientific principles are also important. I agree with Paul that you can formulate

your own principles by closely observing the world around you, but I think that's a starting point for further scientific enquiry. But I could be alone in this. When I'm designing, and I have an observation that I can translate into a principle, I try to corroborate it with existing research.

It's interesting how important observing the world is to the process of design, isn't it. Do you think some principles are better than others, or are all principles roughly equal?
P A very rich source of principles for designers can be found in the human sciences. Almost every principle in psychology, for example, is interesting from a design perspective. I mean, look at Donald Norman: he's a cognitive scientist, and his whole career of critiquing 'bad design' is based on simple psychological principles like 'people want consistency' or 'people need immediate feedback'.

So let me check that I understand what a principle is. There's another example: according to my observation, the progress of technology is taking away people's ability to remember. Nobody remembers phone numbers any more because they are in a directory on a mobile phone. So my principle would be 'people are losing the ability to remember'. Is that something that you mean by a principle?
P No, that's not a principle! We would call that a development, because it is changing over time. The progress of technology, i.e. the changes in technology, are causing people to forget.

Right. So a development is changing and a principle is stable?
M Exactly. The key for me when I'm designing is that the principles I start with form the core of the user-product interaction. The trends and developments give colour. So, in my designs the principles are the most important factors, because they really lend insight into the domain I'm working in. Designers just tend to assume principles without really thinking about them.
P I want to make another important point. Often principles are implicit, whereas trends and developments are often made explicit. Something that is changing is much more visible than something that stays the same. We only notice things when they start to change. That's why people and animals freeze when they are in danger. As long as there is no movement the chances are smaller that the enemy will see its prey. I often give the example of a principle that is behind almost any product: 'people want things to be as easy as possible'. That principle underlies many products. We have to make products that are easy to use.
M Bruno Ninaber says "we're not psychologists, we're designers" but I'm not sure I agree with him. What I really like is that if there are several relevant principles for a particular user-product interaction, the designer has to understand what the relationship between the principles is; in a way the designer *is* a psychologist.

Let's discuss a few more concrete examples of principles. 'Children are more demanding nowadays'. Is that a principle?
P No, do you know why? Because it's changing? It's a development?
M Yes.

Another: 'sitting for a long time is never comfortable because of the anatomy of the human body'. Is that a principle?
M Yes.

How about this one: 'People are becoming more egocentric'. That's a development right?
P Yes, but it's on the border between a trend and a development. Broadly speaking, a development is something in technology, society, or the economy, that is changing over time but also relates to changing human attitudes and values. A trend is specifically about changes in human behaviour. So I don't think this is a trend, I think it's a development.

What would be an example of a trend then?
M Something like 'people watch television more often'. That's a trend, whereas if you say 'people value their personal space more and more' that's a development. Another example of a trend I often use is: 'people eat out more often'. The underlying development may be that 'people have less and less time to cook'. The catch is that a development can also result

in completely different trends. So for example 'people are buying more TV dinners' is a *different* trend that results from the *same* development. The difference may be subtle, but it can be important.

And another: 'dependence leads to frustration'?
P That's a principle, but I don't think it is a good one. I think it is a little too abstract.
M I don't know, I think it's a good one; it suggests quite an interesting direction…

Right, I think I've got the picture now. I can see how principles can really help a designer determine a starting point for design that goes deeper than merely 'trend watching' or coolhunting. The designer becomes a momentary scientist or social scientist. I really like the relationship between design and science here, and the way science can suggest possibilities for design. You two really like principles don't you?
P We could talk about principles for hours!
M Principles are beautiful!

>the interaction is somewhere in between the product characteristics and the thoughts and emotions of the user<

Interview
'Interaction' in the context of ViP

Central to ViP is the concept of interaction. There is even what you have called 'the interaction layer' in the ViP approach. Yet 'interaction' is quite a common word these days. I'd like to ask what you understand by the term 'interaction' in the context of ViP?
M It's a qualitative description of the relationship between an object and a user.
P There are quite a few ways to describe the relationship people have with products. Sometimes it's passive – looking at a product, admiring a car while walking down the street – but most of the time the relationship is active, when a person is actually using a product. There are varying qualities, various properties that are observable in an interaction.

In the interaction itself?
P Yes. Take this mobile phone as an example. My interaction with it – to quite a large extent – is determined by its characteristics. Yet, my interaction is also determined by my intentions or my mood. Because of its size, I can easily protect it, and maybe that's what I want, to prize it highly. So I could say my interaction is characterized by protection. Maybe I should do something typical like sending an SMS. What do you see when I do this?

Concentration.
P Good...

Small physical movements using two hands, focused intent.
P Yes that's interesting, I see tunnel vision.
M What do the small movements indicate to you? When you say 'small movements' you're not really describing the *quality* of the interaction.

It's something like the interaction doesn't 'look' right with such small movements, it looks out of proportion. Pauls' got big hands with big thumbs and he's using this tiny object.
M So there's something like obstruction taking place? Can the interaction be characterized by obstruction?
P Maybe it's something more like inconvenience!

What do you see Matthijs?
M I thought of something like openness. I think a description of the whole relationship is possible: Paul *together* with the object. If I describe the interaction that way, then maybe the idea of 'openness' makes sense. Because (if you think about it) Paul has a motive: to communicate with someone else. And this object provides him with the means to do so.

Like an extension of his body?
M Yes!
P The way we're talking about the mobile phone now is actually very much how we would talk about an interaction during the deconstruction phase. Then, as now, we deal with an existing product and we try to figure out how people interact with it.

It's not that easy to describe the qualities of an interaction; our language is quite limited in this respect. I think you probably saw a lot more in my interaction with the mobile phone than you were able to verbalize. Did you notice how difficult it can be?

Yes. Do you think it's because, superficially, interaction seems such a visible thing, yet there is a lot that is 'invisible'?
P For me, one of the more distinct elements in my interaction had to do with the tactile qualities of the thing. That's very difficult to observe as an outsider.

Well I could hear the keys being pressed. Is that what you mean when you say tactile?
P No, it's more about the 'soft-click' of these keys. They have a particular feeling that I like. That's one of the reasons that I like this phone, because of the 'click', the shape of the keys, and this feedback it gives. It's just *right*. With some phones the click is too soft, in other phones it can be too hard. So in the interaction I can sense some sort of balance. To me the click feels appropriate.

You're saying you like the feel of the keys, but is that really a description of the interaction?
P I can see what you mean, but I'm trying to say what properties of the button make me like it and this reveals the two very distinct facets that together form an interaction. On the part of the user (me), there is a particular disposition, in this case 'liking'. On the part

Paul in a chair

of the product there is the feedback provided by the keys.
M So the interaction is somewhere in between the product characteristics and the thoughts and emotions of the user.

Ah! So an interaction is a relationship?
M Exactly.
P And what's important about it being a relationship is that it simultaneously describes the role of the user *and* the role of the product. The relationship describes user aspects like feelings, experiences, intentions and the like, while simultaneously describing properties of the thing.

I think I get it! So, like any relationship, there are words to describe its character?
P What we sometimes do is ask people to describe an interaction in the terms of a relationship between two people. That makes it easier.
M For example, at a party people talking to each other immediately reveal what kind of quality their relationship has. That's what we're looking for.

Yeah that's true; it's often quite clear who holds the power in the relationship…
M Similarly, a silhouette of a user using a product immediately reveals what kind of interaction is taking place. The silhouette of a racing bicycle user and the silhouette of a normal bicycle user immediately reveal what the difference is in the interaction.

So what are good words to describe the quality of an interaction? How about

words to describe the interaction between that chair and Paul?
M Well, first of all, take a few minutes to get on to this level of thinking.

But what form should the words be? Are they –ing words?
M We have a sentence that helps us: "The interaction can be characterized by X/as Y."
P And the word that fits the X or Y is correct.
M The interaction can be characterised by softness, tenderness, intimacy, or misunderstanding… or the interaction can be characterised as soft, tender, or intimate…
P Or aggressive.

So the quality is the –ness words
P The quality can be expressed as a noun or an adjective. '-ing' words or '–ness' words work, but there are many other suffixes possible. Designers will often invent '–ness' or '–ing' words. If there are no words that describe the kind of quality seen or felt, a new word is called for.

OK so back to the chair then…I feel that there's a sort of old quality, an ageless quality, agelessness, rigidness…
M I'm thinking 'support' in the qualitative way, so 'supportive' because it gives you status, you're sitting upright.

Importance?
P Yes, I do feel quite important here, but that has to do with the context, of course. It makes me sit very upright.

The values here are 'old values' so it's appropriate in this environment.

Yes, there's like a timeless quality, like this chair has been there for a long long time and you're just the latest part of the timeless being of the chair, that the chair's going to carry on, so the interaction might be characterised by timelessness.
M In a way the chair steers Paul's body position, so there's 'dominance' in this interaction. There's strength in the chair somewhere, in a good way.
P Well, one difference between me sitting here in this chair – versus Matthijs' chair – is the armrests. I'm much more balanced than Matthijs, who has no armrests. Look at him; he's almost falling out of it! So as a result of the armrests my position in this chair is much more fixed, and his is much more open.

That's true; your position is… if someone were to walk into the room it would be instantly clear who had the power in the room.
P Yes, so there's 'empowerment'…
M You know, when we find examples together with the students, we run into the same problems as the students. Even as experienced ViPers, we're not quicker or faster. We have to look at each object, and our relationship with it, afresh. Take the example of the mobile phone. We've done it 300 times before and still I think, 'Shit! This interaction between the telephone and me again! What the hell *is* it?' because it's not obvious.

I can see that in describing an interaction you're bringing in abstract words, thing-ness sort of words, that help you – how can I put it – to float your ideas...
P Well, as Matthijs said, the words describe the wholeness created by the values and concerns of a user AND the properties of a particular product. If you consider them simultaneously, at this abstract level, you are already laying a kind of foundation for how these two things are brought together.

So everything seems to revolve around the user here – is that right?
M Not quite. What is actually pivotal is the interaction. If you move too quickly from the context level to the product level, you miss the interaction level, and hence you leave out the user. We call it the 'architectural mistake': going straight from the context to the product.
P You can do that when you're not overly concerned with people, like many architects. That's why we call it the architectural mistake.

So I think the deconstruction phase is quite clear. In the design phase, how do the qualities of the interaction relate to the context that you've designed?
P What would normally happen is that a picture of this context would have been painted, and on the basis of this context a statement is developed.
M You establish your position in the statement.

P And in the statement, the ultimate design goal is formed. The statement is usually expressed like this: "I want people to understand, feel, see, etc...", something like that. So, then, as a designer, the question you should ask yourself at that stage is: what kind of qualities should the interaction have in order to reinforce the statement? That can be quite difficult!

And then the qualities of the interaction have to relate to that statement somehow?
P Right. If the intended interaction works out as planned, the goal in the statement is realised. The statement describes *what* you want to achieve for people, the interaction describes *how* this will be achieved. A lot of the richness from the context can be reflected in the interaction; many clues about how to realise the goal are already present in the context.
M It's complicated, because the kind of product has not been determined yet, and there is only a vague idea of any concerns or intentions. These are partly defined in the context. That's why you have to think of the wholeness, the Gestalt of product and person.

So give me an example from a project that you've worked on.
M Maybe one called "Link" is a good example. It's a project we did for the famous Belgian furniture brand Durlet. It addresses another interpretation of sitting. Could be interesting in relation to the discussion we had about Paul in the chair earlier.

What did Durlet ask you to design?
M The project actually began in 1999. The new millennium prompted Durlet to investigate the kind of new products that might be meaningful in the future. They asked us to design a kind of 'concept car' for the future. That, of course, was a very good starting point for ViP, and it was really a comfortable start to the project. Usually we have to put a lot of effort into the process of reframing a design assignment. But in this case, Durlet showed courage! They asked us to come up with a desirable new object without restricting what that could be.

Wow, they sound like the ideal client. Could you briefly describe what kind of context you came up with?
M OK, I'll keep it simple. Of course we initially defined the domain and timeframe: 'sitting in public environments for 2010'. We came up with 3 main context clusters. The first cluster describes that 'status depends on having strong relationships with other people instead of having a lot of money in the bank'. There had been, and has been, a continued shift from ownership to the ability to establish and maintain human relationships. A second cluster was more about future human behaviour. This trend describes people finding it 'important to have the freedom to really show how they feel', and recognize how important it is that others do the same. "Window dressing" behaviour is no longer seen as

honourable. The last cluster was more about the principle of 'people find(ing) it difficult to be open and come in contact with unfamiliar people in public space'.

Right, so this was your worldview, I suppose. And how did this lead to a new interaction?
M First we had to grasp what kind of position, or statement, was most inspiring in relation to this context. We defined our statement thus: 'we want people to initiate interaction with others' and 'seduce users to show their feelings'. This statement led to interactions like a 'sense of discovery', 'generosity' and 'naturalness', which were meant to accomplish what had been defined in the statement. Is it still clear?

I find it hard to see what 'discovery' and 'generosity' in the interaction mean. Can you explain further?
M Discovery is about making people open up to others. This kind of interaction allows people to get in contact with other people by making thresholds invisible.

Now I see how 'discovery' brings you towards your goal. But how can I put discovery into an interaction? I find it difficult to visualise this.
M Discovery in an interaction is like a dog sniffing around finding out what his role may be at a particular juncture. 'Generosity' represents an interaction that is delightful, of high quality, as when you receive perfect and delicate table service. It makes it desirable to encounter the one who is using the to-be-designed piece of furniture. Both interaction qualities make clear that the quality of the relationship is one where users don't have to be afraid to start using the object.

That sounds interesting, but I'm not entirely convinced...
M Maybe I can explain it by introducing the design, with its specific product qualities that elicit the interactions described earlier. It was decided that the design had to be multi-use, organic, inviting and soothing. In the end, the physical reflection of these product qualities is a very simple piece of furniture. Link is built out of 3 leather elements, connected to each other in the middle. The distance between the centres of the different blobs are closer than what is generally perceived to be a "comfortable distance" when sitting with unfamiliar people. The personal space you really get is smaller than the personal space people usually like to have (to feel secure). Yet the shape of each element is designed in such a way that it doesn't determine a sitting position. It's easy to choose any sitting position, and see in all directions. It's also attractive, with a natural, organic shape. If already in use by another person, a new person is confronted by the other persons' presence, emphasized by the physical connection between the different elements. Now any reaction and emotions revealed are the user's responsibility: take some distance, connect, or act indifferently.

I get the picture. So you imagine someone coming into a room, like a waiting area, and there's already someone sitting at one of the blobs. The person will have to make up his or her mind whether to sit on the same blob or a different one. And facing the middle or looking away, right? There's quite a lot of decision making in the interaction. Is that what you were after?
M It is more an unconscious decision-making process...But because relationships with other people are becoming more valuable and therefore important, you also unconsciously make the decision to start using it!

I see, you added interaction qualities to a piece of furniture that were not there before...
M Exactly! And the Link became a very successful piece of furniture indeed!
P The beauty of this example is that it shows how changing the interaction can redefine the kind of meaning a designer brings to people. Instead of just offering a nice place to sit, the object becomes a mediator of social relationships.

Link by Durlet

>Designing with ViP is like conducting scientific research: there is no way of knowing beforehand what the outcome will be<

Interview
Dealing with the client

ViP projects require the client to play a very different role than the one they usually tend to play. In the ViP model, it is the client's task to provide the ideal conditions for a designer to enjoy as much freedom as possible.

This implies that the client should try to remain reserved whenever possible, especially as regards preconceived ideas about what element should or should not be taken into account. Concurrently, and this is not necessarily a paradox, the designer must try to actively involve the client in all steps taken. A truly valuable final design, in the eyes of the client, can only be appreciated as such in light of the context and visions developed during the process; clients must therefore understand and subscribe to decisions taken at various stages. If possible, clients should even participate in these stages, thereby contributing to the design process.
The following interview with author Matthijs was conducted by Paul. He describes his design firm's experience in dealing with clients' expectations and attitudes.

As a designer you obviously deal directly with clients. Have you found that you need to extensively explain ViP before you begin a project?

Yes. The product development process in ViP asks for a completely different attitude to what the client usually has.

Can you expand on the kind of attitude needed? And how does it differ from a 'traditional' attitude?

We ask a lot of people to start thinking and acting in new ways. This is not easy for them. First of all, the client has to examine their underlying company motives, and be very *honest* about their current position commercially, socially and culturally. If there is denial in this regard, and their action is not grounded in some form of profound insight, then there is no reason to start any kind of ViP-based project. Any money invested would be lost. On top of that, the client has to be convinced to *trust* the ViP process, and actually commit to the outcomes. If they have any fixed ideas about new products, processes or organizations, this can be a formidable task. Designing with ViP is like conducting scientific research: there is no way of knowing beforehand what the outcome will be; we have to ask the client to allow for that. Through ViP, a designer often has the opportunity to advise a company to produce 'things' they are not used to. A lot of people in the organization may reject such changes.

This does not sound easy indeed! What can help clients accept and adopt ViP?

Often, clients think they are experts in their domain – and they are! – but they also make the mistake of imposing a present-day solution on their design problem, rather than considering future possibilities. This is a reaction to the present, and the client often self-defines the design assignment through it. Most of the time, their solution is product-oriented, and doesn't reflect our aim: to be end-user-experience oriented. The brief you get often mainly lists the criteria the final design should meet. This list of criteria is based on what is already known. It becomes impossible to innovate, and inevitably the question arises as to whether these criteria realise the desired effect the client wants to evoke from his users.

The key is in ensuring that the client understands that human-product interaction is central to any successful design, and that this interaction is steered by context. This forces the design process to start with completely different activities than what the client is accustomed to.

Do you mean they tend to respond to how their current products are doing on the market? or to those of competitors?

Both; it depends on their market position. If they are leaders, often a new assignment is based on their current product line. If they have difficulty being meaningful to end-users, they look at which competitor is successful and try to learn from that. The 'learning' in that case is 'trying to understand which product features enjoy commercial success in a specific product domain'.

This is reflected in the way they formulate the design brief, I suppose. Can you give an example of a 'narrowly' defined description?

That's a good question...the funny thing is that because I have already been using ViP for 15 years, my clients do not confront me with the kinds of situations we are talking about anymore, but allow me to reminisce...

We had to do a design for a new shop formula. The client had already been working with another design firm for two years, and that firm had come up with a pilot version of a new kind of supermarket. The pilot was completely different from the supermarkets we had come to expect from this client. They had come up with a very clean concept, with bright, yet 'cold' colours. They were aiming for the most efficient shopping experience. But the efficiency was more a reaction to how the supermarket had been up to that point. The supermarket was known as luxurious, for customers who value quality. The idea behind the efficiency was to target another type of client; the goal was to become a family supermarket. But in the end, families didn't accept the newer, more efficient supermarket as meaningful at all. That's why the management decided to do it differently:

'make the efficient supermarket warmer and more recognizable to our current customers and their families'. This was the new assignment for us.

Did you accept this task as is, or did you convince them to approach the matter in a different way?
Well, we explained to the client that by coming up with a reaction to a reaction, the risk was extremely high that in the end the new formula wouldn't work either. We explained that thorough research on the supermarket's future meaning for their clients was needed.

Did this require a complete reformulation of the assignment?
The funny thing is that there was not much need to write anything down for the assignment. The first thing we had to write down was the desired effect the client wanted to affect with end users. This was the core. With ViP, the designer has to find out, together with the client, how to define the domain and how to match the timeframe with their long-term business strategy. The 'rest' is the outcome of the ViP process. The design starting point is created automatically when executing the ViP process. Each design step in the process generates starting points for the next step. These starting points are collected while executing the ViP assignment; the assignment grows with time. A ViP assignment is a timely, living document.
Were they convinced

immediately? They probably had some market research reports in their pocket telling them that 'warm' and 'recognizable' were the appropriate characteristics of a future shop?
No, not really. It's still difficult for a managing director to agree to 'research' on the future meaning of a supermarket for their clients. They are used to giving an assignment that is well defined and easier to control. That is why starting with design requirements makes the relationship so comfortable from the very beginning. So they had to trust me, or at least the process... The client should *not be afraid* of complexity, things they do not understand immediately. In creating something innovative, something completely new is born. Before boiling all things down to something insightful for the company and meaningful for the end-user, the design team must be allowed to find structure in an unstructured set of building blocks. This is not an easy task; innovating is bleeding! The client must allow the design team to make misjudgements for the sake of understanding, but within the framework of the context. So the supermarket client needed to see other projects that had been successful for other clients, to convince them to work with us.

They may feel they have done or could do the research themselves. After all, a company like this has a big marketing department where they dig deeply into consumer behaviour...my

second question refers to this. How do you get around the marketing department?
We cannot get around them or go beyond them. We work together with marketing. All the data they have on customers is taken seriously. How to use this kind of information, in a way that is fruitful to the design process, is the designer's task.

But if the information is 'reactive', based on evaluations of competitors' shops and current market activity in this case, how can you incorporate this into the process? Do you use this information because you feel you have to (you simply cannot ignore it)? or is it really the kind of info you want and need?
Good question. 'Stay honest with the client' is my answer. Some of the data they have refers specifically to current market situations, of course. But part of it describes other, more useful things, like principles of human behaviour for instance. If the designer can make clear to a client that data considered applicable to the future context will be employed, and data that isn't meaningful for the future will not, the client should understand what the idea behind this design activity is. So *we* take *them* seriously, by selecting which data is relevant for the future.

OK, I get the picture. You distinguish data that is valuable for sketching a future context from data that is just an evaluation of the present. And if they understand the ViP way of thinking, they accept your decisions (teeth grinding). Let's get back to the

assignment: you made them switch from asking you to design something with specs (a warm and recognizable shop) into taking a loosely defined domain – like 'supermarket shopping in ten years' – as a starting point.

Right?
Right.

But this would have had major consequences on the process. Instead of coming up with sketches for a new shop in a few weeks, it could take months to research the situation in 10 years. Do clients generally have this kind of patience? And money?
Do they have the patience? I always tell them that if the assignment is for a product that will be important to them over the next 5 years or so (with shop formulas this is 15 years), they have to take the first stage of the design process very seriously. This is the starting point for everything; if we get the starting point wrong, all the things derived from it are also wrong. Stating this clearly often helps. It is therefore very important to tell them exactly *when* to expect *what* rather than saying "this will take a lot of time and money". The beauty of ViP is that the designer does not know what will be created, but is very clear about how the content creation is structured. This structure, in terms of context, statement, interaction, etc, is used to give the client detailed insights as to when something will be delivered, when the project will be finished, and when the designer expects them to cooperate or make a decision to continue or halt the design process. Usually, if management has given the design department a timeframe, the design firm cannot deviate from that framework. But because ViP has such a huge impact on how the company wants to position itself (through the product under development), top management should always be involved. Thanks to their involvement, changes to the original schedule are easier to get approved.

Does this mean you have various red/green light moments during the process? What are the critical moments?
The client needs to think that they can get out completely if the process is not leading to something fruitful. This idea counterbalances the suspense of not knowing the end result. If the content doesn't lead to any new insights, the client has to be given the freedom to say so and stop the process. Critical deliverables are context factors, context coherence, interaction vision, and concepts. With every presentation of a deliverable, the client can make a judgment on the relationship with the previously approved design step. In the end, the client can't say, "This is not what I meant," which often happens in practice. Now he can only say, "This is not good enough," so then the designer can have a discussion about that evaluation, or come up with a better concept or whatever.

So when and how do you involve the company in content creation?
At the context level. There is so much knowledge available in an organisation. In our experience, when we have asked clients for context factors, the discussions have been extremely fruitful. Thinking of a relevant factor is so different from their daily working activities...they easily give up their preoccupations. Whereas if we asked them to come up with new product ideas, then it is highly probable that these new ideas would be related to the products they produce themselves. The beauty about factors is that if they say a factor is relevant, the designer should take it into account. Don't automatically eliminate any factor that is generated by people of the organization.

If they say a factor is relevant, you just take if for granted? Why?
No, of course not. The designer has to agree that it is relevant, of course.

So you treat them as factor sources...experts in the domain? Are 'they' able to look at the domain afresh and take an original perspective?
They are, yes. For me it is always a pleasant surprise to see so many people in organizations with so much valuable knowledge.

Are there any other steps in the ViP process in which you can and do involve people from the client organization?
The client, if one exists, should define the statement. It is their

responsibility to take a position in relation to how the world will develop. Ultimately it is the designer's responsibility to live with the company statement. Other options are to try to convince the company to define another one, or gently terminate the working relationship.
We utilize the resources in the client organization by asking them to agree on every design step being taken. Do they recognize themselves, especially in the new context? Is it complete? Is it original? Etcetera. If so, the context from there on is the new frame of reference for the rest of the project. The client can no longer use his or her own opinions, values and observations as a reference to make a judgment. That is why different people from the organization must agree on every design step.

But to define a statement, a very good understanding of the context is needed. How do they get this? You designed the context, right?
Defining the statement is not that difficult. Often the context, in its coherence, makes the client understand what the main drivers of this future world will be. Then it is easy to relate the statement to these drivers. Clients have a lot of potential. Do not underestimate them.

Have you ever been in a situation when you had to turn the job down because the client settled on a statement you could not 'live with'?
No. But there was one assignment where our vision, statement and product were so successful that it made me unsure whether I wanted to 'manipulate people' like we do with the things we make. ViP also works in commercial contexts...it sparks a kind of moral dilemma...do I want to make things so commercially successful?

But the client must have been very happy! Was it his statement, or yours? Or did you define it together? What interests me is how you field different opinions to get to the right statement...Could you accept to work with a statement that does not feel completely right?
As regards the commercially successful case, the client agreed with the statement we had created. Often it is very clear what kind of statement fits the company strategy; the designer can sort of 'predict' what the statement should be, given the company identity and strategy. In fact, we have hardly ever had the experience that a client statement was not right. And when it wasn't – in our view – we were able to convince them that their opinion was slightly off...
Once we did a very big assignment for a Dutch 'guanco'. We came up with a very challenging statement about how to maintain their existence: completely change the way they operate. Instead of following our vision they are now firing thousands of people; they say they have no future any more.

What is a guanco?
A government organization that was privatised and became a commercial interest.

I see...so how did they deviate from your vision? As early as the statement stage, or later? Any idea why?
They thought the statement was not feasible. But doing nothing was not feasible either!

Because it was so radical?
It was revolutionary, yes. But it was revolutionary because they hadn't done anything for the last 30 years to change the services they deliver and keep them in touch with the end user.

Up to now, we have discussed the situation where a client asks you to design something quite specific and you create more freedom for yourself by broadening the domain. I guess this is the most common scenario. Have you ever encountered clients that start off too broadly or too generically and you have to make them narrow down the domain first?
No...well, yes, sometimes the client asks you to just 'think out of the box'. Often there isn't even a definite domain. So I tell them that I do actually *need* a domain to start creating a frame of reference, the context, to be able to give value to my new ideas. Using ViP is completely different from 'out of the box thinking'. That kind of openness may feel comfortable, and people often experience pleasure thinking that way, but there is the considerable risk that any results won't be relevant due to lack of context. That is why doing it is so much fun: you are

not required to connect with any frame of reference. It's like free floating…

For most clients, ViP must have been unusual and scary the first time. Can you say a few final words about their comments at the end of the process? Were they generally pleasantly surprised, frustrated, impatient, interested…do many clients come back, or do you never see them again after they get the "ViP treatment"? You can be honest…

I will be honest. Afterwards they are really happy! The fun in executing the ViP process is after it is completed. The beauty of the relationship between every design step is revealed, the desired effect for the end-user can be anticipated, and the proposal can be valued for its originality. Of course during the process the client often thinks, "What we are aiming for is too difficult; what we are going to create is too complex." I always tell them that I have to create complexity before revealing structure. Otherwise it is impossible to come up with something original. Creating originality is doing, and not being understood immediately. In following the process, even the designer does not know exactly what the end result will be. We have to believe in ourselves. While following the process everything becomes clear, you just don't know exactly when. But it does.

And this is completely different from a traditional design process, where the designer is constantly addressing his superiority with his design knowledge (knowledge about manufacturing, materials, etc.). To do research at the context level, and create a new, insightful structure takes a lot of time at the beginning; we have to make that "fuzzy front end" less fuzzy! But by building a *complete* vision, the execution of subsequent design steps can be executed far more effectively; the rest of the process takes less time and money than traditional design processes. Developing a lot of alternative concepts is not required; we know what to accomplish for the end-user in detail. Using ViP is not more expensive for the client (we even think it can be cheaper), but the client has to accept that the allocation of funds in relation to the different design steps is shifted towards the front, or beginning, of the process.

Once they realise this, and most do, they start to appreciate the process and see its value. And that means repeat the business!

Essay
On designing a context

"The context is that part of the world which puts demands on this form; anything in the world that makes demands of the form is context." Alexander (1964, p. 19).

On August 13, 2001, Dutch television showed a documentary in which a young Dutch filmmaker, Maarten van Soest, visited Robert Opron, the French automotive designer of the Citroen GS, CX, SM, and the Renault 5 and Renault Alpine, among other models. Together with Opron, he wanted to design the ideal car.

They started by drawing up a list of parameters the car should satisfy. These parameters were the desired qualitative characteristics of the new car itself, or of interaction with the car. For instance, they decided the ideal car should be playful and obedient, that it should make physical demands on the driver, and be moody like an actress; the driver could become attached to it, like one is attached to one's loved ones. It is not hard to see that these parameters would lead to the design of a car that would be completely different from what we are used to. It is, however, harder to see where these parameters came from. In other words, why did Maarten and Robert choose these parameters as characteristics of the ideal car?

The answer to this question can be found in the general worldview of these two people, and in their particular notions of what is important in the domain of car design. Since these notions and views were not made explicit in the documentary, we can only speculate about them. For example, they may have had the impression that artefacts had become increasingly explicit, leaving less room for personal interpretation. In addition, they seem to have had the view that society had become more and more cultivated, yet increasingly interested in convenience. Finally, perhaps they were of the opinion that the traditional dominant position of men in society was gradually disappearing. Based on these (presumed) views, Maarten and Robert may have concluded that men could no longer behave as they would have liked to – as wanton seducers, for example – and would try to compensate for this by aggressively rejecting authority and regressing into childlike or playful behaviour. Cars were thus seen as a means of revitalizing masculinity. For that reason, they wanted their car to be playful and obedient, physically demanding, and moody like an actress.

Speculative as the above inferences may be, designers actually do hold these kinds of views and opinions on the world they live in. They may be internal, from the designer's own experiences, or external, brought to them by opinion leaders, media, marketers, or friends. They may be very strong, or weak and fluid; they may be at the forefront of the designer's mind, or hidden deep in the unconscious. Either way, whether designers are aware of these views or not, they frame and give direction to their designerly decision-making process. These kinds of views and opinions together form a framework or foundation upon which a design is based (Gijsbers & Hekkert, 1996). Ultimately, any design decision or solution is based on (aspects of) this framework. This framework we call the *context*, and it is our conviction that any design process should start with actively building this framework, thereby making any assumptions underlying a final design as explicit as possible.

If we consider only the above considerations, we might define context as *any views or opinions a designer considers, implicitly or explicitly, for a design*. Yet building the context is a consciously deliberate act in ViP. The development of a context is actually the crucial first stage of the ViP design process, and thus a more appropriate definition of context here would be *the complete set of starting points – and their mutual relationships – selected by the designer for a given design task*. This "set" could contain notions or measurements of the (physical) surroundings, and any meanings users may attach to various properties, but it could also be comprised of any idea, observation, belief, or even obsession the designer holds and regards as appropriate for the project. From this perspective, anything can be a starting point, or what we term a *context factor* (see below), from trends in individual or group behaviour to social or cultural developments; from principles about human needs, human functioning or thinking, to laws of nature. The important thing is that the designer considers the context factor as relevant or potentially interesting.

Context within ViP is thus not constructed on given conditions, nor is it something that can be objectively defined and described, but it is rather a deliberate, conscious construction of the designer (or the design team).[1]

The context consists of all kinds of factors that affect the way people (might) perceive, use, experience, respond and relate to products. It describes the *nature* of the human-product interaction. Context factors are conditions or patterns in the world *as observed by the designer*. They can be classified in three different ways: types, fields or levels.

Distinctions between the four main *types* are mainly based on a dimension of stability in observed societal/behavioural fluctuations. A factor can be stable and (more or less) fixed, which we call a *state* or a *principle*; or it can be in flux during the moment of observation, in which case it is called either a *development* or *trend*. A further explanation of the four types can be found below.

Context factors can also be drawn from various *fields*, such as biology, economics, politics, ecology, sociology, etc. Perhaps the most important field for designing is that of psychology, together with its subfields: developmental psychology, social psychology, cultural psychology, evolutionary psychology, perception and psychophysics, etc. Here you will find fruitful insights into people's abilities and limitations, and the concerns and types of behaviour that are so decisive for human-product interaction.

A field deserving particular attention is that of technology. Although technological innovations drive a significant amount of today's new product development (and could easily be incorporated into any context), we like to see technology as a means to actually achieving a designed interaction, rather than as a factor determining the way that interaction takes place.

Factors can also belong to a very specific *level*. They can be either directly related to the problem domain (the "micro" level: e.g., people anticipate the driving behaviour of fellow road users); or very abstract and further away from the domain (the "macro" level: e.g., people want to survive). To fully understand this, we should take a closer look at the concept of *domain* itself.

The domain is the focus area the designer is dealing with. Domains can be anything from 'communication' to 'mobile services', from 'public space' to 'crowd behaviour', from 'finding the way in a hospital' to 'the car of the future'.[2] In industrial design, often the domain is defined by the design brief or assignment. Imagine a company that wishes to launch a new office chair. In this case, it has obviously been predefined that the final design is a chair to be used in the office. This predefinition will determine the domain and consequently the type of factors you consider relevant for the context.

Now, suppose the same company wants a new line of office products. Here the domain is more openly defined – the result could be a chair, but also a desk, a closet, a trolley, etc. – and the corresponding context is potentially more varied. By discussing this brief with the company, you

may discover that they are not really concerned with offices, but more with 'work' in general. If the discussion leads to a redefinition of the brief in terms of "a new line of products supporting work", the domain is even more widely defined.

Let us now go back to the kind of factors called *types* above. When looking at all the factors surrounding and (possibly) influencing a user-product relationship today, most of these factors will be similar to what they were yesterday (in the past couple of years) and will probably not change very much tomorrow (for the next couple of years). A *state* is our term for a surrounding world condition that will probably not change in the near future, but does not have to be necessarily fixed. States are (or appear to be) relatively stable at the moment of observation. Think of your country's or city's education or taxation infrastructure, the means of transport available, the number of children born each year, or the laws and regulations to obey. In a couple of years, there could be a new means of transport, or a law may have been abandoned or modified, but generally these conditions go relatively unchanged from year to year.

There are also factors that are, by their unvarying nature, constant over longer (and longer) periods of time. These factors we call *principles*. The term refers to immutable laws or general patterns that can be found in human beings or nature. For example: "our capacity to process information seems to be limited to approximately seven chunks" (Miller, 1956), "we generally prefer colours in the order blue, green or red, and yellow" (McManus, Jones & Cottrell, 1981), and "'memes' can, by analogy with genes, be conceived of as units of information transmission in the field of cultural evolution" (Dawkins, 1976).

When a factor concerns a phenomenon that is currently changing, or one that is expected to change in the near future, it is called a *development*. A development can be in the field of technology (e.g., the arrival of Bluetooth), society (e.g., the increasing number of double-income families), economics (e.g., rising interest rates), or demographics (e.g., the continuing increase in the aging population).

A special class of developments is constituted by factors concerning tendencies in the behaviour, values, or preferences of (groups of) people. Such developments we often specify as *trends*. For example, among teenagers, it is currently a trend to send hundreds of text messages per week; in many households it is 'trendy' not to cook at all or, conversely, to prepare immense, five course meals.

Developments are the kind of factors that are often taken to account in "scenario building" (Schwartz, 1991, Van der Heijden, 1996). For a fixed point in time in the future, one tries to predict into what kind of context such a set of factors will lead. To this end, factors are typically grouped into *dimensions*, indicating future directions or driving forces. Combinations of dimensions make up *quadrants* (or *octants*) that describe possible future situations or "scenarios". These scenarios make it possible for decision-makers to take appropriate action well before the envisioned situation actually takes place. Despite the similarities between the "scenario building method" and the use of context in ViP, scenario approaches are fundamentally different in that they are based on (the most) likely futures. By contrast, through ViP we aim to build interesting futures to design for. What makes a context 'interesting' will be explained in the paragraphs below.

A massive number of any of the above types of factors may, theoretically, affect the nature of a user-product relationship. When the domain is quite broad, say, 'the airport in ten years', it is easy to generate hundreds of factors that are all perceived as relevant to what an airport will or should be. Moreover, these factors are interrelated, making the context a complex web of interdependent factors. Ideally, a designer would like to map all possible factors and their interrelations. Since this is an impossible task, the context – as a starting point for the design process – is always a construction of the designer. To this end, the designer must take a number of decisions.

A designer first must assess what factors are relevant to the product that is going to be designed. This decision or task depends to a large extent on the definition (or framing) of the design problem (Schön, 1983). Gielen, Hekkert, and Van Ooy (1998) have shown that a restructuring of the traditional way problems are formulated in the design of toys for disabled children forced the designer to consider types of information, i.e., context factors, that had not been considered before. The way a design problem is framed or structured determines the domain in which the factors could or should have an impact. A domain defines the boundaries of the 'space' in which the designer looks for a new 'solution'. A domain that is related to the assignment 'design a waking device' differs considerably from one based on 'design an emotionally intelligent alarm clock for 20XX'.

Setting the design goal for today, tomorrow, the near or distant future has a heavy impact on the factors to be selected. The further ahead the

goal is set, the greater the uncertainty regarding the factors that may or should affect the domain. Today's developments or trends may take completely different directions tomorrow; the future is inherently unpredictable. As a rule of thumb, it may therefore be recommended to rely more on stable factors, i.e., states and/or principles, when the goal is set further into the future.

Once the domain is set, the designer is restricted to a surveyable selection of factors that is considered relevant to that domain. In the case of the alarm clock example above, a designer might select developments in the field of affective computing and/or trends related to sleeping.

However, a designer could also select factors that, at first sight, may not seem to be relevant to the domain. This may be simply because a certain principle is regarded as interesting in and of itself, or because there is a desire for a particular trend to have an impact on the design. The designer of the alarm clock could incorporate a principle about the function of dreams, or even consider the trend that people are eating at regular hours less and less often. It has been demonstrated that such a 'strategy', i.e., selecting context factors that are not obviously related the problem domain, contributes to the originality of the solution to a design task (Snoek, Christiaans & Hekkert, 1999). Related to relevancy is the issue of validity.

Whether a development, trend or principle, factors can differ to the degree that they are 'objectively' measurable or quantifiable. Some factors may be based on solid numbers (e.g., the number of single households is increasing by 2% each year) other factors draw more on the designer's personal interpretations of events (e.g., there is a general movement towards a refusal to live a hurried life). In addition, principles, although assumed to be universally valid, may be based on assumptions, (e.g., the meme-concept), or personal beliefs (e.g., after death we reincarnate). In sum, factors can be generally agreed upon, or based on indisputable facts, others can be much more idiosyncratic or speculative. Whether the context is constructed of predictable and generally acceptable factors, or by less well founded but desirable factors, is to be decided by the designer. Opting for safe factors has the advantage of creating a context containing likely and defendable elements; selecting less obvious and more personal factors increases the likelihood of coming up with a fresh, new and authentic perspective. In our view, the important thing is that the designer is *aware* of where he positions himself on this 'certainty' scale.

Along with the selection of factors, a designer further shapes the context by assessing a hierarchy among the factors. In other words, a designer can indicate the expectation or desire that some factors should have a higher impact on the domain, whereas other factors are regarded as less important. Both the selection and valuation of factors have a substantial impact on the final design, and it is the designer's *responsibility* to make these choices. On the basis of the selected factors, their importance, and their interrelations, the designer must build as complete and coherent as possible a picture of the context of the user-product relationship that he is going to design.

Finally, it can make a big difference how you (as the designer) see or define a factor, whether as a state, principle, development or trend. If you start off with a universal principle, you can ask yourself how it manifests itself in your target society today, and how it may change in the near future. For example, if you intend to include the principle that 'people want to attain as many goals as possible', this could also be formulated as a development, i.e., 'as a result of the wealth of possibilities in today's Western societies, many people live a hectic life'. If, for some reason, you have to (or want to) consider trends in people's concerns or behaviour in your context, try to determine where these concerns or behaviours stem from: what are the underlying principles? Understanding trends in terms of the underlying principle may crucially affect the impact you foresee. A trend like 'Westerners buy expensive clothes and equipment for their kids' may reflect principles such as 'parents want the best for their kids' and 'people feel guilty, and try to compensate if they cannot do what they believe they should'. To sum up, always try to make sure you consider which (interpretation of the) factor is most relevant and appealing to the domain at hand.

Adapted and modified from Hekkert & van Dijk (2001)

1 Although ViP has been mostly developed for (and this book is directed towards) individual designers, of course we acknowledge that much – if not most – design work nowadays is conducted in teams. This has profound consequences for the execution of the ViP process. At the context level, for example, it is not only about what *you* consider a relevant and interesting starting point to include, but what *you as a team* consider worthy of inclusion. This requires discussion, argumentation, acceptance, and other social interactions.

2 These domain examples have been randomly drawn from master graduation projects following the ViP approach, carried out over the last ten years at our school of IDE, Delft University of Technology.

>In relation to ourselves, we can say that a product has certain sensory properties and functional and behavioural options.

In relation to us, to human beings in general, a product derives meaning<

Essay
On understanding interaction

Perceived in isolation, a product has physical properties, i.e. size, material, texture, (digital) technology, colour, sound, smell, etc. It is produced a certain way, and it has a price. The same holds true for human beings. Defined independently from their surroundings, a human being is 'just' an organism with physical properties, hosting a number of organs, including a brain, and sensory and motor systems delimiting our mental and motor capacities. In being human, we have a limited set of instincts and basic concerns like survival, or reproduction.

Yet in relation to a particular environment, all these capacities and systems take shape and are shaped. Our capacities become skills, expertise, taste and sensitivity, our basic concerns turn into goals, motives, needs, and intentions, and our behaviour reflects a certain personality or temperament. These human aspects can only be defined in relation to an external world. We are skilled in some area, we have sensitivity and taste for something, a temperament towards others, and our goals and intentions are directed towards someone or something. These human attributes only have value in relation to the external world.

Analogously, products can be said to have certain 'secondary properties' that can only be defined relative to human beings. In relation to ourselves, we can say that a product has certain sensory properties and functional and behavioural options. Only in relation to ourselves, can we say that a product is warm or red, loud or flexible, a communication device or a mobility aid, made for sitting or graspable. In relation to us, to human beings in general, a product derives meaning.

When we start to interact with products, this meaning is articulated further. The product is not only rough, but it may to become stubborn or independent; the product may be perceived as 'easy to use' or very sensitive; the product is said to be friendly, feminine, old-fashioned, cool, proud, or smart. These figurative meanings give the product its expression, character or personality. They take shape through interaction with the product, and may change from interaction to interaction and from person to person. For that reason, we can no longer say that these meanings are product 'properties'.

Furthermore, the meaning a product obtains depends on the context or situation in which the interaction takes place. A car is mostly a means

HUMAN			PRODUCT	
Motor System Sensory Systems Cognitive Sysem Instincts	Motor Skills Sensitivity Cognitive Skills Concerns	◄ INTERACTION ►	Sensory Properties Possibilities for behaviour Functionality	Structural Properties Materials Composition Technology Labels

CONTEXT

Model of human-product interaction (adopted from Hekkert & Schifferstein, 2008)

of transportation; in certain situations it can be something to flaunt, it may provide the driver with a stimulating driving experience, it could be the location for secret pleasures, and every once in a while it is something to lean against. Any interaction results from the interplay between a person, the product and the situation in which the two 'decide' to be involved with one another.

To be able to speak of interaction, physical use, or object manipulation (such as playing with it) is not conditional (Desmet & Hekkert, 2007). Orientation to, or involvement with the product is the key. We can passively look at a product, think of it, anticipate using it, talk or hear about it, dream of it, remember or long for it. In all these cases, products have meaning for the person involved with the product, and thus, we can speak of human-product interaction.

From the moment the interaction begins, the person concerned experiences the interaction. His senses and sensitivity form an aesthetic impression of the object's sensory characteristics resulting in pleasure or displeasure; the product's functioning can be understood properly, and denotative or connotative meanings are assigned to the product, loaded with positive or negative affect; the appropriated meaning of the product can be considered as contributing to or conflicting with our intentions or concerns, leading to a set of (often mixed) emotions, each with their own valence (Hekkert, 2006). This product experience springs not only from the interaction itself, but subsequently guides, shapes, and re-orients it. It is therefore fair to say that interaction and experience are fully intermingled, but only the latter takes place 'in the mind (or nervous system) of the beholder'.[1]

Imagine two people passing on the street who recognise each other. He is happy to see her; he smiles, shouts, and makes an effort to pause for a minute while clumsily holding his overloaded bike. She is in a hurry; she wants to finish off their meeting with a simple "hello" and continue on her way to an appointment. Upon seeing him struggle, she realises she cannot comfortably avoid a longer, more drawn out conversation. She stops, reluctantly, giving an onward gesture to signal that the conversation will be very limited. Her answers to his needy questions are short and informative, without sharing much.

To a witness, their interaction says a lot about their relationship. It is not equal, but unbalanced. There is intimacy, but the intimacy is slippery. Because of the inequality of their interest, the relationship is tense and

Playful exploration

could even be called painful. All these characteristics (unequal, slippery, intimate, tense, painful) express what he brings to the situation and, simultaneously, what she brings to the situation. Their skills, needs, and intentions are communicated via the interaction. Their words would also characterise how both respond to the situation, how they experience meeting each other. Two colourless people passing in the street take on meaning during this short scene. You may think of these people afterwards, feel pity for him, and maybe also for her. After all, she had to put up with a guy she was obviously not very impressed with.

Do the verbal characteristics of the interaction adequately describe all the nuances of the relationship at that moment? Probably not. Language is the most important means for communication, yet it has limitations. We are not used to describing interactions and relationships. We can easily describe what takes place, the action, but describing the quality of the action, the character of the relationship, is much more difficult and something we are not trained to do. What's more, we probably see many more qualities than language allows us to describe.

What would people mean if they said, "the interaction is characterized by 'outdoorsiness' or 'pinkness'"? As Pinker (2007, p. 297) puts it, the terms are "coined at the drop of a hat and understood almost effortlessly". Writers and poets may help us out here: "Even when our heart leaps with joy over the successful match between an adjective and a noun which were never perceived together, we are not taken by surprise by the elegance of this event, the liveliness of the spirit, or the technical skill of the poet, but we admire the new reality that came to light."(Cesare Pavese, b.1908-d.1950).

Playful exploration, restricted resonance, shocking devotion, these are some of the matches Pavese is referring to. They indeed express a lot and bring about a (new) reality. Take for instance 'playful exploration'. By characterizing an interaction in this way, we are saying much more than just exploration. The exploration is not careful, or elegant, or hurried, or uncertain, but playful; like two children trying out the affordances of cardboard boxes, and through fantasy and imagination discovering that those boxes can be transformed into cars.

By describing, or better still, conceptualizing an interaction, we simultaneously define what the product offers, and how. This is why a notion of the interaction is the crucial intermediary stage between your statement, or goal, and the final design. The 'what' and the 'how' should be fully

integrated, and strengthen each other's purpose.[2] Only if the two, the what and the how, serve the same purpose, can a unifying experience of the product be realized: you immediately see and feel what interaction the object affords; why it brings you what it does, and how.

The importance and value of describing such interaction qualities has also been recognized by scholars working in the field of Human Computer Interaction (e.g. Löwgren & Stolterman, 2004; Landin, 2009). As an illustration, Löwgren (2006, p. 64) talks about our interaction with Google Earth in terms of "pliability". "As such, it is relational – pliability is not a property of the artifact itself, nor is it a psychological or physiological property of the user. Pliability appears in use." Similarly, Landin (2009) discusses a series of "expressions of interaction", such as alienation, indifference, dependence, trust, and confusion, in relation to ticket machines, ATMs, mobile phones, airline services, and the Nintendo Wii game console, respectively.

The qualities of an interaction are not merely subjective experiences of the person interacting, nor just qualities of the product interacted with; they are qualities of the relationship, "*qualities of organism-environment interactions.* […] They are qualities in the world as much as they are in us. They involve both the structure of the organism and the structure of the environments inextricably woven together, and even attuned to one another. Moreover, they are qualities experienced and shared by other people, who have bodies like ours and who inhabit the same kinds of physical environments that we do." (Johnson, 2007). We could not have expressed it better.[3]

If it becomes problematic describing interaction qualities directly, it can be very useful to think of a metaphor or an analogous interaction to clarify the intended interaction. For a photocopier project (Hekkert, Mostert, & Stompf, 2003; cf. student case study, p. 29), the designer characterized the intended interaction using descriptors like "resonance", "togetherness", and "fascination", characterisations that could be summarised in the metaphor of "a dance". The resulting copier should be inviting, entertaining, seductive, and somewhat unpredictable. For example, the machine has an arm in which the scan unit is placed. If the user moves the arm too quickly or abruptly, the arm will give a little resistance, like a dance partner would.

Although the linguistic description of an interaction is often the first point of entry into this new reality, and can be very effective, various other ways have also been explored, ranging from sketches or collages to (notations of) movements characterizing the interaction (Kloosler & Overbeeke, 2005). The latter have developed a "choreography of

interaction" that supports designers during physical exploration and expression of interaction modes.

As the intermediary between the context and product levels, the validity of an interaction (vision) should be tested in relation to both. With respect to the context, the interaction must be an appropriate means to realising the goal, as laid forth in the statement. With respect to concept formation, the main requirement is that the interaction as stated can be effectively translated into product characteristics. For this, the interaction has to be sufficiently specific, enabling the designer to define what the product must express, should do, and must look like. Finally, the intended interaction is not only a necessary design stage, funnelling the transformation from context to product; it is also a powerful means of communication once the design has been realised. The interaction describes the way the design relates to (will relate to) people and this relatedness emphasizes the value the product will have for people. So, the same interaction qualities and metaphors used to define the product can be neatly used to communicate the value of the product in commercials and advertisements.

1 Although meaning arises in and from interactions, we often tend to ascribe meaning to the object, as if it is a property of the object (see essay "On meaning"). Meaning is as much a result of the interaction – and part of the experience – as aesthetic responses and emotions are.
2 In ViP, this purpose is your goal (statement), which is based on your context analysis.
3 Johnson (2007) and many others (e.g., Gibbs, 2006a; Lakoff & Johnson, 1980) have shown how such bodily interactions with our environment not only shape our current experience, but also are at the basis of our (future) conceptual understanding. That's why we immediately grasp verbal expressions such as "you have to *get over* your grief" or "he *hungers* for adventure" (examples from Gibbs, 2006b).

Ways to visualise qualities of interaction by Sietske Klooster (above) and Rick Porcelijn (below)

Essay
On product meaning

At the most basic level, we can describe a product as it 'is': a material form with components, colour, shape, and other quantifiable characteristics. As such, "it would be no more than a 'piece of junk' lying around" (Verbeek and Kockelkoren, 1998, p. 36). Any product, and in fact any 'being' in the world, such as an artefact, animal, plant, or human, is what it is only in relation to people (Heidegger, 1997). Thus, a 'product' only becomes a functional and meaningful product when it is seen, used, interpreted, or possessed by people.

Strictly speaking, we cannot say x product is *strong*, *simple* or *authentic*. A product does not have meaning, it acquires meaning. Nevertheless, some qualities are, for various reasons, more easily or univocally attached to products than others. To say that the Egg chair is *warm*, *inviting* and *comfortable* would lead to few disputes; many of us would agree that the material, colour, interactive (rotational) and spatial (enclosing the body) properties of this chair permit those qualifications. In fact, we agree to such an extent that the qualities appear as actual properties of the artefact. In such cases, we often talk of qualities as 'attributes' or '(secondary) properties' of something. Strictly speaking, they are not.

This line of thinking does not only hold for the so-called 'figurative' qualities such as *warm* and *simple*. When we speak of a product's functionality, we are also dealing with meaning and functions that can (to varying degrees) appear as properties of the thing. Since functions are often so clearly and unambiguously embodied in products – a plane is designed for flying, a lamp to light up a room, a book for reading and a pen for writing – functions are regarded as (again secondary) product properties. Yet observe the example from Dunne and Raby (2001). What would the functional meaning of that object be?[1]

Products have these functions for humans because we have (or are assumed to have) certain intentions and concerns, and a range of physical and mental abilities. But what is the function of a pen for someone who has lost his hands? Is it still a 'tool for writing'?

Addressing the subject of product qualities (in our description of the complete ViP process), we propose a simple but convenient distinction between 'product character' and 'action-related meaning'.

Object from the Placebo project by Dunne & Raby, 2001

With product character, we are referring to the symbolic, expressive or figurative qualities we assign to humans and objects, or to practically any phenomenon in life. People can be *friendly, flexible* and *stubborn*, and so can a physical product. But services can also be flexible, as much as the weather or a mountain can be friendly (when you have to climb it on your bike). These qualities do not say much about what the 'object' can do or how it must be used, but more what it expresses and communicates, how it acts, or how it responds to you.

People and products can also (seem to) express meanings that indicate how to use or operate them. When someone holds out a hand, most will understand that a handshake is being offered. Analogously, products offer – or as we will see below, "afford" – various actions and operations.

Take the hammer. The handle is shaped in such a way that it perfectly affords grasping and holding it. Since the head is much heavier, the hammer affords swinging and hitting, preferably a nail. *Graspable, swingable* and *hittable* are said to be qualities embodied in a hammer. Product character and action-related meaning are together coined and captured by the concept of (product) semantics, the study of the symbolic qualities of a product's formal properties (e.g., Krippendorff & Butter, 1984; Krippendorff, 2006; Vihma, 1997). Both character and meaning must be embodied in the design to enable or allow for the interaction as it was defined.

Before considering the product character more closely, let us take a second look at "meanings-for-action". In 1979, perception psychologist James Gibson launched the concept of "affordance". An affordance (derived from the verb 'to afford') is a specific combination of invariant properties in an environment *relative to* an organism. We perceive things, Gibson argues, in terms of what they afford to us; a knife affords cutting or scraping, a chair affords a seat, or if we want to screw a bulb into our ceiling light, it affords us a place to stand. That same ceiling however will not afford us a place to walk, whereas it does to a fly. An affordance is a (secondary) property of a product, because the meaning it carries only takes shape in relation to an organism with particular bodily characteristics and abilities.

Norman (1988) adapted this concept of affordance and introduced it to the design field. To Norman, affordances refer to all properties of a thing that determine how the thing could possibly be used, whether learned or not. For Norman, buttons afford pushing, handles afford pulling, and track wheels afford turning. To account for the fact that actual usage is often

unpredictable and depends very much on the situation in which the interaction takes place, others (cf. Boess & Kanis, 2008) have proposed the term "usecue" as an alternative to affordance: "A usecue is any characteristic that people *use* (not *might use*) to attribute functional meaning to a product" (p. 322). If a user fails to see that a particular switch could (and should) be turned, the switch may have afforded the action, but it unfortunately did not have the 'turning' usecue for that user. Usecues allow you to anticipate intended interactions, but they do not prescribe or predict interaction. Actual usage will show if the usecue 'works'.

Products are more than functional machines. They have a character (Janlert & Stolterman, 1997) or personality (Govers, 2004) and communicate a range of emotional, social and cultural messages. They can do this through:

- functionality, e.g., the service provided by a regular airline can be perceived as more *supportive* and *inviting* than the services offered by a low-cost carrier;

- form, e.g., an elongated object, rising upward, is perceived as more *dominant* and *proud* (cf. Van Rompay et al., 2005);

- colour, e.g., while a bluish yellow tends to look *cold*, a reddish yellow seems *warm* (cf. Arnheim, 1974);

- material, e.g., metal is perceived as more *elegant* and less *toy-like* than plastics (Karana & et al., 2009);

- sound, e.g., a high-pitched and rough epilator sound is perceived as *conspicuous* and *alarming,* whereas the low-pitched droning sound of a ventilator is perceived as *inconspicuous* and *soothing* (Özcan, 2008); and

● movement or behaviour, e.g., a door that automatically opens rapidly, with no pause, is seen as most *approachable* (Ju & Takayama, 2009; see also Desmet et al., 2008).

Again, we may talk about the expressive characteristics listed above as attributes of something. In all cases, they arise from an interaction between a product – and its offerings – and a human being, with knowledge and experience, projecting the meaning.

These figurative qualities are attributed to things by means of empathy, metaphors, learned conventions, or "embodied projection" (cf. Van Rompay, 2008, for an overview). The latter process refers to theorizing in the field of cognitive science about the role of our body in understanding our world, and the concepts we have invented to describe our interaction with it. Warm temperatures are more pleasant than cold ones, and so we see *a warm person* (or thing) as more *inviting* and *open*. If things get uncomfortably hot we tend to sense tension, as in *a heated debate*. Similarly, when someone is *down*, the expression refers to being emotionally *low*, and we are mentally *unstable* when we are psychologically *out of balance*. As many scholars in cognitive linguistics and embodied cognition have shown (e.g. Johnson, 2007; Lakoff & Johnson, 1980; Pinker, 2007), these spatial-relational references rooted in bodily experience are omnipresent in our daily language and concept formation. As we have shown, they also allow us to explain and design the expressive character of objects (Van Rompay et al., 2005).

Designers design meanings, and meanings can be designed. Yet since the attribution of meaning is ultimately an act of a person interacting with the product, we can never be sure that the designed meaning is perceived as intended. People may perceive and interpret things in surprising ways, and overlook things you – as a designer – never would have thought could be overlooked.

Consequently, if the meaning is not captured as intended, it is unlikely that the envisioned and desired interaction will take place. As Wright, McCarthy and Meekison (2003, p. 52) argue in a similar vein, "…experience is as much a product of what the user brings to the situation as it is about the artefacts that participate in the experience. What this position implies is that we cannot design an experience. But with a sensitive and skilled

way of understanding our users, we can design *for* experience." Similarly, we can design *for* interaction and design *for* meaning.

1 The object is an 'electro-draught excluder' from the Placebo project, "an experiment in taking conceptual design beyond the gallery into everyday life. We devised and made eight prototype objects to investigate people's attitudes to and experiences of electromagnetic fields in the home [...]. The objects are designed to elicit stories about the secret life of electronic objects -- both factual and imagined. They are purposely diagrammatic and vaguely familiar." (Dunne & Raby, 2001).

Student case studies

Over the years, we have trained numerous students in the ViP approach during 1- or 2-day workshops, in our courses, and for senior/graduation projects. Following you will find a somewhat random selection of projects that were conceived by 10 students from our ViP elective course, where students work from context to concept in 7 weeks.

The main aim of the course is to familiarise students with the ViP process; the quality of the final concept as such is not of prime importance. Each year, an external partner selects a domain for the students. These domains are mostly set in the near future (with a maximum of 5 years ahead).
The interesting thing about designing for the short term is that it shows that the present day is not a restriction for the invention of original ideas. Due to the limited time the students have for the course, they cannot strive for completeness in their context. Rather, they need to find a few starting points/factors that are deemed inspiring to work from. Students are free in the way they build and present their context: some just present a few factors and follow up with a statement; others immediately present a structure without making clear what the underlying factors are.

The projects are presented here to demonstrate the (causal) transitions between the various stages of the ViP process. The main design decisions made during each stage have been summarised.

Mark van der Woning

IJburg street furniture, 2002

→ Venturi Tunnel

1 Background and domain
IJburg is a young and growing district of Amsterdam. It is situated on the Eastern side of the city, and built on a group of artificial islands. The local government wanted to develop its own range of *street furniture* to emphasize the unique character of IJburg.

2 3 Context
The context is built around three main factors/clusters:

Information overflow
Everyday life is busy. Technology makes it possible for us to work harder than ever. We are on show and need to handle a lot of information.

Awareness
We feel stress travelling from one place to the other, while time to relax, stand still, and think things over is becoming scarce.

(Lack of) social exchange
Everything in the neighbourhood is planned. People are numbers living in their houses, in streets that are perfectly arranged in geometrical order. Nobody knows his or her neighbours; everyone just waves and says hello.

4 Statement
I want people to submit to something unexpected, something that makes them talk to each other again.

5 Interaction
The interaction is expressed by an analogy. It is 'like a small object that was not supposed to be removed when the room was cleaned, but was suddenly sucked into the mouth of a vacuum cleaner. It is a force that starts working on an object from a distance. A force that is, in the end, irresistible.'

6 Product qualities
The product should be 'unexpected', 'daring' and 'sublime'.

7 Concept
The concept is an artificial hill that grows out of the landscape. A bicycle road splits the hill into two halves, which form a kind of tunnel that only allows a clear view to the sky and to the exit. The unique shape of the tunnel, wide at the entrance and exit, narrow in the centre, forces wind blowing naturally through the tunnel to accelerate at the centre (the Venturi effect). When riding a bike on this bicycle road, you can be suddenly propelled to the end of the tunnel as if pulled by an invisible force. But if the wind comes from the other direction, you may have difficulty overcoming air resistance. It makes you aware of how unpredictable, changeable, and strong nature can be. This ever-changing experience will provide, over time, fodder for conversation with others on the island.

2

Robier Hartgring

IJburg street furniture, 2002

➡ Street lighting

❶ Background and domain
see previous page

❷ ❸ Context
The context was built on three main factors/clusters:

Orientation
For economic reasons, newly developed areas make use of a lot of repetition. However, people need variety to orient themselves. An environment consisting of similar items and shapes is not only boring, but can also be confusing.

Safety
People need to feel safe.

Day and night cycle
An environment is perceived and experienced differently during the day and at night. When it gets dark, details tend to disappear or are absorbed in the darkness.

❹ Statement
I want to enable people to find their way home comfortably and safely.

❺ Interaction
The interaction with the product is characterized by 'reassurance', 'recognition', 'stimulation', 'relief', and 'amazement'.

❻ Product qualities
The product should be 'varied', 'recognisable', and 'balanced'.

❼ Concept
The street lighting concept enhances the recognisability of a street at night and during the day. Each street has a unique pattern, allowing the road user to determine his or her position. Families of patterns could be used to discriminate between city areas or even complete cities. Thanks to the increased recognition the light patterns allow, road users will feel safer. The patterns on the street would be created by different types of reflectors for each street, located in the armature of available street lighting. An element of some square centimetres can lend a distinctive appearance to a surface area 100 times that size.

3

Emilie Tromp

Laundry process
for Proctor & Gamble, 2004

→ Laundry bag (Wastas)

❶ Background and domain
Proctor & Gamble, the large multinational whose products range from personal care and household cleaning to laundry detergents, prescription drugs and disposable nappies, was interested in '*making the laundry task less of a burden*' to improve their competitive advantage. One of the projects from this edition, by Joost Verburg, is more extensively described in the chapter entitled 'The ViP Process'.

❷❸ Context
These are the main factors/clusters taken into account:

Daydreaming
People daydream to escape the reality of life: they may aspire to a more interesting life and wish to escape monotony.

Control
In a world that is becoming ever more complex and chaotic, people are afraid to lose control. As products become more complex and computerized it takes a lot of effort to truly master them.

Anthropomorphism
When objects evoke emotions in a user, that user tends to describe the object as having human characteristics.

Laundry is feminine
Doing the laundry remains attached to values like 'care' and 'femininity'. The fact that men also do the laundry doesn't make it a masculine activity.

Trivialities
The fast-moving, modern lifestyle doesn't allow time for enjoying trivialities. In a world that's all about kicks and thrills, people do not appreciate simple activities.
Doing the laundry is an activity that is not very highly appreciated; it is seen as a nuisance in an age when time is always short. Yet laundry-related activities do have some comforting and soothing aspects that could be exploited: it is a slow and easy task, it is easy to master and provides an opportunity for the mind to wander.

❹ Statement
I want people who do laundry to enjoy themselves while performing a simple task (that would otherwise be a nuisance).

❺ Interaction
The interaction with the product should be characterized by 'intimacy', 'uncomplicatedness' and 'automatism'.

❻ Product qualities
The product should be 'feminine', 'comfortable', 'modest' and 'accessible'.

❼ Concept
The concept is a soft waterproof laundry bag that can be carried on the belly to transport laundry to and from the washing machine to the washing line and can also act as a temporary 'storage'.
When hanging laundry out on the line, the 'Wastas' makes it possible for the user to experience a continuous process, to experience 'flow'. It prevents the constant bending over to get new laundry from a basket.
The Wastas is soft but retains its form and gives the user a warm lower belly where it rests. The shoulder straps are ergonomically shaped so the weight of the laundry is not a burden. The warm embracing Wastas facilitates daydreaming while doing the laundry, making it a more enjoyable activity.

4

Hanneke Jacobs

Laundry process
for Proctor & Gamble, 2004

→ Iron in time

❶ Background and domain
see previous page

❷❸ Context
These are the most important factors/clusters that were considered:

Craving for recognition
People have a strong need for recognition and respect from others.

Me, myself, and I
People are selfish beings that only care for themselves and their own interests.

Fear of confrontation
People are hesitant in approaching others and aren't fond of others approaching them. They want to avoid the risk of getting hurt.

Mama is the boss
Within a family, the mother is and always will be the manager of the household.

Increase of indirect communication
These days, new means of communication are increasing exponentially (e.g. sms, msn, email, etc.). They all enhance indirect communication. The connection between these factors/clusters is presented below. In summary: When you never express your feelings of appreciation for someone and always wait for others to make the first move, in the end they will stop giving you the recognition you desire. When you always wait for others to take the initiative, nothing is going to change.

❹ Statement
I want people to take initiative in openly expressing their appreciation of others.

❺ Interaction
The interaction with the product should be characterized by 'confrontation', 'competition' and 'concentration'.

❻ Product qualities
The product should 'be attention getting, 'raise the bar of the existing task difficulty', and 'be challenging'.

❼ Concept
The concept is an iron with an additional feature: a digital clock on top. The clock indicates the time required to iron a particular item. When finished, the iron prints a little label with the time and name of the user. This label can be pasted onto the ironed item. This iron invites every member of the household to join in the 'ironing competition'. Only when other members give it a try, and get feedback about their performance, do they realise how difficult the task actually is, and start to appreciate the daily tasks of the household manager (typically the mother).

5

Asako Takahashi

Male emancipation
for the Dutch Ministry of Social Affairs, 2004

→ Cupboard 'patroon' (pattern)

❶ Background and domain
The Dutch Ministry of Social Affairs wanted to *'increase the involvement of Dutch men in daily household activities'*, with the goal of making it easier for women to exploit their talents and start working professionally. Wider female participation in the labour market is considered beneficial to the Dutch economy as a whole.

❷❸ Context
Two factors/clusters played a dominant role in this context:

A 'daily rut'
People are engaged in fixed patterns and repetitive actions because of their regularity and predictability.

The beauty of routine
Daily life can be seen as 'a chain of habits', or even as 'a celebration of the known'. A lot of values are embedded in everyday routines.

❹ Statement
I want people, while performing daily household tasks, to appreciate these daily habits for their comfortable predictability.

❺ Interaction
The interaction with the product should be characterized by 'routine-ness', 'obviousness', 'predictability', and 'enlightenment'.

❻ Product qualities
The product form should 'follow daily activities', and 'be structured', 'personalized', and 'recognizable'.

❼ Concept
The concept 'patroon' is a cupboard. 'Patroon' points out that the regularity and the certainties of domestic life are intrinsic qualities that can restore the household to its crucial position in a person's life. The cupboard visualizes patterns in daily life: products that are required daily shape the place they need in space. Habits are made visible and explicit in the design.

Lara van der Veen

Male emancipation
for the Dutch Ministry of Social Affairs, 2004

→ Ordnung muss Sein

① Background and domain
see previous page

② ③ Context
It is no wonder that men do not feel invited to take part in household activities. The woman does most of the jobs and believes she knows best. She has optimised the efficiency and effectiveness of all household tasks. As a result, she has the advantage over anyone else working in the household on occasion. She appears closed to newcomers who may have a different approach. She puts her nose into everything, and always shows how she would do it, and why. Preferably, she would do it all by herself and if she manages to suppress this urge, she finds it hard not to correct the newcomer's job or do it over.

④ Statement
I want to confront women with their persistent attitude of 'knowing better', and promote cooperation in household activities. By making it possible for the woman to show flexibility and humour, the man is provided with an opportunity to participate.

⑤ Interaction
The interaction with the product should be characterized by 'demystification' and 'light-heartedness'.

⑥ Product qualities
The product should be 'self-explanatory', 'reserved', 'simple', 'manageable' and 'generous'.

⑦ Concept
The concept 'ordnung muss sein' consists of a series of textiles, such as towels, bed linen and shirts, with pre-fabricated creases indicating how the items should be folded. The simplicity of the creases and the banality of the instructions make room for a smile, and allow for the freedom of choice between following the instructions, or just ignoring them. After all, they are just lines on textile; nothing more, nothing less.

Karen Zeiner

In-flight experiences for KLM, 2005

➡ The iflyer

❶ Background and domain
To improve their competitive advantage, Dutch airline company KLM was interested in how to 'enhance passengers' in-flight experience' during intercontinental flights.

❷❸ Context
These were the main factors/clusters considered in this project:

Techno society
We live in a society that depends on technology. Society has become more complex, and it is impossible for the uninitiated to understand its technological underpinnings.

Hyper-tasking
People often find themselves talking on the phone while watching television and eating dinner; they are engaged in hyper-tasking. Hyper-tasking is a manic state of mind resulting from a society focused on performance and an increased reliance on technology.

Technological bubble
People often feel the need to isolate themselves from the rest of the world. This need is facilitated by technology that enables people to hide behind a permanent (technological) barrier.

Human complexity
The human mind is complex. Although one wants to be consistent in one's behaviour, it is difficult to act according to a certain pattern.

Spontaneity vs. planning
People are becoming less flexible, and as a result, they feel an increasing need to be spontaneous and carefree. However, the spontaneity is often of a planned nature; people plan to be spontaneous, e.g., "Let's meet at X and just see what happens".

Curiosity
People are inherently curious; as one of humanity's primary instincts, it is a very powerful motivator. Curiosity stimulates people to learn, develop and discover. In-flight experiences deal with an increased reliance on technology, and the desire for freedom and independence while wanting to be in control. Travelling, as such, has become a symbol of freedom in the Western World. However, flying is often experienced as empty time: the trip begins when one arrives at the destination.

❹ Statement
I want passengers to experience a sense of freedom within the limited space of an aircraft, by stimulating mental travel.

❺ Interaction
The interaction with the product should be of a 'dreaming and pensive nature'; it should be characterized by 'gradual evolvement' and 'surrender'.

❻ Product qualities
The product should be 'curiosity evoking', 'thought triggering', 'surprising', 'non-evident', and 'self-manifesting'.

❼ Concept
The iflyer provides insight into the phenomenon of flying, by 'registering' the planes that cross the KLM flight path within a pre-determined radius. The destination of the encountered flight and its direction is displayed on the screen in front of the passenger.
In tandem, the passenger gets a sense of the spaces they are flying over. When the plane passes over a densely populated area the passenger would feel the rush of movement, whereas flying over the Atlantic Ocean would give an impression of vastness. However, even greater would be the passengers' surprise upon encountering another flight with another destination. The iflyer allows the passenger to experience the freedom and possibility of flight while on the way to their destination.

8

Wybrand Boon

In-flight experiences
for KLM, 2005

→ Shared storage space

① Background and domain
See previous page

② ③ Context
The dominant factors/clusters in this project:

Safety
The most important feeling a passenger must experience before even thinking about pleasure or luxury is safety. Not just physical safety: in the crowded environment of an aircraft, a feeling of "social" safety is especially needed.

Overconsumption
Western society can be characterised by consumption. We always strive for more. We have stopped questioning whether we really need the thing we want; our behaviour has become compulsory.

Tension
In airplanes, passengers are forced to share space and spend time with people they did not choose to sit next to. This very often results in an awkward and uncomfortable tension between passengers. Often, unpleasant feelings experienced in the air are the result of the above aspects. The passenger is expected to behave within strict boundaries established by all kinds of rules and regulations. Passengers' freedom is severely restricted, and stress leading to an increase of tension is possible.

④ Statement
I want the passenger to experience as little inconvenience as possible while providing him/her with a social position in the airplane so he/she must fully surrender to the situation.

⑤ Interaction
The interaction with the product should be characterized by 'modesty', 'sincerity', and 'subtlety'.

⑥ Product qualities
The product should be 'loyal' and 'dedicated', 'shareable', but also 'patient' and 'interested'.

⑦ Concept
The concept design widens the personal space allocated to the passenger; it enables the passenger to behave more freely. The storage space in front of the passenger is enlarged and shared by three or four people. Any printed matter supplied should cover a broad range of interests, including various magazines, newspapers, puzzles etc. In a very subtle way, the design would evoke communication between the passengers. It would lead to a modest, social and sincere form of interaction and enable passengers to feel more comfortable. They can surrender themselves to the situation more easily, and may even start to enjoy flying.

9

Jay Yoon

Train Journey Time
for Dutch Railways, 2009

→ Time-Warp

❶ Background and domain
Dutch Railways (NS) makes an ongoing effort to enhance the quality of the train travelling experience. Together we formulated the domain of last year's assignment as *'turning journey time into your own time'*.

❷❸ Context
Three main factors/clusters were taken into account:

People create stories from what they experience
People's perception is subjective; they interpret what they see based on their previous experiences. From their surroundings they connect various elements into coherent stories.

An object reflects the identity of its owner
Products and spaces are used differently based on the propensity of the owner. Some people, for example, personalize their seats by carefully arranging their belongings, whereas others sit down and do nothing.

From practical to personal
People are increasingly willing to engage in purposeless activities to refresh themselves and escape from their work.

❹ Statement
I want to create moments that enable people to reflect on themselves.

❺ Interaction
Two analogies were used to come up with a vision of the interaction:

Encountering an old friend
When a person accidentally encounters a friend in a crowd, he/she becomes focused on meeting the friend, and thinking is shifted abruptly.

Doodling traces
Seemingly meaningless doodles can show personal footprints, but only the person who left the trace is able to interpret them (correctly). From this, the interaction can be characterized as 'ephemeral' (unpredictable and fleeting) and an 'ambiguous exploration'.

❻ Product qualities
The product should be 'camouflaged' and 'whimsical'.

❼ Concept
Time-Warp is a window-integrated display that is designed to provide travellers with moments of self-reflection during travelling. When people look through the train window, they occasionally see movie clips from the same scenery taken in another season. By showing the outside scenery in a different way, the product brings back memories and stimulates people to reflect on their lives.

People see the scenery through windows

recall their memories after or while seeing outside

The moments of reflection

Movie Clips taken at current location

Artificial Display

Normal Window

Novi Rahman

Train Journey Time
for Dutch Railways, 2009

→ Journey Meter

❶ Background and domain
See previous page

❷❸ Context
People are busy with their minds during their journeys. Their thoughts are influenced by external factors that change the traveller's perception of time and place.
In some situations, people's perception is able to shift when there is distance from reality. The perceived time and place can take on a subjective quality, enabling people to experience their journey time more personally.

❹ Statement
I want to enable people to shift their perception of the travelling time by creating distance from reality.

❺ Interaction
The interaction with the product is characterized by the terms 'absorbing', 'direct', 'convincing', and 'release'.

❻ Product qualities
The product should be 'perceptive', 'illusive', 'powerful', and 'authentic'.

❼ Concept
Journey Meter is a mobile application integrated into 'Reisplanner Xtra' (the Dutch Railway travel planning service. The interface enables people to shift their journey time into activity measurements: reading, playing games, listening to music, and sleeping. For example, Journey Meter would convert journey time into the number of songs passengers can enjoy before reaching their destination. With 'Journey Meter', passengers will have a personalized journey experience without having to regularly check their watch or look at the signs when going through a station. They will not need to worry about missing their destination, favourite music or falling asleep.

Reisplanner Xtra — Music

Welkom Antal — 19 maart 16:57

- Music →
- Reading →
- Sleep →
- Games →
- Meter Setting →

OK — Afsluiten

To reach your destination:
23 Songs

Now playing: Norah Jones - Come Away with Me

- Norah Jones - Cold Cold Heart
- Norah Jones - Don't Know Why
- Norah Jones - Feelin' the Same Way
- Norah Jones - I've Got to See You
- Norah Jones - Lonestar
- Norah Jones - Nightingale
- Norah Jones - One Flight Down
- Norah Jones - Painter Song
- Norah Jones - Seven Years
- Norah Jones - Shoot the Moon

Ververs — Terug

To reach your destination:
Last song

Now playing: Maroon 5 - Wake Up call

Ververs — Terug

Reisplanner Xtra — Reading

Welkom Antal — 19 maart 16:57

- Music →
- Reading →
- Sleep →
- Games →
- Meter Setting →

OK — Afsluiten

To reach your destination:
79 Pages

Now reading: Paulo Choelho - The Alchemist

The boy didn't know what a person's "destiny" was. It's what you have always wanted to accomplish. Everyone, when they are young, knows what their destiny is. At that point in their lives, everything is clear and everything is possible. They are not afraid to dream, and to yearn for everything they would like to see happen to them in their lives. But, as time passes, a mysterious force begins to convince them that it will be impossible for them to realize their destiny. And, when you want something, all the universe conspires in helping you to achieve it.

Ververs — Terug

To reach your destination:
Last page

Now reading: Paulo Choelho - The Alchemist

I don't live in either my past or my future. I'm interested only in the present. If you can concentrate always on the present, you'll be a happy man. Life will be a party for you, a grand festival, because life is the moment we're living now.

In his pursuit of the dream, he was being constantly subjected to tests of his persistence and courage. So he could not be hasty, nor impatient. If he pushed forward impulsively, he would fail to see the signs and omens left by God along his path.

Ververs — Terug

Reisplanner Xtra — Games

Welkom Antal — 19 maart 16:57

- Music →
- Reading →
- Game →
- Sleep →
- Meter Setting →

OK — Afsluiten

To reach your destination:
11 Games

Now playing: Tetris

Ververs — Terug

To reach your destination:
Last game

Now playing: Tetris

Ververs — Terug

Reisplanner Xtra — Sleep

Welkom Antal — 19 maart 16:57

- Music →
- Reading →
- Game →
- Sleep →
- Meter Setting →

OK — Afsluiten

To reach your destination:
70% Sleep time

Ververs — Terug

To reach your destination:
3 % Sleep time

Ververs — Terug

>When you start to look at products in terms of the factors underlying their existence, you will also start to feel, and eventually see, new possibilities<

Essay
On adaptation and fitness

Exactly 150 years ago to this year [2009], Darwin (1979) penned his 'On the Origin of Species', a book that profoundly changed existing viewpoints on the descent of man and all living creatures. New species arise from a process of natural selection, Darwin argued, a process that thrives on variation, selection and replication. As a result of random mutations (in genetic make-up, as was discovered later), variations in features continuously appear in a population. Most often, these mutations lead to poorer performance, and the feature disappears as quickly as it came. Every once in a while though, new features turn out to be appropriate for effective functioning in the organism's habitat. Carriers of those features have a higher chance of survival, and the feature is replicated and passed on to the next generation. The feature is said to have increased the 'fitness' of that organism relative to its environment. Through this slow, mostly gradual and 'blind' process of evolution, functionally adaptive features and complete systems develop (such as the eye) that seem perfectly designed to meet the requirements the environment poses. Without a proper understanding of the process, one might be tempted to ascribe these beautiful designs to an intelligent designer, also known as 'the argument from design'.

It is equally tempting to draw an analogy between evolution and the field of design; to envision a not-so-blind designer as the creator of variations that are tested in practice. If the product is successful in the environment – the market – the design is replicated, i.e., more copies are made, and it survives, albeit for the time being. It is also tempting to see designs as adaptations themselves, purpose-built 'machines' that are created to meet all the requirements an external environment imposes. And it is tempting to regard designs, or design features, as 'memes' (Dawkins, 1976): the cultural equivalent of genes, carriers of cultural information that are passed on from one design to another. Darwin's theory of natural selection is one of such memes, and a very successful one. Design literature is full of (metaphorical) references to this evolutionary process (e.g., Basalla, 1988; Petroski, 1992; Steadman, 1979). Whether the analogy strictly holds, or both evolutionary processes are variations of a universal Darwinism, has been subject to much debate (see Hekkert,

1996; Steadman, 1979). Although cultural evolution seems much more directed than natural evolution, the analogy is a powerful one.

In design thinking, probably the most widely adopted evolutionary concepts are the related notions of adaptation and fitness. Just as biological systems are adapted to their environment (through a process of natural selection), so should products/designs fit into their environment. It is the designer's task to establish this adaptation. Christopher Alexander (1964), mostly referring to architectural designs, puts it like this "...every design problem begins with an effort to achieve fitness between two entities: the form in question and its context". Interestingly, Alexander sees both entities as intangible. Naturally, the form is not yet designed and must be conceived by the designer. But the context, "anything in the world which puts demand on this form", is also an intangible construct that cannot be properly defined; "...unfortunately, we cannot give an adequate description of the context we are dealing with." (p. 20).

Alexander sees the form and context together as a kind of mutual 'ensemble': as much as the form must adapt to its context, so must the context adapt to the form. "Understanding...the context and inventing a form to fit are really two aspects of the same process." (p. 21). In discussing misfits, which are much easier to characterize than their opposite, we get an idea of Alexander's notion of context: "[a] kitchen which is hard to clean, no place to park my car, the child playing where it can be run down by someone else's car, rainwater coming in, overcrowding and lack of privacy, the eye-level grill which spits hot fat right into my eye, the gold plastic doorknob which deceives my expectations, and the front door I cannot find, are all misfits between the house and the *lives and habits it is meant to fit*" (author's italics). Conceiving context in this broad manner, it is not easy for a (self-conscious) designer[1] to find a form that clearly fits, "*...because the number of factors which must fall simultaneously into place is so enormous*" (italics in original). It is harmony, a sort of aesthetic aptness, or fitness, between the two intangibles a designer must search for.

Five years after Alexander, Herbert A. Simon published *The Sciences of the Artificial*, a book that explores the same analogy of adaptation and fitness, but now in a broader framework. In the preface to the second edition, Simon (1996) summarizes the main argument of this classic work: "The thesis is that certain phenomena are 'artificial' in a very specific sense: they are as they are only because of a system's being moulded, by goals or purposes, to the environment in which it lives. If natural

phenomena have an air of 'necessity' about them in their subservience to natural law, artificial phenomena have an air of 'contingency' in their malleability by environment" (p. xi). This 'air of contingency' is caused by the fact that artefacts are what they are in order to satisfy our desires; "they are adapted to human goals and purposes" (p. 3). "Fulfilment of purpose or adaptation to a goal", Simon continues, "involves a relation among three terms: the purpose or goal, the character of the artefact, and the environment in which the artefact performs" (p. 5). Crucially, the artefact is the 'interface' between an inner and outer environment, where the inner environment is constituted by the bare formal and organizational properties of the artefact, and the outer environment is the surroundings in which the artefact operates. "If the inner environment is appropriate to the outer environment, or vice versa, the artefact will serve its intended purpose" (Simon, 1996). Whether pertaining to airplanes or birds, his view of artefacts as adaptive interfaces between inner and outer environment applies to all systems, living or man-made.

Although human beings, with their aims, goals and desires, are also part of the outer environment when it concerns the adaptive role of artefacts, human beings themselves are also adaptively behaving systems. "To the extent that they [human beings] are effectively adaptive, their behaviour will reflect characteristics largely of the outer environment (in light of their goals) and will reveal only a few limiting properties of the inner environment – of the physiological machinery that enables a person to think" (Simon, 1996). Human behaviour, or human-environment interaction, is thus seen as the adaptive response of an organism to its environment. Analogously, we can consider the interface in an artefact-environment system to be human-artefact interaction (Gijsbers, 1995). If this interaction is appropriate, the artefact, or inner environment, is adapted to the outer environment; through the interface, the product acquires purpose, or meaning. "The artificial world is centred precisely on this interface between the inner and outer environments; it is concerned with attaining goals by adapting the former to the latter" (Simon, 1996, p. 113). It is a designer's task – whether working in the field of architecture, medicine, law, business, education or (industrial, graphic, fashion) design – to deliberately establish this adaptive interface.

Perhaps the major refutation of a Darwinian analogy for the process of cultural evolution is based on the 'blindness' of natural evolution. "Technological evolution *differs* from biological by virtue of the participation

of the mind of man and his *active intellectual intervention* in the process. Man introduces that intention and purpose which is lacking from the uncontrollable chance nature and 'fatalism' of organic evolution" (Steadman, 1979). Instead of falling back on a Lamarckian version of evolutionary theory[2], Martindale (1986, 1990) proposed an alternative explanation based on the second driver of evolution, hedonic or sexual selection (Darwin, 1871). People, Martindale argues, select cultural artefacts not (only) because of greater fitness, but because one object brings greater pleasure than the other. This applies to works of art, but also to tools such as axes; people selected steel axes because "they accomplish the same ends as stone axes with less effort" (Martindale, 1986, p. 50). Selection in the case of cultural evolution is thus driven by pleasure and – as a result of repetition – boredom or habituation. Martindale suggested various strategies artists and designers can (deliberately) employ to increase pleasure or avoid saturation (see also Hekkert & Leder, 2008). His theoretical model allowed him to describe and predict evolutionary changes in many fields of art and culture.

In conclusion, let us go back to the concept of memes. A visit to the popular video sharing site YouTube this morning [July 2009] reveals that Leonard Cohen's classic song 'Hallelujah' was not only famously copied by the late Jeff Buckley, but also by a range of other artists, including Bon Jovi, Rufus Wainwright, KD Lang, John Cale, Sheryl Crow, Damien Rice and many less famous performers. Listening to each reveals that each interpretation is different, yet the song is unmistakably Cohen's 'Hallelujah'. The product itself is not copied – although some interpreters stay very close to the original – but the 'instructions', here meaning the tune, notes and song structure, are. These instructions form the meme 'Hallelujah', and this successful meme has been passed on from artist to artist.

Itself a meme, the meme concept was introduced in 1976 by Richard Dawkins. By analogy with the role of genes in natural evolution, memes are replicators of cultural information passed on from human to human, both vertically (from mother to son, from teacher to student) and horizontally (as on the internet). Memes can be ideas, tunes, rituals, customs, fashions or ways of building bridges that propagate themselves from brain to brain via a process called imitation (Dawkins, 1976; Blackmore, 1999). Like genes, "memes are also invisible, and are carried by meme vehicles – pictures, books, sayings (in particular languages, oral or

written,[...]) [...]Tools and buildings and other inventions are also meme vehicles" (Dennett, 1995, p. 347/348). Whatever their exact unit, memes do not often work solo: they are strengthened through combinations into so-called 'memeplexes', such as the various religions (see Dennett, 2006), where they are much more powerful and resistant to extinction (Blackmore, 1999). Like a tortuous song that surfaces in the brain unbidden, memes infect us like viruses, and determine much of our thinking and acting. Luckily:

"We have the power to defy the selfish genes of our birth and, if necessary, the selfish memes of our indoctrination...We are built as gene machines and cultured as meme machines, but we have the power to turn against our creators. We, alone on earth, can rebel against the tyranny of the selfish replicators" (Dawkins, 1976, p. 215). Design is a means to exert this power.

1 Alexander (1964) makes a distinction between a designer in an unself-conscious system and one in a self-conscious system, or culture. A designer in the first, 'primitive', culture is no more than an agent who needs to recognize misfits and correct them. In the self-conscious process, "the artist's self-conscious recognition of his individuality has deep effect on the process of form-making" (p. 59).
2 According to Lamarck, the genetic apparatus – the genotype – directly acquires characteristics that result from bodily – phenotypic – adaptations to an environment (e.g. Dennett, 1995). Today we know that a transformation from revised body parts to DNA is impossible, but an analogous process in cultural evolution, from design to instruction, is entirely plausible (Steadman, 1979).

Essay
On creativity

Ultimately, every design process is a problem-solving activity. Although some will argue – as we have in our introduction – that a problem is not needed, there is usually dissatisfaction with a current state, or some more or less vague notion of a possible and desirable future state. The urge to transform that 'poor' state into a 'better' one, a 'richer' one, even a 'good' one, poses the designer with a problem. What design solution can overcome my dissatisfaction, or fulfil my desire?

Whether the impetus is viewed as a problem or not, the designer often considers the initial state of affairs as ill-defined or ill-structured (Simon, 1996). That is, the description of the state and goals are such that there is no heuristic principle at hand that can be simply applied to arrive at a solution. Solving design problems therefore requires an 'effort' that goes beyond straightforward application. This effort involves a variety of intangible processes or phenomena, such as creative thinking, intuition, productive thinking, insight or *Aha-Erlebnis*.

Extensive research on insightful problem solving has taught us a lot about strategies designers should or could employ to increase the likelihood of finding a creative solution. Generally, these studies have tried to identify aspects of creative thinking by varying the character of the problem, varying the information provided, or comparing untrained problem solvers with expert ones.

Creative solutions are inhibited by functional fixedness, or 'fixation' (e.g., Dominowski, 1995; Smith et al., 1993). Problem solvers tend to fixate on the initial, often self-imposed, structure of a problem representation. As a result their solutions are 'blocked', and a generation of original solutions is precluded. For instance, Jansson and Smith (1991) showed that designers who were given an example design before solving a problem often created solutions that conformed to the example. This fixation effect occurred even when the example contained obvious flaws. Similar effects were demonstrated with respect to problem formulation. 'Closed' formulations that present a concept associated with existing, familiar solutions of similar design problems (e.g., 'design a knee protector for a paver') lead to less creative solutions than 'open' formulations (e.g., 'design a device that will ease a paver's knee ache') that avoid familiar concepts

(Goldschmidt et al., 1996). The way a problem is constructed is highly predictive of the quality of the final solution (Mumford et al., 1996a).

The information people research determines the originality of their solutions to ill-defined problems. Not surprisingly, the amount of time spent seeking information increases the probability of finding novel solutions, and people who attend to relevant information and ignore irrelevant information produce more novel outcomes (Mumford et al., 1996b; Perkins, 1995). Creative people, however, also consider inconsistent facts more often, as these facts can lead to alternative and new ideas (Mumford et al., 1996b). Furthermore, information that, on first sight, may be less related to a particular problem domain can positively affect the originality of the solution to a design task. In an experiment with design students, we showed that they came up with more original solutions when contextual information was considered (i.e., information not directly related to the problem at hand) than when only 'traditional' information (i.e., information that is directly and obviously related to the problem domain), was taken into account (Snoek et al., 1999). The study further demonstrated that this effect was mediated by a more original conception of the problem or problem representation.

Creative insights often draw upon the noticing and application of an analogy from a different domain. Studies on analogical problem solving have demonstrated that people can successfully retrieve information from memory to solve analogous problems, and that there is an optimal 'abstraction level' or representation of the problem (a 'schema') for successful analogical thinking (Gick & Holyoak, 1980, 1983). Since experts tend to code problems at a more abstract or structural level, it follows that they have better access to analogies from remote domains (Novick, 1988; Gentner, 1989). Furthermore, analogical learning is "facilitated when people are taught in problem-oriented learning environments, as opposed to being taught facts; ...and when students are encouraged to take many perspectives and to look at objects from different points of view" (Vosniadou & Ortony, 1989).

Design implications

To make the insights drawn from productive problem solving useful to designers, some authors have tried to develop tools based on these findings (cf. e.g., Baxter, 1995; van Gundy, 1988, for an overview).

Examples include 'problem abstraction', a technique used to reduce problems to their most basic elements; the use of clichés and proverbs; and the brainstorm technique "Synectics", in which groups actively search for analogies in other domains. Although these techniques can be helpful to support a designer at specific stages of the design process, two limitations must be noted. First of all, the techniques have been developed in isolation; they are not incorporated into a design methodology. Consequently, the input or output of a particular creativity method is not logically connected to another method. Secondly, these techniques and methods are open-ended. That is, they do not specify a broad direction in which the search for ideas or analogies can take place, and do not provide any criteria to test the appropriateness of a given idea. Creative solutions cannot be judged in isolation. It is generally acknowledged that a creative solution not only has to be novel or unusual, but also appropriate or valuable (e.g., Runco & Charles, 1993). The appropriateness of a given solution can only be assessed in relation to the cultural or social context in which it functions: "the requirement of value in a creative product implies a dependence on existing values, attitudes and knowledge" (McLaughlin, 1993). Techniques that enhance or promote creativity only tell the designer how to search, not where to search, or when the search is over.

The first thing a ('productive') designer should do is break down the structure of the old problem space. The designer should try to get a firm grasp of the kinds of knowledge, conventions and assumptions he or she possesses regarding the problem, and table them for discussion. The designer has to say "no" to conditioned responses (Goswami, 1996). However, breaking down the old structure is not enough; a new frame of reference must be built (e.g., Akin & Akin, 1996). One of the techniques that could be applied in this respect is restating the initial problem in different ways. Mumford, Reiter-Palmon, and Redmond (1994) demonstrated that even this basic instruction already leads to more original problem solutions; and Okuda, Runco, and Berger (1991) also provide evidence of a strong relationship between problem-construction skills and creative outcomes. Of course, acknowledging the requirement of restating the problem recognises the importance of overcoming fixation. It is also in line with the well-known principle of 'problem finding', which is often regarded as a basic prerequisite of creative problem solving (e.g., Csikszentmihalyi, 1988). 'Finding a problem', or constructing

the 'right' problem, is a problem-solving activity in itself (Simon, 1988).
Making designers aware that human needs change over time – because the (social, technological, cultural, etc.) conditions that shape those needs might have changed – may already expand the solution space the designer explores and force him/her to frame the design problem differently. In an experimental setting, we (Snoek & Hekkert, 1998) compared a test group of designers who were made aware of possible contextual changes with a control group that did not receive such instruction. Both had to design an alarm clock to be used five years from the date of the experiment. Not only did the test group spend significantly more time gathering information, their concept designs were also rated as more creative (a sum score of originality plus appropriateness) than those of the control group. This effect was even stronger when the judges knew the contextual ideas of the designer. Despite some procedural limitations in the study, "it is clear that it is possible to direct designers to creative or innovative solutions" (Snoek & Hekkert, 1998).

Framing the problem in a novel way can serve as a powerful conceptual structure providing the impetus to explore remote domains for creative solutions applicable in the target domain. If the problem is represented abstractly enough, it can give access to analogue solutions in other domains (see Vosniadou & Ortony, 1989). This 'structure' may, however, not only guide the process of solution generation, it might also provide the designer with an important tool for (concept) selection. It has often been emphasized that having selective criteria available to judge the value of a generated solution or idea is a vital element in a creative process (e.g., Campbell, 1960).

Adapted and modified from Hekkert (1997).

Essay
On innovation and novelty

The importance of finding and employing innovative practices, for the sake of competitive business advantage, is constantly stressed in innovation-themed literature. To enhance the success of any innovation, the perspective of the end-user (or customer) has been increasingly incorporated in these practices. This seems justified, since in the end, a firm owes its existence to the customer (e.g., Hax and Wilde, 1999).

Companies need insight on how to attract, satisfy and retain customers. This essay will shed some light on what innovation is all about from a business perspective, and also discuss how people (i.e., customers) respond to innovation as novelty. Finally, an attempt will be made to bring the worlds of users and businesses together.

Innovation from a business perspective

How might one begin to define the concept of innovation? A new idea, change, process, object or improvement is called innovative after it has been introduced on the market and actually used or implemented. If it has not yet been introduced it cannot be called an innovation, but rather an invention. An invention is the first manifestation of a new idea, while 'innovation' describes the introduction of something new into practice (Fagerberg, 2004).

In innovation literature, naturally much attention is given to the development and introduction of new products and services. However, in the early 1900s, the economist Schumpeter (1926) had already described different types of innovation. Apart from the introduction of new products and services, an innovation can take place at the process level (e.g., a new production method), on a market level (e.g., new market penetration), at a supplier level (e.g. applying a new system for the use of new materials and components), and at an organization level (e.g. introducing a new organizational matrix).

Who ultimately profits from innovation? From the above description it becomes clear that end-users, manufacturers and suppliers benefit alike, the latter because innovation may result in lower manufacturing costs or higher revenue thanks to innovative processes, practices or products.

Yet research has also suggested that firms are not always able to reap the financial rewards their innovative efforts ought to have provided; imitation by competitors, or suppliers who price the components or materials necessary for the innovation both ultimately affect profitability (e.g., Teece, 1986).

What or who are the 'sources of innovation'? Who takes the initiative for changes and improvements and is responsible for the start of the innovation process? Customers might indicate that a certain product is no longer satisfactory or a new product is needed, as often happens in the development of scientific instruments. A supplier or manufacturer, or other stakeholders such as governments, may also be the driving force, as when there is the demand for more environmentally sustainable materials, for example. Thus, innovations can be initiated by various players, can benefit different stakeholders, and can relate to more areas than just products or services.

According to Von Hippel (1988), innovation is one of the most crucial activities that a company can undertake. Firms that innovate gain a competitive edge. But not without risk; it may require a high level of initial investment, and commercial success is never guaranteed. It has been estimated that up to 35% of all new products fail after market introduction (Cooper, 1993). And often these failures have very negative consequences.

Failure seems particularly imminent if the company invests in some kind of radical innovation: products or services that are significantly different from what is currently on the market. Often the innovator has difficulty convincing the greater public of the potential value the (radical) innovation has. The famous Wright brothers – whose flying machine was a major advance in technology – were not successful economically. Society was not able to understand the meaning of flying at the time. Verganti (2008) equally emphasizes that the commercial success of an innovation may take time.

Considering the difficulties, risks, and failures that an innovation may present, generally companies need to feel a 'sense of urgency' before investing in innovation. This sense of urgency may emerge when market research concludes that customers experience the products or services the company is offering as outdated, or after a thoroughly executed analysis of company industry attractiveness. One of the means to perform such analysis is by applying Porter's "five-forces framework" (1979). This model provides insight into whether operating in a particular industry is

attractive by examining the intensity of competition between currently existing firms, the threat of new competitors, the threat of substitute products or services, the bargaining power of suppliers, and the bargaining power of customers. After a Porter analysis, any company can better see which (innovative) strategy would best improve their competitive edge.

People generally resist change; while innovation is often needed to maintain competitive edge, implementing required changes or improvements can sometimes make waves within the company. An innovator has to find ways to overcome resistance at every level, from executive suites to work floor. To do so, new ideas, directions, methods and modes of innovation process management may need to be developed and incorporated (Kuhn, 1993). Sucessfully implementing innovation not only depends on the quality of an idea, but is often related to how the company is able to manage the innovation process in terms of people, time and money.

Innovation is business oriented, and design-driven

The term 'innovation' not only refers to the development of new technology or functionality, recently it has begun to refer to the development of new 'meaning'. By analyzing products of famous design-oriented firms like Bang & Olufsen, Alessi, Swatch and Apple, Verganti (2008) argues that the introduction of products with new meanings can lead to economic success, in the same way that selling products with cutting-edge technology and functionality may lead to market dominance. Swatch changed the meaning of a watch as a basic, practical timepiece to an accessory that can be trendy and fashionable. Based on his findings, Verganti introduced the idea of *design-driven innovation*, emphasizing the importance of introducing new values for products and services as an attractive and workable method that businesses can use to innovate.

Design-driven innovation guides the market by introducing products that have new meaning, instead of generating products that have been adapted to current markets. To determine what will be meaningful in the future, design firms gather as much information and insight from as many stakeholders as possible. Innovation stakeholders – whose input is quite different from the practically-minded determinations of the supply chain – are users, designers, artists, suppliers, academics, etc.

Design-driven innovation is primarily inspired by what might have meaning in the future, and doesn't address current user needs, as most

user-centred innovation methodologies do (Ijuri & Kuhn, 1988). The outcomes of design-driven innovation come in the form of options that make it possible for users to embrace new meaning. "Design driven innovation is a *design push* activity" (Verganti, 2009). In Verganti's terms, designers – together with the organizations they work for – are responsible for the development of meaningful products or services that shape the future world. In this sense, design-driven innovation is closer to a *technology push* – the incorporation of new technology as the driver for innovative products (Gaynor, 1996) – than to user-centred innovation, which can be seen as a form of *market pull*.

Verganti states that "innovation may concern a product's functional utility, its meaning, or both" (Verganti, 2008). 'Functionality' and 'meaning' help to distinguish between different types of innovation and aid in concept positioning. "Functionality aims at satisfying the utilitarian needs of customers; the product meaning tickles their affective and socio-cultural needs". Functional innovation implies "an incremental or radical improvement of technical performance".

Innovation of meaning, on the other hand, "is incremental when a product adopts a design language and delivers a message that is in line with the current evolution of socio-cultural models...". What Verganti terms 'radical innovation' "happens when a product has a language and delivers a message that implies a significant interpretation of meanings".

There is always risk involved when a firm innovates, so of course this is true when a firm uses design-driven innovation techniques. Verganti (2008) mentions that commercial success takes time to occur, particularly in the case of radical design-driven innovation: "Users need the time to understand the radically new language and message of design driven innovation to find connections to their [socio-cultural] context, and to explore new symbolic values and patterns of interaction with the product".
To better appreciate this acceptance of innovation or novelty, let's take a look at the psychology of aesthetics.

Appreciation of novelty

Whereas the concept of innovation carries the weight of a business perspective, from a human point of view an innovation is perceived as something different, or 'novel'. Why people appreciate novelty has been widely studied in psychology, especially in the field of empirical aesthetics.

The latter discipline aims to understand the underlying processes of liking, preference, or beauty.

Berlyne (1971) predicted and demonstrated an inverted U-shaped relationship between hedonic tone, i.e. pleasingness or liking, and arousal potential, the amount of attention or excitement that a stimulus, such as a work of art or consumer product, produces. Various properties of a stimulus can lead to an increase in arousal. Among these, the so-called 'collative properties' were regarded as most relevant to the field of art and artefacts. Collative properties, such as complexity, ambiguity and novelty, refer to similarities and differences between stimulus elements. In sum, when the perceived novelty (or complexity, etc.) of products is not great enough, people are not stimulated enough and experience indifference; when there is too much novelty, people are too highly aroused or overstimulated. An average degree of novelty leads to an optimal arousal level and is (therefore) liked most.

Berlyne's theory was challenged in the 70's and 80's by researchers arguing that novelty or complexity only explain a small part of the variance in preference judgements when it comes to valuing real life stimuli, such as products (e.g., Martindale, 1984; Whitfield & Slatter, 1979). They introduced the concept of (proto)typicality as another variable accounting for aesthetic preference. According to the so-called preference-for-prototypes model, humans like those instances of a category that are most typical or familiar. This model was empirically confirmed with a range of products, such as paintings, chairs, and houses.

Since novel products are by definition not typical, and similarly, typical products are not novel, the question was raised how novelty and typicality jointly determine our preferences. Hekkert et al (2003) found that novelty can be optimised without a severe loss of typicality, and showed that products optimising the two simultaneously are most preferred: what are perceived as attractive designs strike a delicate balance between novelty and typicality. This was coined the 'MAYA principle' – Most Advanced, Yet Acceptable – a principle that had been intuitively proposed by Raymond Loewy 50 years earlier.

The MAYA principle explains why innovative products are often not appreciated instantaneously. A fair amount of familiarity needs to be developed first. One of the ways to establish this familarity is by exposure: if we are exposed to something frequently, our familiarity with it increases, and so does our liking for it. This 'mere exposure' effect was already

assumed and tested by Zajonc (1968) in the late sixties. More recently, Leder and Carbon (2005) demonstrated that repeated exposure increases the appreciation of innovativeness in car interior design. Simply instructing people to closely examine the design already enhances the liking for innovative interiors without loss of novelty or innovativeness.

The mere exposure effect, however, has its limitations. At some point in time, after a certain amount of exposure, habituation or boredom creeps in. If people are exposed to the same stimulus too often, their value judgment of this stimulus will decrease (Berlyne, 1971). Due to this habituation effect, novel products have to be introduced all the time; products have to be upgraded or replaced constantly to keep novelty at an optimal level.

There is, however, a limit to the amount of novelty you can add to a product to compensate for the habituation effect. Martindale (1990) discovered this phenomenon in the field of art (music, poetry, paintings, etc.) where he found that styles, such as impressionism, have a specific life expectancy. An artist can add novel elements to a style until people no longer experience the added novelty as valuable to the existing style. The style becomes saturated. At that point the artist has to make a more fundamental change than only adding novelty to what exists. The artist has to come up with a paradigm shift and introduce a new style that is based on a new artistic lexicon. The result of this process is a cyclical pattern in artistic change, which Martindale demonstrated in many art domains and in the careers of several individual artists. Martindale's theory makes it possible, in principle, to predict when existing products can simply be improved to maintain novelty and when there is a need for the introduction of a more fundamental stylistic change.

A bridge between innovation and novelty

As argued, people have to get used to a new paradigm. The pitfall of introducing a paradigm shift to overcome the effects of saturation is that at first, any appreciation felt for the new style is less than the appreciation felt for the old, saturated style. Time is needed to understand what this new style is all about, the same time needed to make customers adapt to the outcome of design-driven innovation. In the field of design, a paradigm shift often entails introducing new meaning to consumers. So-called 'early adopters' are the first to appreciate such a new paradigm. They will take

the lead in recognizing new meaning and provide an example for people to follow.

When is it necessary to take the risk of introducing such a paradigm shift? To understand if increasing novelty or the introduction of a paradigm shift is needed for a product to retain meaning, the concept of appropriateness must be introduced. Appropriateness refers to the degree of fit between the product and the context in which it is consumed. More precisely, appropriateness signals if a human-product relationship fits in with its socio-cultural environment. Changes in this socio-cultural context thus determine if new meanings for products are needed. The context creates a frame of reference for what kinds of products are beneficial for people in the future.

Following the above argumentation, 'novelty' can be defined as the introduction of new features in products and/or services, or by the introduction of new technologies used in products and services, the latter leading to a more radical type of innovation (Ijuri & Kuhn, 1988). New meaning arises when people have a new interaction with the product or service. Analogous to Martindale's model, a shift in style resembles a shift in interaction quality between user and product. A paradigm shift in product design thus deals with the introduction of new interactions required to fit the future context. In conclusion, it is important to point out that it is not always necessary to design new meaning. The context determines if the introduction of new meaning is needed.

Essay
On feeling and thinking

What are designers actually doing when they describe their process?

Whitfield (2007) recently asked himself this question, and he continued with the following answer, "A plausible explanation is that they construct an account based upon the limited information introspectively available, and supplement this with strategic in-fills that give direction, coherence and apparent logic to the process."

More and more studies in the fields of emotional, neuro- and social psychology seem to support Whitfield's claim. We have little access to why we make certain decisions and perform certain behaviours, because the process of decision-making mostly operates unconsciously (e.g. Nisbett & Wilson, 1977; Wilson, 2002; cf. below). Famous experiments with split-brain patients (patients who have no connection between the two lobes of the brain) support this conclusion. When the right hemisphere was instructed to do something, like wave or laugh, the left hemisphere, witnessing the action, made up an explanation as if it knew why the action was performed. The split-brain patient argued that he saw someone he knew (when waving) or the experimenters were funny (when laughing). The explanations were based on the response, not on its causes (Gazzaniga & LeDoux, 1978).

Surprisingly, however, design researchers have always relied to a large extent on introspection for understanding the design process. In studies based on so-called 'think- or 'talk-aloud protocols' (Ericsson & Simon, 1993), designers are required to describe and comment upon all the actions taken during a design exercise (cf. Cross, Christiaans & Dorst, 1996; McDonnell & Lloyd, 2009). Transcripts of these commentaries are then carefully analyzed for patterns of thinking. These insights are not only used to understand the process as it appears, they are also taken as ingredients for the formation of new methodologies. However, "we have to be very careful when we use verbal reports based on introspective analyses of one's own mind as scientific data." (LeDoux, 1996).

Imagine you are looking for a new apartment and have to choose between two alternatives that both meet your initial requirements, but of

course differ in many respects. What do you do? You (a) make an immediate 'gut' decision, (b) consciously go over the list of apartment attributes and decide, or (c) do something else for a while (like watching TV) and let your unconsciousness do the job. What strategy would lead to the best decision? Dijksterhuis (2004) convincingly demonstrated that strategy (c) would most often result in the right choice. The main reason for this is that the processing capacity of our unconscious mind is much larger that the capacity of our conscious mind. Conscious decision makers can only compare a few attributes, and they weight these poorly (Wilson, Lisle, Schooler, Hodges, Klaaren, & LaFleur, 1993). Unconscious thinkers, on the other hand, are able to make holistic judgments, weighting the relative importance of the various attributes 'naturally'. Especially when decisions are complex, i.e., involving many aspects to consider, choices are better delegated to our unconscious (Dijksterhuis, Bos, Nordgren & van Baaren, 2006).

> What does research tell us about our conscious thought?

Consciousness is very good at following rules, solving logical problems and convergent thinking. But due to its limited capacity, conscious thought is mostly top-down, relying heavily on existing schemas, expectancies and stereotypes. Although stereotypes are activated unconsciously, it is our consciousness that makes most use of them. Studies confirming this effect made Dijksterhuis and Nordgren (2006) conclude "...it is hard to avoid 'jumping to conclusions' when one thinks consciously. It may feel as if one is processing information with the goal of making a decision when what one really – unknowingly – is doing is processing information with the goal of confirming an expectancy." The unconscious is less rule-based, associative and more divergent, thereby increasing the likelihood of generating original ideas. From all this evidence, it is safe to conclude that designers – like all decision makers – should trust their (thorough) unconscious processing skills more. Call it intuition.

> Now, let's have a look at feelings.

Every once in a while my 4-year old daughter starts to cry. This is nothing special; children cry. When I ask her why she is crying, she mostly responds "I don't know!". Just like adults, this 4-year old has little access to the processes that lead to her feelings or emotions. Unlike adults, my daughter is honest, whereas adults tend to confabulate all kinds of explanations.

Our consciousness creates those stories that make the most sense.

If designers, like ordinary people, have little access to the reasoning underlying their decision-making and feelings, what makes them decide what is right? Again, Whitfield (2007) offers a tentative answer: "...much of designing deals with aesthetic decision-making"; we feel what is good or bad without being able to precisely articulate the reasons underlying the feeling. Much research in the field of neuroscience has demonstrated that affective reactions are quick and effortless and need no conscious deliberations. Again, when a stimulus is presented to the right hemisphere of split-brain patients, the left hemisphere can accurately judge whether the stimulus is 'good' or 'bad', but has no idea what the stimulus is (LeDoux, 1996). Such a feeling of good and bad is what Russell (2003) calls "core affect", a combination of pleasure and activation. It is a primitive and simple feeling that can "exist without being labelled, interpreted, or attributed to any cause" (Russell, 2003).

According to Zajonc (1980; Murphy & Zajonc, 1993), the experience of this affect may be a mental affair, it does not require cognitive or reflective processing. Zajonc based this claim on a series of (now classic) experiments on the 'mere exposure' phenomenon. When stimuli such as nonsense words or Chinese ideographs are repeatedly presented, a liking for these stimuli increases with exposure frequency (Zajonc, 1968). The world of advertising is based on this principle. The interesting thing is, however, that the repeated exposure can be so short that people are not aware of being exposed at all (Kunst-Wilson & Zajonc, 1980). Even with subliminal exposure, liking is enhanced. This affective priming under subliminal conditions is considered to show that affective reactions can be evoked with (virtually) no cognitive processing and are, in that sense, primary to cognition. Although this latter claim has been widely disputed (e.g., Lazarus, 1984; cf. below), Zajonc's 'mere exposure' studies have been replicated often, with very consistent results (Bornstein, 1989). Up to a certain point when boredom or saturation may arise, we prefer nonsense words, polygons, and people we have seen before, whether we are aware of it or not.

The primacy of affect, if correct, does not imply that it is not based on cognitive processes; "it remains entirely possible that *unconscious* cognition preceded the conscious affect" (Parrott & Sabini, 1989, italics in original). In fact, recent studies in social psychology previously mentioned suggest that these unconscious processes can be quite elaborate. To conclude again with Whitfield (2007), "Given its evolutionary priorities,

it [our brain] is less concerned with us understanding the process of decision-making than with the actual decision and the consequent action. For this reason, we know the decision and the prescribed action, but not the decision-making process. We *feel* the decision, but not what led up to it. After the event, we can seek to unravel the decision-making process via introspection or feel, but this is not easy."

Not easy indeed, "... if there is one thing about emotions that we know well from introspection, it is that we are often in the dark about why we feel the way we do." (LeDoux, 1996). Emotion and cognition are separate mental functions. But, these functions, and the brain systems that mediate them, interact. The two systems cannot live without one another. All kinds of (pre)cognitive appraisal processes underlie our emotions. Even for the most basic of our emotions, such as fear and sadness, we first need to appraise an event as frightening or saddening. Likewise, most of our cognitive processes, such as remembering, reasoning, and decision making, rely in large part on feelings. When an area of the brain responsible for the production of gut feelings is damaged (the prefrontal cortex), people have great problems making decisions, focusing on relevant information, and setting priorities (Damasio, 1994). Their day-to-day lives become quite dysfunctional. Just think of what that damage would do to a designer.

Essay
On the primacy of
universal human principles

Designers – like all people – largely focus on what is changing (from before) or what is different (between people). Inspired by market research, they are inclined to concentrate on trends in people's values and behaviour, e.g., 'because of a concern with environmental pollution and the scarcity of resources, people's behaviour is increasingly sustainable', or 'people are increasingly concerned with health issues'. In a steadily growing global economy, designers and design researchers alike have also started to emphasize the (cultural) differences between people: Saudi Arabians dress differently from the Chinese and have much larger families; Germans tap beer differently than the Dutch; in the US, PC penetration is much higher than in Latin America (all examples from Van Eijk, 2007). This attendance to changes and differences is not surprising. After all, the human visual system has been trained to perceive things that are in motion, and is very sensitive to contrast and fine-grained differences (Goldstein, 2002). Things that are not moving, and commonalities, are much harder to perceive.

Currently, and not only in the field of design, cultural diversity is a prominent topic. In Holland, believers and non-believers in a multicultural society are expanding upon the differences between 'native' Dutch citizens and immigrants from various origins, mostly Islamic countries. To stimulate another type of conversation on the topic, designer Sara Emami created a culturally stimulating memory-type game. As with a traditional game of memory, pairs of identical cards are randomly placed face down on the floor (or table), and players are required to turn over two cards at a time until a matching pair is found. But instead of making the pairs completely identical, Sara's pairs refer to similar elements in the Dutch (Western) and Middle Eastern cultures. Of course there are overt and subtle differences between these two cultures, but the underlying similarities are much more striking.

Products are designed for people. Designers therefore need to understand people: why do people think, act, live, behave, feel, reason, and respond the way they do? And what do people aspire to, expect, like, need, value and dream of? To answer these kinds of questions, design researchers nowadays usually delve into the lives of ordinary people. They go out to

Cross-cultural memory game by Sara Emami

interview and observe them. Then they use different creative techniques to map (the contexts of) people's everyday experiences (e.g., Sleeswijk Visser et al., 2005).

These efforts may bring us insights into *some* people's daily routines, in a *particular* cultural and social context, at *some* point in time. To understand people in a more profound and fundamental way, we need to understand *why* people do what they do and feel what they feel in the first place. In sum, we have to understand human nature. Human nature is made manifest in the principles shared by all peoples from all cultures throughout our short history.

Researchers looking for intercultural differences based on the premise that culture is an arbitrary, distinct phenomenon, and the fundamental determinant of human behaviour (Brown, 1991), have mainly dominated the field of anthropology. "Because *everybody* likes to hear that 'they' are different from 'us', anthropologists dwell on the differences" (Brown, 1991). But even the godfather of this movement has already admitted, "We find not only emotion, intellect and will power of man alike everywhere, but also similarities in thought and action among the most diverse peoples. These similarities are [...]detailed, [...]far reaching, [...]vast, [...] and related to many subjects." (Boas, 1963). He was right. The following random list of some human universal traits is, unless otherwise stated, adapted from Brown (1991).

People of all cultures and throughout the ages:

> like to share and give gifts;
> seek adventure, diversity and excitement;
> are more likely to help attractive people (Etcoff, 1999);
> have some form of etiquette;
> share moral sentiments;
> aesthetically prefer 'order-in-chaos'
> or 'unity-in-variety' (Hekkert & Leder, 2008);
> use figurative language
> such as metaphors and metonyms;
> get bored over time;
> infer the mental states and intentions
> of others (Baron-Cohen, 1995);

need authority;
are prone to altruistic
behaviour (Warneken & Tomasello, 2009);
wish to stand out from others;
impose meaning on
the world (Eibl-Eibesfeldt, 1989);
tend to overestimate
the objectivity of their thought;
rarely know the causes of their
own behaviour (Wilson, 2002);
engage in magic, poetry,
and pretend play;
are prone to learn and
explain the unknown;
and are able to recognize pictorial
representations without previous
training (Hochberg & Hochberg, 1962); etc.

Human universals like these have been studied and identified in the behavioural and social sciences over the last century, although sometimes they are probably more like 'near universals', e.g., 'men almost universally find lighter skin pigmentation attractive in women'. Universals hold true for people in general, men and women alike. Some universals have been coined that polarise the sexes: 'men are physically and verbally more aggressive than women'; 'women everywhere predominate in childcare'; 'men have a greater ability to manipulate three-dimensional objects in space in the mind'; 'women experience basic emotions more intensely'; 'men have a higher tolerance for pain', etc. (see Pinker, 2002, Chapter 18 for an overview). These constants and commonalities in people's behaviour, thinking, and feeling can be powerful drivers for product development and need to be understood initially, before we can start to look at and design for cultural and individual differences.

In a recent graduation project at Delft's faculty of Industrial Design Engineering, Simon Akkaya (2009) explored whether new design concepts could be developed using a single universal principle as a starting point. He selected the following principle: 'people have a tendency to promote the well being of the other, primarily for the other's sake'. This principle of altruism is visible on the Internet, where thousands of people have invested

a significant amount of effort into an online encyclopaedia (Wikipedia), ostensibly so that others are able to find the accurate, up to date information they seek. Simon looked at the potential of this principle within three separate domains: food, garbage and immigration. The garbage domain result is shown on the right: a garbage bag specifically designed to invite people to throw away items they no longer use, but think might be of value to other people.

In line with current thinking in evolutionary psychology (see Buss, 2005, for an overview), these universal traits (or psychological mechanisms) have become part of the human repertoire through hundreds of thousands of years in human evolution. In the same way that biological mechanisms have evolved to serve a particular function, such as our intestines to digest food, the heart to pump blood and the liver to filter toxins, so our brain has been 'designed' to process information, and has concurrently developed a range of specialised functions. To understand why particular evolved psychological mechanisms have come into being, we need to go back to our ancestors, the hunter-gatherers. The functional architecture of the mind is formed as a result of problems our ancestors had to solve under the conditions of our ancestral environment, not by the kind of problems modern humans are dealing with today (Tooby & Cosmides, 2005).

As a result of being faced with primordial challenges related to self-defence, protection, and survival – searching for food, finding shelter, avoiding predators, protecting children, basic cooperation, etc. – humans have acquired specialised mechanisms through a process of adaptation or natural selection. These mechanisms vary from specific sensory systems and neural programs for language acquisition, to traits for emotional communication, stranger anxiety, kin recognition, incest avoidance, mate preference, altruism, morality, sibling rivalry, etc. Take for example mate preference. Hundreds of studies have demonstrated that males generally prefer symmetrical women with high cheekbones, a glorious mane of hair, and a specific waist-to-hip ratio (e.g., Buss, 1994). These female features point at youth and high reproductive fitness, and that was all our male ancestors needed. Not all mechanisms are 'true' adaptations, in the sense that they were *selected*: many of them are by-products that have been causally coupled to traits that were adaptations...like our sense of beauty. It has been extensively argued that we aesthetically prefer certain properties, such as contrast, symmetry, and congruence in our environment, because the properties serve the functioning of our sensory systems (e.g., Hekkert,

Altruistic garbage bag by Simon Akkaya

2006; Johnston, 2003; Pinker, 2002). Our sense of beauty can thus be regarded as a by-product of our sensory systems, which are clear adaptations.
Whether an adaptation or a by-product, psychological mechanisms have become part of our human toolkit and often govern our behaviour. Yet even though our behaviour is not a direct response to the selection pressures our ancestors faced (e.g., the need to reproduce), we still blindly execute the adaptive response. That explains why those able to afford more children often choose to have fewer (Vining, 1986). In fact, the behaviour generated by these evolved mechanisms may have been adaptive in ancestral environments; there is little guarantee that it will be so these days. "Domain-specific programs organize our experiences, create our inferences, inject certain recurrent concepts and motivations into our mental life, give us passions, and provide cross-culturally universal frames of meaning that allow us to understand the actions and intentions of others. They invite us to think certain kinds of thoughts; they make certain ideas, feelings, and reactions seem reasonable, interesting, and memorable. [...] That is, they play a crucial role in shaping human culture" (Tooby & Cosmides, 2005).

> "The social and cultural are not alternatives to the biological. They are aspects of evolved human biology[...]." Tooby & Cosmides, 1992
> "There is no question of opposing nature versus nurture; nurture is just one of the many forms that nature may take." Tomasello, 1999
> "Behaviour is not just emitted or elicited, nor does it come directly out of culture or society. It comes from an internal struggle among mental modules with differing agendas and goals." Pinker, 2002

What these citations (from leading thinkers in the field of evolutionary psychology) share is the conviction that social or cultural phenomena can only be understood and predicted thanks to the light cast by the aforementioned evolved mechanisms. As it makes no sense to oppose nurture versus nature, so we should not oppose culture (or social patterns) to nature: Cultural or social manifestations result from an interaction between the psychological mechanisms and the world people are living in.

"[...] [T]he circuit logic of each evolved mechanism contributes to the explanation of every social or cultural phenomenon it influences or helps to generate" (Tooby & Cosmides, 2005). If the (natural, economical, political, societal, environmental) circumstances are different or change, so will the way these principles are manifested, leading to variants at a group level (society/culture) and maybe even at an individual level.

To illustrate how cultural and individual manifestations can be explained (and predicted) on the basis of universal, psychological mechanisms, we turn to two universal principles in the field of user experience. Designing for user or product experience[1] has received much attention over the last two decades (e.g., Desmet & Hekkert, 2007; Schifferstein & Hekkert, 2008). Recognised as one of the components of product experience, Hekkert, Snelders and van Wieringen (2003) found evidence supporting the operation of the "MAYA principle" in people's aesthetic response. This principle holds that people aesthetically prefer objects that maximize their novelty or originality (advanced) while maintaining an optimal level of familiarity or typicality (acceptable). The evolutionary logic behind this principle is that both exposing oneself to the new enhances fitness, in that it facilitates learning, and staying close to the familiar has survival value, by decreasing the risk of jumping into a life-threatening adventure (Bornstein, 1989).

Striking an optimal balance between novelty and familiarity does seem to be the most effective strategy from a hunter-gatherer point of view. Yet, what is novel to one may be very familiar to another on the other side of the mountain (and vice versa). One's subjective assessment of a stimulus' novelty or familiarity depends on a range of context variables (e.g., frequency of appearance) and background variables (e.g., previous experiences). Thus, people differ to large extents on what objects they see as novel or typical for a particular product category. As a result, predictable differences in aesthetic preference arise at a group (culture, expertise, etc.) or individual level.

Another, much investigated component of product experience is our emotional response (e.g., Desmet, 2008). As most psychologists today in the field of emotion agree, emotions are evolutionarily hard-wired, adaptive responses that make us approach something that is beneficial and avoid events that may harm us (Frijda, 1986). These tendencies have clear survival value (e.g., fear makes you freeze or run away from the snake) and result from a cognitive, but mostly automatic and unconscious appraisal process. In this process, we estimate the extent to which an

incoming stimulus, or product, corresponds or conflicts with one or more of the many concerns we have in life, such as goals, values, and needs. As humans, we share a number of basic concerns, e.g., survival, socializing, justice...and stimuli that conflict with these concerns will universally lead to negative emotions like fear, grief, or indignation. However, many of our concerns are not this basic, and partly reflect the social or cultural group to which we belong, or characterize us as individuals. As a result, predictable differences in emotional responses arise at a group (culture, social group, etc.) or individual level.

Universal human principles are the driving forces of our being human, and should therefore be central in new product development (NPD). Whereas marketers have established their role in NPD through investigating various changes in the market and pinpointing (target) group differences; and engineers develop and promote the latest technological solutions; designers might feasibly define their role in the process by appointing themselves masters and protectors of the human condition. This would give them a unique and autonomous position in the process, and prevent them from being squeezed out by the other two players. Since these other players, i.e., marketers and engineers, are claiming more and more ownership of the new product idea, designers are in need of just this kind of driving position (rather than presenting themselves as mere integrators). By taking ownership of these universal principles, designers are (back) in charge of the design process, since the final design finds its main justification in these same universal principles.

Adapted and modified from Hekkert (2009)

1 These two concepts can and have been used interchangeably: it is the user who does the experiencing, hence 'user experience', it is the product that evokes the experience, hence 'product experience'.

Above Model of product emotions (adopted from Desmet, 2002)
Below Interdependence of universal mechanisms, cultural phenomena and individual behaviour (U=Universal; C=Cultural/group; I=Individual)

Interview
Talking design methodology

ViP helps to structure the design process, and so it can be called a design methodology. We have always refrained from using that term to avoid unwanted connotations, and have framed our process as a 'design approach'.

To find out how to position ViP in relation to traditionally accepted design methods, we (Matthijs and Paul) have conducted an interview with an expert in design methodology, Peter Lloyd, from the Open University.

M *Can you define 'design methodology'?*

I suppose it is a structure that helps you organize the process of design. Something that changes your behaviour, takes you through a sequence of things, and that helps you produce a design in the end.

P *So is it prescriptive?*

Yes; a prescriptive design process is an instruction to do something; that a designer should follow a particular sequence of steps. It doesn't simply describe a designer's behaviour, although that's another part of design methodology where good designers are studied to see how they design. A methodology tries to model the successful aspects of how experts are designing and that helps other people to design. I think that the discipline of design methodology is focused on employing the best type of structure to help people design better. I think that's the ultimate aim that methodologies are trying to capture: what is best practice in design, establishing some sort of design standard. 'If everyone designed like *this*, if everyone was systematic, then the design field would be much better.'

M *Why should observations about other people designing, when written down, help a novice designer to design?*

Well, if an instructor wants to teach the novice designer, he or she can take some aspect of what an expert designer does and represent that somehow to the novice student, and the student can model it. A novice chess-player who wants to see and learn how to play chess better studies an expert. If a novice designer is told how an expert would do it, then that provides insight into how the novice might begin.

M *Yes, but that insight is really driven by what motivates the behaviour of the designer, isn't it? If you describe only what the designer does, you are only describing the actions he executes, not the thoughts or intentions or feelings or frustrations that may also contribute to the design…*

Yes, all you're describing are actions, but that's generally what a method does. So, the designer looks at the different phases of the design process, "here's this expert collecting information", "here he's sketching", "here he seems to be producing a lot of ideas, a lot of concepts", etc. And somehow this is built into a method, a methodology.

P *What Mathijs is saying, I think, is that the underlying thinking is more important than the activity. "Why is he doing what he is doing?" instead of "what is he doing?". Perhaps this 'why' is more important than the how or what.*

I see; so just ask designers what they're doing. You can get them to think aloud, or you can just say, "What are you doing?" If I come to your office and watch you designing and say, "What are you doing now?" you could say, "Well, normally at this point in the process what I do is I put everything on a wall and I look at it and I try and make connections," something like that. That could be an idea for a method that can be given to someone else.

M *But I'm still missing the fundamental "why do I the designer put things on a wall?" That can also be asked. And the expert might say, "because it helps me structure the problem space," or "it helps me break down the problem," or "it helps me make creative connections." I think in a way that's what methodology is, it's things that work, rather than the reasons why they work.*

M *Yes, but that's a pity. You have said that methodology books describe a structure for a designer to adopt, but structure is not process. So if a structure is used to design, it won't help the novice understand why the expert would want to design the object that way.*

M *If I look at all those design books, I can't work with them, because they don't give me a start and they don't give me an end. There's a structure but there's no process: it tells me something about what you said – collecting information, generating ideas, creating concepts – but these are all tools for a designer. Then I say OK, interesting, but how do I use these tools in generating good, novel ideas?*

But I think the underlying assumption is that there is a problem. At the start, someone has provided a design problem. It might be the design tutor, it might be some client, and the designer thinks, "Where do I start with this? This is the problem I've got, where do I start?"

P *That's interesting, do all experts start with a problem? Do they all consider that the design task should start with a problem?*
Yes, I think so.
P *So what would happen if a company just decided to put something new on the market because they feel it's time to come up with something new, would there be a problem there?*
So they're looking for a new idea, or a new –
P *– they know the market gets saturated after a certain amount of time, so "time to come up with a new bicycle, because…"*
Like Sinclair, maybe he's a good example, because first he did computers and then he knew that he had to do something else and then he created that strange bicycle.
P *There wasn't a problem there…*
No, but then I think design methodologies are meant for a certain stage in a design process, so until there is a problem the methodologies don't help that much. So maybe first use a…yes, a SWOT analysis or something.
P *Looking for opportunities.*
So before Sinclair gets to the point where he thinks, "OK, yeah, this thing has got to have three wheels", he's got a rough idea of price, he's got a rough idea of what he wants it to be, a problem, then he goes to work with a design method.
P *Go on…*
I think there are some methods that give a process, like Roozenburg and Fekels do. And there are some methods, like in the John Christopher Jones book, that kind of…well, he gives you a process, but it's much more a collection of tools that can be used at various points in the process. So depending on what problems there are, depending on whether some user interaction or some computer system or something is being examined, a different method is selected. It's like having a toolbox: select the right tool to do the right job, to provide the right information…yet they're all tools of analysis.
M *Exactly! They're all analysis tools. They don't inspire new ideas.*
Yeah, even Synectics, or the creativity techniques. Again, they're sort of analytical. That's always what the early design methodologists say; they all mention this idea of a 'creative leap'. Jones says you can write everything down but you still have to have this.
P *This synthesis.*
This x-factor.
M *So that's something to go for?*
Yeah, but I think that's implicit in the process. If enough information is laid out and problems are being considered, things emerge. It's like a pattern system: by using a number of tools and by following a process, a pattern is created and then something is seen in that pattern. I think that the experts wouldn't consider the creative leap as a mystical thing. You know: if it happens, it happens. I think they think that it's a mechanical thing that happens once you've done all this analysis work. It's an ability that every person has, it's just the nature of people to look at patterns and make associations or construct solutions.
M *That's true, but 'solution construction' is still not guided by those methodologies. Understanding the act of designing requires methodology, but a methodology can't help to the designer react to the world with the designs he or she makes.*
But even with something like a simple methodology, after you've had your ideas and think, you work up three different concepts. That's quite usual in design practice: present to a client option A, option B, option C and let them make a decision.
M *But if it's only about making three options then none of them could be appropriate! That's strange about methodology: if it's only about making options then there's something missing. So, for a designer, what do they provide?*
They provide a structure, something to hold on to. The novice gets to a point where it is possible to discuss the design process.
M *But then you are relying on the intuitive powers of an expert designer to design things that make sense. You fully trust the intuition of a designer that way.*
In what sense?
M *It's the same when you go to a baker at the corner and you say to him. "Tomorrow I want to have a nice tasty loaf of bread," and then he starts working and he shows me three options the next morning. He just tried to create*

something nice. That's what we're talking about! We don't know how the designer decided these options are tasty options. We don't know why. That's why you have to generate more concepts, to increase the chance that you will get it right.
M *Yeah, but still totally relying on intuition, right?*
Or on the criteria that you've derived from your problem analysis.
M *True...*
Of course there's intuition all the way through a process, the desire to go in this or that direction, or the feeling that over there is the wrong direction to go in.
P But what a methodology basically helps the designer to do is establish all the constraints and requirements of a design, frame all the things to be taken into consideration, that's one aspect. Then there is the moment of generating ideas, which is hardly supported by any methodology.
Yes, here the creativity techniques come in.
P Right, you get into the brainstorming and the flow of ideas and intuition comes into play. Which results in a couple of ideas or concepts and then the process of analysis begins again: evaluating concepts very carefully on the basis of all the criteria set out previously. But I think the difference between design *education* and design *practice* is that in education you ask someone to produce three concepts. The way they evaluate those concepts is to look back and say, "Does it fit with the problem we've got? How suitable is this concept? Ah yes this one is about 89% fitting, this one only 75% therefore we're going to choose the first one." But in practice, these concepts are really only discussed. "This direction goes this way, this direction goes that way, let's talk about it." The designer is establishing a connection with someone that really wants something. For a student, who is the connection with? It's an academic exercise that announces" OK, my process is well-balanced because I came up with this variable, I analysed the problem in this way, and this solution optimises this variable". The student is always looking backwards.
M *You are saying that with a methodology the external world that provides some feedback, is missing. That is still a strange way of working to me.*
Yes.
M *It's strange. Going back to my favourite example of a painter, I think a designer should have the opportunity to work as a painter. He should kind of create his own frame of reference to understand what he really wants to do, what positions he wants to take in this world. Is there a methodology that supports a designer creating a kind of internal reference? Because I think that's what a methodology should do. Otherwise those three options, the three concepts, are just options – without any predetermined meaning, they* 'explode' *in every direction. This isn't efficient designing.*
Someone looking to use a methodology is looking for help. You're describing designers that are trying to develop their own vision, that are trying to develop themselves, and they're people who already have a good sense of what they want to do.
M *Yes, but don't you think that's the core of being a good designer? That if you talk about methodology, going back to the actions, that it's not about collecting information, or about idea generation, or about concepting as such? Those are just normal design activities and have little to do with being a designer. Being a designer is creating your own reference. Are there methodologies that focus on that aspect of design?*
No prescriptive methodologies. I mean, there are books that talk about how you develop a way of seeing problems and how you develop yourself, like Donald Schön, in *The Reflective Practitioner*. But it's not a prescriptive methodology. He's not saying "OK, in order to be a reflective practitioner, you have to do this, this, and this". He's showing ways in which people actively reflect when they discuss things. And he's saying that this is the hallmark of a good designer.
M *Yes, but a methodology should give a designer tools to start working and shed light on what designing is really all about. Like in 'Zen and the Art of Motorcycle Maintenance'. Remember, there's that girl who wants to write an article*

about the city? She couldn't; there were so many things to write about, it was impossible to start. He tells her, "OK, just start writing about this brick in the house on the left corner of that street." And then she had a starting point! The student knows "ok, start writing about the brick, that's easy, I can do it...it has colour, texture, it has a kind of feeling, this side is connected to, oh, wait a minute, that's interesting why is it there?" Then, suddenly, relationships begin to emerge... That "helping hand" (as it were)...I don't see it anywhere in design methodology. But in an educational context you usually have people that will help you. A student gets stuck and someone comes up and says, "What you need to do is this, this, this, and this".
P "Why don't you start here?" Yes. "Why don't you start here?" Someone in Mexico opens up a design methodology book, looks through it and reads it, and gets a feeling of what to do in design without following anything in detail. Get a rough idea of what designing is like. Take on the spirit of the thing, take on the global message of the thing, without starting at page 1 and going to page 2 and then going to page 3, all the way through your problem. I think you're right, there is no real, strong starting point without someone to tell you "this is how you should start".
M They don't help you! You're looking for some kind of grasp of the situation, and instead you get told "what to do" – not how to find this grasp – which is exactly what you don't need!
If I look at mechanical engineering, OK, this kind of approach works. If I want to find out if a steel beam is rigid enough for a particular construction, there's a nice clear algorithm for verification. It's an X kind of beam, there's y amount of force, there are material properties and you can go with the flow. I've never seen such a methodology or process for designers, addressing and clarifying what design is all about in essence. "What does this design proposal imply for the people who will interact with it?" And I think it's possible.
P Maybe that's not in the methodologies themselves, but it's certainly in the teaching. I know some teachers who would say, "If you want to design this or that, go outside and start to observe people. See what they're doing and try to describe it. What do you see? What problems do they have? What do they lack? Talk to them, ask them."
"Find the problem."
P 'Find the problem' in current practices; find the problem that addresses how people are currently dealing with and designing similar products.
M But does such an explicit methodology exist? Are these questions usually written down as part of a methodology? Remember: this is only one way of looking at design...
Yes, I think those tools are available. They tell you to "use user-centred research"...they tell you in detail what you need to do. Obviously individual problems are different so there has to be a kind of general element to it.
P They even offer instruments to generalise, like questionnaires, or observation instruments; there are all kinds of instruments to use. Like the "probes" technique...
M Exactly, but those are techniques.
That fit in at an appropriate place.
M But what do you think?
Well, I think the philosophy is that you give people tools as part of a toolbox; in any particular situation they have the right tool. If they need to generate ideas they can use brainstorming, if they need to see how people are using products they can film them and analyse time and motion or something. So you're giving them experience of all these techniques and at the end of their education they have a big toolbox that they can go out and apply. They can arrange those techniques in a way that forms a process and I think that's a reasonable thing to do.
M Is there a book? Is there a toolbox book?
Yes!
M Because you started off by saying a methodology gives structure, it describes designer behaviour, and you weren't talking about describing tools.
No, but all design methodology books are essentially toolboxes. So Roozenburg and Eekels, John Chris Jones, Nigel Cross Design Methods, they all have a description of tools somewhere in the book. Halfway through the book they start talking about the datum method or evaluating solutions,

or how you generate ideas, and linking those things together is their idea of the design process. So they say "OK, this tool here, you should use this at this point in the design process".

M *That's nice. Generally, the analytical tools come before the tools for synthesis. So there's the idea that designers analyse before they synthesize. But what a lot of research shows is that solutions and problems go together. Sometimes you think of a solution and that tells you what the problem is, somehow. There's this cycle between problem and solution that gets lost if the designer uses a strict analysis-synthesis process. So the actual order in which tools are used might be loose; maybe there's no strict process. Pick up a tool and think, "Ah this looks like an interesting tool, maybe I'll use this to see where my thinking goes."*

M *But are the tools now being described in methodology books appropriate? If tools are at the core of a student methodology book or design manual, do you think the tools currently being described really help designers or are those tools too general?*
A lot of these tools are really just concerned with showing evidence, showing a pattern of reasoning so that, especially in education, an instructor can give a load of first year students a problem, lock them up in a room and say "give me a solution in 4 hours time". Maybe some of them will produce great solutions, maybe some of them won't

produce any solutions…but if they are taken through a process and told "OK, at this point in the process we want to see that you've analysed the problem or you've generated 20 ideas". They've got to give the evidence of where they are in the process, and that's what tools help them to do. They're a means of organising information so it can be looked at. So here's a morphological chart to show someone. "This is what I've done, this is the work that I've done in this design process"…and that makes discussion possible.

P *Right. Let's take a typical problem that comes to mind. Nowadays, offices are more and more flexible; people don't have their own desk space, but they still have their own stuff. So how to deal with personal stuff in a flexible office? Now start making a morphological chart: think of ways to take the stuff along: the bag, the trolley, a rail, etc. Systematically go through all kinds of ways to take stuff along: carrying it, leaving it, copying it…in this way the whole solution space is framed.*
Well I think, well yes, with a morphological chart you're mapping out the main variables. There's the example of someone designing a new lawnmower – so basically 4 wheels or 3 wheels, various positions to sit in, at the front or at the back, up the top, down the bottom, so look at each combination of 4 wheels up the top, 4 wheels in the middle, … You generate all these things in order to

find which one you like best.
P *Which configuration works best?*
Yes, so run through every possible configuration. But maybe the result of using this method is the conclusion "this isn't what I want at all, this isn't getting me anywhere"!
P *And it took a month and a half to come to that conclusion...*
M *You know why? Because the tools have mainly been developed for the concepting, design and materialisation stage. No tools exist that help designers understand why products must be what they are and what the underlying principles are. All kinds of ideas are generated without knowing why they are meaningful and if they are realistic. There is absolutely no point in coming up with all kinds of seating positions for the lawnmower if some do not meet the desired expression of the lawnmower, and others create instability while driving it. That's knowledge. If this knowledge is used on top of a kind of morphological map, 90% of the ideas already written down can be omitted. Idea generation without having any understanding of where to aim and what is realistic is prehistoric designing, shooting in the dark in all directions. I really get angry about it. It really is …*
So you presuppose that it's better to have an intelligent analysis of the problem to start off with.
P *Often, with students, they analyse and analyse...* The wrong things?

P Well, unintelligibly, they just analyse and analyse and there is no critical reflection on what they're analysing whatsoever. They don't have the tools to say what is valuable and what is not, what's appropriate and what is not. It's just analysing until someone says, "Well now I think you've analysed enough." And then they start the next stage.
M Which leads me to another question. Do you think using creativity is directionless? I have a feeling that there is a misconception about creativity allowing everything.
That's not what I think. There are some published papers that make a big thing of creativity somehow arising out of constraints. It's like the patent system. If Hewlett Packard wants to develop a new inkjet system, they look at all the patents that all the other print companies have and try to come up with something that's not infringing on those patents. It's a tightly controlled situation, and that's often where creativity can be put to best use. The more constrained, the more naturally creative one has to be and a lot of design methodology is about getting people to restrict themselves; to look for the important variables and then say" Right, there are two things that I think are really important and my solution somehow has to incorporate these things." If an architect has to design a house, it's easier if there's a rich environment around, a tightly constrained environment, than if you've got a desert, like when you have to come up with a new skyscraper in Dubai.
M Maybe, but I don't think so. That's the traditional way of looking at designers and creativity. There's a misconception there, I think. We know that creative thoughts originate from a specific mental condition. I think that no single situation exists where creativity works best…I think a designer should always create the conditions to be creative in, and this is not related to the amount of freedom or time given.
The thing is…I don't really believe in 'creativity' as a concept. It's just what people do; it's natural behaviour. To treat it as something special I think misunderstands the nature of human behaviour.
P Back to your example of the architect and the job to create something in a rich environment or an empty environment: when there is a rich environment, he can relate his design to the environment. So the richer the environment, the more means with which to establish relationships – at an aesthetic level, at a societal level, at a cultural level, whatever…
No, it's not just that, I was talking about being practically constrained. If a plot of land has certain dimensions, the design can't exceed those dimensions. These are the boundaries. So the designer says, "OK, I've got these fixed dimensions, but really I want a house that's bigger than these dimensions." And thinks, "How can I get a house that's bigger than these dimensions?" Since the dimensions are fixed, creativity is needed to get around that. Whereas if there are no dimensions, no constraints, thinking which dimensions are desirable, and why, is a more difficult problem to solve probably.
P Establish the constraints. Yes, because decisions are necessary…
P The point in the case of the rich environment I was making was: where and how the design should fit is more or less defined; whereas in the case of the empty environment, where and how it should fit is not very well defined, so the designer has to define the conditions into which it fits.
Yes, you're right, describing one method as 'difficult' and one as 'easier' isn't really a useful distinction. One is more interesting maybe.
P Let's go back to the initial question. Your answer was that most methodologies are developed by observing and analysing designers and design situations…
Right.
P …and all the way through the interview I've been thinking: is there another way, are there methodologies that are not based on observing good practice, but on something else?
Well, when methodology is derived from science, I suppose, but that's more on the 'tool' side than the 'methodology' side. It has less to do with how the design process is organized and more to do with what sort of information is needed for the design process.
P I was thinking more whether there have been any methodologists in the past

who just sat at a desk, thinking, "What would be a logical way to reason from A to B?"
Yes, I think that's part of what Norbert Roozenburg tried to do, have a design logic. The problem is that this isn't a language the average designer can understand. They may use it creatively somehow, as stimulation for something, but to actually swallow the whole…

M *So describe the beginning and describe the end.*
But how universal is that though? That's the question. I always think of car salespeople. They really go through a detailed process with clients. Someone comes in looking for a new car and there's a 22-step process to take the client through. Sometimes it's a way of talking, sometimes it's looking at the car, making positive comments about their car, and then going on to the next stage, and then the next stage, etc. The idea is, at the end, a sale is completed. But I think that's difficult to apply to design, because even though in sales there's flexibility, even though two different salespeople will go through the process in a different way, with different clients, saying different things, there's a very well defined goal at the end: sell the car for as much money as possible. The process is only directed by maximising the difference between what the garage is paying for the car and what the customers are paying for the car.

M *My last question: those methodologies described in books give tools for analysis, but not for creation?*
I think creation is something that just happens, that everyone does. I think it's more difficult *not* to create than to create.

P *Right, but to create something that makes sense is not that easy! But generating ideas without any context, that's easy, but to create a good idea that makes sense and fits into a context, that's something else.*
But I think the idea behind the design methods is that if you use enough methods and if you follow them systematically then the creativity falls out, it's a consequence of following a method systematically.

M *They hope.*
Yeah, they hope… and there are enough students where that doesn't happen; they use lots of methods and…

M *I think design methodology is very important, and I think there's still a lot of work to be done. So people started writing about design methodology in the 1970s; the practice is only 40 years old now. That's really young, isn't it. What do you think?*
Well, it's sort of gone round in circles a bit, hasn't it? I wouldn't say that the design methodologies coming out now are any better than ones that came out in the 1970s. Like the "probe method": someone comes up with a new way of doing things, but basically it's only another chapter in the John Chris Jones book. It's not a whole new way of looking at design.

M *What's your favourite design methodology book?*
Well the book that got me going on it all was *Developments in Design Methodology*, which is a book that Nigel Cross edited. There were chapters on philosophy of design, the logic of design, some were on prescriptive design methodologies, some were on design behaviour. It laid out all the subjects related to design methodology and I read it from beginning to end, made detailed notes. It was the book that really made me interested in everything related to design.

P *That was 25 years ago?*
Yeah…

>This book aims to guide you in your creative process. It presents a design framework that supports you in your search

for the 'right' things at the 'right' time to make the proper design decisions when needed<

Epilogue

"Nothing can be reasonable or beautiful unless it's made by one central idea, and the idea sets every detail." Howard Roark in The Fountainhead (Rand, 1943, p. 24)

The name ViP was coined in the early days, some 15 years ago, and we have been thinking about changing it recently. After all, does it accurately describe what we are aiming for? 'Vision' is an emotionally charged and ambiguous concept. Everyone claims to have a vision. Visions take many shapes. Above all, a vision is just words, ideas, and as such of little value..."You can't drive a vision" unless you are able to put your vision into action. Which was our goal here.

We have also seriously questioned the second part of the label: 'product' design. At various places in this book we have stressed that a product can be much more than a physical manifestation, something you can drop and it says 'booom'. The term is perhaps begging to be expanded in light of today's user- (or person-) driven world.

The word 'design' may also have aroused one's hopes that the book would extensively explain the embodiment and detailing stage of a design process. Although we consider this activity very important, the surplus value of ViP lies not in that final stage, and therefore it has received relatively limited treatment. Nevertheless, the product should carry the vision with verve. End users will not experience a designer's intentions if the product's qualities are not appropriately expressed.

The end user interacts with the product, not with the vision.

Despite all these considerations, we decided to stick with our initial name. We trust you, the reader, will understand it as expansively as we have tried to present it.

Yet many things still have not been said. Standing in front of a new class of students last week, we realised (again) that every situation calls for its own response. And we came up with more metaphors, techniques and tricks that work. They could not all be covered here; there is no need

for that. They will always be based on the essence of the book, the ViP body of ideas, and if you adopt this body, you can – after some experience – invent the tools yourself.

Some things could never have been properly expressed if we had not set up a certain dialogue, and some other issues would never have been treated (properly) if we had not included theoretical essays. Conveying the ViP story through different formats, including essays, descriptions, interviews, and dialogues certainly worked for us.

There is a lot of variety in our written formats and we know that people and designers like that. Instead of handing over the ViP framework on a silver platter, we hope the a-linearity of our composition stimulates designers to discover structure themselves.

There is a hidden structure – the ViP body of ideas – combining these 336-odd pages and this structure is the essence of what ViP is about. Let us try to summarize this essence one more time.

> ViP is a context-driven design method

ViP is based on the observation that products do not only affect the world in which we live, but that this same world governs which products are appropriate. This world – the context – is not a given, but a construction of the designer. The designer deliberately shapes a future world by bringing together all kinds of considerations he/she believes are appealing and relevant to the domain.

> ViP is an interaction-centred design method

People are the mediators in the relationship between the world and its products. We can only understand the meaning of products when examining their interaction with people. For that reason, conceptualising (the meaning of) interactions is crucial before a product can be conceived. Designing according to ViP is "Designing for Interaction".[1]

> ViP is a human-centred design method

The human is everywhere: in the context, in the statement, and in the interaction. The whole vision – the central idea – is based on human nature, on trends in people's behaviour, and all those associations that people have collectively established (culture, society, economy, etc).

ViP also remembers that the designer is a (unique) human being, someone with a view and opinions, someone with taste and ideas, someone with... responsibility.

As Brown (2009) indicated, the playing field of the designer has expanded rapidly over the last few years. Instead of being a mere fulfiller of individual user needs, designers nowadays propel change in diverse areas such as health care, social cohesion, sustainability, neighbourhood safety, equal rights for women, and well-being at the so-called 'Base of the Pyramid' (BoP). In designing for such major social issues, designers need to take responsibility and can no longer simply design what people appear to be asking for.

Collective interests often go beyond the needs of individuals. To come up with designerly interventions that are appealing to individual users AND meet social demands is a major challenge for designers. We believe – and recent projects have attested to this fact – that ViP is a method suited to deal with these issues.

Over the years we have had feedback of all sorts from design students working with ViP: "ViP takes so long!" It does, especially at the early stages of context building and vision development. But once you have passed these, the 'actual' design process goes so much faster and more smoothly simply because you know exactly what you're after. ViP shifts the main portion of the work to the 'design thinking' stage of the process.

"ViP turns you into a psychologist, sociologist, biologist, etc." Right, we indeed think that a designer should understand what people are and what drives them. But, the designer can freely 'use' specialists and sources to quickly find the information needed. The designer does not need to know all about 'it', but only find a few mechanisms or principles to design for, mechanisms that are 'designable'.

"ViP offers few concrete tools and techniques that tell you *how* to do it." True again. We deliver a theoretical framework and a process, but not a range of hands-on tools to conveniently escort a designer through the process. We invite the designer to adopt existing tools or invent new ones at every stage of the process, whenever the designer thinks it is helpful. We believe this inspires much more than simply 'executing a technique'.

Furthermore, many of our students have struggled with parts of the process, while others have experienced the pleasurable sensation of coming up with something they had never expected, with the added bonus of having a sound defence for each design decision made. Whether they

employ the approach completely, or only certain aspects of it, they have started to design differently, to actually look at the world and themselves differently: with an open mind, authentically and responsibly.

1 *Design for Interaction* is actually the label of one of the Master programmes at our faculty of Industrial Design Engineering in Delft. It is built on the same assumption that design should foremost be concerned with people-product relationships instead of products *per se*. Although the label perfectly covers what it stands for, it often leads to confusion with the much more narrowly defined notion of 'interaction design' that typically refers to the design of interfaces with digital devices.

References

A

Akin, Ö. & Akin, C. (1996). Frames of reference in architectural design: Analysing the hyperacclamation (A-h-a-!). *Design Studies, 17*, 341–361. **Akkaya**, S. (2009). *Altruism in design: Addressing people's tendency to help.* Master thesis, Delft University of Technology. **Alexander**, C. (1964). *Notes on the synthesis of form.* Cambridge, MA: Harvard University Press. **Arnheim**, R. (1974). *Art and visual perception.* Berkeley and Los Angeles: University of California Press.

B

Baron-Cohen, S. (1995). *Mindblindness: An essay on autism and theory of mind.* Cambridge, MA: MIT Press. **Basalla**, G. (1988). *The evolution of technology.* Cambridge, MA: Cambridge University Press. **Baxter**, M. (1995). *Product design: Practical methods for the systematic development of new products.* London: Chapman & Hall. **Berlyne**, D. (1971). *Aesthetics and psychobiology.* New York: Appleton-Century-Crofts. **Blackmore**, S. (1999). *The meme machine.* Oxford: Oxford University Press. **Boas**, F. (1963). *The mind of primitive man.* New York: Collier Books. (Original work published 1911). **Boess**, S. & Kanis, H. (2008). Meaning in product use: A design perspective. In H.N.J. Schifferstein & P. Hekkert (Eds.), *Product experience* (pp. 305–332). San Diego: Elsevier. **Bornstein**, R.F. (1989). Exposure and affect: Overview and meta-analysis od research, 1968–1987. *Psychological Bulletin, 106*, 265–289. **Brown**, D.E. (1991). *Human universals.* Boston, MA: McGraw-Hill. **Brown**, T. (2009). *Change by design: How design thinking transforms organizations and inspires innovation.* New York: Harper Collins.**Buss**, D.M. (1994). The evolution of desire. New York: Basic Books. **Buss**, D.M. (Ed.)(2005). *The handbook of evolutionary psychology.* Hoboken, NJ: Wiley.

C

Campbell, D.T. (1960). Blind variation and selective retention in creative thought as in other knowledge processes. *Psychological Review, 67*, 380–400. **Csikszentmihalyi**, M. (1988). Motivation and creativity: Towards a synthesis of structural and energistic approaches to cognition. *New Ideas in Psychology, 6*, 159–176. **Cooper**, R.G. (1993). *Winning at new products*, Second edition. Reading, MA: Addison Wesley. **Cross**, N. (2008). *Engineering design methods: Strategies for product design*, 4th edition. Chichester: John Wiley and Sons. **Cross**, N.G., Christiaans, H.H.C.M. & Dorst, C.H. (Eds.) (1996). *Analysing Design activity.* Chichester: Wiley.

D

Damasio, A.R. (1994). *Descartes' error: Emotion, reason, and the human brain.* New York: Harper Collins. **Darwin**, C. (1979). *The origin of species.* New York: Random House. (Orginally published 1859). **Darwin**, C. (1871). *The descent of man, and selection in relation to sex.* London: Murray. **Dawkins**, R. (1976). *The selfish gene.* Oxford: Oxford University Press. **Dawkins**, R. (2009). *The greatest show on earth: The evidence for evolution.* London: Bantam Press. **Dennett**, D.C. (1995). *Darwin's dangerous idea.* New York: Touchstone. **Dennett**, D.C. (2006). *Breaking the spell: Religion as a natural phenomenon.* London: Allen Lane. **Desmet**, P.M.A. (2002). *Designing emotions.* Unpublished doctoral dissertation, Delft University of Technology. **Desmet**, P.M.A. (2008). Product emotion. In: H.N.J. Schifferstein and P. Hekkert (Eds.), *Product experience* (pp. 379–397). Amsterdam: Elsevier. **Desmet**, P.M.A. & **Hekkert**, P. (2007). Framework of product experience. *International Journal of Design, 1*, 57–66. **Desmet**, P.M.A., Ortíz Nicolás, J.C., & Schoormans, J.P. (2008). Product personality in physical interaction. *Design Studies, 29*, 458–477. **Dijksterhuis**, A. (2004). Think different: The merits of unconscious thought in preferences development and decision making. *Journal of Personality and Social Psychology, 87*, 586–598. **Dijksterhuis**, A. & Nordgren, L.F. (2006). A theory of unconscious thought. *Perspectives on Psychological Science, 1*, 95–109. **Dijksterhuis**, A. Bos, M.W., Nordgren, L.F., & van Baaren, R.B. (2006). On making the right choice: The deliberation-without-attention effect. *Science, 311*, 1005–1007. **Dominowski**, R.L. (1995). Productive problem solving. In S.M. Smith, T.B. Ward, & R.A. Finke (Eds.), *The creative cognition approach* (pp. 73–95). Cambridge, Mass: MIT Press. **Dunne**, T. & Raby, F. (2001). *The Placebo project.* Available at http://www.dunneandraby.co.uk/. [accessed 12 February, 2010]

E

Eibl-Eibesfeldt, I. (1989). *Human ethology.* New York: Aldine de Gruyter. **Eijk**, D. van (2007). *Cultural diversity & design.* Inaugural lecture, Delft University of Technology. **Ericsson**, K., & Simon, H. (1993). *Protocol analysis: Verbal reports as data* (2nd ed.). Boston: MIT Press. **Etcoff**, N. (1999). *Survival of the prettiest: The science of beauty.* New York: Doubleday.

F

Fagerberg, J. (2004). Innovation: A guide to the literature. In J. Fagerberg, D. Mowery, & R. Nelson (Eds.), *The Oxford handbook of innovations* (pp. 1–26). Oxford: Oxford University Press. **Frijda**, N. (1986). *The emotions.* Cambridge, MA: Cambridge University Press.

G

Gaynor, G. (1996). *Handbook of technology management*. New York: McGraw-Hill. **Gazzaniga**, M.S. and LeDoux, J.E. (1978). *The Integrated Mind*. New York: Plenum Press. **Gentner**, D. (1989). The mechanisms of analogical learning. In S. Vosniadou & A. Ortony (Eds.), *Similarity and analogical reasoning* (pp. 199–241). Cambridge: Cambridge University Press. **Gentner**, D., Holyoak, K.J., & Kokinov, B.K. (2001). *The analogical mind: Perspectives from cognitive science*. Cambridge, MA: The MIT Press. **Gibbs**, R. (2006a). *Embodiment and cognitive science*. New York: Cambridge University Press. **Gibbs**, R. (2006b). Metaphor interpretation as embodied simulation. *Mind & Language*, 21(3), 434–458. **Gibson**, J. J. (1979). *The ecological approach to visual perception*. Boston: Houghton Mifflin. **Gick**, M.L. & Holyoak, K.J. (1980). Analogical problem solving. *Cognitive Psychology*, 12, 306–355. **Gick**, M.L. & Holyoak, K.J. (1983). Schema induction and analogical transfer. *Cognitive Psychology*, 15, 1–38. **Gielen**, M.A., Hekkert, P. & van Ooy, C.M. (1998). Problem restructuring as a key to a new solution space: A sample project in the field of toy design for disabled children. *The Design Journal*, 1, 12–23. **Gijsbers**, Y. (1995). *Ontwerpgedachte en ontwerpproces* (Design thought and design process). Delft: Unpublished Master Thesis. **Gijsbers**, Y. & Hekkert, P. (1996). Making vision visible: Design thought and design process. *Proceeding of Doctorates in Design*, Volume 2. Delft University of Technology, Faculty of Architecture. **Goel**, V. & Pirolli, P. (1992). The structure of design problem spaces. *Cognitive Science*, 16, 395–429. **Goldschmidt**, G., Ben-Zeev, A. & Levi, S. (1996). Design problem solving: The effect of problem formulation on the solution space. In R. Trappl, *Cybernetics and systems '96: Vol. 1* (pp. 388–393). Vienna: Austrian Society for Cybernetic Studies. **Goldstein**, E.B. (2002). *Sensation and perception*, Sixth Edition. Pacific Grove, CA: Wadsworth. **Goswami**, A. (1996). Creativity and the quantum: A unified theory of creativity. *Creativity Research Journal*, 9, 47–61. **Govers**, P.C.M. (2004). *Product personality*. Doctoral dissertation, Delft University of Technology, The Netherlands. **Gundy**, A. van (1988). *Techniques of structured problem solving* (2nd ed.). New York: Van Nostrand Reinhold.

H

Hax, A. & Wilde, D. (1999). The Delta model: Adaptive management for a changing World. *Sloan Management Review*, Winter, 11–28. **Heidegger**, M. (1997). *Being and Time: A Translation of 'Sein und Zeit'*. New York: New York University Press. (Original Work Published 1926). **Heijden**, K. van der (1996). *Scenarios: The art of strategic conversation*. Dorchester: Wiley. **Hekkert**, P. (1996). The designer as a 'Hox gene': The origin and impact of vision in the evolution of design. *Proceeding of Doctorates in Design*, Volume 2. Delft University of Technology, Faculty of Architecture. **Hekkert**, P. (1997) Productive Designing: A Path to Creative Design Solutions. *Proceedings of the Second European Academy of Design Conference*, Stockholm, Sweden. **Hekkert**, P. (2006). Design aesthetics: Principles of pleasure in product design. *Psychology Science*, 48, 157–172. **Hekkert**, P. (2009). Something that is not moving is hard to perceive: On the primacy of universal human principles in design. *Proceedings of the 3rd IASDR conference*, Seoul, Korea. **Hekkert**, P. & Leder, H. (2008). Product aesthetics. In H.N.J. Schifferstein & P. Hekkert (Eds.), *Product experience* (pp. 259–285). Elsevier Science Publishers. **Hekkert**, P., Mostert, M., & Stompff, G. (2003). Dancing with a machine: A case of experience-driven design. *Proceedings of the 2003 International Conference on Designing Pleasurable Products and Interfaces* (pp. 114–119), Pittsburgh. **Hekkert**, P. & H.N.J. Schifferstein (2008). Introducing product experience. In H.N.J. Schifferstein & P. Hekkert (Eds.), *Product experience* (pp. 1–8). Amsterdam: Elsevier Science Publishers. **Hekkert**, P., Snelders, D. & van Wieringen, P.C.W. (2003). 'Most advanced, yet acceptable': Typicality and novelty as joint predictors of aesthetic preference in industrial design. *British Journal of Psychology*, 94, 111–124. **Hekkert**, P. & van Dijk, M.B. (2001). Designing from context: Foundations and applications of the ViP approach. In P. Lloyd & H. Christiaans (Eds.), *Designing in Context: Proceedings of Design Thinking Research Symposium 5*. Delft: DUP Science. **Hippel**, E. Von (1988). *The sources of innovation*. Oxford: Oxford University Press. **Hochberg**, J. & Brooks, V. (1962). Pictorial recognition as an unlearned ability: A study of one child's performance. *American Journal of Psychology*, 75, 624–628.

I J

Ijuri, Y., & Kuhn, R. (1988). *New directions in creative and innovative management: Bridging theory and practice*. New York: Ballinger/Harper & Row. **Janlert**, L.E. & Stolterman, E. (1997). The character of things. *Design Studies*, 18, 297–314. **Jansson**, D.G. & Smith, S.M. (1991). Design fixation. *Design Studies*, 12, 3–11. **Johnson**, M. (2007). *The meaning of the body*. Chicago: The University of Chicago Press. **Johnston**, V.S. (2003). The origin and function of pleasure. *Cognition and Emotion*, 17, 167–179. **Jones**, J.C. (1992). *Design methods*, 2nd edition. New York: John Wiley & Sons. **Ju**, W. & Takayama, L. (2009). Approachability: How people interpret door movement as gesture. *International Journal of Design*, 3, 77–86.

K

Karana, E., Hekkert, P. & Kandachar, P. (2009). Meanings of materials through sensorial properties and manufacturing

processes. *Materials & Design*, 30, 2778–2784. **Klooster**, S. & Overbeeke, C.J. (2005). Designing products as an integral part of Choreography of Interaction: the product's form as an integral part of movement. *Proceedings of Design and Semantics of Form and Movement* (pp. 23–35), Newcastle. **Krippendorff**, K. (2006). *The semantic turn: A new foundation for design*. Boca Raton: CRC Press. **Krippendorff**, K., & Butter, R. (1984). Product semantics: Exploring the symbolic qualities of form. *Innovation: The Journal of the Industrial Designers Society of America*, 3, 4–9. **Krippendorff**, K & Butter, R. (2008). Semantics: Meaning and contexts of artifacts. In H.N.J. Schifferstein & P. Hekkert (Eds.), *Product experience* (pp. 353–376). San Diego: Elsevier. **Kuhn**, R. (1993). *Generating creativity and innovation in large bureaucracies*. Westport: Quorum Books. **Kunst-Wilson**, W.R. & Zajonc, R.B. (1980). Affective discrimination of stimuli that cannot be recognized. *Science*, 207, 557–558.

L

Lakoff, G. & Johnson, M. (1980). *Metaphors we live by*. Chicago: University of Chicago Press. **Lazarus**, R.S. (1984). On the primacy of cognition. *American Psychologist*, 39, 124–129. **Norman**, D.A. (1988). *The psychology of everyday things*. New York: Basic Books. **Landin**, H. (2009). *Anxiety and trust and other expressions of interaction*. Unpublished doctoral thesis, Chalmers University of Technology, Göteborg, Sweden. **Leder**, H. & Carbon, C.C. (2005). Dimensions in appreciation of car interior design. *Applied Cognitive Psychology*, 19, 603–618. **LeDoux**, J. (1996). *The emotional brain*. New York: Simon & Schuster. **Lindgaard**, G., Fernandes, G., Dudek, C., & Brown, J. (2006). Attention web designers: You have 50 milliseconds to make a good first impression. *Behavior & Information Technology*, 25, 115–126. **Löwgren**, J. (2006). Pliability as an experiential quality: Exploring the aesthetics of interaction. *Artifact*, 1, 55–66. **Löwgren**,

J. & Stolterman, E. (2004). *Thoughtful interaction design. A design perspective on information technology*. Boston, MA: The MIT Press.

M

Martindale, C. (1984). The pleasures of thought: A theory of cognitive hedonics. *The Journal of Mind and Behavior*, 5, 49–80. **Martindale**, C. (1986). On hedonic selection, random variation, and the direction of cultural evolution. *Current Anthropology*, 27, 50–51. **Martindale**, C. (1990). *The clockwork muse: The predictability of artistic change*. New York: Basic Books. **McLaughlin**, S. (1993). Emergent value in creative products: Some implications for creative processes. In J.S. Gero & M.L. Maher (Eds.), *Modelling creativity and knowledge-based creative design* (pp. 43–90). Hillsdale, NJ: Lawrence Erlbaum. **McDonnell**, J. & Lloyd, P.A. (2009). *About: Designing: Analysing design meetings*. London: Taylor & Francis. **McManus**, I.C., Jones, A.L. & Cottrell, J. (1981). The aesthetics of colour. *Perception*, 10, 651–666. **Miller**, G.A. (1956). The magical number seven, plus or minus two: Some limits on our capacity for processing. *Psychological Review*, 63, 81–97. **Mumford**, M.D., Baughman, W.A., Threlfall, K.V., Supinski, E.P., & Costanza, D.P. (1996a). Process-based measures of creative problem solving skills: I. Problem construction. *Creativity Research Journal*, 9, 63–76. **Mumford**, M.D., Baughman, W.A., Supinski, E.P., & Maher, M.A. (1996b). Process-based measures of creative problem-solving skills: II. Information encoding. *Creativity Research Journal*, 9, 77–88. **Mumford**, M.D., Reiter-Palmon, R., & Redmond, M.R. (1994). Problem construction and cognition: Applying problem representations in ill-defined domains. In M.A. Runco (Ed.), *Problem finding, problem solving, and creativity* (pp. 3–39). Norwood, NJ: Ablex. **Murphy**, S. T., & Zajonc, R. B. (1993). Affect, cognition, and awareness:

Affective priming with optimal and suboptimal stimulus exposures. *Journal of Personality and Social Psychology*, 64, 723-739.

N O

Nisbett, R.E. & Wilson, T.D. (1977). Telling more than we can know: Verbal reports on mental processes. *Psychological Review*, 84, 231–259. **Norman**, D.A. (1988). *The psychology of everyday things*. New York: Basic Books. **Novick**, L.R. (1988). Analogical transfer, problem similarity, and expertise. *Journal of Experimental Psychology: Learning, Memory, and Cognition*, 14, 510–520. **Okuda**, S.M., Runco, M.A., & Berger, D.E. (1991). Creativity and the finding and solving of real-world problems. *Journal of Psychoeducational assessment*, 9, 45–53. **Özcan**, E. (2008). *Product Sounds: Fundamentals and Application*. Doctoral dissertation, Delft University of Technology, The Netherlands.

P

Pahl, G. & Beitz, W. (1996). *Engineering design: A systematic approach*, 2nd edition. London: Springer. **Parrott**, W.G. & Sabini, J. (1989). On the "emotional" qualities of certain types of cognition: A reply to arguments for the independence of cognition and affect. *Cognitive Therapy and Research*, 13, 49–65. **Perkins**, D.N. (1995). Insight in minds and genes. In R.J. Sternberg & J.E. Davidson (Eds.), *The nature of insight* (pp. 495–533). Cambridge, MA: MIT Press. **Petroski**, H. (1992). *The evolution of useful things*. New York: Vintage Books. **Pinker**, S. (2002). *The blank slate*. New York: Viking Penguin. **Pinker**, S. (2007). *The stuff of thought*. London: Penguin Books. **Pirsig**, R.M. (1974). *Zen and the art of motorcycle maintenance: An inquiry into values*. New York: Bantam Books. **Porter**, M. (1979). How competitive forces shape strategy. *Harvard Business Review*, March–April, 1–10, reprint 79208.

R

Rand, A. (1943). *The fountainhead.* New York: The Bobbs-Merrill Company. **Roozenburg**, N. & Eekels, J. (1995). *Product design: Fundamentals and methods.* Chichester: John Wiley and Sons. **Rompay**, T. van (2005). *Expressions: Embodiment in the experience of design.* Doctoral dissertation, Delft University of Technology, The Netherlands. **Rompay**, T. van, Hekkert, P., Saakes, D., & Russo, B. (2005). Grounding abstract object characteristics in embodied interactions. *Acta Psychologica, 119*, 315–351. **Runco**, M.A. & Charles, R. (1993). Judgements of originality and appropriateness as predictors of creativity. *Personality and Individual Differences, 15*, 537–546. **Russell**, J.A. (2003). Core affect and the psychological construction of emotion. *Psychological Review, 110*, 145–172.

S

Schifferstein, H.N.J. & Hekkert, P. (Eds.) (2008). *Product experience.* Amsterdam: Elsevier. **Schön**, D.A. (1983). *The reflective practitioner.* Basic Books: New York. **Schumpeter**, J. (1926). *Theorie der Wirtschaftlichen Entwicklung*, zweite neubearbeitete Auflage. München: Ducker & Humbolt. **Schwartz**, P. (1991). *The art of the long view: Planning for the future in an uncertain world.* New York: Doubleday. **Simon**, H.A. (1996). *The sciences of the artificial*, 3rd edition. Cambridge, MA: MIT Press. **Simon**, H.A. (1988). Creativity and motivation: A response to Csikszentmihalyi. *New Ideas in Psychology, 6*, 177–181. **Sleeswijk Visser**, F., Stappers, P.J., van der Lugt, R. & Sanders, E.B.-N. (2005). Contextmapping: Experiences from practice. *CoDesign, 1*, 119–149. **Smith**, S.M., Ward, T.B., & Schumacher, J.S. (1993). Constraining effects of examples in a creative generation task. *Memory & Cognition, 21*, 837–845. **Snoek**, H., Christiaans, H. & Hekkert, P.

(1999). The effect of information type on problem representation. *Proceedings of 4th International Design Thinking Research Symposium* (pp II.101–112). Boston, MA. **Snoek**, H. & Hekkert, P. (1998). Directing designers towards innovative solutions. In B. Jerrard, M. Trueman & R. Newport (Eds), *Managing new product innovation* (pp 167–180). London: Taylor & Francis. **Steadman**, P. (1979). *The evolution of designs: Biological analogy in architecture and the applied arts.* Cambridge: Cambridge University Press.

T

Teece, D.J. (1986). Profiting from technological innovation: Implication for integration, collaboration, licensing and public policy. *Research Policy, 15*, 285–305. **Tomasello**, M. (1999). *The cultural origins of human cognition.* Cambridge, MA: Harvard University Press. **Tooby**, J. & Cosmides, L. (1992). The psychological foundations of culture. In J. Barkow, L. Cosmides, and J. Tooby (Eds.), *The adapted mind* (pp. 19–136). New York: Oxford University Press. **Tooby**, J. & Cosmides, L. (2005). Conceptual foundations of evolutionary psychology. In D.M. Buss (Ed.), *The handbook of evolutionary psychology* (pp. 5–67). Hoboken, NJ: Wiley.

U V

Urban, G.L., Hauser, J.R., Qualls, W.J., Weinberg, B.D., Bohlmann, J.D., & Chicos, R.A. (1997). Information Acceleration: Validation and Lessons from the Field. *Journal of Marketing Research, 34*, 143–53. **Verbeek**, P. and Kockelkoren, P. (1998) The things that matter. *Design Issues, 14*, 28–42. **Verganti**, R. (2008). Design, meanings, and radical innovation: A meta-model and a research agenda. *The Journal of Product Innovation Management, 25*, 436–456. **Verganti**, R. (2009). *Design driven innovation: Changing the rules of competition by radically innovating what things mean.* Boston, MA: Harvard

Business School Corporation. **Vihma**, S. (1997). Semantic qualities in design. *Formdiskurs, 3*, 28–41. **Vincenti**, W.G. (1993). *What engineers know and how they know it: Analytical studies from aeronautical history.* Baltimore: The Johns Hopkins University Press. **Vining**, D.R. (1986). Social versus reproductive success: The central theoretical problem of human sociobiology. *Behavioral and Brain Sciences, 9*, 167–216. **Vosniadou**, S. & Ortony, A. (1989). *Similarity and analogical reasoning.* Cambridge: Cambridge University Press.

W Z

Warneken, F. & Tomasello, M. (2009). The roots of human altruism. *British Journal of Psychology, 100*, 455–471. **Whitfield**, T.W.A. (2007). Feelings in design: A neuroevolutionary perspective on process and knowledge. *The Design Journal, 10*, 3–15. **Whitfield**, T.W.A., & Slatter, P.E. (1979). The effects of categorization and prototypicality on aesthetic choice in a furniture selection task. *British Journal of Psychology, 70*, 65–75. **Wilson**, T.D. (2002). *Strangers to ourselves: Discovering the adaptive unconscious.* Cambridge, MA: The Belknap Press. **Wilson**, T.D., Lisle, D, Schooler, J.W., Hodges, S.D., Klaaren, K.J., & LaFleur, S.J. (1993). Introspecting about reasons can reduce post-choice satisfaction. *Personality and Social Psychology, 60*, 181–192. **Wright**, P., McCarthy, J. & Meekison, L. (2003). Making sense of experience. In M.A. Blythe, A.F. Monk, K. Overbeeke & P.C. Wright (Eds.), *Funology: From usability to enjoyment* (pp. 43–53). Dordrecht: Kluwer Academic Publishers. **Zajonc**, R. B. (1968). Attitudinal effects of mere exposure. *Journal of Personality and Social Psychology, Monograph Supplement, 9*, 1–27. **Zajonc**, R.B. (1980) Feeling and thinking: Preferences need no inferences. *American Psychologist, 35*, 151–175.

Glossary

A

Adaptation
Metaphorically, adaptation refers to a product's '*fitness*', or suitability, to the context for which it is designed. Contrary to the biological origin of the term, adaptation in design is a deliberate act by the designer; in ViP, the designer shapes both the context and the product adapted to it. The 'fit' between product and context is established through and within the *interaction*, making it the logical intermediate point between the two.
→ p. 278, 304

Aesthetics
Principles of aesthetics play a crucial role in assessing the quality of decisions made within and between the stages of ViP. Predominant among these is the principle of maximum effect for minimum means: a solution or idea is considered beautiful when only a few parameters or assumptions can explain/describe a range of phenomena.
→ p. 180, 278

Principles of aesthetics can also play a role as *factors* within a *context*, since they determine the aesthetic appreciation and acceptance of the final design. In treating aesthetic principles at the context level (and not as product requirements), we acknowledge that product *manifestations* of these principles change over time, due to changes in the underlying characteristics (e.g. expertise, sensitivity).
→ p. 93, 148, 291, 304

Appropriateness
A final design (product) is appropriate when it optimally *fits* in with or is *adapted* to the *context* for which it is designed. The assessment of appropriateness is therefore always relative to the context built.
→ p.78, 86, 162

Authenticity
Only by staying 'true to himself' the designer can make his context personal and distinctive, and the ultimate outcome *original* and impassioned.
One of the three main values underlying the ViP approach, together with *freedom* and *responsibility*.
→ p. 17, 78, 132, 204

Awareness
By being aware or conscious of all decisions made (at every level of the process) the designer can overcome any implicit assumptions that may creep in. If a designer wants full responsibility for her choices and actions, she needs to be aware of them.
An important value in ViP, very much related to *authenticity* and *responsibility*.
→ p. 17, 94

C

Coherence
Refers to the logic of both the process and the connections within and between the three levels of *context*, *interaction* and product. If these connections are coherent – *aesthetically* sound – the final product naturally fits into the context it has been based on.
Related to the concepts of *adaptation* and *appropriateness*.
→ p. 159, 296

Coherence is also the driving force when structuring a context. *Context factors* must be brought into a coherent whole to understand any and all contextual interrelations.
→ p. 62, 102, 148

Concerns
A 'container concept' adopted from emotion psychology. It covers people's goals and desires (*needs*) and our values and norms (standards), and sometimes also includes our likings, attitudes or taste. Concerns can be reflected in various *context factors* (e.g., as a principle, as in 'the goal of survival'; or a development, as in 'our growing need for healthy food'). At the *interaction* level, specific product related concerns are implicitly defined at the human end of the human-product relationship.
→ p. 38, 308

Concepting
Concepting is about the translation of a *vision* into a *manifestation*. It involves both generating the concept idea and concept design, a definition of the features that can literally be perceived, used and experienced.
→ p. 54, 111, 166

Concept testing
Testing a concept that does not fit the current *context*, but is expected to fit a new and future one, requires different tools and methods. An appropriate test needs to bring people to a new mindset that is defined by the context underlying the concept.
→ p. 176

Constraints
Many design assignments come with constraints or requirements, about price, production method, available technology, etc., which of course determine what the final product can and cannot be. Such limitations should be taken into account as late in the process as is acceptable, in order to provide the designer with the *freedom* needed to conceive the most *appropriate* response.
Constraints – of any kind – should have as small an effect as possible on concept generation.
→ p. 10, 16, 174

Context
The context consists of a number of carefully selected *factors* (*principles, states, developments,* and *trends*), which have been deemed relevant and interesting with respect to the defined *domain*, and

brought into a *coherent* structure. Building the context is the first stage in the ViP design process; it is the frame of reference on which all further design decisions are based.
➔ p. 38, 97, 124, 204, 230

Creativity
The ViP method is constructed in such a way as to optimize the creative skills of the designer. It therefore builds on studies that describe how creativity is limited or enhanced.
➔ p. 80, 284, 317

D

Deconstruction (or 'destructuring')
The designer is required to ask himself *why* existing solutions and current interactions in the domain are what they are. In this way, she frees her mind from preconceptions, and regresses to the *context* level, where she can start to discuss the legitimacy and relevance of the old context *factors*.
Often carried out at the first stage of any ViP process, to overcome *fixation* with existing solutions as a result of the *design brief*. Although it may not always be necessary to go through the deconstruction stage, it is a comfortable way to 'get one's bearings'.
➔ p. 86, 90, 120, 134

Development
Changing or unstable pattern in the environment or in the *concerns* of people in general. Developments can refer to technological, economic, societal, environmental, cultural, etc. changes in the world around us. They can be found in any media source (newspapers, internet, TV, etc.) and, if adopted into a context, can have a profound impact on the final design. One type of *factor* included in a *context*.
➔ p. 97, 142, 233

Domain
The domain is the focus area of the design process and is normally defined in the *design brief*. Before a designer starts collecting factors, he must set the domain for which the chosen factors will be relevant. A domain can vary from a particular product for a predefined group, such as "a wheelchair for children" to (preferably) a particular area in life, such as "working at home" or "social cohesion".
➔ p. 87, 137, 232

E

Emotions
According to prevailing appraisal theories on emotion, emotions arise when an event (such as seeing or using a product) matches or conflicts with one of our *concerns*. The *interaction* with a product can thus give rise to a repertoire of emotions and the emotion envisioned is often (indirectly) represented in the vision on the interaction.
➔ p. 216, 296, 307

Empathy
With its strong emphasis on human-oriented *principles* and *developments* at the *context* level, ViP requires the designer to have a deep understanding of and empathy with people's motives, drives, and *concerns*. This is not to say that users (we prefer to talk about people; at the context stage there is nothing to use yet!) should be involved in the design process (see *user involvement*).
➔ p. 183

Experience
One of the buzzwords of current design practice, a 'product experience' can be tentatively defined as the entire set of effects arising from the **interaction** between a user and a product, including the degree to which our senses are gratified [*aesthetic experience*], the meanings we attach to the product [*experience of meaning*], and the feelings and emotions that are elicited [*emotional experience*].

Given this close relationship between interaction and experience, ViP can also be considered an *experience-centered* design approach.
➔ p. 242, 252

F

Factors
Factors are the building blocks of any *context*: the observations of patterns in the world that are selected (by the designer) as relevant to the established *domain* and its *scope*. These patterns can be (relatively) stable, referred to as *principles* and *states*, or unstable, referred to as *developments* and their accompanying *trends* in human behaviour.
➔ p. 10, 62, 97, 141, 230

Fit
In ViP, a designer reasons from context to product, to ensure that the final design is an appropriate response to the context. If successful, the result naturally fits, or *suits* the interaction, and the interaction fits the context.
➔ p. 86, 176, 278

Fixation
Designers, like all people (including users), suffer from fixation. As soon as a *design brief* is presented to them, they will immediately see a range of existing solutions to similar problems. To overcome any predisposition to imagining existing solutions, a process of *deconstruction* may help a designer 'descend to' the context level of a design.
➔ p. 62, 233, 284

Framing (and Reframing)
A concept borrowed from Schön (1983) that refers to a designer's inclination to selectively view a design situation in a particular way ("seeing as"). In the first stages of the ViP process – domain setting and context building – the

designer is guided to carefully and deliberately frame (and reframe) the design situation he is working on/in.
→ p. 10, 217, 234

Freedom
Refers to the emptying of a designer's mind (as much as possible) of any preconceptions and constraints, in order to take *deliberate* and *authentic* action. One of the three main values underlying the ViP approach, together with *authenticity* and *responsibility*.
→ p. 16, 48, 78, 87, 217, 222

I

Innovation
Inventing an appropriate and novel (= original) response to the context as defined.
→ p. 52, 223, 288

Interaction
How a product is used or how it otherwise interfaces with the *context*. Defining it is the crucial intermediate stage in any ViP process.
Based on the desinger's view of the context and the *statement/opinion* formulated; the designer must try to conceptualise the *qualities* of the interaction that will meet the set goal. This conceptualisation is often referred to as the interaction *vision*, and can come in many forms: words, images, scenarios, movements, etc. This vision of the interaction guides the formation of *product characteristics*, the subsequent product concept, and its *manifestation*.
→ p. 50, 104, 122, 158, 190, 214, 240

Intuition
The ViP process allows designers to rely heavily on intuition, the pre-conscious knowledge that has not (yet) entered awareness.
Intuition as such can, however, never be used as a given; the designer must always analyse, explain, and substantiate the value of intuitive ideas.
→ p. 79, 313

M

Manifestation
Interaction and product *visions* developed during a ViP process not only guide the designer towards a new concept, but can subsequently be used to make decisions at the level of a product's manifestation. The vision is the central idea that sets every detail.
Includes materialisation, use cues, appearance, tactile qualities, expression, sound, etc.
→ p. 60, 172, 177

Meaning
A central premise of ViP is that products obtain their meaning through *interaction* with people, and this meaning should be *appropriate* to the context defined. As one of the constituents of any *experience*, it is thus reflected in the *interaction vision*: the kind of meaning the (future) user will give to the to-be-designed product.
→ p. 68, 163, 248

N O

Needs
Most often used in marketing as a basis for new product development, where needs are often disconnected from the context, leading to inappropriate proposals. One type of *concern* often represented in the list of selected *context factors*.
→ p. 18, 62, 240, 287

Originality
If the ViP process is applied properly, the end result is *appropriate* (for the *context*) and often novel, especially when the context *factors* selected have not been considered before in the *domain* at hand. This combination of appropriateness and novelty defines an original or inno-
vative design; although originality is not a condition, it is (thus) most often the result of a ViP process.
→ p. 18, 78, 144

P

Possibilities
With its strong emphasis on building a new *context* as the starting point for a design process, we claim that ViP is *not about solving problems* (with current products), as most design methods are, but about exploring possibilities. The final solution may of course also solve problems people have today, but this is not the primary goal.
→ p. 16, 204

Principles
The (more or less) *stable patterns* in life, from physical and biological to social and psychological; they can be laws of nature and – most often – fundamental human concerns or patterns of behaviour. Because of their resistance to change they are often overlooked in so-called 'scenario approaches' to design. This same resistance makes principles the primary type of factor to consider when looking reasonably far into the future where predictions about *trends/developments* become notoriously unreliable.
→ p. 62, 142, 208, 233, 300

Product qualities
The character of the to-be-designed product. The product characteristics that reveal *qualitatively* what the new product should express and afford in order to evoke the desired interaction.
→ p. 48, 109, 163, 248

Q

Qualities
Both the *interaction* and product *vision* refer to the qualitative characteristics – not physical properties – as perceived or experienced by a person. For example,

the interaction can be characterized by 'anxious exploration', the related product characteristic could be one of 'strangely familiar': when a product is strangely familiar, it may stimulate the user to explore it anxiously.
→ See *Interaction* and *Product qualities*

Raison d'être
The *context* created and the resulting *statement*/*opinion* form the reason of existence (*raison d'être*) for the product that is to be designed.
One can always explain why the final product is what it is on the basis of this foundation; only in this light a product can be evaluated as *appropriate*.
→ p. 16, 132

Relationship
An interaction can be conceived as the relationship between a person and a lifeless product. The person and product bring their own qualities to the relationship, together determining the quality of the interaction.
→ p. 42, 158

Requirements
→ See *constraints*

Responsibility
We believe a designer must take full responsibility for design decisions, the final product, and the impact it has on people and society. A designer should never be allowed to put the reasons for any decision or actions outside herself, blaming the wrong assumptions of a client or the limited view of would-be users, for example. To be able to act responsibly, the designer must be very much *aware* of (the consequences of) all his choices and actions. One of the three main values underlying the ViP approach, together with *freedom* and *authenticity*.
→ p. 17, 78, 236

Statement (opinion)
In the statement, the designer defines what he wants to accomplish for people. The ViP *context* describes the *coherence* between a set of *factors* considered relevant to and important for the *domain*, but carries no value judgements. In order to be able to proceed, the designer must take a stand, and define how he wants to respond to this context view: what should people experience, understand or be able to do, given the context?
This position (or statement) can be seen as the design goal.
→ p. 68, 102, 154

States
Refers to phenomena that appear as fixed, but do not need to be so in the long run. One could think of the Western value of "freedom of speech".
Together with *principles*, states are the stable *factors* included in any *context*.
→ p. 62, 142, 233

Thinking/feeling
To think out and logically clarify what one intuitively feels as right or important and, ipso facto, to be sensitive to the consequences of decisions taken rationally. Taking a step forward often starts with a feeling, and is followed by an understanding of why this step ahead is *appropriate*.
One of the major challenges for a ViP designer is to strike a balance between feeling and thinking.
→ p. 18, 78, 296

Trends
Trends are reflections of *developments* in human behaviour and can also be considered as *factors* in a *context*. When the economy goes down (a development), people spend less money on luxury goods (a trend). Note that the combination of a development and a trend can in itself be a *principle*!
→ p. 97, 142, 233

User involvement
Within ViP, user involvement is often restricted to collecting new context factors and/or testing the final concept or design. If needed, designers can observe people, talk to people and even consult people, but these responses should in no way limit the *freedom* or take away the *responsibility* of the designer. *Empathy*, understanding people, and humanism are not synonymous with user involvement.
→ p. 183

Vision
A vision is a view of something to come. *Vision* in Product design (ViP) thus refers to a view on what the to-be-designed product should do and be, before it has been conceived. This vision consists of a *statement* describing what to offer people, and a *definition* of how this goal is to be attained through specified *interaction* and *product qualities*. In this vision, the contour of the new product is laid down.
→ p. 46, 68, 132, 156, 163, 166, 177, 314

Acknowledgments

Jianne Whelton > Who or what prompted you guys to try and formalise your thinking? Where did ViP start? *Matthijs van Dijk* < Right from the start, I think it is important to give credit to the person who asked us to think about this approach: **Jan Jacobs**. He was our professor of Applied Design, and he was intrigued by the gap between how a designer works and what design methodologies offer. *Jianne Whelton* > So it was in conversation with Jan? *Paul Hekkert* < Well, Jan encouraged us – his two young (at the time) brains – to start looking into that gap. *Matthijs van Dijk* < Yeah, a combination of a psychologist and a designer... *Jianne Whelton* > Your taskmaster... *Paul Hekkert* < Jan was our professor, and our boss. *Jianne Whelton* > Was it just the two of you? *Matthijs van Dijk* < At the start it was only the two of us, but very soon we started to work with **Yvon Gijsbers**, who was a graduate student at the time. *Jianne Whelton* > Her brain must have been useful. *Matthijs van Dijk* < It is impressive when a student trains her mind on one subject; there is so much new, relevant knowledge and so many insights she can come up with. This was the case with Yvon. *Paul Hekkert* < She was a very clever student; she was very much interested in the theoretical, philosophical and methodological ideas behind both design and change processes. She wrote an incredible thesis that is still highly relevant to this day! She developed many of the ideas that are now part of ViP. ViP was just an idea – a hunch – at the time... we're talking 1995! *Paul Hekkert* < An exceptional case indeed. *Jianne Whelton* > You owe her a real debt of gratitude... *Paul Hekkert* < We do. *Matthijs van Dijk* < Absolutely. *Jianne Whelton* > She's not the only student to have contributed to ViP's development,

right? *Paul Hekkert* < Since the development of ViP into some form of method, let's say around 1997, many many students have worked with it for our electives, as graduate projects and during all kinds of workshops. We are indebted to each and every one of them for the time they contributed to its development by doing and reflecting. *Jianne Whelton* > So it's been an ongoing process... *Matthijs van Dijk* < ...where some of them introduced new notions and concepts that we have actually integrated into ViP. *Jianne Whelton* > What about your academic peers? *Paul Hekkert* < Some colleagues have really helped to sharpen our thoughts and ideas over the years... *Matthijs van Dijk* > One of them is **Pieter Desmet**, who specialized in the emotional response to products. *Paul Hekkert* < Pieter has been our partner on ViP projects for years, and as a designer and academic himself, he has helped us enormously to improve the structure of our approach. *Matthijs van Dijk* < Don't forget **Nynke Tromp**! *Paul Hekkert* < Impossible. Nynke was a grad student and is now expanding ViP for her PhD research. She did this wonderful project where she applied ViP in a social context. She is of the same rare species as Yvon, someone who can analyse and create at a high intellectual level. *Matthijs van Dijk* < There were also a lot of other colleagues who helped us teach ViP, so they came up with all kinds of ways to improve the approach; not to mention the fact that they were even willing to start working with ViP in the first place! *Paul Hekkert* < And the skeptics! The critics! They have helped us tremendously! *laughs Jianne Whelton* > You mean that not everyone recognized the usefulness of the approach?!? *Paul Hekkert* < Not always, and not directly, but I think it is quite accepted and respected by now... *Matthijs van Dijk* < Thanks to them we started to emphasize the more unique aspects of ViP, instead of simply addressing its differences in relation to

existing methodologies. *Jianne Whelton* > Unify instead of divide? *Paul Hekkert* < Right. *Jianne Whelton* > So the university must have seen the value in your efforts; is that how the book idea came about? Tell me about how the people who recognized the value of ViP helped you concretely, or shall we say...materially. *Paul Hekkert* < The school recognised the value of our approach and encouraged us to lay it down in a book. *Matthijs van Dijk* < Our dean, **Cees de Bont**, was a main source of motivation! *Jianne Whelton* > Talk is cheap... *Matthijs van Dijk* < He also stimulated us by allocating the money we needed to start working on the book! In the end, it's all about money! *laughs Paul Hekkert* < To get the book started, we first contacted **Peter Lloyd** from the Open University. He is an expert in design methodology, and we very much felt we needed such expertise to shape the book and the method. *Jianne Whelton* > So Peter helped you with the methodology – the theory – and, of course, the pedagogy... *Matthijs van Dijk* < Peter was our sounding board, and an integral part of our reflection. We discussed a lot of ideas with each other, and Peter played a major role in many of the dialogues that are in the book. As such, he clarified what the unique qualities of ViP are. *Paul Hekkert* < Peter also played a decisive role in the format the book finally took. We were sceptical at first, but now we believe he put us on the right track. It took several dinners to see this... *Matthijs van Dijk* < Another academic designer who supported our book and ideas was **Kees Dorst**. *Jianne Whelton* > Another professor? *Paul Hekkert* < He's at UTS in Sydney. Like Nynke, who looked into the first draft of the book and unerringly revealed all its shortcomings, Kees read various parts and gave painful comments...helpful ones too... *Matthijs van Dijk* < ...and our colleague **Gerda Gemser** upgraded a particular text we were not comfortable with. *Jianne Whelton* > One of the

'coolest' aspects of this book, and the emergence of the ViP approach actually, is that it incorporates three perspectives: theoretical, academic and *practical*. *Paul Hekkert <* On the practical side we have had great support from **Jeroen van Erp**. He not only allowed me to use his office, where I spent most of the last few months finishing the manuscript, but also uses ViP (the 'light' version) in his design firm, and is constantly saying that ViP is so easy to apply... *Jianne Whelton >* He proves your theories for you. *Paul Hekkert <* Yeah, in a down to earth, client-oriented way. *Jianne Whelton >* A living lab…like KVD? *Paul Hekkert <* Right, the real thing is done at KVD, Matthijs' office. There they use ViP to the max…apply it in every detail. Many examples are in the book… If you want to work at KVD, you have to take, and pass, all the ViP exams! *Jianne Whelton >* I was just about to ask if people get a crash course when they are hired... *Matthijs van Dijk <* We catch them if they fall... **Gijs Ockeleon**, my business partner, is very enthusiastic about ViP, because working with ViP underscores the place of humans in the world. Gijs really was and is very important to me: he kept on pushing the relevancy the book would have for designers in general. *Jianne Whelton >* Which of the employees actually helped with the nuts and bolts of this book? *Matthijs van Dijk <* **Femke de Boer** collected and made all images for the book.... *Paul Hekkert <* …meticously and sensitively, bringing in many new and bright ideas for images. *Matthijs van Dijk <* ...and one thing I also want to address is the trust our client companies had in ViP. The proof is only in the pudding after all...it is nice to feel that companies are so open to working on content! *Paul Hekkert <* But then to actually write a book...we needed different people... *Matthijs van Dijk <* One that comes to mind instantly is **Rudolf van Wezel**, the publisher of the book, who believes in a new role for designers in society. *Paul Hekkert <* And he has always believed in the book, and us, and we are eternally grateful for his support. But we did have to actually write it…which took us a couple of years... *Matthijs van Dijk <* Four years, Paul. *Jianne Whelton >* Where did you find the time? The space? *Matthijs van Dijk <* In between everything else... *Paul Hekkert <* …and when we finally had a draft, we found the best copy-editor we could dream of. She, **Jianne Whelton**, "jazzed up" the book in a way that went beyond the normal duties of a copy-editor. She made us sound English! *Jianne Whelton >* Thanks, guys. *Matthijs van Dijk <* That goes double for me! And then of course we had to think about the concept, and the actual physical manifestation of the book. While at a conference in Hong Kong, we heard a lecture by **Irma Boom**. She was speaking from the heart, the heart of a graphic designer in this case. We thought: she is the one! *Jianne Whelton >* Have we covered everyone? *Paul Hekkert <* Well, even though it sounds like a horrible cliché, authors thanking their families for all the suffering they had to endure while they were writing and writing... *Jianne Whelton >* because words are never enough *Paul Hekkert <* …nevertheless, I am very grateful to Mira, Darwin and Bodhi for sticking by me, all the time, and giving me the space I needed to do my thing, writing this book. *Matthijs van Dijk <* I also was thinking with whom to finish… In the end, I have to thank **my mother**! Throughout her career as a professional piano player, she showed me how to live out the talents you have and accept the consequences for them.

Colophon

Authors
Paul Hekkert and Matthijs van Dijk

Concept and design
Irma Boom and Julia Neller

Copy editor
Jianne Whelton

Image editor
Femke de Boer

Photography
p. 71: www.flickr.com/photos/
storem/497829378
p. 139: www.flickr.com/photos/
yourdon/3742695994
p. 185: Bram Budel
p. 195, 197, 199, 201, 203: Peter Lloyd
p. 265, 267: Roel Visser

Dividers, in order of appearance:
Femke de Boer
Edoardo Costa
Hanchul Jung
Hanchul Jung
www.flickr.com/photos/
rosino/2818375882
Bart Baekelandt
www.flickr.com/photos/
takomabibelot/3598975647
www.flickr.com/photos/udono/408633225
www.flickr.com/photos/
pjanvandaele/4034179415
Beatrix Haeger
Femke de Boer
www.flickr.com/photos/
hamed/303386242
Bart Baekelandt
Femke de Boer
Thomas Visser
www.flickr.com/photos/
michale/119346559
www.flickr.com/photos/
liquene/3794258121
www.flickr.com/photos/
faceme/4344196396
www.flickr.com/photos/cosmic_
bandita/2148146594
www.flickr.com/photos/cosmic_
bandita/2148146594

All flickr photo's published under
a Creative Commons license

BIS Publishers
Borneostraat 80-A
1094 CP Amsterdam
The Netherlands
T (31) 020 515 02 30

bis@bispublishers.com
www.bispublishers.com

3rd printing 2021
ISBN 978-90-6369-371-8

Copyright © 2011 Paul Hekkert, Matthijs van Dijk and BIS Publishers

All rights reserved. No part of this publication may be reproduced or transmitted in any form or by any means, electronic or mechanical, including photocopy, recording or any information storage and retrieval system, without permission in writing from the copyright owners.

While every effort has been made to trace all present copyright holders of the material in this book, any unintentional omission is hereby apologized for in advance, and we should of course be pleased to correct any errors in acknowledgements in any future edition of this book.